After the Revolution Women Who Transformed Contemporary Art

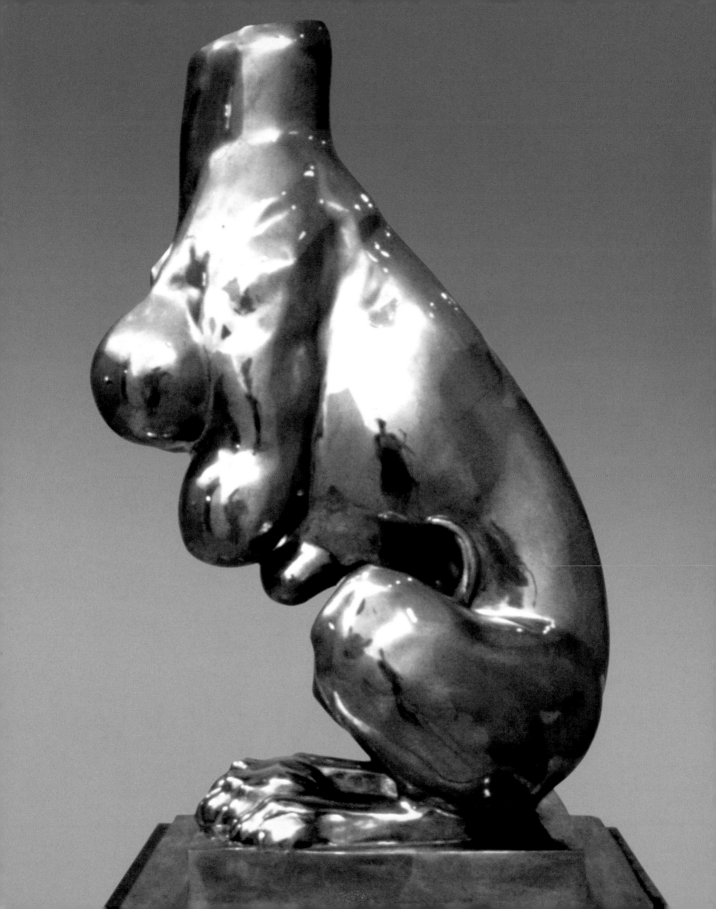

After the Revolution Women Who Transformed Contemporary Art

Eleanor Heartney

Helaine Posner

Nancy Princenthal

Sue Scott

With a Foreword by

Linda Nochlin

PRESTEL

Munich · Berlin · London · New York

Front cover: Kiki Smith, *Lilith*, 1994. see p. 199
Frontispiece: Louise Bourgeois, *Nature Study*, 1984.
Bronze and polished patina, 30 x 19 x 15 in.
(76.2 x 48.3 x 38.1 cm). Whitney Museum of
American Art, New York. Courtesy Louise Bourgeois
Studio. Photo: Allan Finkelman

© Prestel Verlag, Munich · Berlin · London · New York.
2007
© for the text by Eleanor Heartney, Helaine Posner,
Nancy Princenthal, and Sue Scott. 2007
For illustrations of works of art under copyright refer
to picture captions.

Prestel Verlag
Königinstrasse 9
D-80539 Munich
Tel. +49 (89) 38 17 09-0
Fax +49 (89) 38 17 09-35

Prestel Publishing Ltd.
4, Bloomsbury Place
London WC1A 2QA
Tel. +44 (0) 20 7323-5004
Fax +44 (0) 20 7636-8004

Prestel Publishing
900 Broadway. Suite 603
New York, N.Y. 10003
Tel. +1 (212) 995-2720
Fax +1 (212) 995-2733
www.prestel.com

Prestel books are available worldwide. Please con-
tact your nearest bookseller or one of the above
addresses for information concerning your local
distributor.

Library of Congress Control Number: 2007920962

British Library Cataloguing-in-Publication Data:
a catalogue record for this book is available from the
British Library. The Deutsche Bibliothek holds a
record of this publication in the Deutsche National-
bibliografie; detailed bibliographical data can be
found under: http://dnb.ddb.de

Editorial direction by Christopher Lyon
Editorial assistance by Reegan Finger and
Brandon Peterson
Copyedited by Mary Christian
Cover and design by Liquid, Augsburg
Layout and production by Stephan Riedlberger,
Munich
Origination by Reproline mediateam, Munich
Printed and bound by MKT Print, Ljubljana

Printed on acid-free paper
ISBN 978-3-7913-3732-6

Contents

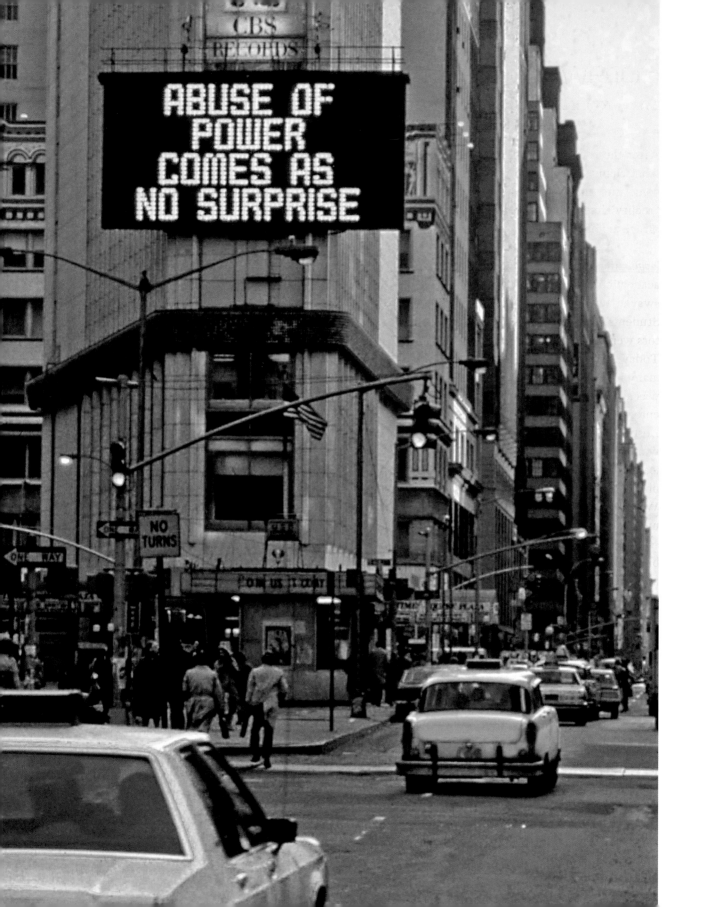

Foreword

LINDA NOCHLIN

After the revolution comes the reckoning. Exactly what has been accomplished, what changed? What individuals or groups, previously repressed or ignored now come into the foreground, gain status and confidence? How has the nature of "reality" itself changed as a result of the revolution, peaceful in this case, that took place, and has continued, as a result of the feminist movement in art?

A great deal has changed, not just in the art world, but also in the world at large, since the first feminist manifestations and manifestoes of the seventies. Any academician of my age remembers, for example, the strict parietal rules that held sway at Vassar College when I went there and started teaching in the early fifties. Students, all women of course, had to sign in and out to leave overnight. Male visitors were allowed access to a student's room only if the door was partially opened. Today students have co-ed dorms and total freedom to come and go as they will; many live off campus with groups of their own choosing. More seriously, when I was a freshmen, two young women students committed suicide because they had entered into Lesbian relationships; today, in the same college, there is a Gay and Lesbian center that holds dances and puts out a newsletter. When I was a young woman, a woman doctor was a rarity. When my female cousin wanted to go to medical school, there was more or less one choice: a women's medical school in Philadelphia. Today, it is as normal to have a woman doctor or lawyer as to have a male one. When I was young, the presence of blacks in a restaurant or a theater was practically unheard of; today it is totally accepted, indeed, unnoticed. Back in the fifties, a person of color as a fashion model or a talk show host would have been unthinkable; a black family advertising soap flakes or cereal impossible—today it seems totally "natural" to have an Oprah Winfrey or a Naomi Campbell, or a black family advertising some product on the TV screen.

In a sense, the most profound results of a revolution are those that have become so assimilated and normalized that they are no longer noticed, have become part of the unconscious fabric of our lives. Of course, there are exceptions—gay bashing, anti-Semitism, color prejudice. But in terms of cultural practice, things have changed mightily. The powerful presence of women artists within the world of contemporary art has become an accepted fact. Yet it is important to locate its genesis within the context of the broader social and cultural revolutions—black, gay, feminist, post-colonial—that have taken place since the seventies and are still ongoing.

Still, contemporary women artists as a group need to be singled out for critical attention. This is partly because their work has been less studied than that of some of their male colleagues and partly because only by taking them as a group can the range and variety of their stylistic and expressive projects be understood. For it

JENNY HOLZER
Times Square Sign, 1982
© 2007 Jenny Holzer, member
Artist's Rights Society (ARS),
New York

is difference rather than similarity that is at stake here. No subtle or summarizable "essence" of femininity unites the work of Louise Bourgeois, Jenny Holzer, and Marina Abramović. On the contrary, all their work is marked by extreme divergence of media, style, and implication. Indeed, in many cases, like that of Louise Bourgeois or Cindy Sherman, for example, the work itself is marked by extreme diversification. Can we unite the film stills of Sherman's early career with the horror shows of her later career? And how do we assimilate Louise Bourgeois's multipart Cells with her delicate marble carvings?

What unites all the artists considered in these essays, though, is originality, invention, complexity, and a certain oppositional stance, whether it be Sherman's deconstruction of the myth of a single, fixed identity or Shirin Neshat's refusal to attach her work or her attitudes to a single national or ethnic culture. None of these women artists is creating so-called "positive images" of women or "great goddesses," thereby perpetuating existing stereotypes; their practice might be said to be critical rather than positive, a characteristic marking much of the post-modernist enterprise of our time. All of them have created new formal languages to express intensely new ideas, or rather, the new formal languages and the new ideas have come into being together, as they must in any kind of original art.

Finally, all of these artists occupy important, indeed, in some cases, major positions in the art world today, internationally as well as domestically. Younger artists, male and female, look to their work as a source of inspiration and stimulation, as they once looked to male artists alone. As the inspiration to future generations of artists, these women artists bear witness to the revolution that has taken place in art. Whether they are "great" or not is beside the point today; there is something stodgy and fixed about the very word "great," something that smells of the past and tradition. Leave greatness to Michelangelo and Cézanne, if you will. They are dead and gone. For the women artists considered in this book, it is vitality, originality, malleability, an incisive relationship to the present and all it implies, and an ability to deal with darkness and negativity and ambiguity that is at stake, not some mythic status that would confine them to fixed, eternal truth. It is in this sense that they are both revolutionaries and post-revolutionary at the same time.

Introduction

ELEANOR HEARTNEY, HELAINE POSNER,

NANCY PRINCENTHAL, SUE SCOTT

Linda Nochlin, in a landmark essay of 1971, asked the intentionally provocative question "Why have there been no great women artists?"[1] She was not simply questioning the absence of women in the history of art. She was, instead, revealing the conceptual inadequacy, in the field of art history, of the white Western male viewpoint, in accepting as "natural" what she termed "the unstated domination of white male subjectivity."[2] She went on to recast the question not as one of innate capacity ("greatness" or "genius") but as an issue rooted in "the nature of given social institutions and what they forbid or encourage in various classes or groups of individuals."[3] By examining what she called "the whole erroneous substructure" of the question, she aimed to stress "the institutional—that is, the public—rather than the individual, or private, preconditions for achievement or the lack of it in the arts."[4] Nochlin's essay has rung down through the succeeding decades like a clarion call, challenging each generation to assess changes and improvements in the conditions under which women artists work.

It may seem contradictory to preface a book surveying the achievements of twelve individuals with reference to an essay focusing on the institutional obstacles

NANCY SPERO, *To the Revolution* (detail), 1981. Handprinting and collage on paper, 20 x 113 in. (50.8 x 287 cm). Courtesy of the artist

to women artists. But though it is possible to statistically assess the changes in women's representation in galleries and museums, or in monographs, in the decades since Nochlin's essay, as we have done below, there is of course no way to measure women's stature as artists, in terms of sustained accomplishment, critical acclaim, or influence, except individually. We remain mindful of Nochlin's observation that "the existence of a few superstars or token achievers" does not at all mean that institutional obstacles don't remain deeply entrenched, and our essays on the twelve artists we have chosen are not intended to establish their "greatness." Nevertheless, we hope the cumulative weight of their individual achievement may help to demonstrate an underlying institutional shift, during the past thirty-five years, which has helped make possible these artists' critically successful and sustained careers.

In his review of the Salon of 1845, Baudelaire singled out the painter Eugénie Gautier for praise, writing, "This woman knows her old masters—there is a touch of Van Dyck about her—she paints like a man. ... Mlle Eugénie Gautier's painting has nothing to do with *woman's* painting."[5] Georgia O'Keeffe is reported to have complained, "I would hear men saying 'She's pretty good for a woman; she paints like a man.'"[6] The greatest compliment Lee Krasner received from Hans Hofmann, with whom she studied, was, "This is so good you would not know it was painted by a woman."[7] The senior artists represented in this book still could hear such left-handed compliments in their youth. During the testosterone-charged Abstract Expressionist period, women like Krasner were likely to be seen as muses or help-mates to male artists, and when they had the effrontery to make art themselves, they tended to be ignored or relegated to the status of minor players.

The situation of women artists changed decisively in the 1960s and 1970s, when the feminist movement helped set off a social revolution with repercussions that are still being felt. Feminism challenged the assumptions about women's proper roles that had been put back in place in the postwar years after the gains made by women in the workplace during World War II. This "second wave" of feminism (the "first wave" was the women's suffrage movement) rose in tandem with social liberation movements—especially the civil rights movement—as marginalized groups demanded equal rights and opportunities. Feminism's resurgence in the 1960s saw the forming of the National Organization of Women in 1966 "to bring women into full participation in society"; the passage by Congress in 1972 of the Equal Rights Amendment to the Constitution, which, however, was not eventually ratified by all the states; the founding of the feminist magazine *Ms.* by Gloria Steinem, also in 1972; and the Supreme Court's 1973 decision in the case of Roe vs. Wade, which established that most state laws against abortion violated a constitutional right to privacy under the Fourteenth Amendment. American women more forcefully asserted their claims for equal status in the political, social, cultural, and personal spheres. Support for the work of women artists, opportunities for professional development, and recognition were being demanded of the art establishment (with

some success) and initiatives were being taken by the artists themselves. Along with this institutional activity, women artists attempted to find an authentic voice. This task, difficult for any artist, was especially hard for women artists, faced with institutional resistance and demands to balance artistic ambitions with the responsibilities of home and family.

The need to find a voice and an arena in which to be heard has been a concern for most of the artists represented in *After the Revolution* and for their contemporaries across three generations. For artists such as the feminist heroines Louise Bourgeois and Nancy Spero, art-world recognition came only after many years of working in relative anonymity, with only occasional opportunities to exhibit. Both of these women spent decades juggling their artistic practices with the demands of motherhood (each had three sons) and marriage to prominent art-world figures.[8] In the early 1970s Nancy Spero created the *Codex Artaud*, paintings on paper that incorporate the "ferocious language" of the French writer Antonin Artaud, which can be understood on one level as expressing her fury at being silenced (see pp. 53, 58–59).[9] Like many of her contemporaries, she also marched, demonstrated, wrote, and organized to further the recognitions of women in art. These activities culminated in her participation in the founding of A.I.R., the first cooperative gallery dedicated to exhibiting women's art.

Louise Bourgeois also actively participated in feminist meetings, protests, and exhibitions, but responded differently to her marginalization. In 1992 she stated, "I worked in peace for forty years," a situation that gave her the privacy she required to create a deeply psychological body of work exploring her past and her own complex inner workings.[10] The female figure as a subject has been pivotal to the work of these very different artists and has, in fact, been Spero's only subject since 1974. For each, the feminist movement was a career-defining experience and absolutely crucial to the critical reception, relatively late in their careers, of their now highly respected work.

The fervent, single-minded feminism of the early political phase became more complicated and ambivalent as the woman's movement progressed. Members of the transitional generation such as Elizabeth Murray were well aware that their lives had been transformed by feminism, and they were the first to deal directly with the complexity of assimilating this major cultural change and negotiating newly defined personal and professional relationships. While many women artists recognized the benefits of entering an art world more open to women, and seized the opportunity to create work that explored a multiplicity of subjects, styles, media, and ideas, others distanced themselves from the movement for fear of being ghettoized. As Murray, who exuberantly reinvented in her work the traditionally male domain of formalist painting, said in 1984, "I don't believe there's such a thing as 'women's art.' It's a distasteful phrase, like any categorization … I see my own work as androgynous."[11] Yet she freely introduced more conventionally female, domestic imagery into her painting and she has spoken openly about her warm family life,

acknowledging a pleasure in domesticity that might have seemed problematic to an earlier generation of women trying to make it in a man's world.

The momentum of the 1970s was fruitful as women artists moved to the forefront of advanced artistic production in the 1980s. Cindy Sherman's postmodern photographic tableaux dissecting the cultural constructions of femininity and Jenny Holzer's posters, electronic signboards, and monumental light projections, which address social injustice, political and sexual violence, death, and grief, added to conceptualism a socially informed, feminist perspective. Marina Abramović, in partnership with artist Ulay beginning in 1975 and on her own since 1989, created indelible, meditative performance works using her body as the primary subject and medium. Ann Hamilton constructed room-sized, immersive environments that activate the senses and encourage the viewer to experience more holistic ways of knowing, through the body as well as the mind. These artists and others—such as Janine Antoni (see p. 107), Sophie Calle, Janet Cardiff, Jana Sterbak, Roni Horn, Rebecca Horn, Annette Messager, Laurie Simmons, and Lorna Simpson (see p. 266)—worked in the areas of installation, performance, and new media that transformed the landscape of contemporary art in the 1980s and 1990s.

Women also took leading roles in the main cultural discourses of the 1980s and 1990s, when issues of gender, identity, and multiculturalism dominated contemporary art and academic inquiry. For nearly fifteen years, from the early 1980s until the mid-1990s, Kiki Smith represented the female body, both fragmented and whole, in often tender yet visceral sculptures, as part of a body of work that aimed to heal private wounds and mend social divisions. She depicted the female form not as the idealized object of male desire but as the site of women's lived experience. Smith assumed an unflinchingly feminist point of view in her reclamation of the female body as a subject, and she remains clear about her allegiance to its principles, stating, "I came of age in the sixties and seventies and that I exist is a result of feminism."[12]

With the late 1990s and first years of this century another generation of women artists came to the fore. Iranian artist Shirin Neshat created photographs and, more recently, poetically beautiful and mysterious video works that examine divisions between the Islamic and Western worlds, male and female, and tradition and modernity. Her work is a paradigm for women attempting to forge a hybrid cultural identity, which she achieves through a sophisticated use of new media. Having come of age at a time when women artists are highly visible in galleries, museums, and art schools, such artists feel free to explore all aspects of contemporary art. They can be found in every corner of the contemporary art world, exploring ethnic and racial identities from a female perspective, invading the once-male bastions of abstraction, and opening art up to explorations of narrative, fantasy, and myth. They contribute to the melding of art with fields such as science, popular culture, architecture, and urbanism. No longer regarded as second-class citizens of the art world, these women happily partake in the freewheeling pluralism that characterizes art today.

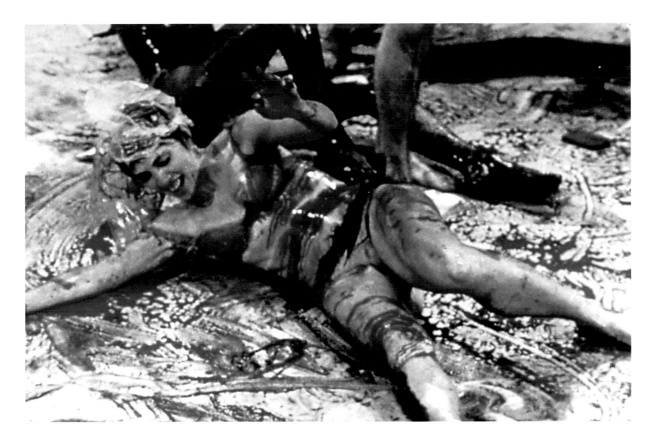

As this rapid survey suggests, feminism as a social movement underlies all the work in this book to the extent that it created an environment in which women's art could be taken seriously and women artists could pursue their craft with at least an approximation of the conditions available to male artists. The relationship of feminist art theory to the works seen here is a more complicated issue. While many women artists have enthusiastically embraced the label of feminist artist, others, like Elizabeth Murray, have been more ambivalent, reluctant to confine themselves to what they perceived as an overly limiting definition of their art practice. But in fact, a survey of the evolution of feminist art reveals that this is a complex and many-layered movement, and that feminist theory and contemporary art have been entwined in a state of continuous evolution.

Beginning in the late 1960s, the feminist art movement mounted an attack on some of the most ingrained assumptions about art and artists. Linda Nochlin, as we have seen, and many others objected to a historical narrative of art that ignored the contributions of women. Many of them challenged the idea that the criteria for judging art's quality have universal validity. In their attack on the "quality issue," as it came to be called, feminists asserted that behind claims to universality were a plethora of unexamined biases and special interests, and that Western taste was in

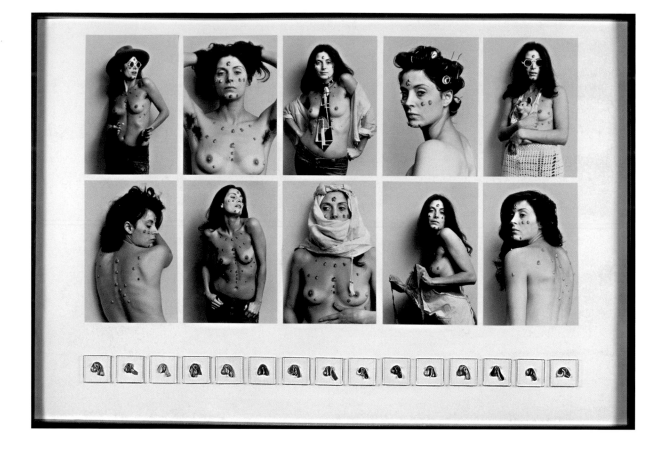

HANNAH WILKE,
*S.O.S. Starification
Object Series*, 1974–82.
Ten silver-gelatin photo-
graphic prints with fifteen
chewing gum sculptures in
plastic boxes mounted on
board and framed, 41 x 58 in.
(104.1 x 147.3 cm).
The Museum of Modern Art,
New York.
© Marsie, Emanuelle, Damon and
Andrew Scharlatt/Licensed by
VAGA, New York, NY

JOYCE KOZLOFF,
Three Facades, 1973.
Acrylic on canvas, 80 x 59 in.
(203.2 x 149.8 cm).
List Visual Arts Center,
Massachusetts Institute of
Technology, Cambridge,
Massachusetts.
Courtesy of DC Moore Gallery,
New York

fact grounded in the assumptions of a patriarchal culture. Similarly, feminists suggested that certain subject matter, materials, and approaches had been dismissed from serious consideration because they were associated with female experience and forms of expression.

These developments opened the door to a new generation of women artists who were not afraid to create from their unique place in the world. In 1975 feminist critic Lucy Lippard listed some of the recurring motifs that she believed suggested a female sensibility. These included the abstracted sexuality inherent in circles, domes, eggs, spheres, boxes, and biomorphic shapes; a preoccupation with body and bodylike materials; and a fragmentary, nonlinear approach in the work of women that set it off from the art of their male counterparts.[13] She argued that such qualities could be traced to societal differences, noting, "the overwhelming fact remains that a woman's experience in this society—social and biological—is simply not like that of a man. If art comes from inside, as it must, then the art of men and women must be different too. And if this factor does not show up in women's work, only repression can be to blame."[14]

This new freedom led women in remarkably different directions. Some challenged the tyranny of the male gaze, which had organized the representation of

women in art to maximize the pleasure of the male viewer. Sylvia Sleigh attempted to reverse the male gaze by painting male nudes in poses that deliberately mimicked the luscious odalisques and flirtatious Venuses of the old masters. Joan Semmel personalized the gaze by presenting the view of her own and her lover's naked body as seen through her own eyes. Artists such as Carolee Schneemann (p. 13), Hannah Wilke (p. 14), and Mary Beth Edelson explored the varieties of female pleasure, posing naked as goddess figures or sex kittens and taking back the female nude for their own ends. Judy Chicago enlisted the efforts of many artists to create a monumental work, *The Dinner Party*, a table laid with ceramic plates, featuring imagery supposedly derived from butterflies and symbolic of a "vaginal core," presented on beautifully embroidered runners, all dedicated to great women of myth and history.

Other artists defiantly resuscitated crafts and applied arts that had traditionally been dismissed as "women's work." Joyce Kozloff based paintings on the intricate decorative patterns of non-Western cultures (p. 15). Faith Ringgold incorporated quilting and other craft traditions into work that dealt with her own history and that of her African American ancestors. Miriam Schapiro invented a format she called "femmage," collage paintings using lace, aprons, embroidered handkerchiefs, and other feminine materials. Nancy Spero explored archetypes of female power and vulnerability in paintings that asserted an alternative kind of monumentality from that of works by her male contemporaries; she expressed herself with delicate and fugitive images stenciled, stamped, collaged, or traced onto transparent papers, assembled in scrolls of up to twenty-five feet in length.

Yet others explored the traditional identification of women with nature and body. Artists like Mary Miss, Nancy Holt, Michelle Stuart, and Alice Aycock addressed the burgeoning interest in earth works and land art, but did so from a female perspective, creating environmental works that melded with nature rather than ripping it open in the manner of male counterparts like Michael Heizer, whose *Double Negative* (1969–70) is a trench 1,500 feet long, 50 feet deep, and 30 feet wide, cut into facing slopes of a Nevada mesa. Women artists such as Mary Frank and Ana Mendieta, who dealt explicitly with the body, communicated experience from the inside out in ways that contrasted sharply with the more objective expressions of male figurative artists.

Nor were women artists content simply to develop alternative kinds of art. The 1970s were also full of experiments in social and institutional organization, as women artists formed cooperative galleries, organized exhibitions of women's work, and generally saw their art as a form of feminist consciousness raising. One of the most influential of these enterprises was the short-lived Womanhouse, a women-only installation and performance space in Los Angeles that was the brainchild of critic Arlene Raven, Sheila de Bretteville, and Judy Chicago.

By the late seventies, however, a reaction was setting in against the approach embraced by many of these pioneers. It was part of a larger turn toward postmodernism, which replaced the freewheeling pluralism of the late sixties and

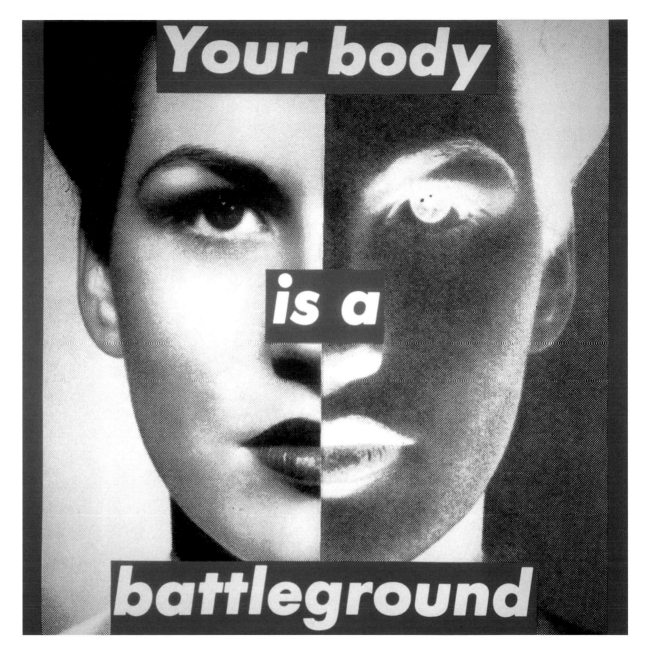

BARBARA KRUGER,
*Untitled (Your Body Is
a Battleground)*, 1989.
Photographic silkscreen
on vinyl, 112 x 112 in.
(284.5 x 284.5 cm).
The Broad Art Foundation,
Santa Monica.
© Barbara Kruger, courtesy of
Mary Boone Gallery, New York

SUZANNE
MCCLELLAND, OOO
(for Martha), 2003. Oil,
acrylic, and pastel on linen
with pearls, 48 x 40 in.
(121.9 x 101.6 cm).
Courtesy of the artist

seventies with an approach to art making that was more structured, theoretical, and critical of aesthetic pleasure. Postmodernism has many definitions, but it is closely identified with a critique of the modernist faith in authenticity, value, and originality. Hence postmodernism shifts the focus from firsthand experience and personal expression to an analysis of the representations that create our sense of reality.

From a feminist perspective, postmodernism provided tools for critiquing the representations of women in art and popular culture. It also undermined the efforts of first-generation feminist artists by suggesting that they were guilty of essentialism, that is, of perpetuating the search for a mythical female essence. According to this critique, the embrace of authentically female modes of expression and experience simply reinforced the exclusion imposed upon women by a patriarchal culture. In this view, efforts to embrace the identification of women with nature, body, or intuition were nothing more than putting a positive spin on qualities denigrated by the larger culture.

Instead, postmodern feminists believed their job was to reveal the ways in which all our ideas of womanhood and femininity are socially constructed. Rejecting the notion of female essence, they sought to demonstrate that categories like

"male" and "female" are internalized sets of representations. In this view, femininity is a masquerade, a set of poses adopted by women in order to conform to societal expectations about womanhood. Articulating this idea, artists such as Barbara Kruger worked with mass-media images of women, combining them with text to suggest the implicit messages about female submission and vulnerability that they were designed to convey (p. 17). Cindy Sherman explored a variety of female personas in photographs that were read as a postmodern critique of female representation. Mary Kelly created a scrapbook of the first six years of her son's life that examined psychoanalytic accounts of the child's process of socialization. Suzanne McClelland has used traditionally made paintings to examine the social construction of power. Her ongoing series of target or "O" paintings, begun in the late nineties, explore the way women—specifically controversial or high-profile women—are "targeted" for negative attention in the media (opposite).

In its strictest form, postmodern feminist theory took issue with art's traditional concern with aesthetics, seeing instead a link between visual pleasure and the objectification of women. Feminist critics such as Laura Mulvey and artists such as Silvia Kolbowski advocated a kind of iconoclasm, arguing that traditional representations of the female body should be avoided or dismantled because they uphold the patriarchal gaze. In a highly influential essay on images of women in Hollywood movies, Mulvey concluded, "It is said that analyzing pleasure, or beauty, destroys it. That is the intention of this essay."[15]

This went too far for many artists and observers, and by the mid-1980s, galleries were filled with art that represented the body and the female experience in ways that combined the approaches of both the pioneers and the postmodern feminists. There were a number of reasons for the sea change. For one, the notion of the body as an abstract social construct ran counter to the experience of very real bodies subject to the ravages of the AIDS epidemic. There was also a growing interest among some feminists in old theories of gender-based dualisms that attributed qualities of nature, intuition, and body to woman, while associating culture, reason, and mind with man. These distinctions, which go back to the ancient Greeks, are so deeply embedded in Western culture that they have become almost invisible. In challenging them, feminists took a variety of approaches. Some, like Bul Lee and Orlan (see p. 270), attempted to expose and dismantle the traditional identification of women with nature, while artists like Helen Chadwick, Mary Lucier, and Petah Coyne chose to embrace and redefine these associations in more positive terms.

Some women began to explore the idea that there might be a kind of carnal knowing that depended on the melding of mind and body. Finally, the return of the body as the subject of art served as an alternative to the growing reach of disembodied virtual experience provided by the electronic revolution. This time around, art grounded in the body and its experiences was embraced by male and female artists alike—a signal that the feminist revolution had made significant inroads into the social consciousness. Artists like Kiki Smith and Janine Antoni were joined by male

CECILY BROWN,
*The Girl Who Had
Everything*, 1998.
Oil on linen, 100 x 110 in.
(254 x 279.4 cm).
© Cecily Brown, courtesy of
Gagosian Gallery, New York

artists such as Robert Gober, Paul McCarthy, and Mike Kelley in the presentation of art works that presented the body in all its messy physicality. Also in the 1980s and 1990s artists like Smith, Karen Finley, Tania Bruguera, and Sue Williams reengaged questions of violence and abjection which had been raised in the 1960s and 1970s by artists like Marina Abramović, Yoko Ono, and Hannah Wilke.

By the 1990s and the first years of the new century, feminism became so integrated into the fabric of women's lives that rights and privileges which seemed hard-won only a few years before were taken for granted. The early and impressive successes of a younger generation of women artists including the gestural figurative painters Cecily Brown (above), Jenny Saville, and Dana Schutz; the semiabstract painter Julie Mehretu; and Kara Walker, who revived the art of cut-paper silhouettes (opposite), and sculptor Sarah Sze (both awarded a MacArthur Foundation Fellowship), all suggest the degree to which the status of women artists has changed. These younger artists have enjoyed wide recognition both in the museum world and the marketplace.

Discussions of the market are often considered taboo in a historical and critical study of contemporary art, but gallery representation and market demand are revealing indicators of change. Women artists' growing presence in major public and private collections does indicate that a shift has occurred in situation of women artists. Female artists in their twenties and thirties are not only represented by some of the most influential galleries in New York, but they command prices for their work that exceed those of their female predecessors and surpass those of their male counterparts.

Interestingly, younger women artists' awareness of increasing opportunity is often accompanied by a sense of disconnection and even discomfort with feminism generally and the feminist art movement in particular. When they hear the "f-word," this generation of women artists tends to think of the early stages of activism and essentialism, of a feminism they reject for its associations with anger and a sense of victimization, and for being devoted to simplistic, retrograde representations of the female body. Contributing to such rejection, perhaps, is a retrospective caricature of early feminism as a movement that rejected all that was male and disapproved of heterosexuality. (Such ideas were in fact embraced only by a radical faction of the early feminist movement.) Latter day feminists, while fully embracing equality, are less eager to insist on being separate from men. Younger

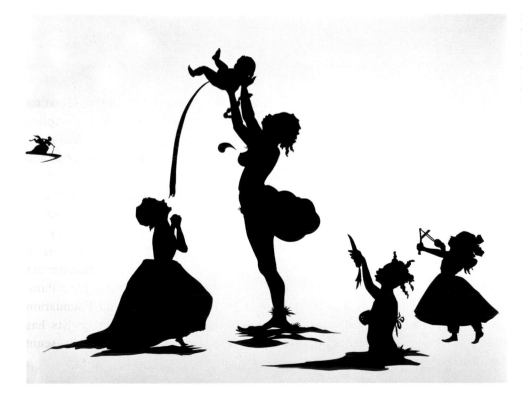

KARA WALKER, *Camptown Ladies* (detail), 1998. Cut paper and adhesive on wall, overall: 9 x 67 ft. (274.3 x 2042 cm). Courtesy of Sikkema Jenkins & Co.

women artists are perhaps not so aware of the profound impact of feminism, or its subtle influences, and this curious oblivion may help explain a tendency to dismiss feminism as an outmoded ideology.

The discomfort runs both ways. Some older feminist artists look askance at the "bad girls"—Kara Walker, Lisa Yuskavage, Cecily Brown—who ironically employ sexist (or racist) clichés in their work, often to undercut male prerogatives or assumptions. But where older artists see backsliding, younger women may see such work as defending against the creeping puritanism of contemporary culture. They may point to the practices of such pioneers as Hannah Wilke and Carolee Schneemann to reinforce the notion that beauty, pleasure, and the raucous celebration of female sexuality are not alien to feminism. Such internal skirmishes cannot obscure how significantly feminism has expanded the possibilities for women artists.

How far have we come? As curators and critics with at least twenty-five years of experience each, we are aware of the strides made by women artists since the advent of the feminist movement and the resulting growth of support on the part of museums, galleries, and educational institutions. We were uncertain, however, whether those strides are measurably significant. We wondered, for example, what percentage of solo exhibitions featured women artists over the course of the past thirty-five years. To obtain an overview, we identified and surveyed twenty influential galleries in New York City, chosen for their prominence in terms of sales and

Figure 1: Number and percentage of solo exhibitions at galleries by gender

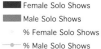

Female Solo Shows
Male Solo Shows
% Female Solo Shows
% Male Solo Shows

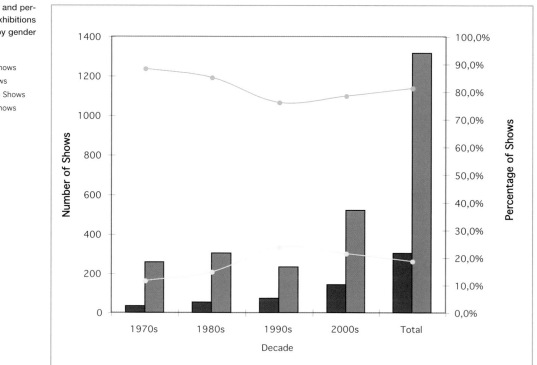

critical reputation, and a representative selection of museum contemporary art exhibition programs in the United States. Data were acquired through gallery and museum publications, websites, and responses to telephone inquiries. While this is not a comprehensive study, the statistics we assembled provide an indicator of women artists' progress in the past few decades.

Because certain women artists–from thirty-year-old Dana Schutz to nonagenarian Louise Bourgeois–currently have high profiles in galleries, major private collections, museums, and the marketplace, it may be perceived that the situation for women artists has improved significantly during the time period covered in this book. But is this really the case?

Examining the number of solo exhibitions by women artists presented from the mid-seventies until the present, through a representative sampling of influential galleries, we can see that the situation did improve until the 1990s, but that it appears to have reached a plateau. In the 1970s, women accounted for only 11.6 percent of solo gallery exhibitions. In the 1980s, the percentage of solo exhibitions by women crept up to 14.8 percent, and in the 1990s the number increased to 23.9 percent, but the percentage has dropped slightly, to 21.5 percent, in first half decade of the twenty first century. The current number of solo gallery exhibitions by women artists is not notably better than the average of women's exhibitions for the entire period under consideration, 18.7 percent. While the number of women artists' exhi-

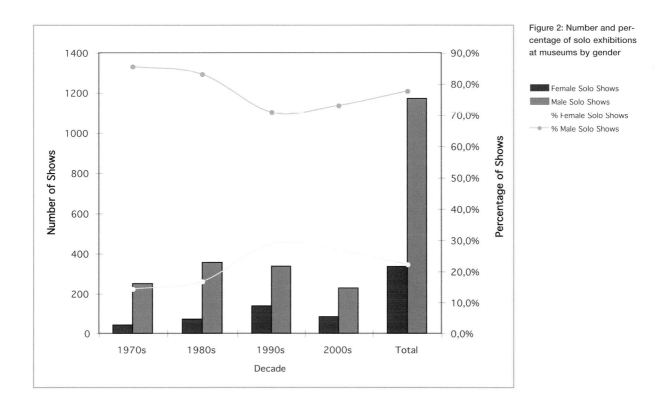

Figure 2: Number and percentage of solo exhibitions at museums by gender

Female Solo Shows
Male Solo Shows
% Female Solo Shows
% Male Solo Shows

bitions has doubled since the early seventies, it has really only kept pace with an expanded market: women still have roughly one opportunity for every four of the opportunities open to men.

Museums have a slightly better track record. During the thirty-five years we surveyed, 22.5 percent of solo museum exhibitions presented the work of women artists. Of 3,894 museum exhibitions in our data base, 1,688 were one-person shows. Of that number, 1,309 were devoted to men and 379 to women. The percentages of museum solo exhibitions devoted to women per decade parallel the comparable percentages for galleries, but, perhaps reflecting the greater freedom of non-profit environments, women's representation was somewhat better, most notably in the 1990s, when women's portion of solo shows in museums nearly reached 30 percent. In the first five years of the new century, women's portion dropped back to about one-quarter.

We also looked at women's representation in monographic publications since 1970. A monograph was defined for this survey as a publication on a single artist: either a collection catalog, a biographical work, or an exhibition catalog. Statistics were compiled for trade (commercial) publishers and museum publishers. Eleven key U.S. museums were surveyed; and a separate survey was made of a database for a distribution service that specializes in making available to libraries exhibition catalogs from throughout the world.[16]

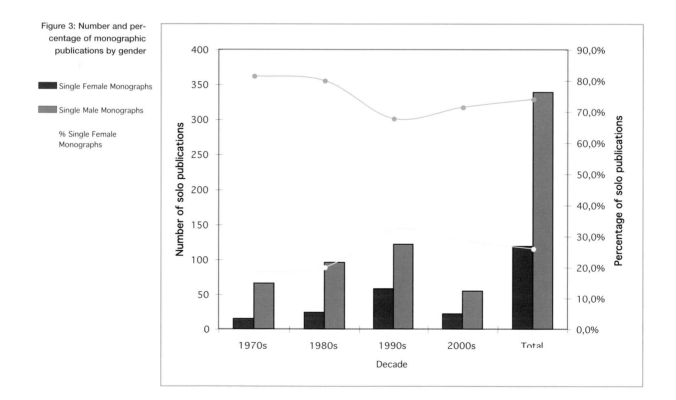

Figure 3: Number and percentage of monographic publications by gender

■ Single Female Monographs

■ Single Male Monographs

% Single Female Monographs

The numbers of monographs published by decade dedicated to contemporary (living) women artists was compared to the total number of publications issued by each publisher during the time period. Generally the searches included all markets, but in some cases were restricted to the U.S. and U.K. Given the variety of sources of data, specific numbers may not always be exact, but the overall trends are similar for each type of publisher.

Books on contemporary women artists published by U.S. museums were in most cases exhibition-related, although some were catalogues raisonnés and collection catalogues. In the case of museum publications, three numbers were gathered: monographs dedicated to one female artist, ones dedicated to one male artist, and total publications per decade.[17]

The results of all three surveys demonstrated similar trends. The overall percentage of commercial publications dedicated to female artists grew steadily from the 1970s to the present, from less than one-half of one percent to approximately 2.7 percent. Interestingly, publishers specializing in photography (notably Aperture, Nazraeli, Scalo, Schirmer/Mosel, and Twin Palms) had significantly higher percentages of their total lists devoted to single-artist books on women. This suggests that photography may have been, for various reasons, something of a "gateway" medium for women seeking recognition in the arts.

In the case of museum publications, there is also a steady rise through the 1990s but a slight drop-off in the period of 2000–2005, though the numbers for 2006 suggest that the latter part of this decade may see an upswing. The slowing of publication of monographs generally may reflect an overall weakness in the market for art books, as well as a continuing rise in costs of publishing and reductions in U.S. museum budgets during the past decade.

In the survey of eleven U.S. museum publishers, we took the opportunity to compare percentages of women's and men's one-person publications. The number of one-person publications devoted to women artists averaged about one-quarter the total number of one-person publications, so three men's publications appeared for every one devoted to women. As the table here shows, the proportion of one-person publications of women's art increased significantly from the 1970s and 1980s, when it hovered around 20 percent, to the 1990s, when it reached nearly a third of the total, but it declined a bit in the past five years or so. In conclusion, while an overall rise in the number of publications dedicated to female artists is certainly encouraging, the comparison of that number to the number of publications dedicated to male artists tempers one's optimism.

The book we set out to write is not a manifesto for women's art. It is not meant to be hortatory nor especially prospective—we are not heralding a brave new art form being brought forth by women marching boldly in formation into a clearly envisioned future. Instead, we've tried to look back at the last thirty-five years of artmaking by a small number of key figures to gain a better understanding of how art

works by women have shaped the art of our time. Gender does not provide anything like an exhaustive explanation for the meanings or motivations of the work under consideration, or of its impact on our culture. But neither is gender incidental to those things. Simply put, it seemed to us that to take stock of these women's contributions would be illuminating.

Above all, we wanted to demonstrate the complexity and variety of work made by women, incontrovertible evidence that what feminism set into motion when it urged attention to neglected voices in the arts was an embrace of limitless possibility rather than of any kind of dogma. Introducing a recent book of papers assembled from a conference on women's art, Carol Armstrong wrote, "coloring by otherness, by outsiderness, by difference, is a positive, not a negative—an expansion, not a reduction, of what it means to be a person and an artist."[18] The abandonment of fixed standards of valuation is a benefit, Armstrong said, "not only for women but for men as well, for we all gain by the changed face and expanded definition of humanness that ensues."

Choosing the dozen artists we've focused on in this book was, needless to say, very hard. We started with a much longer list, and every time we tried to winnow it, it grew. Deciding to reverse direction and discuss an arbitrarily small number was a radical solution, and we feel it worked. We hope these artists will be considered representative of a large community, rather than the full membership of an exclusive club. Inevitably, some of our criteria for inclusion are hard to quantify: when the subject is art, definitions tend to dissolve. But some were clear from the outset. We wanted to illustrate the diversity of women's contributions—to write about a spectrum of viewpoints, of starting positions (where the artists came from, both biographically and stylistically) and of chosen solutions in terms of medium, process, and subject. One outcome of these decisions has been, for us, a clearer picture of just how much those disciplines and formats that are of key importance in current art, including installation and performance art, figurative painting and sculpture based on internal experience, and indeed all those forms that allow exploration of identity, have developed in and around work by women.

As its title suggests, our project was undertaken in a cultural moment heavily colored by a complicated kind of nostalgia. The *post*-ness of all things is now much remarked upon, not least in the terminology of cultural categorization: postmodernism has bred, conspicuously, both post-blackness (a term of Thelma Golden's coinage) and, no less nebulously, or contentiously, post-feminism. But we hardly believe the story to be over. Another way of looking at our title's implications is to note that this is not a book about a finished narrative, but a hopeful beginning. If it is a little wistful (the revolution, however it is defined, is a historical episode, not a living event), our book is intended to be more optimistic than elegiac, celebrating an expanded approach to viewing and judging art as well as making it. In Carol Armstrong's publication, Linda Nochlin writes, "In the post–World War II years, greatness was constructed as a sex-linked characteristic in the cultural strug-

gle in which the promotion of 'intellectuals' was a cold war priority. ... Today, I believe it is safe to say that most members of the art world are far less ready to worry about what is great and what is not."[19] The battles may not all have been won, and equality of opportunity across gender (and race and class) remains an elusive goal, but the barricades are gradually coming down, and work proceeds on all fronts in glorious profusion.

1 "Why Have There Been No Great Women Artists? (1971)" in Linda *Nochlin, Women, Art, and Power and Other Essays* (Harper & Row, 1988), pp. 145–78

2 Nochlin, p. 146

3 Nochlin, p. 158

4 Nochlin, p. 176

5 Charles Baudelaire, "The Salon of 1845," in *Art in Paris 1845–1862*. Trans. and ed. Jonathan Mayne (Oxford: Phaidon, 1965), p. 18.

6 Susan Fillin-Yeh, "Dandies, Marginality and Modernism: Georgia O'Keeffe, Marcel Duchamp and Other Cross-Dressers," *Oxford Art Journal*, v. 18, no. 2 (1995), p. 37.

7 Anne Middleton Wagner, *Three Artists, (Three Women): Modernism and the Art of Hesse, Krasner and O'Keeffe* (Berkeley: The University of California Press, 1996), p. 115.

8 Bourgeois is the widow of the art historian and curator Robert Goldwater and Spero of the painter Leon Golub.

9 Quoted in Katy Kline and Helaine Posner, "A Conversation with Leon Golub and Nancy Spero," in *Leon Golub and Nancy Spero: War and Memory* (Cambridge, Mass.: MIT List Visual Arts Center, 1994), p. 39.

10 Quoted in Charlotta Kotik, "The Locus of Memory: An Introduction to the Work of Louise Bourgeois," in *Louise Bourgeois: The Locus of Memory, Works 1982–1993* (New York, Harry N. Abrams, Inc., 1994), p. 16. Originally quoted in Louise Bourgeois, "In Conversation with Christiane Meyer-Thoss," in Christiane Meyer-Thoss, *Louise Bourgeois: Designing for Free Fall* (Zurich: Ammann Verlag, 1992), p. 139.

11 Paul Gardner, "Elizabeth Murray Shapes Up," *Art News*, September 1984, p. 55.

12 Dierdre Summerbell, "Marrying Your Own Personal Nutty Trips with the Outside World: A Conversation with Kiki Smith," *Trans>arts.cultures.media*, 9/10, 2001, p. 208.

13 Lucy Lippard, "What is Female Imagery?" in *From the Center: Feminist Essays on Women's Art*, (E. P. Dutton, 1976), pp. 81–82.

14 Lucy Lippard, "Prefaces to Catalogues," in *From the Center*, p. 49

15 Laura Mulvey, "Visual Pleasure and Narrative Cinema," reprinted in Wallis, ed., *Art After Modernism*, New Museum of Contemporary Art, New York, in association with David R. Godine, Boston, 1984, p. 36.

16 Worldwide Books (http://www.worldwide-artbooks.com/) specializes in making available to libraries exhibition catalogs from throughout the world. Their on-line database was surveyed by decade to see how many listed catalogues were dedicated to one female artist. The results were divided by territory into U.S., Europe, Asia, and "other".

17 For these statistics, searches were done on-line in Dadabase, the on-line library catalogue of the Museum of Modern Art, New York. The nature of this institution's collecting policies ensures that its library collections are representative of the trends that were being tracked. To ascertain numbers for MoMA itself, the on-line catalog of the Library of Congress was used, since the museum collects vast amounts of ephemera related to itself that would skew the statistics.

18 Carol Armstrong, preface, *Women Artists at the Millennium*, Armstrong and Catherine de Zegher, eds. (Cambridge, Mass. and London: The MIT Press, 2006), p. xii

19 Nochlin, op. cit. p. 22.

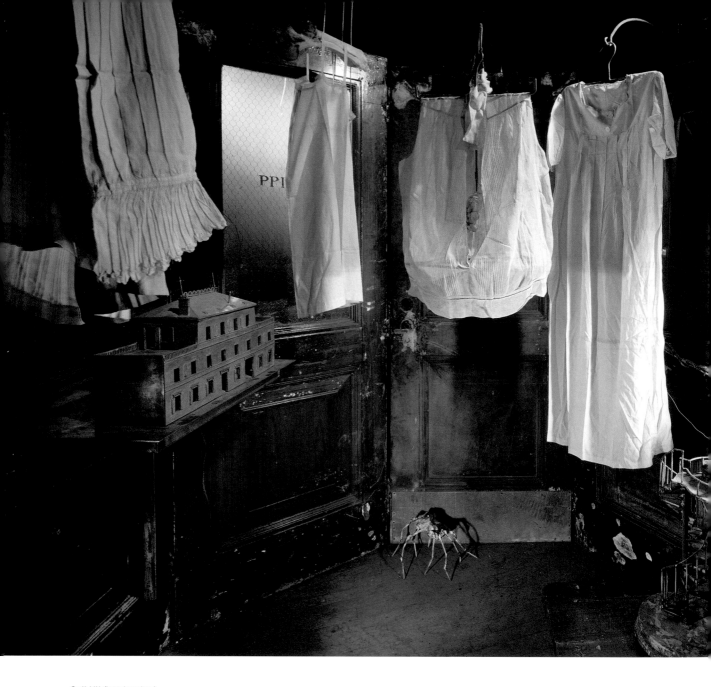

Cell VII (interior view),
1998. Mixed media,
81¹/₂ x 87 x 83 inches
(207 x 221 x 210.8 cm).
Friedrich Christian Flick
Collection, Berlin.
All reproductions of art by
Louise Bourgeois courtesy of
Louise Bourgeois Studio

Louise Bourgeois: Intensity and Influence

Helaine Posner

Writing in *Artforum* in March 1975, feminist art and cultural critic Lucy Lippard observed, "It is difficult to find a framework vivid enough to incorporate Louise Bourgeois's sculpture. Attempts to bring a coolly evolutionary or art-historical order to her work, or to see it in the context of one art group or another, have proved more or less irrelevant. Any approach—non-objective, figurative, sexually explicit, awkward or chaotic; and any material—perishable latex and plaster, traditional marble and bronze, wood, cement, paint, wax, resin—can serve to define her own needs and emotions. Rarely has an abstract art been so directly and honestly informed by its maker's psyche."[1]

In her perceptive appraisal of Bourgeois's sculpture, Lippard effectively captured the nature of the artist's uniquely personal and compelling body of work in terms that had only recently been made familiar through the language of feminism. Her pivotal essay described the extraordinarily expansive and inventive psychological approach to art making that Bourgeois had, in fact, been practicing for over thirty years, but for which she was only beginning to receive wide attention. It was a time of major change in the art world. The strict formalism that had dominated art since the advent of modernism was giving way to a more emotionally rich and stylistically varied art ushered in by feminism, postmiminalism, and other cultural forces. In 1982 the artist belatedly received her well-deserved recognition when the Museum of Modern Art presented a major and highly successful retrospective exhibition of her work, and she rightly assumed the mantle of "feminist foremother."[2] The past twenty-five years arguably have been her most ambitious, productive, and creative to date. Remarkably, her retrospective exhibition at age seventy-one prompted a new beginning for this senior artist.

Bourgeois's body of work (including painting, drawing, printmaking, sculpture, and installation) constitutes a profound, life-long examination of her complex inner workings, often intense and fragile relationships, and personal anxiety.[3] She has simply stated, "I identify myself with extreme emotions," and the sensations her work evokes resonate deeply with the viewer.[4] These emotional states and the imagery the artist created from them are based on her difficult experiences growing up in a largely patriarchal society. Fear and pain, anger and aggression, and sexuality and obsession frequently find expression in the artist's charged representations of the body—or body part—and the home. Eventually, maternal themes also began to emerge. Although she initially practiced modernist abstraction and later anticipated many of the innovations of postmodern art, Bourgeois has never conformed to a

single movement or style. She decided to pursue a more eccentric path, choosing instead to give form to the urgings of her psyche. Her means have ranged from the abstract to the figurative, from hard to soft; from single object to architectural environment; and from skillful carving, modeling, and casting, to the precise arrangement of found objects—all in an effort to plumb the depths of human experience, from desire to death.

Bourgeois's personal history, which she first made public at the time of her 1982 retrospective, has been the source of her work from the start. It is the stuff of legend; though certainly embellished over time, it nonetheless seems to be true. Not surprisingly, it is a psychological narrative, based on unresolved conflicts and tensions arising from her childhood years in France that have continued to affect her emotional life as an adult. Born in Paris in 1911 to an affluent family who were in the business of repairing and selling seventeenth- and eighteenth-century tapestries, she was the middle child of a capable, nurturing mother, who headed the family's restoration workshop, and a handsome, flirtatious, often volatile father, for whom she was named and whose attentions she courted. She attended the prestigious Lycée Fénelon with her sister and brother and did well, particularly in mathematics. During her formative years, her father invited his English mistress, Sadie, into the household to be the children's tutor; while her mother accepted this situation, it was intolerable to the young Louise, who was required to ignore her father's blatant infidelities, endure his betrayals, and accept Sadie, the hated rival for her father's love. The anxiety, jealousy, and rage born of this bizarre family drama have fueled aspects of her passionately expressive art throughout her career and, as observed by art historian Robert Storr, are the source of her obsessional return to early trauma.[5]

As a young woman Bourgeois went on to study mathematics and philosophy at the Sorbonne and art history at the Louvre. Beginning in 1934, she shifted her focus to art and continued her studies at the École des Beaux-Arts, the Académie de la Grande-Chaumière, the Académie Julian, and the Académie Ranson, and with the noted artists Fernand Léger and André Lhote, among others. Bourgeois was invited to exhibit her work at the Salon d'Automne in 1938, the year she met and married the American art historian Robert Goldwater, who published that year the classic text *Primitivism in Modern Art*. He would become a prominent curator and professor of fine arts at Queens College and later New York University. Until her husband's death in 1973 he remained one of her most ardent supporters.

Bourgeois and Goldwater settled permanently in New York in 1938, just prior to World War II; there they raised three sons, Michel, Jean-Louis, and Alain. In addition to her traditional European education, Bourgeois participated in the most sophisticated avant-garde artistic and intellectual circles of her time, first in Paris, and later New York, which became the new center of advanced culture after the war. Already as a student she had been acquainted with the Surrealists in Paris, and in New York she knew and socialized with members of the Surrealist community in exile, as well as with the leading writers, scholars, and curators who were her

husband's friends and colleagues. She absorbed, integrated, rejected, and transformed the art of two continents while developing a distinctly independent and idiosyncratic artistic vision. Yet in general, she remained a loner.

During her student years Bourgeois practiced an abstract style of painting and drawing, based on the tenets of Cubism, and also began to explore a more introspective, figurative mode of expression influenced by Surrealism, later blending aspects of each to create her *Femme Maison* paintings of the late 1940s. The artist had an understandably guarded attitude toward the Surrealists, with whom she was acquainted as a student in Paris and later knew as a professional artist in New York. Although she shared some of their aesthetic concerns—such as the desire to give visual form to subconscious subject matter, its traumatic and erotic compulsions, and strange disjunctions—she rejected the phallocentric, doctrinaire stance of André Breton (1896–1966) and others in his circle who relegated women artists to the role of muse, either *femme-enfant* or *femme fatale*, and refused to accept them as artistic peers. Nevertheless, aspects of Surrealism, often subjected to her witty, feminist reinterpretations, infuse Bourgeois's work to this day. Parallels also exist between Bourgeois's work and that of such early twentieth-century sculptors as Jean Arp (1886–1966), Constantin Brancusi (1876–1957), and Alberto Giacometti (1901–1966), in the pure, simplified, biomorphic forms of their work and the Surreal or Existentialist aura that surrounds it—qualities that inform Bourgeois's first major series of sculpture, called the Personages. She has emphasized her stylistic affinity with these artists: "I seek formal perfection, that goes without saying"—a statement that reveals little about her emphatically personal content.[6]

From 1945 to 1947 Bourgeois created a series of disturbing works, all titled *Femme Maison* (Woman house), in which a house replaces or engulfs the head of a nude woman, negating her identity and isolating her from the outside world (p. 32). Here the traditional domain and supposed haven of women is made a suffocating confinement, more a prison than a source of familial contentment. Oddly, while her head is concealed by the house, her nude body remains vulnerably exposed. These flat, schematic paintings and drawings are penetrating icons of private and cultural estrangement and indelible works of feminist commentary. In format, they recall the Surrealist exquisite corpse, a collective game in which players pass on a folded piece of paper on which they have drawn, then concealed for the next participant, a different zone of the body, creating a final image of disjunctive parts. Bourgeois surely knew this technique and reimagined it from the feminist perspective that has informed her entire career.

In the late 1940s Bourgeois decided to abandon painting because she was "not satisfied with its level of reality," and she took up sculpture as her primary medium in the belief that its tangible, physical presence would better convey her experiences and intense emotions.[7] As she explained, "I could express much deeper things in three dimensions."[8] From 1947 to 1950 she created the Personages, a collection of about thirty sculptures basically consisting of simple carved wooden posts

Femme Maison, 1946–47.
Oil and ink on linen,
36 x 14 inches
(91.4 x 35.6 cm). Agnes
Gund Collection, New York.

Photo: Eeva Inkeri

with color added or various objects attached. In addition to their modernist sources, these primal forms also suggest fetish figures or ancient ancestor totems, and seem to be imbued with a similar power. According to the artist, these evocative life-size, anthropomorphic forms were meant to represent significant people in her life, including family members and friends left behind in France during the traumatic war years. The individual Personages, and their assembled presence, helped to soothe the artist's painful feelings of separation and loss. When these works were exhibited at the Peridot Gallery in New York (1949 and 1950), the artist scattered single figures or pairs, and small groupings, around the space to suggest a gathering of disparate individuals and the various interactions that might or might not take place among them (below). Upon entering the gallery, the viewer was free to mingle with the curious occupants of this early installation work.

As the fifties progressed Bourgeois's wooden sculptures became more formally and conceptually complex. She began to assemble the previously solitary Personages in related groups and mount them on a single base, an arrangement that underscored the relationships among them. In *One and Others* (1955) she expanded on this theme, creating a dense cluster of colorfully painted, different-size, bio-morphic shapes that suggest both healthy organic growth and the close contact of various human beings (p. 34). The work's title, *One and Others*, according to Robert Storr, "names the fundamental social and psychological dynamic at the basis

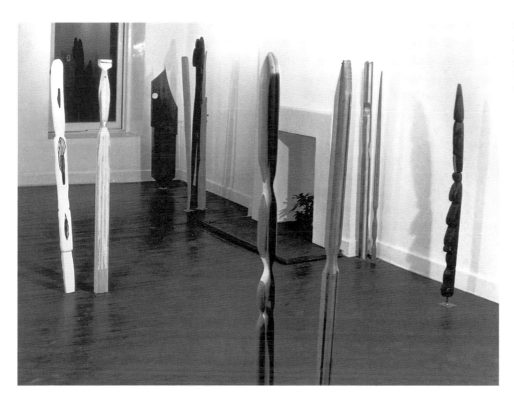

Personages in *Louise Bourgeois: Sculptures*, October 2–28, 1950. Installation view, the Peridot Gallery, New York.
Photo: Aaron Siskind

One and Others, 1955.
Painted and stained wood,
18^{1}/$_{4}$ x 20 x 16^{3}/$_{4}$ in.
(46.4 x 50.8 x 42.5 cm).
Whitney Museum of
American Art, New York.
Photo: Peter Bellamy

of all of Bourgeois' work of this period, and much of it since, that being the uneasy coexistence of the individual and the community" as it also alludes to the protections, tensions, and inequities of family life in its tight huddle of alternately smaller and larger forms.[9] The accumulation of abstract components was a thoroughly new approach for the artist that permanently entered her artistic vocabulary and allowed for her deeper investigation of human relations.

Bourgeois came into her own as an artist in the lively New York art world of the early 1950s with several solo exhibitions, regular inclusion in the Whitney Annuals, and participation in group shows with the Abstract Expressionists, including Willem de Kooning, Jackson Pollock, and Mark Rothko. Although she enjoyed initial success and recognition, the private idiosyncrasy of her art kept her from the mainstream for many years. In addition, Bourgeois's lifelong struggles with anxiety and depression made it difficult for her to work, at times for extended periods, in the 1950s causing her to withdraw from the art scene for more than a decade, until she re-emerged in the 1960s with a solo exhibition at the Stable Gallery (1964) and in Lucy Lippard's groundbreaking *Eccentric Abstraction* (1966), an exhibition focusing on the antiformal, process-based approach that Lippard recognized in Bourgeois's work and in that of such important younger artists as Bruce Nauman, Keith Sonnier, and Eva Hesse.

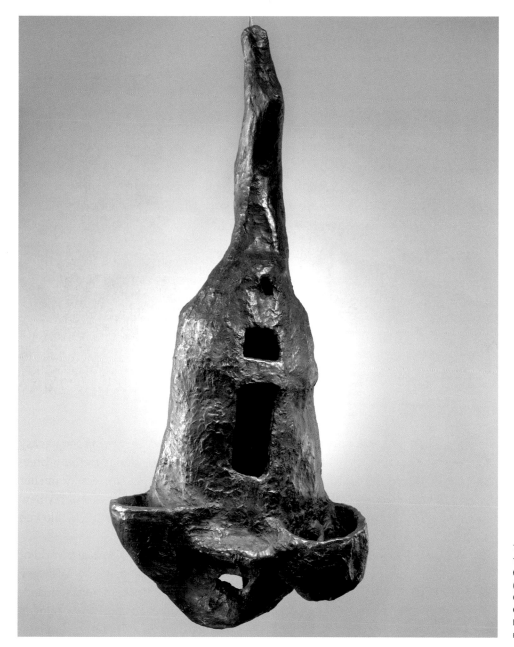

The Quartered One,
1964–65. Bronze,
62¹/₄ x 24 x 20 in.
(158.1 x 61 x 50.8 cm).
Collection of the artist.
Courtesy of Cheim & Read,
New York.
Photo: Christopher Burke

The fifty-year-old artist experienced a time of tremendous experimentation in the sixties. Change and variety manifested themselves in everything from her choice of materials to the distinctive forms and imagery seen in her new work. Whereas her earlier sculpture consisted of vertical figures constructed of wood, her latest work was fashioned from plaster, cement, latex, and plastic-fluid materials that allowed the artist to explore increasingly amorphous physical and psychological

states. Twisted labyrinths and towers, rough spirals, knotted masses, and primitive nests proliferate, as the artist made a major shift from, in her words, "rigidity to pliability."[10] The nestlike *Lairs*, organic shapes with oddly formless exteriors and dark, inchoate interiors, typify this direction. As their name implies, these sculptures suggest sites of refuge or retreat, a shelter or a hiding place or, quite possibly, a trap, evoking conflicting feelings of safety and threat. *The Quartered One* (1964–65), a large bronze pod from the *Lair* series, hangs from the ceiling like a swollen sack (p. 35).

Finally, formalist modernism was beginning to yield to a new antiformal approach, practiced by Bourgeois as well as some other progressive, mostly younger, artists. This new movement, called postminimalism by its spokesman, the art critic Robert Pincus-Witten, was characterized by "eccentric processes, substances, and colorations" and by "art activities stressing autobiography, the artistic persona and psyche, stripped bare."[11] Much of the work was unstructured or open in form and gestural or expressive in execution. The precepts of postminimalism were closely aligned with those of the growing feminist movement, in which Bourgeois was active, manifested in their mutual concerns with autobiography and the personal, the inclusion of previously devalued subjects, techniques, and materials, and a developing interest in representation of the body and sexuality. For the

EVA HESSE, *Area*, 1968.
Rubber latex on wire mesh
and metal wire, 20 ft. x 36
in. (609.6 x 91.4 cm).
Wexner Center for the Arts,
The Ohio State University,
Columbus, Ohio.
Purchased in part with
designated funds from
Helen Hesse Charash.
© The Estate of Eva Hesse.
Courtesy of The Wexner Center
for the Arts, The Ohio State
University, Columbus. Photo:
Lynette Molar

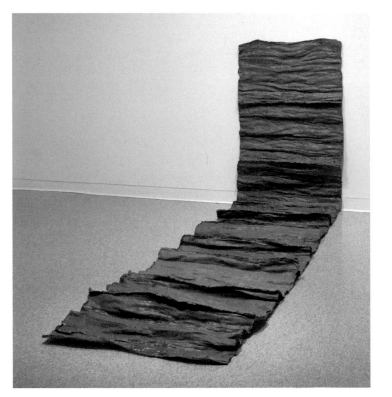

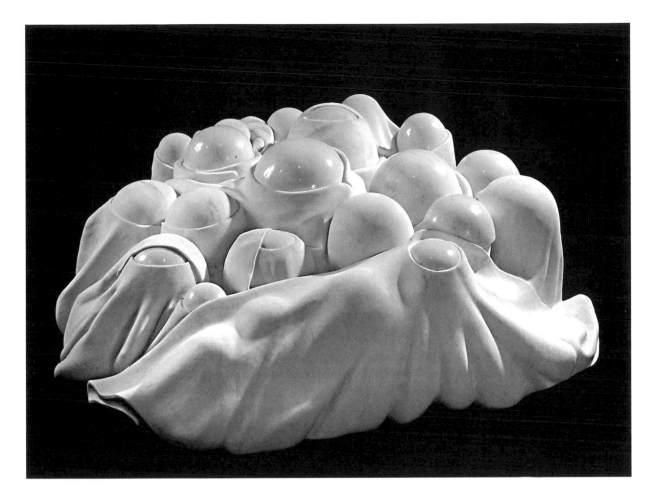

Cumul I, 1969. Marble,
22³/₈ x 50 x 48 in.
(56.8 x 127 x 121.9 cm).
Musée national d'art
moderne, Centre Georges
Pompidou, Paris.
Photo © by Peter Moore

first time, Bourgeois's highly independent art was in sync with a current tendency (although minimalism and pop art predominated) and was sometimes ahead of the curve. She shared the interest of Robert Morris, Barry LaVa, Lynda Benglis, and Eva Hesse in investigating idiosyncratic forms and unusual substances. Bourgeois and Hesse had the most in common. Each was experimenting with sensual, organic shapes and malleable materials, particularly latex, a signature medium for Hesse though Bourgeois's use of it preceded Hesse's by a couple of years (p. 36).

Depictions of the body, more specifically the psychosexually charged body part, began to emerge in a potent and provocative group of sculptures that Bourgeois produced in the late 1960s—in materials ranging from pliable latex and poured plaster to exquisitely carved Italian marble. In *Cumul I* (1969), a burgeoning mound of closely-clustered, rounded protrusions, Bourgeois created a fecund and evocative expression that alludes to the human body and sexual desire (above). As she has said, "Sometimes I am totally concerned with female shapes—clusters of breasts like clouds—but often I merge the imagery—phallic breasts, male

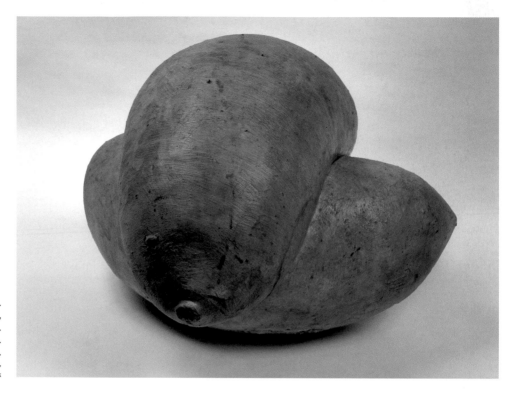

Le Trani Episode, 1971.
Plaster and latex,
16$^1/_2$ x 23$^1/_8$ x 23$^1/_4$ in.
(41.9 x 58.7 x 59.1 cm).
Collection of the artist.
Courtesy Cheim & Read,
New York

and female, active and passive."[12] This unsettling merger of the symbols of sexuality is epitomized in *Le Trani Episode* (1971), a work that portrays two soft, round, elongated shapes resting on each other in intimate union (above). Each of the tender, bulbous forms has a nipple on the end and both resemble penises. The conflation of gender difference or the collapse of opposites in Bourgeois's work—including such dualities as male/female, penis/breast, inside/outside, dark/light—produces what French writer Georges Bataille (1897–1962) has called the *informe*, a formlessness that dissolves both physical shape and categorical distinction. In fusing opposites in *Le Trani Episode* and related works the artist approaches the *informe*, creating uncanny objects that defy the rule of reason to explore the ambivalence of the psyche.[13]

The most outrageous member of this group of works is *Fillette* (1968), a two-foot-long, rough-textured, latex-covered object resembling an enormous penis with strange breastlike testicles (oppposite). This sculpture may be displayed in a different ways—it may be hung from its head by a wire hook, cradled in one's arms like a baby, or tucked under an arm like a trophy, as in Robert Mapplethorpe's famous photograph of the artist claiming her creation with a sly, subversive smile. Bourgeois further confounds us by calling this large phallus *Fillette*, French for "little girl," injecting some humor into this highly charged, fetishistic work. The sculpture elicits a variety of powerful, multivalent responses from the viewer,

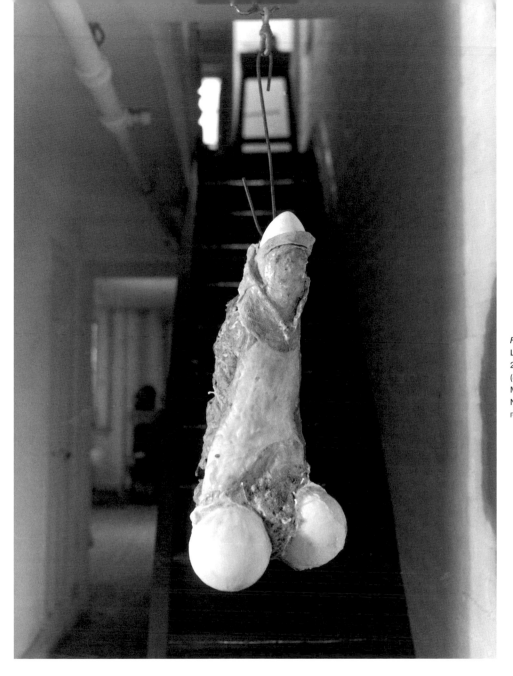

Fillette, 1968.
Latex over plaster,
23¹/₂ x 10¹/₂ x 7³/₄ in.
(60.7 x 26.7 x 19.7 cm)
Museum of Modern Art,
New York.
Photo: Peter Moore

according to art historian Mignon Nixon, ranging from repulsion to attraction, danger to desire, and fear of castration to penis envy, and may be seen, alternately, as a threatening symbol of violence and aggression or as an essentially helpless object in need of protection.[14]

In her book *Fantastic Reality*, Nixon approached Bourgeois's work from a feminist and psychoanalytical perspective, noting that "its disavowal of formal criteria of consistency and consecutive development, coupled with its intensive focus

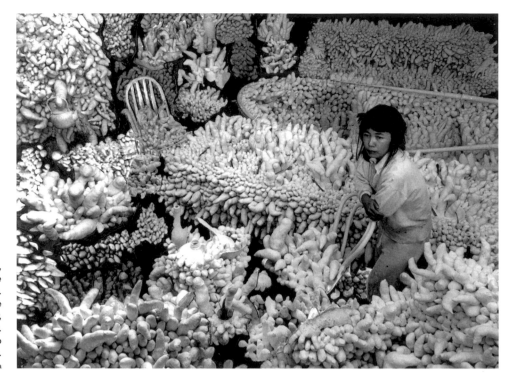

on the dynamics of sex and violence, points to the work's psychoanalytic logic."[15] Drawing on the work of the renowned psychoanalyst Melanie Klein (1882–1960), she went on to identify the artist's use of body parts, particularly the breast and penis, as an embodying of instincts or drives. *Fillette* is a part-object never to be made whole. The part-object also appears in the work of Bourgeois's contemporary, the acclaimed Japanese artist Yayoi Kusama, in the form of dense growths of upholstered phallic shapes that sprout from such domestic items as chairs, sofas, and ironing boards, as well as women's shoes and clothing, in her *Accumulation* sculptures of the 1960s. This proliferation of parts is obsessive, overtly sexual, and also comic. The depiction and repetition of phallic forms in the works of both Bourgeois and Kusama is firmly rooted in primal impulses or psychic drives, but appropriating the most potent masculine symbol may also be understood as an early feminist attempt to symbolically subvert and lay claim to male power.

Bourgeois more dramatically confronted male power a few years later in a large, complex installation that the artist revealingly titled *The Destruction of the Father* (1974) (opposite). In a darkened environment like a large lair, a platform strewn with multiple roughly shaped latex mounds and casts of animal parts is juxtaposed with a collection of bulbous forms hovering from above, generating a disturbing "atmosphere of oppression" and implied violence.[16] According to the artist, "This piece is basically a table, the awful, terrifying family dinner table

headed by the father who sits and gloats. And the others, the wife, the children, what can they do? They sit there, in silence. The mother of course tries to satisfy the tyrant, her husband. The children are full of exasperation. We were three children: my brother, my sister, and myself. ... My father would get nervous looking at us, and he would explain to all of us what a great man he was. So, in exasperation, we grabbed the man, threw him on the table, dismembered him, and proceeded to devour him."[17] Obviously, the artist's extreme anger and aggression toward her overbearing father and, by extension, an oppressive patriarchy is the animating force behind this cannibalistic scene of death and destruction. In making this work the artist gave tangible form to a childhood fantasy of revenge and found its effect to be cathartic.

Fleshlike mounds and what appear to be the rotting remains of a bizarre feast occupy the enormously long, draped table of *Confrontation* (1978), a major installation that recalls *The Destruction of the Father* in its engagement with sexuality and with a highly charged private ritual of ingestion, decay, and death. These two works also reveal the artist's ongoing interest in expanding her scope by experimenting with new forms, such as environmental installation as well as

The Destruction of the Father, 1974.
Plaster, latex, wood, fabric, and red light,
93 5/8 x 142 5/8 x 97 7/8 in.
(237.8 x 362.3 x 248.6 cm).
Collection of the artist.
Courtesy of Cheim & Read, New York. Photo: Rafael Lobato

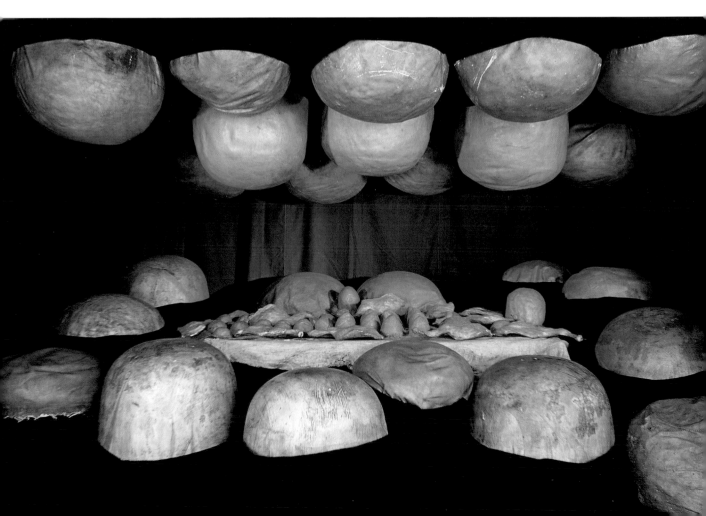

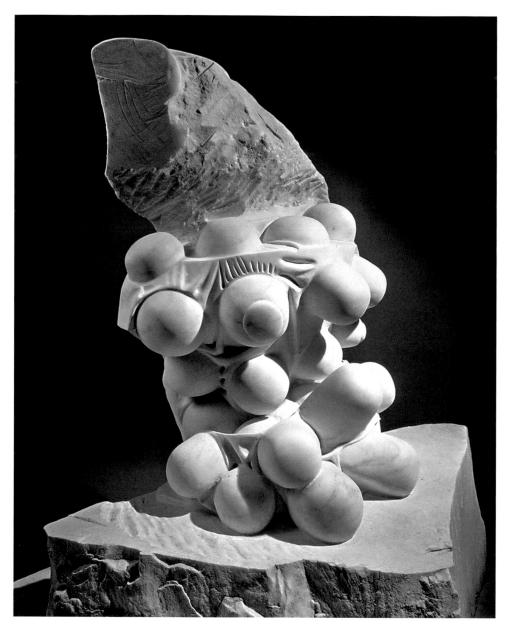

Blind Man's Buff, 1984.
Marble,
36$^{1}/_{2}$ x 35 x 25 in.
(92.7 x 88.9 x 63.5 cm).
Cleveland Museum of Art.
Photo: Allan Finkelman

performance art. For example, she presented an audacious performance titled *A Banquet/A Fashion Show of Body Parts* in conjunction with *Confrontation*, in which both male and female models donned outlandish outfits studded down the front with numerous breastlike protuberances. With this theatrical happening the artist introduced an air of freshness, exuberance, and fun to her body of work and made clear her intentions to explore new ideas and approaches into her sixties and beyond.

By the 1970s Bourgeois had achieved fame as an artist and as a feminist heroine—a position that was secured with her 1982 retrospective at the Museum of Modern Art. Her period of greatest recognition and influence, however, lay ahead. Throughout her career, Bourgeois had bravely confronted deeply personal and psychological states of being, often using representations of the fragmented body as her primary vehicle of expression. Her enduring investigations of autobiography and identity, sexuality and gender, and emotional extremes, as well as her tangible, visceral approach to art-making, had tremendous resonance in the 1980s as these issues moved to the forefront of contemporary art and culture, permanently broadening and altering and our appreciation of art and its relationship to life.

During the 1980s Bourgeois returned to marble as her preferred material for representing the human form, though she also worked in bronze, and she continued to experiment with large-scale installation. Having attempted to purge herself of hostility toward her father in her work of the 1970s, she shifted to the theme of the mother, focusing on her fearsome, monstrous, and fiercely protective aspects at this time. *In Nature Study* (1984), a grotesque yet highly seductive polished bronze figure, she combined the clawed haunches of a beast with a female torso adorned with six swollen breasts (see p. 2). This bizarre hybrid recalls the ancient sphinx, one charged with powerful and aggressive maternal impulses. Bourgeois made the destructive side of the maternal drive manifest in a series of steel spiders created in the 1990s, in which these ominous, towering creatures appear to hover between an intensely protective and dangerously menacing stance. As in much of Bourgeois's work, negative impulses invoke their opposite, and the power of the life force remains. The human-animal merge that defines *Nature Study* also suggests a being in a perpetual state of becoming. A related work, *Blind Man's Buff*, also of 1984 (opposite), comprises an abundance of exquisitely carved breastlike shapes emerging from a chunk of rough-hewn marble, a life struggling to be released from a stone, much like Michelangelo's four unfinished slaves in the Galleria dell'Accademia in Florence.

For the first forty years of her career Bourgeois worked in a studio in her home, traveling to Italy from the late 1960s to the early 1980s to sculpt marble and cast bronze. In 1980 she purchased a large ground-floor loft space in Brooklyn that permitted her to store her sculpture and materials, and to work on several projects concurrently. The level of production and scale of her work greatly increased at that time. She began to create large, complex installation work, as well as the major indoor and outdoor public sculptures that were now being commissioned by museums and cities internationally. In order to maintain this ambitious schedule, she hired assistants to aid in the fabrication of her work. Significantly, her art maintained its intensely personal, psychological focus even after it assumed a more public dimension.

By the 1980s, Bourgeois had become a model, both as foremother and as practicing artist, for a number of the most important younger artists who came of age at that time, including Kiki Smith, Rona Pondick, Robert Gober, Janine Antoni,

Cindy Sherman, Annette Messager, and Sophie Calle, among others, and their work is clearly indebted to her ground-breaking example. The breadth of Bourgeois's influence can be seen in the diverse approaches that Smith, Pondick, and Gober have taken to representing the psychologically and physically fractured body in their sculpture of the 1980s and early 1990s. The specter of sexual oppression and violence, primal impulses, gender uncertainty, illness, and loss variously informs the work of these artists. For nearly fifteen years, beginning in the mid-1980s, Smith committed herself to creating tender yet visceral depictions of the human body, both fragmented and whole, in an attempt to heal private wounds and mend social divisions. Like Bourgeois, she created emotionally urgent works to help exorcise her private anxieties. Her beeswax sculpture of a bloodied, battered woman, *Blood Pool* (1992) (below), explores raw and primal psychological states of extended suffering. She lies on the floor curled into the fetal position, her face undifferentiated, and her spinal cord starkly exposed. According to Smith, this painful work "deals as much with the psychic fragmentation caused by abuse as with the actual violence itself."[18]

Primal urges, fears, and desires also drive the work of artist Rona Pondick. Focusing on such Freudian fetishes as the mouth, the breast, and excrement, for example, her provocative, surreal works, like Bourgeois's sculpted body fragments, are part-objects or isolated components that viscerally embody an impulse or a drive. In *Little Bathers* (1990–91), an unsettling assemblage of approximately five hundred roughly shaped pink balls fitted with decayed yellow teeth, a group of cackling

KIKI SMITH, *Blood Pool*, 1992. Wax and pigment, 16 x 24 x 42 in. (40.6 x 61 x 106.7 cm). The Art Institute of Chicago. Twentieth Century Discretionary Fund, 1993.
© Kiki Smith, courtesy PaceWildenstein, New York

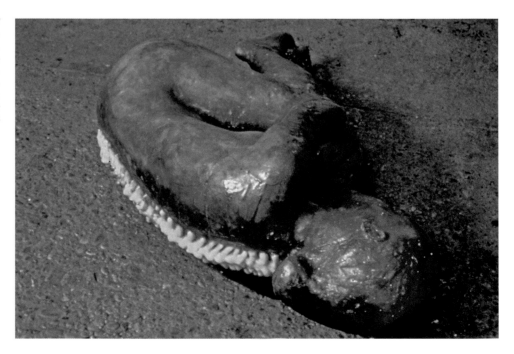

mouths seem to reduce human behavior to pure appetite. Two spherical white mounds titled *Milk* (1989) (below), comprised of numerous seemingly saturated, elongated sacks of paper towels capped with rubber nipples, conflate the breast with the baby bottle to create a striking symbol of orality that also evokes Bourgeois's psychosexual hybrids. Like Bourgeois, Pondick is unafraid to delve into the subconscious mind to reveal to the animal impulses behind society's civilized mask.

At the same time, artist Robert Gober was exploring the anxieties of childhood and adolescent domestic life in a group of works that are handmade variations of household objects such as tilted cribs and playpens, narrow beds, pristine yet distorted sinks, drains, and urinals—items that call for the presence of the body and evoke feelings of loneliness and loss in its absence. As Swiss curator Harald Szeemann observed, Gober was the first of a younger generation of sculptors to create work in which "thoughts and feelings circle, as if spellbound, around crucial childhood experiences, around first impressions and perceptions, first painful encounters with violence, constricting jealousy, and injustice." This reminds us of the emotional world of childhood trauma that pervades Bourgeois's art, though Gober conveys it in a decidedly detached, reserved, at times opaque, tone.[19] In Gober's works of the early 1990s, the furnishings used by the body evolved into charged body fragments and heterogeneous anatomical forms that expose extreme vulnerability and gender ambivalence. A wax candle rising from a hairy base is an obvious but impotent phallic symbol, easily extinguished. Severed from the body, it also implies a violent castration, as in Bourgeois's *Fillette*. In an untitled work of 1990, a

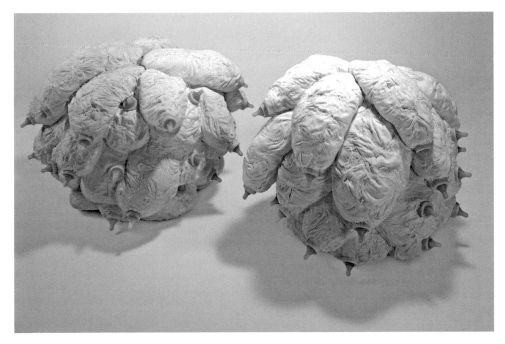

RONA PONDICK, *Milk*, 1989. Mixed media, left: 22 x 35 x 32 in. (55.9 x 88.9 x 81.3 cm); right: 22 x 33 x 32 in. (55.9 x 83.8 x 81.3 cm). Whitney Museum of American Art, New York

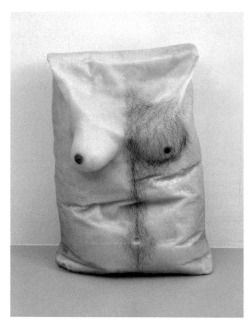

ROBERT GOBER,
Untitled, 1990. Beeswax,
human hair, and pigment,
24¹/₄ x 17 x 11 in.
(61.6 x 43.2 x 27.9 cm).
Collection of the artist.
Courtesy of the artist.
Photo: Jan Engsmar, Malmö

startling and improbable hermaphroditic beeswax torso takes the shape of a crum-
pled paper bag (above). With a woman's breast on the left and sprouting male chest
hair on the right, this floor-bound sack is the picture of gender uncertainty or col-
lapse and calls to mind the psychic impulse behind the Bourgeois's male/female
cumulus forms.

I have already mentioned that the latest phase of the artist's career has been
marked by an astounding burst of creative energy. Throughout the 1990s and into
the present century Bourgeois has built an extraordinary series of architectural
installations, collectively called the Cells, a title that may refer to a living organism
or, more aptly, to an anxious site of enclosure, confinement, and solitude (opposite).
The Cells are highly charged theaters of memory. Most often assembled from ele-
gantly sculpted body fragments and found objects of personal use and value, these
evocative works reveal a woman's interior life as an essentially fluid realm in which
internal states and external reality merge. In these installations, references to the
body and the home, ever-present in Bourgeois work, abound. As observed by cura-
tor Nancy Spector, "The psychosexual drama of the home has pervaded Bourgeois's
art from its very inception. *Femme Maison* drawings from the 1940s represent
woman and the house as inextricable entities … Reiterated over and over again in
Bourgeois's sculptural nests, lairs, and labyrinths, the home is portrayed as a female
site, the interstices of which encompass the pleasures and pains of woman's experi-
ence."[20] With the Cells Bourgeois has extended the metaphor of the home creating
intimate spaces into which the artist projects herself or her feelings to construct an
environment that personifies an emotional state. As she explains, "The Cells repre-

Cell (Choisy), 1990–93.
Marble, metal, and glass,
120¹/₂ x 67 x 95 in.
(306.1 x 170.2 x 241.3 cm).
Ydessa Hendeles Art
Foundation, Toronto.
Photo: Peter Bellamy

sent different types of pain: the physical, the emotional and psychological, and the mental and intellectual ... Each Cell deals with fear. Fear is pain."[21]

A claustrophobic atmosphere of isolation, loneliness, tension, and threat envelops these works. Each Cell is enclosed with chain-link fencing, recycled windows, or discarded doors through which we must peer, or in some cases may enter, to observe the haunting scenes within. In *Cell (Choisy)* (1990–93) (p. 47), a marble model of the artist's childhood home, a sign from her father's workshop, and a raised guillotine, caged in chain link, recall conflicted memories of youth and signify her "fear of being cut off from the past."[22] A woman's tender experiences of adulthood are suggested in *Cell II* (1991) (below), containing a collection of Shalimar perfume bottles and a beautifully carved pair of clasped female hands reflected in a circular mirror. The contrast between the strain of the tightly gripped hands and the pleasure suggested by the fragrance of the perfume invoke painful, unfulfilled longings for romance and sexuality.

Among the fetishized objects assembled in *Cell III* (1991) (opposite) are an amputated marble leg, with its toes curled under (in pleasure or in pain), emerging from a rough-cut base, and a paper cutter resembling a miniature guillotine poised above a small, tensely arched figure—an agonized image that the artist later

Cell II, 1991. Mixed media, 83 x 60 x 60 in. (210.8 x 152.4 x 152.4 cm). Carnegie Museum of Art, Pittsburgh.
Photo: Rafael Lobato

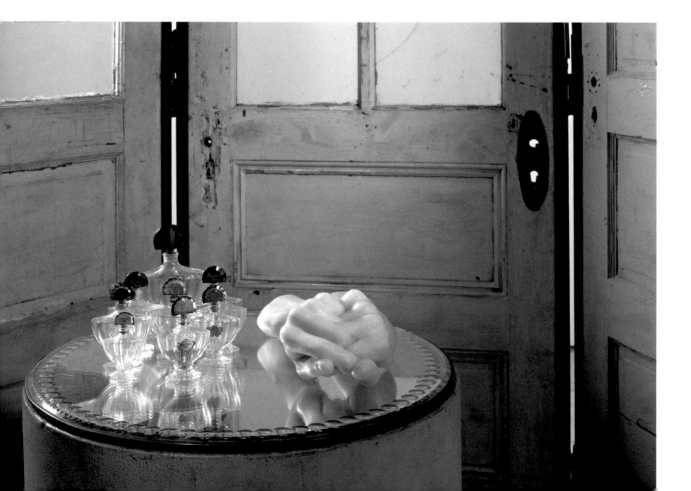

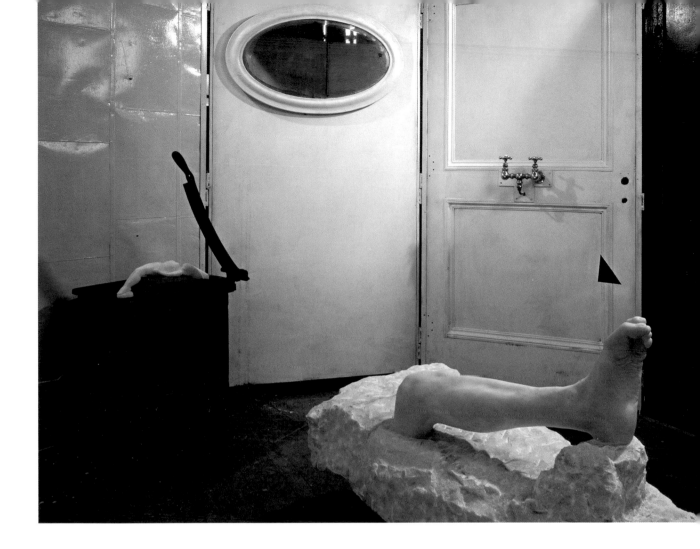

increased to life size and accompanied with a band saw in *Cell (Arch of Hysteria)* (1992–93). Although the narrative may be ambiguous, the acute physical and psychological tension of the horizontal body and its juxtaposition with dangerous implements create an overriding sense of risk, potential violence, and extreme unease. In each of these scenes a woman's well-being is dependent upon or imperiled by her relationships with others, ensuring that she will remain in a perpetual state of vulnerability. More recently, Bourgeois's Cells have been filled with personal items such as the dresses, nightgowns, and undergarments of her past, as well as the artist's stuffed cloth figures, including couples and families in various forms of embrace, summoning some of the more gentle chapters of her life story.

In the latter part of her tenth decade, Bourgeois is acknowledged as one of the most critically acclaimed, widely exhibited, and endlessly creative figures in the art world. Having persevered through years of personal trauma and public indifference, she has proven herself to be remarkably innovative and resilient, even tough.

Cell III, 1991.
Mixed media,
111 x 130¹/₂ in. x
13 ft. 9¹/₈ in.
(281.9 x 331.5 x 419.4 cm).
Ydessa Hendeles Art
Foundation, Toronto.
Photo: Peter Bellamy

Over time, and through the rise and fall of many trends or movements, Bourgeois has steadfastly pursued her own idiosyncratic course, anticipating and inspiring the work of younger generations of artists and persistently taking on major new challenges. In recent years her public commissions, predominantly the monumental and magnificent spiders, have been featured around the world in cities—New York, Washington, Ottawa, London, Bilbao, Moscow, and Tokyo—at a point in the artist's life when she seldom leaves her home. Over nearly seventy years as a practicing artist, Bourgeois has been a singular and singularly influential presence, for feminists among others, and has, most likely with great ambivalence, attained the status of artistic mother of us all.

Spider, 1997. Steel, tapestry, wood, glass, fabric, rubber, silver, gold, and bone, 14 ft. 7 in. x 21 ft. 10 in. x 17 ft. (444.5 x 665.5 x 518.2 cm). Collection of the artist. Courtesy of Cheim & Read, New York.
Photo: Attilio Maranzano

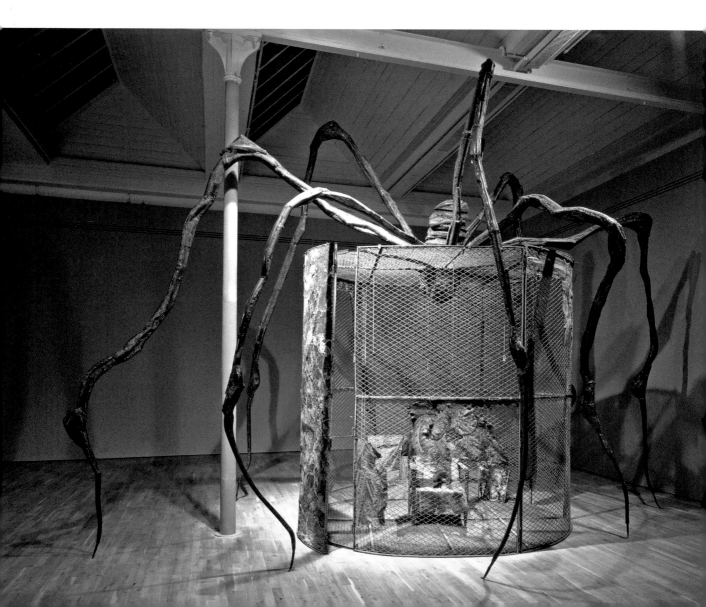

1. Lucy Lippard, "Louise Bourgeois: From the Inside Out," in *Louise Bourgeois*, ed. by Peter Weiermair (Kilchberg/Zurich, Switzerland: Edition Stemmle AG, 1989/1995), p. 13.

2. Mignon Nixon, *Fantastic Reality: Louise Bourgeois and a Story of Modern Art* (Cambridge, Mass., and London: MIT Press, 2005), p. 273. Bourgeois was often associated with this role: as Robert Storr recently summarized, "almost immediately she started to show signs of being the public icon, the alternately good and bad—charming and acerbic, wise and harsh-'mother of us all' that she has since come to epitomize." In Storr, Paolo Herkenhoff, and Alan Schwartzman, *Louise Bourgeois* (London: Phaidon Press, 2003), p. 31.

3. According to Deborah Wye, curator of the MoMA retrospective, "The work of art serves a psychological function for Bourgeois, for she believes that making art is the process of giving tangible form to, and thus exorcising, the gripping, subconscious states of being that fill one with anxiety." Deborah Wye, *Louise Bourgeois* (New York: The Museum of Modern Art, 1982), p. 14.

4. "Paulo Herkenhoff in Conversation with Louise Bourgeois," in Storr et al., *Louise Bourgeois*, p. 20.

5. Robert Storr, "A Sketch for a Portrait: Louise Bourgeois," ibid., p. 40. I am also indebted to Robert Storr and to Deborah Wye for the details of Bourgeois's biography.

6. Bourgeois quoted in Wye, *Louise Bourgeois*, p. 15.

7. Bourgeois, taped interview, July 2, 1979, as quoted in ibid., p. 18.

8. Bourgeois, as quoted in ibid., p. 18.

9. Storr, p. 57.

10. Bourgeois, as quoted in Wye, *Louise Bourgeois*, p. 24.

11. Robert Pincus-Witten, *Postminimalism* (New York: Out of London Press, 1977), p. 14.

12. Bourgeois, as quoted in Wye, *Louise Bourgeois*, p. 27. From a statement in Dorothy Seiberling, "The Female View of Erotica," *New York Magazine*, February 11, 1975, p. 56.

13. Rosalind Krauss, "Portrait of the Artist as *Fillette*," in *Louise Bourgeois*, ed. Peter Weiermair (Kilchberg/Zurich, Switzerland: Edition Stemmle, 1989/1995) p. 28. Krauss introduces the notion of Bataille's *informe* in relation to Bourgeois's sculpture of the 1960s in this essay.

14. Nixon, *Fantastic Reality*, p. 240.

15. Ibid., p. 3.

16. Wye, *Louise Bourgeois*, p. 29.

17. Bourgeois quoted in Nixon, *Fantastic Reality*, p. 258. From "Louise Bourgeois", exhibition installation booklet, Museum of Modern Art Archives.

18. Roberta Smith, "Body, Body Everywhere, Whole and Fragmented," *New York Times*, May 15, 1992, section C, p. 24.

19. Harald Szeemann, "The Fount of Youth: Gober* la Bourgeoisie!," *Parkett No. 27*, March 1991, p. 74.

20. Nancy Spector, "Statements," in *Louise Bourgeois: The Locus of Memory, Works 1982–1993* (New York: Harry N. Abrams, 1994), p. 81.

21. Louise Bourgeois, "On Cells," in *Louise Bourgeois: Destruction of the Father, Reconstruction of the Father, Writings and Interviews 1923–1997*, edited and with texts by Marie-Laure Bernadac and Hans-Ulrich Obrist (Cambridge, Mass.: MIT Press, 2005), p. 205.

22. Storr, "A Sketch for a Portrait," p. 82.

Nancy Spero: Radical History Painter

HELAINE POSNER

I believe I'm directly contradicting the way human beings are represented in our society. I think the universal is the male. And so in my deliberately turning this around and trying to universalize the female—the rites of passage for the woman— birth, puberty, childbirth, death would become the universal. I tried to challenge myself to look at the world as I wanted to, as a woman artist, realizing the complexities of doing so because the world isn't really that way. – NANCY SPERO[1]

A pioneering feminist with a career spanning more than fifty years, Nancy Spero is recognized as both an iconoclast and an exemplar whose art and activism have inspired two subsequent generations of women artists. Her success has been hard won. Working outside the mainstream in a figurative expressionist mode when abstract, minimal, and conceptual art prevailed, and eventually representing only the female on delicate hand-printed and collaged paper scrolls and architectural surfaces, Spero's work was for decades ignored or dismissed as marginal. With the rise of the women's movement in the late 1960s and 1970s and the expansion of subject matter, materials, and perspective it championed, this always-independent artist was able to assert her identity and begin to lay claim to her place in a male-dominated art world. She expressed her vision through an encyclopedic compendium of images and tales of women throughout time, including mythological and historic figures and texts drawn from a wide range of ancient, classical, and contemporary sources. This diverse collection gradually grew into a stock company of more than three hundred characters appropriated and developed by the artist to convey the multiplicity and heterogeneity of women's lives.

Mothers and lovers, goddesses and peasants, acrobats and bondage figures are featured among the artist's cast of female players, consisting of a core group of about fifty. Throughout her body of work Spero represents women not as individuals, but as archetypes who collectively encompass the breadth of female roles and experiences. Whether portrayed as victims of harrowing abuse and torture or in joyful celebration of their strength, sexuality, and possible liberation, Spero's women are the active protagonists, persistently supplanting the male as the universal. In this way, the artist maintains a defiant stance as women, regardless of their status or circumstance, occupy center stage, stubbornly and energetically disrupting long-established patriarchal standards and subverting the objectifying male gaze.

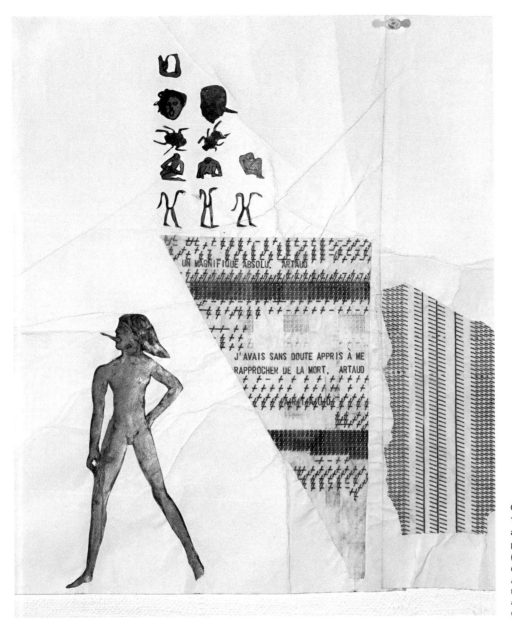

Codex Artaud VII (detail),
1971. Typewritten texts
and painted collage on
paper, 20^1/$_2$ x 12 ft. 6 in.
(52.1 x 381 cm).
Collection of Paul Golub.
All reproductions of art by
Nancy Spero courtesy of the
artist. Photos: David Reynolds
unless otherwise noted

Nancy Spero was born in Cleveland, Ohio, in 1926 and moved with her family to Chicago in 1927. In 1949 she received a Bachelor of Fine Arts degree from the School of the Art Institute in Chicago and later that year attended the École des Beaux-Arts and Atelier André Lhote in Paris. While studying at the Art Institute, Spero's fellow classmate was the figurative painter Leon Golub, who became her marital and studio partner for over fifty years. From the start the

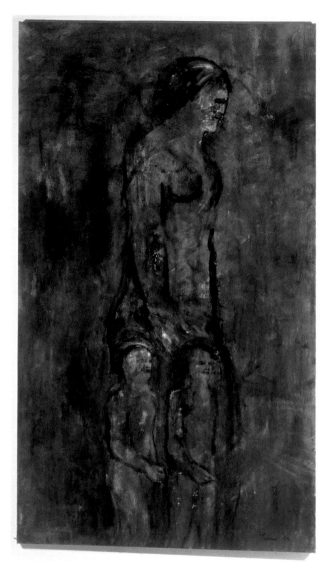

Mother and Children,
1962. Oil on canvas,
76³/₄ x 43¹/₂ in.
(194.9 x 110.5 cm).
Collection of the artist

artists shared a passionate moral engagement with world issues and events, confronting the harsh realities of social injustice, war, and the abuse of power in their work. Together they bore witness to the major conflicts of the twentieth century, Golub in monumental history paintings of men acting out aggression and violence and Spero by providing an alternative history of women with a distinctly delicate touch, turning the traditional genre of history painting on its head. Their "continuous dialogue,"² often critical, always brutally honest, was a vital aspect of their long and devoted relationship.

As students in Chicago, Spero and Golub were fascinated by the ethnographic objects they discovered at the Field Museum and were impressed with Art

Brut (raw art) as promoted by the French artist Jean Dubuffet, whom they heard lecture at the Art Institute. Their commitment to figuration and profound interest in the history of art led the couple to move to Europe in 1956, living in Ischia and Florence for a year, painting and exploring Etruscan tomb sculpture and Roman art. After a two-year interlude in Bloomington, Indiana, they settled in Paris in 1959, making it their home for nearly five years, having decided to bypass New York, then dominated by Abstract Expressionist painting, judging that environment to be hostile to their content-based work. They believed the artistic, philosophical, and political milieu of postwar Paris would better suit their art and their interests. Golub and Spero strongly identified with Existentialism, and with its two most prominent French exponents, Jean-Paul Sartre (1905–1980) and Simone de Beauvoir (1908–1986). Sartre's slogan "existence precedes essence" conveys existentialism's most distinctive idea, that the meaning of human existence is established through existing itself, not through preexisting categories. Beauvoir's famous recasting of that slogan from a socially grounded, feminine viewpoint, "One is not born, but rather becomes, a woman,"[3] defined the category of "woman" as socially constructed. The book in which it appeared, *The Second Sex* (published in the United States in 1953), helped to launch the postwar feminist movement and came to provide an essential philosophical foundation for the work of Spero and other artists. From this basic existential insight depend the notions of alienation, authenticity, and tragic dignity popularly associated with Existentialism and expressed powerfully in Spero's first major series of works, the Paris Black Paintings (1959–64), which depict isolated figures mysteriously suspended in a darkened void.

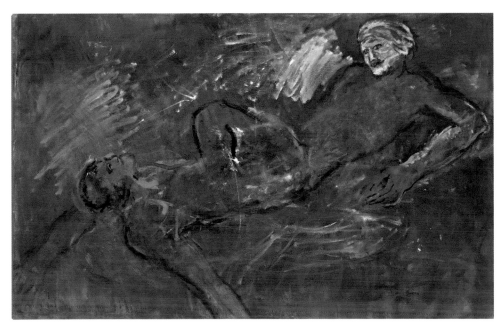

Lovers VIII, 1964.
Oil on canvas,
51³/₄ x 80⁷/₈ in.
(131.4 x 205.4 cm).
Camille and Paul
Oliver-Hoffman, Chicago

The Male Bomb, 1966.
Gouache and ink on paper,
24 x 36 in. (61 x 91.4 cm).
Private collection, Brussels

By 1961 Spero had given birth to three sons, Stephen, Philip, and Paul—adding the considerable responsibilities of motherhood to those of wife and practicing artist. Because she was occupied with domestic life during the day, she created the Paris Black Paintings at night while her children slept (p. 54). In these works, scumbled linear apparitions emerge from murky expanses of dark, heavily worked oil paint. Images of mother and child and, frequently, lovers are among the enduring and intimate subjects of these deeply personal, expressionist works. The artist portrays the sketchy, silhouetted forms of these erotically charged couples as seemingly adrift in a dim, strangely insular and hermetic space, calling to mind Alberto Giacometti's solitary, angst-ridden figures. As Spero explained, "these are paintings of the night revealing things that happen in the night. The darkness envelopes the figures and gives them a sense of protection. These works were meant to be about isolation. The figures are related and yet they are not. We are ultimately alone and isolated. I wanted to make an existential statement about the self. Look at the paintings of the lovers. Even though they appear to be together they are ultimately alone."[4] (p. 55) The sense of alienation and displacement embodied by these private, introspective figures also reflects the artist's experience of cultural dislocation and taps into the desolate condition of Europe after World War II.

Spero's isolation as a young artist was happily interrupted when she was invited to present three solo exhibitions of her work at the Galerie Breteau in Paris

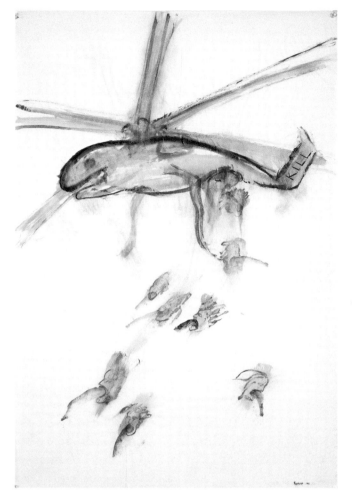

Helicopter and Victims,
1967. Gouache and
ink on paper, 36 x 24 in.
(91.4 x 61 cm).
Private collection

beginning in 1962, an opportunity not soon repeated after the artist and her family
returned to the United States in 1964 and settled in New York. She then entered an
art world dominated by the cooler styles of pop art and then minimalism. Perhaps
predictably, there was little interest in her work, a situation that frustrated her for
many years. Her return home also heightened the artist's political awareness,
already awakened by the experience of violence and protest in France during the
Algerian conflict. Spero's anger, as she watched on the nightly news the death and
devastation wrought by the Vietnam War, found expression from 1966 to 1970 in
the War Series, her manifesto against American imperialism, which marked a major
shift in her work from the private, internalized world of the Black Paintings to one
of public outrage and moral urgency sparked by a ruinous war. In this series, the
artist created a fierce and grotesquely sexualized iconography to convey her mount-

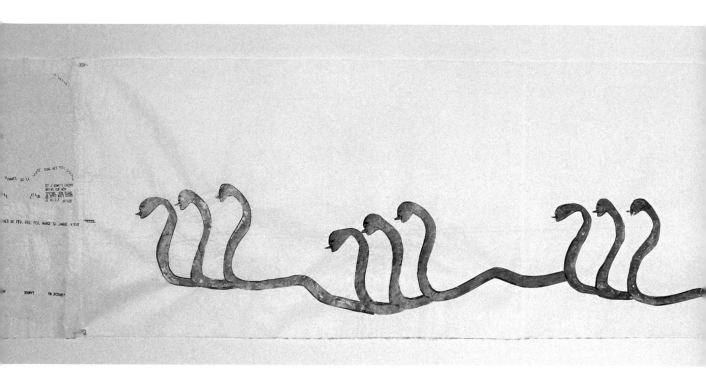

Codex Artaud XXV,
1971–72. Typewritten texts
and painted collage on
paper, 28 x 16 ft. 4 in.
(71.1 x 497.8 cm).
Collection of Philip Golub

ing disgust. These drawings have been likened Goya's masterpiece series, the Disasters of War (1810–11), as each body of work powerfully and timelessly bears witness to the atrocities of their day.

The War Series is Spero's scathing indictment of the Vietnam War expressed through exaggerated phallic imagery and the depiction of monstrous machines. In works like *The Male Bomb* (1966) (p. 56), an enormous, thrusting penis ejaculates its venom into the mushroom cloud enveloping his body, while the cloud spawns multiple heads that spew their poison onto the populace below. The phallus is again linked with destruction in *Crematorium Chimney* (1967) as the smoke of burning bodies is released from a tower emblazoned with swastikas. The artist also portrays the military helicopter as a giant devouring bug, terrifying Vietnamese peasants and soldiers alike, and ultimately defecating their vomiting heads from its fuselage (p. 57). She reinforces the violence and obscenity of this imagery with equally obscene language, inscribing "kill," "search and destroy," "fuck you," and "I laid my stuff all over it" on these symbols of death. For the artist, the carnage perpetrated by the U.S. military, and by implication the armies of all nations and eras, as evidenced in her use of the swastika and the crematorium, is intrinsically fascist and specifically, aggressively male.

In the War Series Spero not only dramatically redefined and externalized her subject matter, she also arrived at a new formal approach that became her signature mode for the next twenty years. "Materially delicate yet brutal in their imagery," wrote art historian Robert Storr, "these hybrid works on paper set forth the basic terms of Spero's aesthetic."[5] Spero had abandoned the slow layered process of the black paintings and adopted a less deliberate, more spontaneous working method, using gouache and ink on paper and eventually collage and hand-printing, to create increasingly angry and subversive, yet fragile, works. By the 1970s the anger she focused on the horrors of war gave way to a more fundamental and expansive rage. At this time, her deep personal resentment at being ignored and consequently silenced as a woman artist was running high, exacerbated by the chronic physical pain of progressive arthritis, which struck the artist at age thirty-four. Spero discovered an eloquent if unlikely voice for her bitterness in the extreme and anguished works of the French writer Antonin Artaud (1896–1948), advocate of the "theatre of cruelty." As the artist notes, "Encountering Artaud, I recognized his extraordinary alienation. I decided I would reach out to his ferocious language to express my anger."[6]

The *Codex Artaud* (1971–72) (above and p. 53), a work of tremendous ambition and scope, is one of Spero's most significant contributions to recent art his-

...torture was considered to produce probatio probatissimi, 'the proof of all proofs', and its practice was meticulously regulated and codified.... the 'question' was divided into different degrees ordinary extra ordinary, preparatory, and preliminary torture was administered in a special chamber by a civil servant who also served as the public executioner.

Above and opposite:
Torture of Women
(details of panel III and VIII),
1976. Gouache, typewritten
texts, collage, and
handprinting on laid paper,
overall:
24 1/2 in. x 132 ft. 6 in.
(62.2 x 4039 cm).
National Gallery of Canada,
Ottawa

tory. To create the codex, or chronicle, the artist juxtaposed bulletin-typed segments of Artaud's lacerating rants with small collaged images of sometimes fragmented human and animal forms, rhythmically deploying them across thirty-three horizontal paper scrolls, several of which reach almost twenty-five feet in length. The scroll, as well as the interweaving of word and image introduced in the *Codex Artaud*, became a hallmark of Spero's work. It recalls the Egyptian *Book of the Dead*, whose earliest versions date from the sixteenth century B.C., in its realizing of a contemporary hieroglyphics in an extended serial format. Spero's potent imagery includes multiheaded snakes, beetles, mythological and modern assassins, and, importantly, disembodied heads with phallic tongues, perhaps representing the artist belligerently sticking her tongue out at the world while using the voice of the angry, nearly insane poet to articulate her fury. Although fueled by pain and resentment, the *Codex Artaud* is also a carefully composed and highly complex work. In it Spero channeled her personal demons in a sophisticated visual language of signs, symbols, and texts that became, in the scrolls to follow, a means to address the struggles and distress endured by women on political, social, physical, and philosophical levels.

Spero has said that for her "the personal and the political are indistinguishable."[7] Relegated to the margins for so long, she became galvanized by the women's movement of the late 1960s and 1970s, which helped her define the direction of her work and, from then on, a focus for her activism. She became involved with the Art

LAURA RAGGIO
20 years old
SILVIA REYES
19 years old
d: 21 april 1974 both
students and left wing
militants, they were
arrested during a
house search in monte
video. in the same
operation another girl,
DIANA MAIDANIK received
35 shots when she open
ed the door. although
the authorities claimed
the three girls had
died in cross fire,

URUGUAY

neighbors saw ms. raggio,
ms. reyes and two men
being carried away by
security men. the next day,
the bodies of the two
girls were delivered to
the families, showing –
besides bullet injuries –
signs of beatings and
areas of the skull where
large strands of hair had
been pulled out.

In the image, the following text appears within the artwork:

...there is no essence of woman...
...there is no truth about woman...
...the feminist women...are men
feminism, indeed, is the operation
by which woman wants to come
to resemble man...the whole
virile illusion...feminism
wants
castration,
even that of
woman. jacques derrida
1971

Workers Coalition and helped form WAR (Women Artists in Revolution), whose activities included writing letters to the directors of major museums demanding parity for women artists in exhibitions and collections. As a member of the Ad Hoc Committee of Women Artists she participated in protests against sexist and racist museum policies, picketing New York's Whitney Museum of American Art with her colleagues to demand fifty percent representation of women in their annual exhibition. Unsatisfied with merely protesting the inequities of the art world and analyzing the power structure that excluded them, Spero and five other artists—Dotty Attie, Maude Boltz, Mary Grigoriadis, Susan Williams, and Barbara Zucker—founded A.I.R., the first cooperative gallery in New York dedicated to showing women's art. A.I.R. opened its doors in September 1972 and Spero exhibited the *Codex Artaud* there in 1973, marking at age 47 her first solo exhibition in New York.

By the early 1970s Spero had defined her artistic practice as one of resistance and rebellion, gradually eliminating from her work the standard materials, methods, and subjects by which "great art" is evaluated. Beginning in 1966, she adopted the use of paper, instead of oil on canvas, the traditional choice for major works, consciously attempting to subvert the expectations of museums and collectors. The artist also underscored the fragile, ephemeral quality of her paper scrolls by handprinting and collaging tiny images sporadically across their length, thereby resisting the imperatives of both permanence and monumentality. In 1974 Spero made the

crucial decision to banish the male figure from her repertoire of images. At that point she embarked on her "life's project," described by art historian Jo Anna Isaak as "writing her epic story of the women of her time with her own lexicon of female figures."[8] Still fueled by a rage both personal and political, Spero decided to make her first directly feminist work a mournful document of women's pain and victimization across cultures and times. She called this work *Torture of Women* (1974–76) (pp. 60–61).

In these scrolls, Spero combined mythological tales and figures with contemporary media reports to reveal a hidden history of atrocities committed against women around the globe. The assembled images and accounts are laid down sparingly and with a typically delicate touch that belies their devastating message. Snakes, winged monsters, tiny disembodied heads, and gesturing females are among the symbolic forms that punctuate the ancient texts, such as a Babylonian myth describing the creation of the world from the body of a destroyed goddess, and modern case histories, taken from Amnesty International newsletters recounting the horrific abuse of women political prisoners. These personal or eyewitness accounts of the torture and rape of named and anonymous women, often at the hands of authoritarian regimes supported by the United States, testify to their terrible suffering and shameful death, and to the impact of this brutality on families and communities. *Torture of Women* quietly and cumulatively enters our con-

The First Language, (panel 2, detail), 1979–81. Painting, collage, and handprinting on paper, 20 in. x 190 ft. (51 x 5790 cm) overall. National Gallery of Canada, Ottawa

sciousness to explosive effect, unfolding over fourteen horizontal panels that bear witness to the physical and psychological trauma of torture used against women as a tool of state control.

Spero continued her study of victimage in her next extended scroll titled *Notes in Time on Women* (1976–79) (p. 62). This work, measuring 215 feet in length over 24 panels, was originally conceived as a continuation of *Torture of Women*, but its size and trajectory dictated a different focus. Along with typewrit-

*Sky Goddess/Egyptian
Acrobats*, 1987–88.
Handprinted and printed
collage on paper,
overall: 108 in. x 22 ft.
(270 x 670 cm).
Hiroshima City Museum
of Art.
Photo: Charles Crist

ten accounts of the torture and murder of women from Amnesty International akin
to those in the earlier scroll, *Notes in Time* includes quotations from poets and
philosophers through the ages who denigrated women. The blatant misogyny
voiced by such noted thinkers as Pliny, Hesiod, Nietzsche, and Derrida, Spero
implies, attests to the pervasiveness of sexism throughout the culture and rational-
izes women's continued subjugation. Refusing to allow these men to have the last
word, Spero counters their statements with multiple images of dancing, running,

Above and opposite:
*Sheela and the Dildo
Dancer* (details of
panels 4 and 7), 1987.
Handprinting and printed
collage on paper, overall:
24 in. x 73 ft. 3 in.
(61 x 2233 cm).
Collection of the artist

and leaping females who use their energy, strength, sexuality, and good humor to physically interrupt the texts and actively debunk their message. The figures of Artemis, goddess of the hunt, ancient Greek dildo dancers, and athletic figures running with abandon are among the mythological, historic, and contemporary characters who express their autonomy and independence through their bodies in this work. These women and their sisters have become the protagonists in increasingly optimistic scenarios that celebrate their vitality and potential.

After completing *Notes in Time*, Spero dispensed with the text that had been such an important component of her work until then to fully focus on the expressive possibilities of the unfettered female body in motion. In her next major work an ever greater number of physically and sexually vibrant women engage in a jubilant, nearly frenetic dance to express their growing sense of freedom and empowerment. The gestures, movements, and expressions of these figures, or their body language, function as both "image and text" in the artist's new work.[9] In a scroll aptly titled *The First Language* (1979–81) (p. 63) these figures become a type of hieroglyphic of the buoyant female spirit. With this work Spero's shift from depicting woman as victim to woman in joyful celebration of herself became more complete, reflecting her growing sense of self-confidence as an artist and her changing fortunes aided, in no small measure, by the advances of the feminist movement. By the late 1970s Spero had broadened her range to cover the spectrum of women's experiences and possibilities, and while joy often prevailed, the darker realities of life were never ignored.

By the 1980s Spero was assembling, juxtaposing, printing, collaging, and over-printing numerous celebratory female figures across multipaneled horizontal scrolls and vertical totems, a pictorial space that suggests a nearly limitless field of activity. Her encyclopedic cast of characters had grown to include a cross-cultural pantheon of prehistoric and aboriginal figures; ancient goddesses, acrobats and athletes; and contemporary peasants and movie stars, carefully culled from the archives of high and popular culture. Spero has said that one of her "main strategies has been

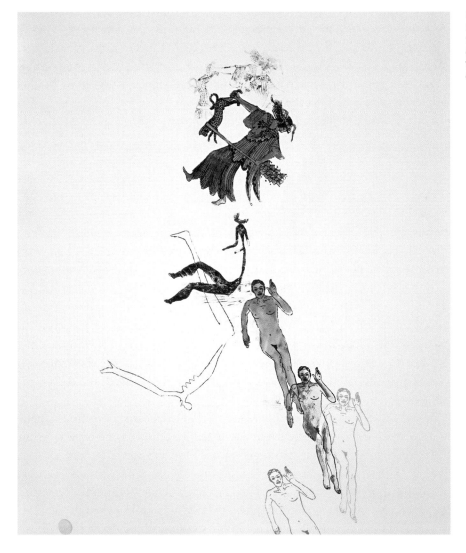

To Soar III (detail), 1991.
Handprinting on ceiling,
17^1/$_2$ x 125 ft.
(44.4 x 3810 cm). Harold
Washington Library,
Chicago

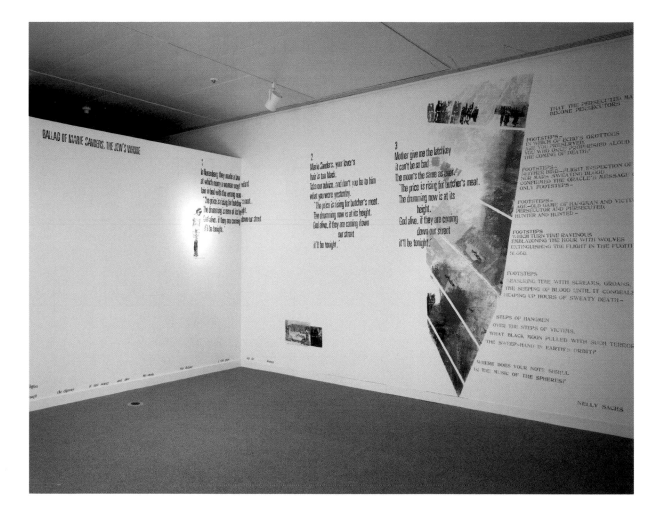

The Ballad of Marie Sanders/Voices: Jewish Women in Time, 1993. Handprinting on walls. The Jewish Museum, New York

to construct a simultaneity of women through time" from an image bank that reaches from the annals of art history to recent media imagery, even pornography.[10] She is, in a sense, a history painter who ignores standard chronological history and established hierarchies, preferring to take an intuitive, synchronic approach to telling the epic story of women. Her approach to narrative is nonlinear and open-ended, and favors the poetic over the pedantic.

From the late 1980s to the early 1990s Spero created some of the most colorful, stunning, and energetic works of her career. Her typically small, stylized figures, highly animated, often beautiful, and occasionally transgressive, move through space at an accelerated pace in installations that visually envelop the viewer. Some of the star players depicted and often repeated in these lively scenes of strength, sexuality, and healing include: a robust prehistoric fertility figure; the

Egyptian sky goddess, and an Egyptian acrobat performing backflips; Artemis, the huntress and healer of women's pain; Aphrodite, goddess of childbirth and prostitution; Sheela-na-gig, a ninth-century Celtic goddess of both fertility and destruction; an old Vietnamese peasant woman; the film star Marlene Dietrich in drag; a Thai go-go dancer; and a female Olympic athlete. Spero's extraordinarily diverse, wide-ranging collection of female figures attests to her intellectual and cultural curiosity as well as her ability to select and combine mythological and historical figures whose attributes resonate most fully with the women of her time.

Sky Goddess/Egyptian Acrobat (1987–88) (pp. 64–65), comprising eleven vertical totems printed with more than thirty-five individual figures and vignettes, is one of the most spectacular works from this exceptionally productive period. In the first few panels Spero harks back to themes of pain and victimization in horrific scenes of women being tortured and hung, while a crouching, skeletal pre-Columbian figure keeps watch. As the work progresses, these brutal scenes yield the stage to multiple figures embodying the female life force in its varied forms. The delicate, arched figure of Nut, Egyptian mother of the gods and goddess of the sky and heavens, assumes her proper position at the top of these totems while the powerful toga-clad Artemis strides with raised fist at the bottom. In between, Egyptian acrobats do backflips, aboriginal figures spring into action, various classical nudes dance and leap, and a naked, high-heeled woman provocatively spreads her legs. The protagonists of these panels exalt in their freedom, manifested in exhilarating expressions of physical and social release. In a related 1987 scroll, Sheela, a Celtic goddess who grins widely while boldly displaying her giant vagina, is joined by a merry chorus line of Greek dildo dancers (pp. 66–67), who collectively mock the male and all cultural constraints to pursue their own forms of erotic pleasure. In these works, and others from this time, Spero presents the possibility of a witty and subversive feminist utopia.

These energetic figures eventually leaped off their paper totems and scrolls and directly onto the architectural surfaces of museums, galleries, and other public places in the late-1980s, freeing themselves of the limits of the frame and entering real space while also implying fictive space, as in the illusionistic dome paintings of Correggio (1490–1534). Spero's hand-printed installations may be seen both as extensions of her artistic practice and as a bold new direction in her work. She deployed her typically delicate graffiti-like figures on walls, ceilings, alcoves, and staircases, often choosing peripheral locations, where the viewer would only gradually become aware of their presence. Although a few of these site-specific installations are permanent, most are temporary, surviving only in memory or through photographic documentation—making them even more ephemeral than the artist's fragile works on paper. The installations, like much of Spero's art, are episodic and ethereal in execution, yet extraordinarily ambitious in scope. They have become an essential aspect of the artist's oeuvre and are, perhaps, the ideal expression of her aesthetic.

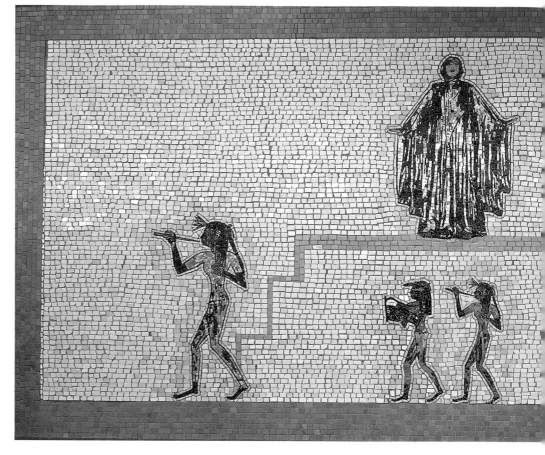

Artemis, Acrobats,
Divas, and Dancers
(detail), 1999–2000.
22 glass and ceramic
mosaic panels.
Metropolitan Transporta-
tion Authority,
Arts for Transit, New York

In *To Soar* (1991), an exuberant band of female athletes and others led by dancing Maenads, worshipers in the orgiastic cult of Dionysus, gaily sprint across the ceiling of Chicago's Harold Washington Library while multiple images of the Egyptian sky goddess lightly reign over the heavens (p. 67). As the title suggests, these figures appear to take flight in what Spero terms "a release, an escape from the heaviness and gravity of one's own body," a statement that reflects the spirit of the work and refers to the artist's ongoing struggle with the increasingly debilitating effects of chronic arthritis.[11] A similarly buoyant air fills *Premiere* (1993) installed in the lobby of the Ronacher Theater in Vienna. In this work a colorful array of leaping aboriginal figures, backflipping acrobats, running and skipping athletes, and sky goddesses energetically ascend the lobby walls, mingling with images of female performers from different cultures and times including an ancient Egyptian lute player, the exotic dancer Josephine Baker, popular French singers Mistinguett and Yvette Guilbert, and others who entertained at this the-

ater during its heyday in the early part of the twentieth century. These celebratory installations and others to yet to come concentrate on female creativity and the female life force actively laying claim to their new architectural surroundings.

Art historian Jon Bird has observed that a "dialectic of pleasure and pain runs through the scrolls, totems, prints and installations," and while the work of the late 1980s and 1990s was often charged with the pleasure of female agency, Spero continued to cast an honest and unflinching eye on the exploitation and oppression of women over time.[12] In the early 1990s she created three powerful installations exploring the theme of Jewish women's suffering during World War II, based on an archival photograph of a naked young woman, tightly bound with rope, gagged, with a noose around her neck, bearing the chilling caption "Document found on a member of the Gestapo." The anonymous figure on display has been abused and fetishized, and her degradation has been made a souvenir. Spero underscored the obscenity of this image by pairing it with a 1934 poem written by Bertolt Brecht

titled *The Ballad of Marie Sanders, the Jew's Whore*, which she hand printed on a stairway wall at the Smith College Museum of Art in 1990 and included in an exhibition at the Jewish Museum, New York, in 1993 (p. 68). The poem tells of a Christian woman who was humiliated and tortured for having sex with a Jew and sounds a general alarm to the German populace. In Spero's installation of the same name, image and text eloquently inform and contextualize each other, powerfully resonating down the gallery wall and in the viewer's mind.

As noted above, the theoretical framework for much of Spero's art may be found in the work of such radical French thinkers as Simone de Beauvoir and, a generation later, Hélène Cixous. In *The Second Sex*, a classic text of feminist philosophy, Beauvoir observed that woman "is defined and differentiated with reference to man and not he with reference to her; she is the incidental, the inessential as opposed to the essential. He is the Subject, he is the Absolute—she is the Other." This is a

Cri du Coeur, 2005.
Handprinting and printed
collage on paper, 26 in.
(66 cm) high,
length variable. Collection
of the artist

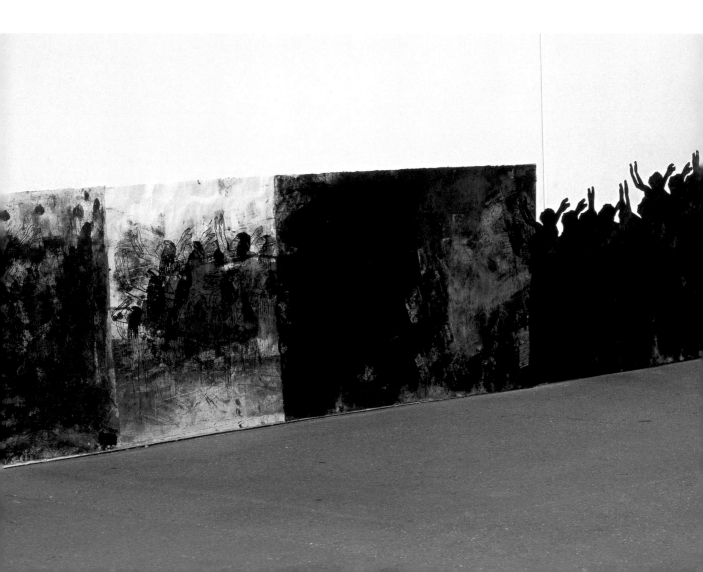

fundamental concept that Spero recognized early on and constantly sought to subvert by universalizing the female as protagonist.[13] Beauvoir also expounded a feminist existentialism in which she factored the oppression of women into Sartre's notion of the absolute freedom of the individual. She believed that women's circumstances—their subjugation and exclusion, as well as their relationships with and responsibilities to others—limit their ability to be truly free. In Spero's work from the seventies on, she has portrayed women's freedom, autonomy, and joy as continually constrained by the tyranny of an unjust patriarchy, adopting Beauvoir's feminist, socially conditioned reading of existentialism as a premise for her politically informed work.

In her 1975 essay "The Laugh of the Medusa," Cixous proclaimed, "Woman must write her self: must write about women and bring women to writing, from which they have been driven away as violently as from their bodies."[14] She called for

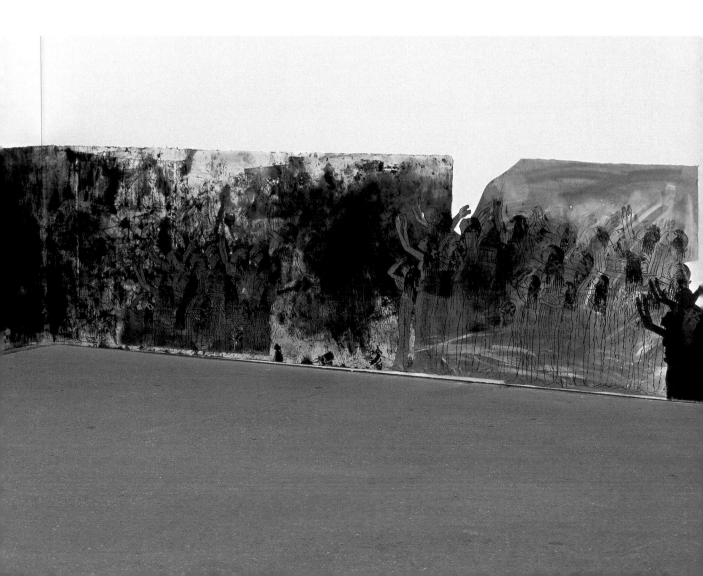

the creation of an *écriture feminine*, a form of writing derived from women's different experience of pleasure, desire, and sexuality. Cixous contended that in writing from the libidinal body women could resist our culture's phallocentric tradition at it deepest levels to create a persuasive alternative discourse, one that would assert her meaning in history.[15]

The notion of *écriture feminine* provides the theoretical underpinnings for Spero's *peinture feminine*, a corresponding visual form in which the artist's multiple, cross-cultural, and pan-historical images of physically and sexually unfettered women directly express themselves through the language of the body. Both *écriture* and *peinture feminine* provide a means for women, whose experience has been systematically repressed and excluded from the history of Western thought, to fully emerge as a powerful creative force, capable of resisting and even transforming the existing culture. According to Cixous and other feminist thinkers like Julia Kristeva and Luce Irigaray, women may accomplish this liberating and transgressive feat through *jouissance*, a joyful passion that extols female sexual pleasure and the maternal. In Spero's art the female body in motion, brightly colored and in joyful celebration of her being and desire, manifests an enormous capacity for *jouissance*, her energy and glee signifying the tremendous strength of the female spirit.[16] Throughout her career Spero has been drawn to, and maintained a fitful relationship with,

ANA MENDIETA, *Untitled* (Silueta series in Mexico), 1976. The Estate of Ana Mendieta Collection. Courtesy of Galerie Lelong, New York

cultural theory. Rather than adhere to any given philosophy, she seems to anticipate the intellectual Zeitgeist, intuitively appropriating and synthesizing ideas and images to create a body of work that forms a more fluid, encompassing, and multi-faceted picture of women over time.

In 2000 the artist unveiled her most dazzling and ambitious site-specific installation to date in the highly public space of the Sixty-sixth Street subway station in New York City. The work was inspired in part by its location near Lincoln Center, the city's major venue for the performing arts, as well as its proximity to the lively neighborhood bordering Central Park. The artist's *Artemis, Acrobats, Divas*

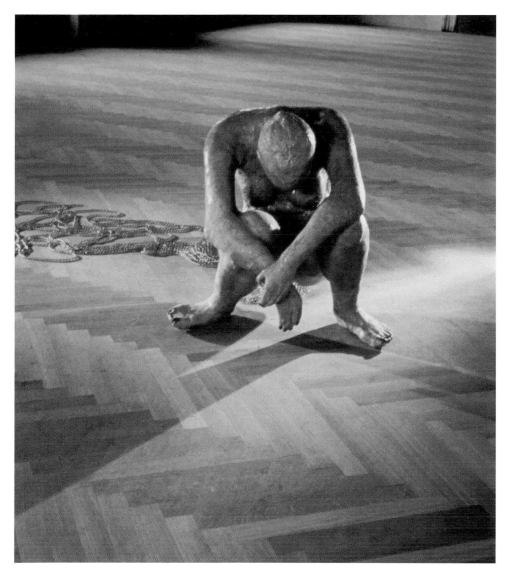

KIKI SMITH, *Pee Body*, 1992. Wax and glass beads, 27 x 28 x 28 in. (68.6 x 71.1 x 71.1 cm) Barbara Lee, Emily Pulitzer, and the Harvard University Art Museums
© Kiki Smith, courtesy PaceWildenstein, New York.

and Dancers (1999–2000) (pp. 70–71), adorns the length of the subway platform's opposing walls with spirited scenes of female singers, dancers, musicians, athletes, and acrobats, in performance and in motion. Once again, Spero drew on her stock company of female protagonists, including goddesses Artemis and Athena; historical personages such as Roman dancers, Egyptian flautists, lyre players, and acrobats; and contemporary runners and roller-skaters. She added a new star to her company, a Viennese opera singer from the 1920s, the Diva, as a symbol of the arts (see p. 79). This permanent installation unfolds in a rhythmic sequence of twenty-two vividly colored glass-mosaic panels, a medium employed by the artist for the first time and to great effect. The Diva, particularly splendid in her glimmering gold and red gown, appears repeatedly, slowly raising and lowering her arms to produce an animated or cinematic effect, best seen by viewers on a passing train. *Artemis, Acrobats, Divas, and Dancers* brings color, movement, beauty, and grace to a typically nondescript underground space, weaving an unexpected utopian moment into the fabric of everyday urban life.

Throughout the 1990s and the first years of the new century, Spero has continued to make extended hand-printed and collaged paper totems and scrolls that parallel her installation practice, including works that express both tremendous joy such as *Azur* (2002), an exuberant, richly colored, three-tiered scroll packed with celebratory female figures, and great sorrow, on an individual and universal level. In *Cri du Coeur* (cry of the heart, 2005) (pp. 72–73), the artist flawlessly fused form and content to produce a profound meditation on grief. She placed the long, mostly dark, friezelike scroll along the perimeter of the gallery at floor level in a gesture that seems to echo the weight of its subject. The work takes the viewer on a course that begins with heavily overprinted blacks, progresses through deep blues, greens, browns, and bloody reds, and culminates in a light yellow section that provides some visual relief. From this somber background a densely layered procession of Egyptian female mourners, seen in profile with heads turned upward and arms raised high in supplication, emerge. Spero drew this stately chorus from images discovered in the tomb of Ramose of Thebes (c. 1411–1374 B.C.). Their assembled forms evoke those who have suffered death and destruction wrought by war and natural disaster throughout time and recalls the multitudes who mourn these calamities to the present day. *Cri du Coeur* constitutes a restrained yet heartfelt lament and serves as a solemn reminder that the act of mourning is mostly performed by women. It is also a personal expression of loss after the death of the artist's husband of fifty years in 2004.

Over the years, Spero's work and undeniable integrity have served as a beacon to at least two generations of women artists, critics, curators, and others. She is often cited as an influence on younger women whose works constitute a feminist reappraisal of the meaning and representation of female body, including Ana Mendieta, Kiki Smith, and Lesley Dill, among other kindred spirits who share her deeply humanistic impulse. Like Spero, Mendieta (1948–1985) borrowed freely from multiple cultural traditions to create her ephemeral body-centered performance work.

As a Cuban traumatically exiled from her homeland as a child and relocated to the United States, she was determined to assert her transcultural feminist identity, often drawing on the symbols and practices of the indigenous cultures of Cuba, Africa, Mexico, Central America, and Europe to generate a deeply personal body of work art rooted in native traditions. She created her signature Silueta series (1973–80), in which she inserted her naked body into the natural environment or shaped its silhouette from such materials as earth, twigs, flowers, sand, and rocks (p. 74), to make works that, like those of the senior artist, reference the power of ancient goddesses and make the archetypal female central to her practice. Mendieta also shared Spero's awareness of the persistence of female victimage, drawn from her painful personal experiences of exile and displacement, and, like her, sought to find her voice in part through social activism, energetically working as an informal liaison between artists and cultural organizations in the United States and Cuba.[17]

Both Spero and Kiki Smith have portrayed the nude female body as a site of resistance and transgression. Whether representing ancient figures boldly displaying their vaginas or dildo dancing, or contemporary women publicly exposing private acts, for example expelling bodily fluids in the form of yellow or red glass beads, as in Smith's sculptures (p. 75), both artists present the female body in ways that defy societal norms, essentially depicting women who refuse to behave. Each has also gone on to portray the sacred as well as the profane, representing a pantheon of mystical heroines derived from various religious, mythological, and folkloric sources to express the fullness of women's vitality, beauty, and strength.

At age eighty, Nancy Spero is both a legendary feminist and an active working artist. Her multipart works of the 1970s and early 1980s, such as the *Codex Artaud*, *Torture of Women*, and *The First Language*, are documents of great visual and conceptual importance and constitute one of the major statements of the women's movement – one grounded in contemporary realities while edging toward utopian possibilities. From the late 1980s until today she has created paper totems and scrolls, and site-specific wall installations that continue to scrutinize the human condition, challenging and confronting the organization of patriarchal society and, at the same time, celebrating the strength of empowered womanhood. In art and life she is rebellious, independent, determined, and courageous, yet for all her toughness she remains remarkably kind, generous, engaging, and accessible. Spero is, and has always been, an artist of her political, social, and cultural moment, while resolutely standing apart from the mainstream as a unique creative presence.

1. Quoted in Jo-Anna Isaak, "Nancy Spero: A Work in Comic Courage," in *Nancy Spero: Works Since 1950* (Syracuse: Everson Museum of Art, 1987), p. 28.
2. Quoted in Katy Kline and Helaine Posner, "The Good Fight," in *Leon Golub and Nancy Spero: War and Memory* (Cambridge, MA: MIT List Visual Arts Center, 1994), p. 12.
3. Simone de Beauvoir, *The Second Sex*, trans. and ed. H. M. Parshley (New York: Alfred A. Knopf), p. 281

4. Quoted in Elaine A. King, "The Black Paris Paintings," in *Nancy Spero: The Black Paris Paintings 1959–1966* (Pittsburgh: Hewitt Gallery, Carnegie-Mellon University, 1985), p. 11.

5. Robert Storr, "When This You See…" in *Nancy Spero: Women Breathing* (Ulm: Ulmer Museum, 1992), p. 17.

6. Quoted in Katy Kline and Helaine Posner "A Conversation with Leon Golub and Nancy Spero," in *Leon Golub and Nancy Spero: War and Memory* (Cambridge, Mass.: MIT List Visual Arts Center, 1994), p. 39.

7. Robert Enright, "On the Other Side of the Mirror: A Conversation with Nancy Spero," *Border Crossings* 19, no. 4 (2000), p. 30.

8. Jo Anna Isaak, "The Time of Her Life," in *Nancy Spero: Weighing the Heart Against a Feather of Truth* (Santiago de Compostela: Centro Galego de Arts Contemporánea, 2004), p. 71.

9. Susan Harris, "Dancing in Space," in *Nancy Spero* (Malmö: Malmö Konsthalle, 1994), p. 30.

10. Quoted in "Extracts from an Interview by Jon Bird," *Nancy Spero: Woman Breathing* (Ulm: Ulmer Museum, 1992), p. 39.

11. Quoted in Pamela Wye, "Freedom of Movement: Nancy Spero's Site Paintings," *Arts*, October 1990, p. 56.

12. Jon Bird, "Dancing to a Different Tune," in *Nancy Spero* (London: Phaidon Press, 1996), p. 44.

13. Simone de Beauvoir, *The Second Sex* (New York: Vintage Books, 1989), p. xxii.

14. Hélène Cixous, "The Laugh of the Medusa," in *New French Feminisms: An Anthology,* ed. and intro. Elaine Marks and Isabelle de Courtivron (New York: Schocken Books, 1981), p. 245.

15. Ann Rosalind Jones, "Writing the Body: Toward an Understanding of l'Écriture Féminine," http://webs.wofford.edu/hitchmoughsa/Writing.html . Jones discusses the work of Julia Kristeva, Luce Irigaray, Hélène Cixous, and Monica Wittig with particular attention to the concept of *l'écriture féminine.*

16. Bird, "Dancing to a Different Tune." I am grateful to Jon Bird for his insights into the theoretical foundations of Spero's art.

17. Olga M. Viso, "The Memory of History," in *Ana Mendieta: Earth Body, Sculpture and Performance 1972–1985* (Washington, DC: Hirshhorn Museum and Sculpture Garden and Ostfildern-Ruit: Hatje Cantz Verlag, 2004). I wish to thank Olga M. Viso for her excellent essay on Mendieta's art and life.

Opposite:
Artemis, Acrobats, Divas, and Dancers (detail of Diva), 1999–2000. 22 glass and ceramic mosaic panels. Metropolitan Transportation Authority, Arts for Transit, New York

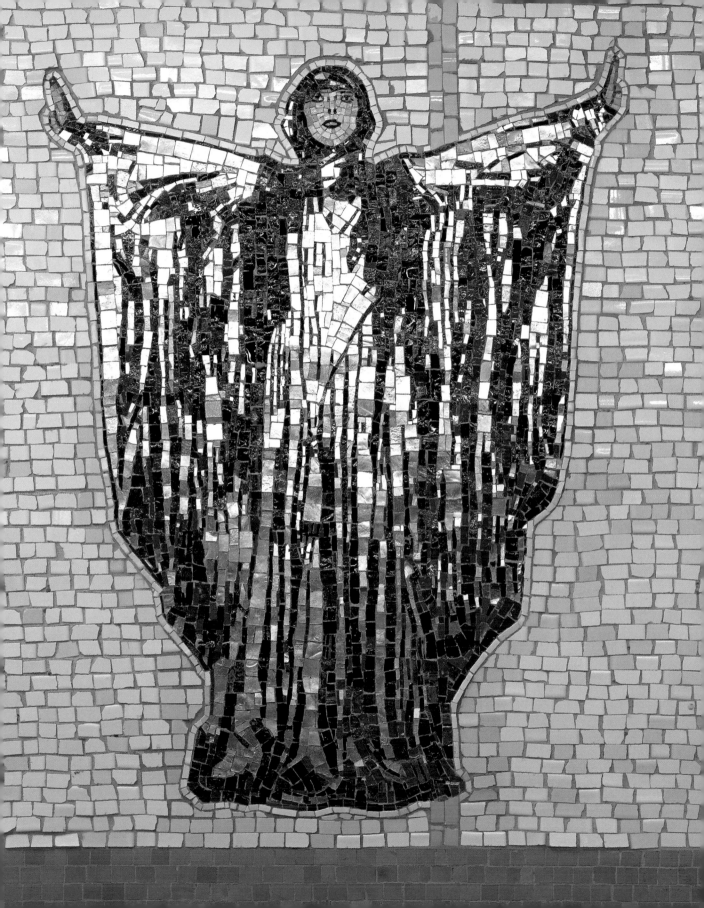

Elizabeth Murray: Fractious Formalist

NANCY PRINCENTHAL

To choose to be a painter, in the wake of modernism, is to choose a place in history—not as a bid for fame, but in order to take up the themes of an ongoing narrative. Elizabeth Murray is leery of being positioned in that story. "I don't see myself as part of art history," she said in a 1997 interview; "All that stuff belongs to the guys, that way of seeing themselves historically." [1] But when she talks about her work and its development, as when others do the same, manifold connections to painters past and present are inevitably explored. For all its gate-crashing irreverence and abounding self-invention, Murray's painting plunges deep into the story of modern art and its legacy, carrying on relationships with peers and predecessors that brim with heated emotion, canny intelligence, and, always, the pleasures of surprise. Whether tracking the eccentric path of a narrow but bold pink line navigating a big black field, as in *Pink Spiral Leap* (1975) (see page 87) or, as in the ironically titled *Euclid* (1989) (opposite), turning the tables on standard geometry by looking at an ordinary piece of furniture from the bottom, interior, and top at once, Murray has remained concerned with what are generally called formal issues—the shapes, space, and masses in the image. And that despite the fact no one is less concerned with painting's formalities.

Born in 1940 in Chicago to Irish Catholic parents, Murray took a rather slow and circuitous route to New York City, where her work first gained recognition in the mid-1970s. Her father, a lawyer, became ill when Elizabeth was six, leaving his wife and children without a source of income. Murray has talked about the subsequent difficulties they faced, which were considerable,[2] with forgiving humor, an inclination evidently established early. "The really deep, awful stuff you just cover up," she told novelist Jessica Hagedorn about her family's emotional habits. "The bad part is that the humor can dissipate into sentimentality... Everything is an exaggeration." The good part includes not only a sometimes heroic resilience, but a gift for exuberance powered by energies of great force and variety, and not excluding sadness and anger. It is easy to find links between these character-shaping family traits and Murray's painting; in fact, she draws the connection herself. "All that cultural stuff that you inherit from your family goes into your work."[3]

In any case, art was in the family, too. Murray's mother, who had wanted to be a commercial artist, encouraged her precociously talented daughter to paint. With the further support of an exceptional high school art teacher, Murray entered the School of the Art Institute of Chicago in 1958. The painters Leon Golub and Nancy Spero, both figurative artists whose work explored dark corners of the

cultural and political past, preceded her there by roughly ten years, and she does not recall being aware of them; Jim Nutt, a painter whose raw, cartoony imagery came to define the leading edge for a group called the Hairy Who, was a classmate, though Murray was not connected with him then either. The hyperrealist painter Ivan Albright is instead the dominant Chicago painter in her memory of the years at the Art Institute. But then Murray didn't go there seeking mentors in the fine arts; she was instead determined to become an illustrator or animator, which seemed viable careers—as painting unequivocally did not. It was only slowly, and largely through enforced daily exposure to the Art Institute's superb collection, that Murray changed direction. Incrementally and then in sudden moments of understanding, she grew to appreciate, that for the artists she was coming to admire, including Cézanne, Beckmann, Picasso, and de Kooning, visual experience need not be put to the service of illustration. One important insight was that for Cézanne, apples "are just paint containers."[4] Admitting the value of intuition, embracing the distinctive properties of paint, canvas and brush, and engaging with the tension between illusion and material presence that painting engenders were lessons learned in Chicago. During her last year at the Art Institute, in 1962, Murray first saw the work of Jackson Pollock and Jack Tworkov, and also of Jasper Johns and Robert Rauschenberg. This telescoping of art history is not as radical as it might seem—in fact the distance between the high point of Abstract Expressionism in the early 1950s (Pollock's first drip paintings were made in 1947), and Johns's and Rauschenberg's breakthrough proto-Pop paintings and assemblages in the middle of the same decade, is vanishingly small.

One striking feature of the roster of artists whose work awoke Murray's ambition is that they are all men, which complicated the already difficult decision to switch from commercial to fine art. But she never thought of the choice as a feminist gesture. "I was terrified of the idea of painting," Murray has said. "There were a thousand times in art school when I said to myself I'm getting out of here, I can't do this. But," she continued, in response to an only implicit question, "it had nothing to do with being a woman at all. In the early sixties for me, feminism didn't exist. I never thought about it, but"—and this little conjunction again speaks volumes—"I was one of the few women who were trying to be painters."[5] Not differently in spirit, she had said in an earlier interview, "There was no tradition for a woman to be a painter, although, oddly enough, painting always seemed a feminine pursuit."[6] And, to Paul Gardner, in 1984, "I don't believe there's such a thing as 'women's art.' It's a distasteful phrase, like any other categorization. ... I see my own work as androgynous. ... Art is sexy, but it doesn't have sex."[7]

This unyielding ambivalence has been noted—and sustained—by some critics. Lucy Lippard, a sympathetic observer of women's art from the early seventies on, recalls that "For a lot of feminists, formalism represented the patriarchy."[8] Writing in 1987, Roberta Smith said Murray contributed to a "de-genderization of art" and "helped re-work abstract painting from a specifically non-male point of

view." But Smith also wrote that Murray touched a "kind of craziness" conventionally thought of as female.[9] Whatever its still debatable feminine content, Murray's work has been received in ways that clearly reflect shifting attitudes about women in art. Robert Storr, who organized a 2005 survey of Murray's paintings at the Museum of Modern Art in New York, only the fifth substantial exhibition there for a woman artist, writes that "sexism's effects kick in most decisively when the economic and institutional stakes rise."[10] Observing that painting, especially in the Abstract Expressionist lineage, has been castigated by some feminist critics as an essentially male, patriarchal pursuit, and that Murray has always operated (by her own description as well as in critical judgment) outside of that tradition, Storr claims that "the pictorial and material conjugation of that 'otherness' in a language thought to be an exclusively male idiom is precisely where Murray's historical significance begins."[11]

Whether or not the daunting prospects for an aspiring woman painter contributed to her voluntary detour after finishing her undergraduate work at the Art Institute, Murray didn't go east to New York, which was then arguably the center of the art world; instead she went west, to graduate school at Mills College in Oakland, California. At first she served as a resident advisor in an undergraduate dorm, where one of the students was Jennifer Bartlett, who became a lasting friend. In the orbit of the San Francisco cultural scene, Murray evolved from (as she remembers it) a bobby-soxer to a Beat, and her view of art broadened considerably. But progressive though it was, the local art community's outlook was strongly regional, and Murray was made to feel she was selling out when she decided to move east. "When I told people in San Francisco that I wanted to go to New York it was like telling them that I wanted to join hands with the devil," she has recalled. "It was like selling out before I'd even started."[12]

The accusation was made even though the New York Murray set out for in 1965 with her first husband, the sculptor Don Sunseri, was not Manhattan, but its westernmost city, Buffalo. There she taught for two years at Rosary Hill College, a Catholic women's college, and made odd, oversize, and by most accounts rather ungainly sculptures, some of them motorized so parts would move. *Daddy Reading the Newspaper* (now lost), for instance, involved an enormous pair of pants with huge shoes and motors in the knees that allowed them to turn around; it sounds almost vaudevillian in spirit, partaking of the family inclination to theatrics. Indeed, this body of work's awkwardness seems thorough enough to have been deliberate. (Roberta Smith has called the work of the early 1960s "conventional ... and frequently close to awful."[13]) Hardly a total naïve at that point, Murray was making art that violated every protocol followed by her progressive contemporaries. At the same time, she was working through ideas presented by the most provocative new art being made in New York, in particular Claes Oldenburg's equally refractory sculptures made of drooping canvas or lumpy plaster messy with paint.

*Madame Cézanne
in Rocking Chair*, 1972.
Oil on canvas,
35$^1/_2$ x 35$^1/_2$ in.
(90.2 x 90.2 cm)

In 1967 Murray finally moved to New York City, arriving as a heterodox painter/sculptor in a community dominated by the stringencies and antipainting tendencies of minimalism (which favored simple geometric objects of implacable opacity) and conceptualism (which was inclined to dispense with physical artifacts altogether, in favor of language and gesture). The energies of Pop were abating, although its darker sense of comedy and cultural engagement would soon arouse renewed interest. Despite the decidedly dim view that vanguard culture in the late sixties took of conventional family life, Murray and Sunseri embarked on parenthood in 1969, with the birth of their son, Dakota. Motherhood (Murray would later have two daughters) and domesticity were conditions she would always celebrate—or at least, decline to hide—in her life and her work. In that respect too she set herself markedly apart. In any case, Murray knew few other artists in Manhattan when she arrived there; Bartlett, whom she'd met at Mills, was an important friend and source of forthright studio talk; so was the sculptor Joel Shapiro. Though Murray's perception at the time was that "painting was just not feasible after conceptualism,"[14] her commitment to the medium grew increasingly firm, and by 1971 she had dedicated herself to it conclusively.

The pace of change in her early paintings was rapid. Cézanne provided a kind of ballast, anchoring work as disparate as *Beer Glass at Noon* (1971), a small, studious, earthen-toned still life, and the far more expansive and utterly irreverent *Madame Cézanne in Rocking Chair* (1972) (opposite), in which each square of a thirty-six-unit grid contains a schematic rendering of the famous artist's wife. As in a storyboard for an animation, Mme Cézanne rocks back and forth from one frame to the next, with enough vigor that she ultimately propels herself right out of an open window, through which bright yellow moonlight shines on the midnight-blue room in every scene. This work was (like many at this time) anomalous. As Murray's paintings progressed, both narrative and easily recognized subjects disappeared, replaced by simple linear structures freed from describing solid form though not altogether divorced from real objects: fans, ladders, steps, and letters of the alphabet are variously detectable. Despite their reductive, essential graphic composition, these modestly scaled paintings of the early seventies have thick, bumpy surfaces that are densely material. And while many are built for stasis, around more or less rectilinear armatures, some break into swirling mobility, as in *Wave Painting* (1973), a raked green field of surging parallel curves. Frank Stella's dour pinstripe paintings lurk behind this body of work, as do Agnes Martin's gossamer penciled grids, though Murray violates geometry far more freely than either. With *Möbius Strip* (1974) (p. 86), the subject line—here a sideways figure eight that signifies both infinity and the spatial puzzle of its title—assumes full independence from both real objects and the last remnants of the grid. This unleashed line animates a number of succeeding paintings, including *Pink Spiral Leap* (1975) (p. 87), with its lazily circling ribbon of paint, and the considerably larger (9 ft. 4 in. x 9 ft. 6 in.) *Beginner* (1976), which has a tense little red coil at its heart. By the end of the decade, Murray

had extended her investigation of eccentric form to the contours of the painted field; her first shaped canvases, big irregular quadrilaterals sometimes involving curved sides, appeared in 1977, followed by even more radical, asymmetrical star-shaped canvases in 1978–a milestone year in her career.

As it happened, it was also a landmark year for painting in New York. At the New Museum, a show titled *Bad Painting* brought together figurative artists working in more or less direct violation of the protocols of minimalism, including Joan Brown, Neil Jenney, and William Wegman. *New Image Painting* at the Whitney Museum, also in 1978, featured some of the same artists. The influence of Philip Guston's late paintings of the previous decade or so, in which the one-time abstract painter explored a bleakly comic world of bloodshot eyes, bare bulbs, and worn shoes, was enormous. Among the alternatives to minimalism and conceptualism that gained ground by the early 1980s was a loosely affiliated group of artists whose work came to be called the Pattern and Decoration movement. Murray's work was influenced by, or at least took its place among, these new currents in a rising tide of painting; other colleagues important to her development include Ron Gorchov, whose doubly-curved, saddle-shaped abstract canvases anticipated Murray's sculptural paintings. Also important were the nuanced investigations of color and line in the work of Brice Marden, and of dizzyingly fractured space by Al Held; the multi-panel and shaped paintings of Robert Mangold; and the iconic figuration of Susan Rothenberg. The very multiplicity of this list suggests that in most respects, Murray is (like any noteworthy artist) sui generis. Rather than simply making images, she constructs *things*—objects that have representational value but also exist in real time and space in the world, as do Jasper Johns's targets, or Donald Judd's boxes. In one way or another, either because of the emphasis on the paint's materiality, or, more

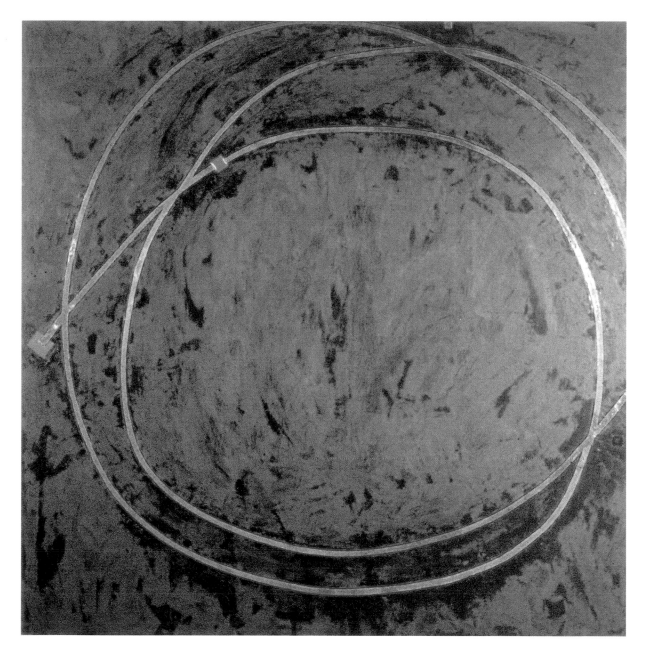

Pink Spiral Leap, 1975.
Oil on canvas, 78 x 76 in.
(198.1 x 193 cm).
Baltimore Museum of Art

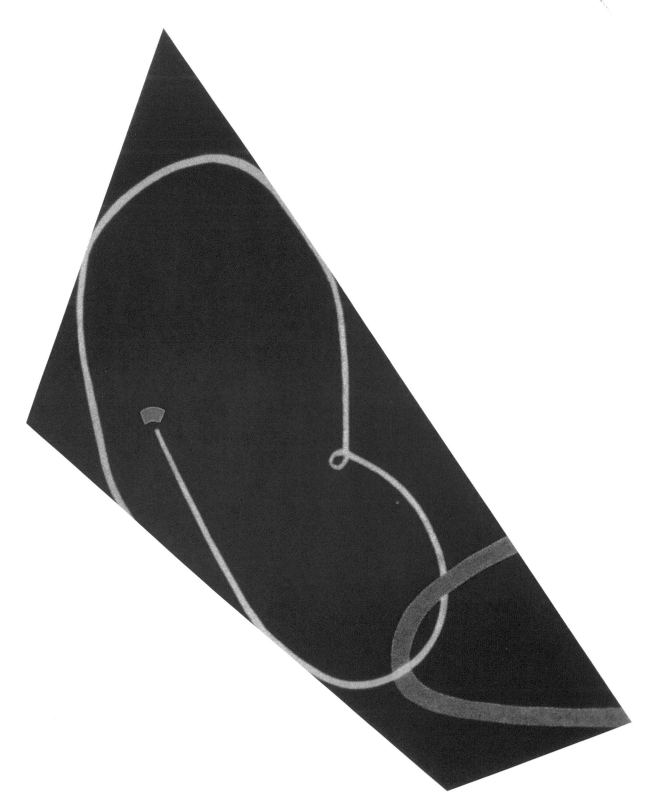

insistently, by working with canvases stretched on irregular wooden frames that by the mid-1980s would have all the complexity of sculpture (or furniture), she places as much stress on physical presence as on illusionism.

Even in the brief early period during which her painting was altogether abstract (she reintroduced recognizable imagery in the 1980s), Murray's work relied on habits of looking and composing grounded in the real world. Robert Storr expressed this duality at the heart of her work as a balancing act between Cubism (with its emphasis on resolving the flat, painted surface to three-dimensional space beyond) and Surrealism (which concerns actual objects and their psychological associations).[15] The competing claims in Murray's work can also be framed in terms of less highbrow traditions: craft and cartoons. She has been clear about the connection to animated cartoons and comic strips, from Loony Toons to Little Orphan Annie, having gone so far as to say, "All my ideas about art came from looking at comic books."[16] In a more qualified statement, Murray has distinguished her interest in comics from the appropriation of mass-media imagery that became so prevalent in American art of the 1980s. That movement, she explained, drew intellectual support from European structuralist theory—which grew out of a postwar condition of social and cultural devastation that had no parallel, and little meaning, in the U.S. of the 1980s. In her own use of cartoon imagery, Murray said, "There's no subtext"[17]—a claim for reading content at face value, without the pretense of cultural critique, that also distinguishes her work from the Pop artists who preceded her.

Less often discussed is the connection between Murray's painting and certain crossover artists who operate between craft and art. They include, to name just a few, John Cedarquist, whose illusionistically painted tables, benches, and chests of drawers confound perception of the actual (usable) furniture's skewed shapes; Faith Ringgold, whose quilts lie between painting and textile art; and Ken Price, whose ceramic cups have long since shifted from functionalism to pure, perversely gorgeous form. These artists are each involved in crafting the accessories that appear in painted still lifes, while operating in painterly ways themselves, straddling a boundary that Murray also has vigorously challenged.

But these are not the ideas and influences cited in the first critical responses to Murray's painting. Jeremy Gilbert-Rolfe, writing for *Artforum* in June 1974, praised the modesty of *Möbius Band* (1974), claiming it has "an authoritativeness that's not rhetorically overblown"—a slightly backhanded compliment. Four years later, in the first feature article on Murray's work, Donald Kuspit, also writing in *Artforum*, began by quoting Sartre's 1956 *Being and Nothingness* on "plugging up holes ... and symbolically establishing a plenitude";[18] Kuspit went on to say that in Murray's work the plenitude was there from the start, and the problem was to make the holes. Camus's *The Rebel* (also 1956) was cited too, for describing "audacities of eccentricity" as being "among the hallmarks of dandyism"—this by way of introducing the idea that Murray's is a "dandyish abstraction" (the title of Kuspit's article). But Kuspit doubles back to conclude that where once dandyism was a rebel's stance,

Opposite: *Desire*, 1976–77.
Oil on canvas,
98 1/2 x 80 in.
(250.2 x 203.2 cm)

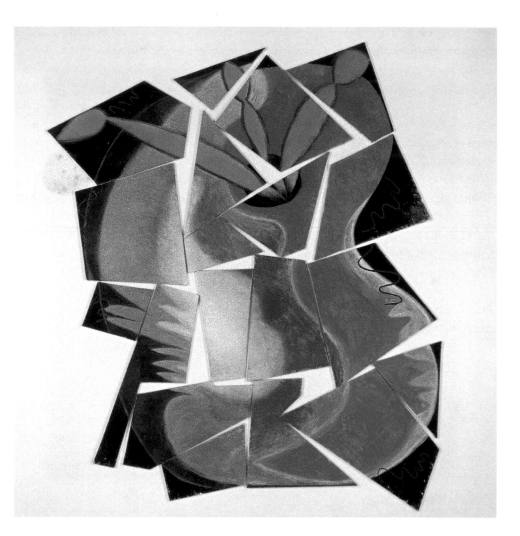

Painter's Progress,
1980–81. Oil on canvas,
114³/₄ x 96¹/₂ in.
(291.5 x 245.1 cm)
The Museum of Modern
Art, New York

it had since come to be associated with "domesticity with a lilt, i.e., thoroughly domesticated abstraction trying hard to be lyrical and adventurous." Turning around yet again, he concludes by allowing that Murray "gives us a degraded and thereby enlivened, freshly expressive formalist purity."[19] All this is worth noting only because in the then-preeminent journal of contemporary American art, a magazine strongly committed to abstraction, the terms of discussion tended to based in postwar French theory (as to a surprising degree they still are, though the existentialists have long since fallen out of favor). Notable, too, is how hard it was to accept authority, much less applaud it, in Murray's work.

 The paintings that Kuspit rather obliquely addressed were a conventionally rectangular untitled canvas of 1974 in which a field of black was broken by simple linear figure at the center, and the much more animated *Desire* (1976–77) (p. 88),

a tomato-red work swept with curving bright yellow and green lines inscribed within an irregular trapezoidal canvas 98 inches high. In the late seventies and first year or two of the eighties, Murray went back and forth between conventional rectangular paintings and ever more fancifully shaped canvases, in which combustible, pointy-edged forms either consorted with biomorphic figures inside the frame, or burst through it to determine the work's physical contours. Ultimately, unitary forms of any configuration proved too confining, and in two key works of 1981, each nearly ten feet across, the canvas surface was shattered into roughly twenty fragments, some triangular, some trapezoidal, some complex five- and six-sided forms. Right angles are rare. At the same time, recognizable subjects reappeared in force. In both of these fragmented paintings, the subjects are the tools of the painter. A palette doubles as a head in *Painter's Progress* (opposite), its eye—or thumbhole—sprouting a jubilant trio of orange brushes that are barely contained even by the loose boundaries of this painting; a single brush is brandished by a giant hand in *Art Part* (below), its issue a flourish of paint that begins as a cursive line and becomes a virtual torrent. The colors are equally bold and jarring—greens, oranges, pinks, deep vibrant blue. In *Yikes* and *Keyhole* (both 1982) (pp. 92 and 93), Murray returns to

Art Part, 1980–81.
Oil on canvas,
115 x 124 in.
(292.1 x 315 cm)
The Nelson-Atkins
Museum of Modern Art,
Kansas City

Yikes, 1982.
Oil on canvas, 116 x 113
in. (294.6 x 287 cm).
The Museum of Modern
Art, New York

autumnal shades of deep red, gold, gray, and brown, though the structure of these works is even more novel. Each is a kind of Cézannesque still life condensed and then blown apart, *Yikes* focusing on a single coffee cup, *Keyhole* on a lone beer glass. In both there are probing up-thrust forms that could be the fingers of a grasping hand—or, in *Yikes*, rising steam, echoed in the scalloped edges of an interior rift that vertically divides the painting, the outer contours of which are curved too. The jagged-edged and generally more jangly *Keyhole*, in which component canvases are both abutted and layered one on top of another, is organized around a central void that is shaped like a big, goofy cartoon keyhole. The jokiness of Murray's descrip-

Keyhole, 1982.
Oil on two canvases,
99$^1/_2$ x 110$^1/_2$ in.
(252.7 x 280.7 cm)
Agnes Gund Collection,
New York

tive language, and the punning involved in, for instance, linking the (empty) center of the painting—the formal mechanism that unlocks its meaning—with a means of ordinary entry and also of secret surveillance, tend to obscure the complexity and subtlety of these works, and the visual intensity of effort they involve for artist and viewer alike.

By the early 1980s, when Murray's shaped, fractured, and layered canvases were first appearing, painting, in the form of neo-Expressionism, had regained prominence in New York. At the same time, a strong existing postwar tradition of European figurative painting began to find favor in the United States, forging inter-

national links that suited the newly vigorous and increasingly global art market. Murray, making work that literally broke the mold of painting, had reason to believe she would be celebrated along with other suddenly famous local painters, including David Salle, Eric Fischl, and Julian Schnabel. Instead, she was rather thoroughly eclipsed–except when she was vilified, for supporting the very values with which the media and the marketplace were so reluctant to identify her. In a bitter condemnation of the huge and hugely popular 1981 Picasso exhibition at the Museum of Modern Art in New York, critic Douglas Crimp singled out "the recently successful painter Elizabeth Murray" for championing the twentieth century's most famous artist, and for embracing the obsolete (to Crimp) "notion of art as bound only by the limitations of individual human creativity."[20] (In fact, in an *Art in America* published symposium on the occasion of the MoMA show, Murray had called Picasso a monster and a shark, among other things, and concluded by saying, "It does seem ridiculous to write in praise or blame of this art. ... He does not feel like someone I must get past or around.")[21] Though other, likelier targets abounded, Crimp concluded his essay by returning to Murray's paintings, calling them "academic extensions of a petrified modernism."[22]

In retrospect, the rather malign neglect might be called a blessing. Murray's work continued to prosper, developing along a trajectory that took her ever further from the most noisily championed (and later mostly dismissed) painters of the eighties–though she didn't decline to use what suited her; Schnabel's smashed plates, for instance, attracted her interest. Nor was she uninterested in the work of younger artists, a few of whom became at one time or another studio assistants. Robert Gober, a soon-to-be-well-known sculptor and installation artist, worked briefly with Murray in the early 1980s, helping her with *Keyhole* and with the development of increasingly sculptural stretchers for ever more eccentrically shaped canvases. Another painting of this period, *More Than You Know* (1983) (opposite), centers on a green table, its four legs splayed pinwheel style; its top, a distorted square loosely analogous to a traditional painting support, is painted a slightly discouraging forest green, messily aswirl with pinks and blues. However unconventionally, what could be called the painting's subjects are located here: a piece of paper with an indecipherable angry red scrawl, and a disembodied, almost comically ghoulish head, mouth agape, eyes agog, all outlined in red around lurid green. Notes of comforting domesticity cushion this imagery, including a bifurcated spindle-backed red chair, its seat a big welcoming lap for the green table, and, behind, a cheerful expanse of yellow wall; these elements, along with brown flooring, are depicted on a handful of squarish canvases added on at odd angles as needed to complete the picture. The urgent figure of that green table, though, with two legs dangling down and two reaching diagonally up in a semaphore of alarm, upsets any impression of composure the painting might otherwise establish.[23]

Van Gogh and Munch, Disney and Dalí can all be felt lurking behind *More Than You Know*; so can bereavement (Murray had recently lost her mother). But

Opposite:
More Than You Know, 1983. Oil on canvas, 111 x 108 x 8 in. (282 x 274 x 20.3 cm). The Edward R. Broida Collection

there is also an irreducible and altogether individual quality of centrifugal energy, an exuberance that overrides the work's more baleful notes. In a 1984 interview, Murray said she learned to paint by studying de Kooning, and she went on to note how, in his work of the early sixties, "he got paint to move across canvas, the way he used his brush—it's almost as if he was expressing words with paint."[24] Her interest in the connection between words and images, second nature to an artist intent from the start on storytelling and alert to the pleasures of comic strips, was strengthened by Murray's marriage in 1982 to the poet Bob Holman, whom she had met in 1980. They had two children together, Sophie in 1982 and Daisy in 1985, and the warmth of their busy household is liberally evident in Murray's work. But complicating undertones are seldom altogether silenced. Even in the colossal pair of midnight-blue shoes that danced across the opening wall of the MoMA survey, their towering twin heels pointing skyward and snaking orange laces trailing from one to the other, there is, along with nods to Elvis Presley and Olive Oyl, a hint of the melancholy named in the work's title, *Dis-Pair* (1989–90). In any case, by the time Murray had completed this painting, which is nearly ten feet square and more than a foot deep—a rough measure, since this is as close to sculpture as Murray's work gets, the shoes each an independently realized construction with interior voids and heavily painted surfaces—a contracting economy and other factors led Murray to simplify her studio life, considerably reducing her reliance on assistants.

But the essentials of her practice have remained fairly consistent throughout. Paintings begin in drawings, which she describes as "completely fun and easy and they roll right out of my mind."[25] Many are discarded; those that interest her are traced, plotted for enlargement, and turned over to an assistant, along with small (a few inches square) clay models. The next step, which can take six to eight weeks, is building stretchers by laminating and shaping plywood; canvas is then glued and stapled to the armature's various parts, and then sized with rabbit-skin glue and primed with gesso—final steps that are as old as oil painting. From there, Murray takes over again. At this point, she told critic David Frankel in 1998, the picture is "like a little baby, you just sort of enjoy watching it go 'Googoo.'" Her process, which can take months, is at first relaxed and fairly ad hoc, but there soon comes an anxious moment when "it feels like it has to start turning into something." In Frankel's account, "part of the anxiety, obviously, is the balancing act of color and shape, but there is also the simple intractability of painting." Murray says, "I get some really mucky moments, where the colors slide together into this Ryderesque morass. ... Things are always happening where it feels completely out of control—or it's in your control but it's also got a mind of its own." This is the turning point, the moment when things start to really cook. "I like getting into this chaos," Murray continued. "It makes me feel good. The painting is as miserable as I am." Similarly, she told Robert Storr in 2005 that the moment when the process grows deeply uncomfortable is when she gains some confidence in the work's success: "If something doesn't feel right, you just haven't gone down with it yet ... You have to hate

Bop, 2002. Oil on canvas,
118 x 130¹/₂ in.
(299.7 x 331.5 cm)
Pace Wildenstein Gallery,
New York

it."[26] And, to Sue Graze and Kathy Halbreich in 1987, "I don't start finishing a painting until the moment I begin to hate it and I almost welcome the feeling because I know I'm finally starting to put the screws on, to get objective."[27]

The consistency of these accounts over the course of nearly two decades is striking. In the work of the first years of the new century, Murray turned to a fresh, electric palette, cleaner definitions of shape, and a more open relationship to cartooning. *Do the Dance* (2005) is a pinball machine of a painting, its puzzled-together pieces, in neon-bright shades of yellow, purple, orange, green, and blue, creating a blinking, chiming circuit of false starts, bumpy obstacles, and fast detours. It is figurative only to the extent that there are linear elements familiar from highways and railroads: cross ties, dotted white lines, lane dividers. Piet Mondrian's jazzy, New York-inspired *Broadway Boogie Woogie* (1942–43) is certainly in the background; so are cartoon- and graffiti-influenced artists of the eighties, including Keith Haring and Rodney Alan Greenblatt; the meticulously wacky paintings of Jim Nutt are also kin. In Murray's only slightly less raucous *Bop* (2002–3) (p. 97), what look like a variety of comic-strip thought balloons—linked blocks, blobs, and zigzags in crisp orange, bright pink, and deep blue and green—assemble for a bumptious, cheerful colloquy. Almost completely released from both characters and words, these tightly congregated forms harbor, here and there, a few small figure remnants: a googly-eyed red dog's face, an upside down Tweety Bird's head.

The timing of the tone change in Murray's work is striking. Just as touch and craft returned in force among young painters, with an emphasis on the fey and would-be innocent, Murray began to play down the craftedness of her work, to strike bold high notes in a nearly commercial palette. There is, clearly, an element of the contrarian in her sensibility, which has always been one source of its strength. But it would be wrong to conclude that Murray's choices are made in deliberate counterpoint to the aesthetic of the moment. Of all the visual art practices, painting has often been thought to be the most isolated—the product of a brooding artist alone in a studio. With every painting she makes, Murray dispels that myth. Bursting at the seams with the profuse gifts of lively sympathy, insatiable curiosity, and profound visual intelligence, her work is social in the very highest sense. And the range of its influence in the work of younger painters, from her near-contemporary Carroll Dunham to the much younger Dana Schutz, testifies to its generosity.

1. Elizabeth Murray, quoted in Joan Simon, "An Interview with Elizabeth Murray," in *Elizabeth Murray: Recent Paintings* (New York: PaceWildensein, 1997), p. 8, cited in Robert Storr, "Elizabeth Murray: Shape Shifter," in *Elizabeth Murray* (New York, The Museum of Modern Art, 2005), p. 14.

2. "I spent some nights as a kid riding the subway because we didn't have a place to stay," she told Robert Storr. "We were poor. Didn't go to school for a few years." "Interview with Elizabeth Murray" in *Elizabeth Murray* (New York, The Museum of Modern Art, 2005), p. 187.

3. Jessica Hagedron, with Elizabeth Murray, *Bomb*, Winter 1998, p. 59.

4. Sue Graze and Kathy Halbreich, in *Elizabeth Murray: Paintings and Drawings* (New York, Harry N. Abrams in association with the Dallas Museum of Art and the MIT Committee on the Visual Arts, 1987), p. 123.
5. Hagedorn, interview, p. 59.
6. Graze and Halbreich, "Interview," p. 125.
7. Paul Gardner, "Elizabeth Murray Shapes Up," *Art News*, September 1984, p. 55.
8. Susan Stoops, "From Eccentric to Sensuous Abstraction: An Interview with Lucy Lippard," In Stoops, ed., *More Than Minimal: Feminism and Abstraction in the '70s* (Waltham, Rose Art Museum, Brandeis University, 1996), p. 29.
9. Roberta Smith, "Motion Pictures," in *Elizabeth Murray: Paintings and Drawings*, p. 9.
10. Storr, "Elizabeth Murray: Shape Shifter," p. 15.
11. Ibid., pp. 17-18.
12. Hagedorn, interview, p. 63.
13. Smith, "Motion Pictures," p. 11.
14. Storr, "Interview with Elizabeth Murray," p. 190.
15. Storr, "Elizabeth Murray: Shape Shifter," p. 78.
16. Graze and Halbreich, "Interview," p. 122.
17. Hagedorn, interview, p. 63.
18. Donald Kuspit, "Elizabeth Murray's Dandyish Abstraction," *Artforum,* February 1978, p. 28.
19. Ibid., p. 30.
20. Douglas Crimp, "The Museum's Old, The Library's New Subject," in *On the Museum's Ruins* (Cambridge, MA and London, MIT Press, 1993), p. 69.
21. "Picasso: A Symposium," *Art in America*, December 1980, p. 19.
22. Crimp, p. 78.
23. Further to that point is the basis of this painting's title in the first line of a poem by Bob Holman, whom Murray had married. Called "What It Is," the poem begins, "More than you know me there is/Something in my eye. Is it/A volcano?" In Graze and Habreich, *Elizabeth Murray: Paintings and Drawings*," p. 7.
24. Gardner, "Elizabeth Murray Shapes Up," p. 51.
25. David Frankel, "Ifs, Ands, and Buts—Elizabeth Murray's Cup Paintings," *Artforum*, March 1998, pp. 71–75.
26. Storr, "Interview with Elizabeth Murray," p. 182.
27. Graze and Halbreich, "Interview," p. 131.

Marina Abramović: Between Life and Death

SUE SCOTT

In November of 2002 I participated in *House with Ocean View* (opposite) by Marina Abramović at Sean Kelly Gallery in New York City. In the performance Abramović lived in the gallery for twelve days in a structure consisting of three open white boxes suspended at one end. Each minimal cube functioned like rooms in a house—bathroom, living room, and bedroom connected by an open space of about eighteen inches so the artist could walk between them. Descending from each space were ladders with butcher knives instead of rungs. This was not just to evoke a visceral response from the audience; Abramović wanted an image about one's ability to control the body through spiritual transformation. She had in mind a Brazilian shaman she knew of who could walk on the blades when in an altered, meditative state. As she wrote in her outline for the project: "This performance comes from my desire to see if it is possible to use simply daily discipline, rules and restrictions to purify myself. Can I change my energy field? Can this energy field change the energy of the audience and the space?"[1]

The rules for Abramović's confinement were relatively straightforward. She fasted during the twelve days, drinking only mineral water. Sleep was restricted to seven hours a day and she could not talk, write, or read, though she could sing if she wanted. Bodily functions—defecation, urination—were done in full view of the gallery audience; she could shower three times a day. Her costume of loose pants and buttoned shirt, in colors of yellow, orange, blue, black, white, or purple that she changed daily, was inspired by Alexander Rodchenko.

As with most of her performances, Abramović had expectations of the public. She asked them to remain silent, to establish an "energy dialogue" with her, and to use the high-powered telescope in the gallery for close observation of her activities. In an ancillary performance in an adjacent room, volunteers had been recruited to spend one hour inside a rectangular box, wearing a cloth jumpsuit with magnets on the feet and hands. As she has often done with performances involving the audience, Abramović requested that her volunteers sign a contract agreeing to the relatively undemanding terms of the event: show up at a predetermined time, spend one hour in the box, and write about the experiences in a dream book.

The day I was to participate was extremely hectic and I barely made it to the gallery on time. It was only the second or third day of the performance. I glanced into the gallery where she was preparing to shower and was immediately captivated. She was nude, facing the audience, still as a statue. Abramović held her hand under the shower head and the water splashed down on her hand. She held the pose for

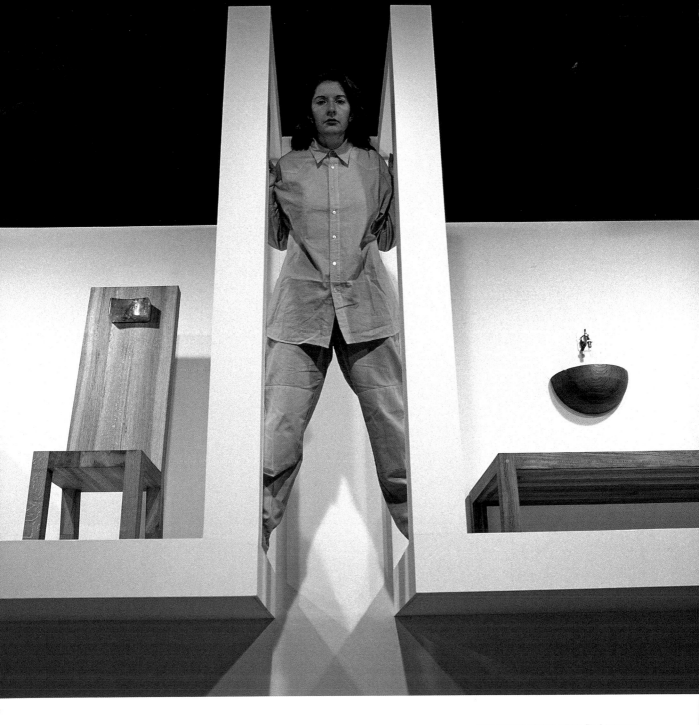

House with Ocean View. Performance,
Sean Kelly Gallery, New York, 2002.
All reproductions of art by Marina Abramović
courtesy of the artist and Sean Kelly Gallery,
New York. Photo: Steven P. Harris

101

several minutes. I thought not about a woman showering in a New York City art gallery, but of a Renaissance painting, a single figure standing in mid-gesture. I put on a loose purple jumpsuit and got into the box—an oblong shape resembling a casket. I lay there for a moment, thinking more about the demands of my day than about the performance; time slowed down as I could hear some moving and murmurings from the other room; I was awakened when it was time to do the next step, write the journal entry.

"Nobody's life is changed by somebody else's experiences." Abramović had said, "I want more from the public. I want them to be involved and go through changes as I do. It's very difficult and it's a pioneering job because for so long there have been set rules: the artist performs, the public observes. They are not used to the new role I am giving them."[2] It is now generally agreed that *House with Ocean View* was the most significant performance to have taken place in New York since Joseph Beuys's *I Like America and America Likes Me* at Rene Block's gallery in May 1974. In 2003 Abramović was given a Bessie Award, honoring New York dance and performance, for the piece.

This transformative experience of performance art on body, mind, and soul has been at the heart of Abramović's work since the early 1970s. Calling herself "the grandmother of performance art," she alone of the pioneers—among them Chris Burden, Vito Acconci, and Dennis Oppenheim—continues to execute dangerous, painful, and psychologically challenging works. Her influence is far-reaching not only because of these performances but because she teaches at academies and universities around the world, demanding that her students go through rituals called "cleaning the house," often involving silence and fasting not only as a purification, but as a way to learn to control the body. As she sees it, these extremes are at the heart of the performance, "that energy on the other side of the pain that transforms the way you see. Pain is the obstacle. It's the door each of us goes through one way or another. And you can grow from this."[3]

Abramović learned that process trumps the tangible at an early age. When she was barely a teenager she wanted to paint her dreams using only green and blue. Her father arranged for lessons from a local artist, who arrived at her small studio, put an irregular strip of canvas on the floor, covered it with glue; sand; red, yellow, and black pigments; then poured gasoline on it and lit a match. As the canvas exploded, the artist observed, "this is sunset" and left. Abramović nevertheless placed the work on the wall like a proper picture and left with her family for vacation. By the time she returned, the picture had disintegrated into dust. "Later on I understood why it was so important, because to me the process has always been more important than the result, the performance more important than the object."[4]

By the time she was sixteen Abramović was painting her dreams in blue and green, an activity that evolved into painting truck accidents, then sky paintings that tracked the dissolution of clouds. She saw in the transient process of skywriting a

metaphor for drawing and went to the military requesting fifteen planes to help make her drawings. Her father, a general in the army, was called to bring her home. Abramović then became interested in sound, and wanted to recreate the sound of a bridge collapsing. She recorded the sounds from a building demolition and installed it on the bridge where it played every three minutes. This experience altered her perception of her art, which she came to realize could never return to a two-dimensional format and would always focus on the body.

Clearly, Abramović's rebellion was apparent from an early age with her worldview formed by an extreme and restrictive upbringing. Born in Belgrade, Yugoslavia, in 1946, she came of age in the Tito era. Both her parents were partisans in World War II. Her father, Vojo Abramović, was a war hero in the Serbian army and her mother, Danica, a major in the army, was named director of the National Museum of Revolution and Art in Belgrade in the mid-sixties. Her grandfather, a patriarch in the Serbian Orthodox Church, had been murdered by the state—he was rumored to have been poisoned by diamond dust mixed in his wine—and was later granted sainthood and embalmed at St. Sava's church in Belgrade. Abramović's father left his family in 1964, when she was eighteen, and her mother took strict control of her daughter and son, enforcing a firm ten o'clock curfew that lasted until she finally left home at twenty-nine.

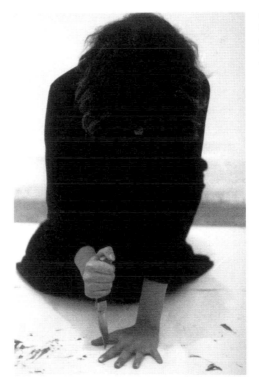

Rhythm 10.
Performance, Museo d'Arte Contemporanea, Villa Borghese, Rome, 1973

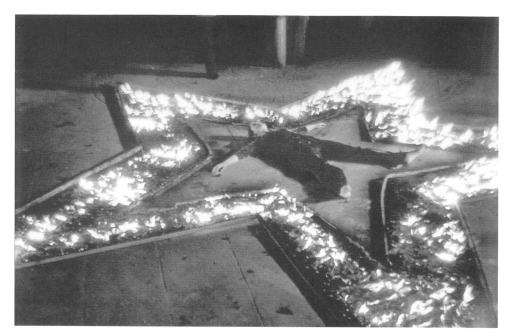

Rhythm 5. Performance,
Student Cultural Center,
Belgrade, 1974.
Photo: Nebojša Čanković

Opposite: *Rhythm 0.*
Performance, Studio
Morra, Naples, 1974

Abramović's life had always been one of excessive punishment and self-abuse, as her childhood diaries attest, and in those pages are many clues as to why her art developed as it did.[5] As a student at the Academy of Fine Art in Belgrade (1965–70), she made performances that involved cutting, whipping, and putting herself in perilous situations, all before curfew. One night her mother received a telephone call: "your daughter is hanging naked in the museum."[6] When Abramović came home, her mother threw a heavy crystal ashtray across the room at her, saying, "I gave you life and now I am taking it from you."[7] At the last minute she ducked, but it is not surprising that Abramović has more than once quoted Bruce Nauman, who said, "Art is a matter of life and death."

Abramović's early extreme performances were executed while she was living not only under the repressive Tito regime, but also in the abusive situation at home with her mother. For *Rhythm 10* (p. 103), a performance for the 1973 Edinburgh Festival, she used ten knives (later twenty) and two tape recorders. She laid the knives on a large sheet of paper, turned on the recorder, and reenacted a Russian game of rhythmically stabbing at the spaces between the fingers on her hand as quickly as possible. Each time she cut the flesh, she changed knives. After using all of the knives—or rhythms—Abramović replayed the tape, attempting to repeat the actions of stabbing exactly as she heard them thus, synchronizing "the mistakes of time past and time present."[8]

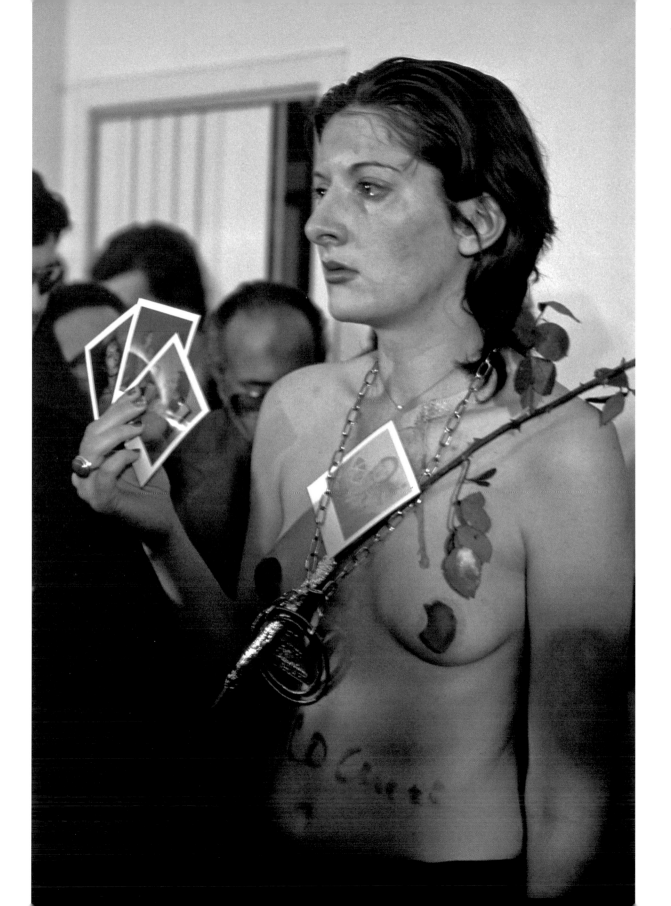

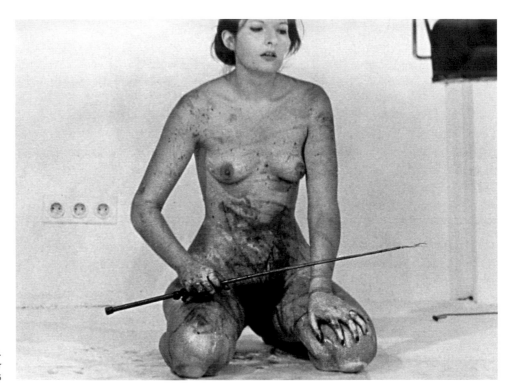

Thomas Lips.
Performance, Krinzinger
Gallery, Innsbruck, 1975

In 1974 at the Student Cultural Center in Belgrade, Abramović enacted a performance in which she not only placed herself in a life-threatening situation but the performance reached a crisis where the intervention of the audience was crucial. In *Rhythm 5* (p. 104), she built a huge five-pointed communist star on the floor, covered it in gasoline, and lit a fire. As the star was burning, she ritualistically cut her hair, fingernails, and toenails and threw them into the fire. She then jumped across the fire into the center of the star and lay down. Amidst the smoke and fire, the audience could not discern she had lost consciousness due to lack of oxygen until she did not move when the fire touched her leg. A doctor finally noticed she was inert and with the help of other observers, pulled her from the flames. The performance was a turning point for the artist: "That was when I realized that the subject of my work should be the *limits* of the body. I would use performance to push my mental and physical limits beyond consciousness."[9]

Abramović further investigated the power of the audience in what is perhaps her most famous work, *Rhythm 0* (p. 105), performed at Studio Morra, Naples, in 1974. Here she assumed a passive role. She placed seventy-two items—as varied as blue paint, perfume, a feather, chains, a gun, a bullet, a whip, needles nails, flute, alcohol, flowers, and wire—on a table along with a sign instructing the audience to use the items any way they wanted. Initially during the six-hour performance, members of the audience were passive and calm, but they became

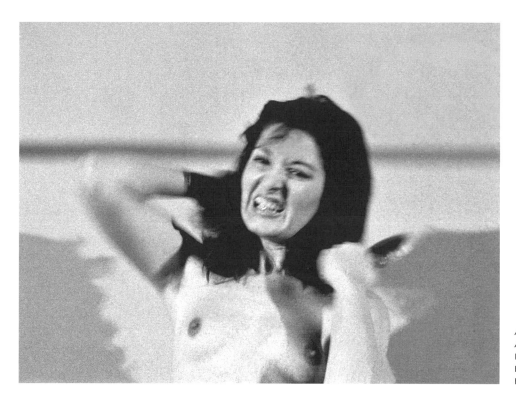

*Art Must Be Beautiful,
Artist Must Be Beautiful.*
Performance, Charlotten-
burg Art Festival, Copen-
hagen, 1975

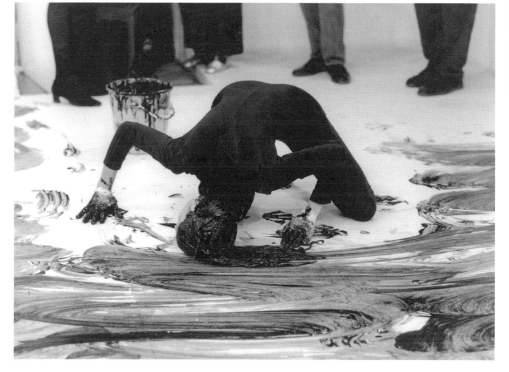

JANINE ANTONI,
Loving Care. Performance
with hair dye, dimensions
variable, Anthony d'Offay
Gallery, London, 1993.
Courtesy of Luhring Augustine,
New York. Photo: Prudence
Cumming Associates

more aggressive as the night wore on. During the performance she was alternately caressed, written on, chained, blindfolded, had her shirt torn off, and was threatened with the gun, all the while remaining passive. This performance was not only about switching roles with the audience, it also incorporated the unpredictability of chance. At the end of the six hours, Abramović, who had been detached and unresponsive during the entire performance, once again engaged and approached the audience, which quickly dispersed once the power had shifted. Though she continues to demand participation from her audience, she never again relinquished so much control to the audience. One critic saw the piece as exploring a female tradition of submission and passivity, but for Abramović, the courage to complete the performance was more about male energy. Following the performance, there was also a certain amount of controversy about using props so blatantly, and they become the residue of the performance—with their own tie to the market.

One of her most visceral early works is *Thomas Lips* from 1975 (p. 106), performed at Krinzinger Gallery, Innsbruck. Abramović was nude, seated in the corner of a gallery, behind a small table covered by a tablecloth. She ate a kilo of honey with a silver spoon and then drank a kilo of red wine from a crystal wine glass. After breaking the wine glass, she slowly cut a five-pointed star on her abdomen with a razor, whipped herself repeatedly, and then lay down on blocks of ice with a heater suspended above. The heater caused Abramović to bleed more profusely even as the ice froze the backside of her body. The audience interceded ending the performance by dragging Abramović from the ice and wrapping her in coats. Though the period of *Thomas Lips* coincides with important developments in feminist art, the content is more informed by life under Tito's regime and Abramović's awareness of other performance art than by the politics of feminism. And Abramović herself does not see a connection to feminist body art. "When feminism became an issue, I was in Yugoslavia. In Yugoslavia women were partisans, absolutely in power, in control, from the government level to any other level. When I began my career in Italy after I left Yugoslavia, there was not a single woman artist on the scene, but I had everything I ever needed. I never felt that I didn't have things because I was a woman."[10]

One might, however, see feminist overtones in *Role Exchange*, also from 1975, in which Abramović traded places with a prostitute from the red-light district in Amsterdam. Each had been a "professional" for the same period of time; each performed an action in exchange for money. For a four-hour period, they acted as each other's alter ego; the artist sat in the window of the red light district while the prostitute attended the gallery opening. They split the artist's fee of 300 dollars. Though the exchange might raise questions of gender roles and control, for Abramović, the performance was about spectacle, power, and commerce.

Likewise in *Art Must be Beautiful, Artist Must be Beautiful* (p. 107) Abramović confounds the boundary of performance and fashion as it relates to gender. In a performance at the Charlottenburg Art Festival in Copenhagen in 1975, she

Opposite:
Imponderabilia
(with Ulay). Performance,
Galleria Communale
d'Arte Bologna, 1977.
Photo: Giovanna dal Magro

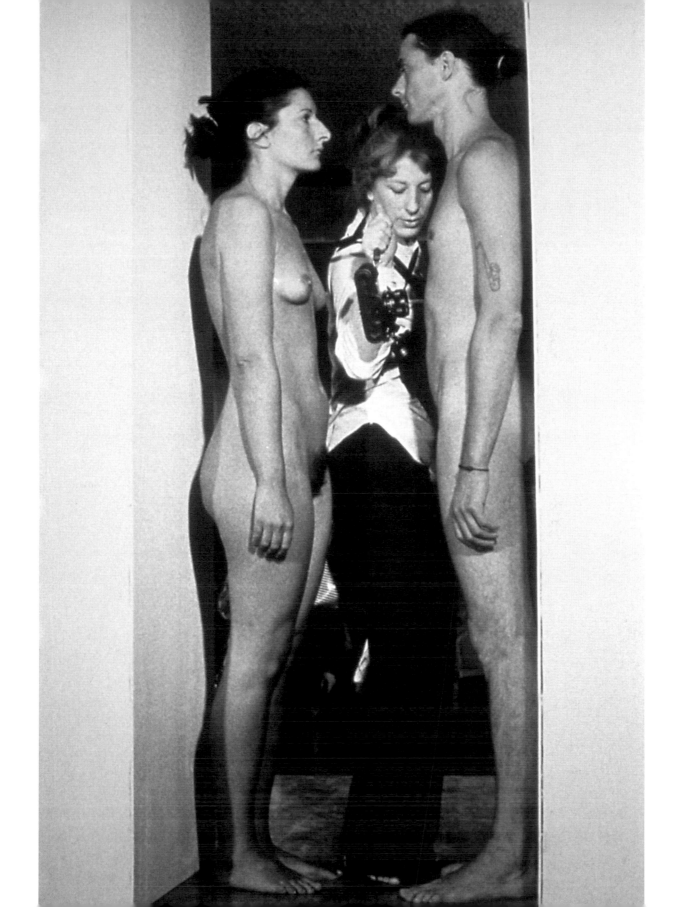

violently brushed her hair with a metal brush in her right hand and a metal comb in her left hand for an hour, repeating the words "art must be beautiful, artist must be beautiful," until she had completely damaged her hair and wounded her face. Though at the time Abramović had no interest in fashion, the piece nevertheless speaks to the feminine desire for beauty. Abramović is not only asking if a woman needs to be beautiful to make art. She is questioning the very nature of it: does art need to be beautiful to be effective? In retrospect, this piece is prescient in terms of later cross-pollination between art and fashion. Hair has its own mythology: Mary Magdalene washed Christ's feet with her hair in a gesture of love and servitude; cutting of hair can symbolize loss of power; in the Hassidic tradition, women shave their heads on their wedding day. In Abramović's own *God Punishing*, 1993, she used hair from Korean virgins. In *Loving Care* (p. 107), performed in 1992 by

Light/Dark
(with Ulay). Performance,
International Art Fair,
Performance Section,
Cologne, 1977.
Photo: Elmar Thomas

Janine Antoni, an artist who has been particularly influenced by Abramović, the artist dipped her hair in dye and mopped the gallery floor, an activity that references both the act of painting and domestic activity.

Abramović met Ulay (Uwe Layseipen) in 1975 in Amsterdam, where he and other performance artists, among them Vito Acconci, had come together for the filming of a television special on performance art. There was an immediate connection between the two, beginning with their shared birth date of November 30. Within three months and after many hours of talking on the phone, Abramović left home and met Ulay in Prague, an event that had a profound effect on Abramović's work, which evolved from aggressive assaults on the body to explorations of relationships. In many ways, it was a relief for Abramović, who felt that her work had become so masculine and intense that she was on a trajectory that could lead to her death.

The early Relation performances were concerned with the way people interact and connect in space. In *Relation in Space*, 1976, they passed each other quickly and repeatedly until the collisions became increasingly intense and painful. In

The Lovers—The Great Wall Walk (with Ulay). Performance, The Great Wall of China, 1988

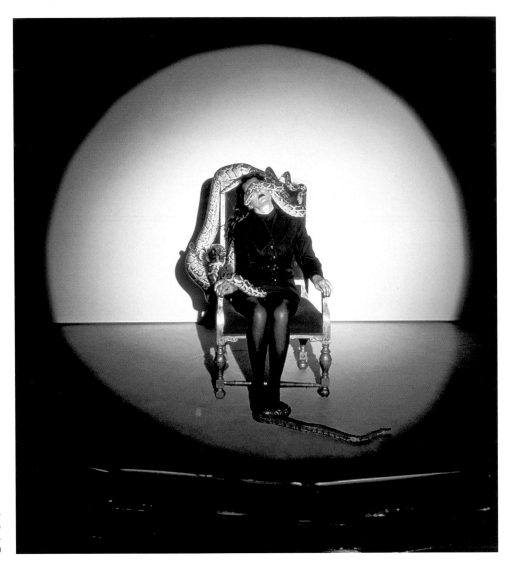

Dragon Heads.
Performance (video-still),
Kunstmuseum Bonn, 1993.
Photo: Wolfgang Morell

Opposite:
Balkan Baroque.
Performance-
Installation (detail),
Venice Biennale, 1997.
Photo: Attilio Maranzano

Breathing Out Breathing In, performed at the Stedelijk Museum, Amsterdam, in 1978, Ulay and Abramović kneeled, facing each other, fully clothed and breathed in each other's exhaled air. Although the action appeared loving and erotic, this "deadly kiss" was toxic as oxygen was very quickly replaced with carbon dioxide. *Imponderabilia*, from 1977 (p. 109), was one of the most effective performances of the Relation works because of the way it involved the public. Abramović and Ulay stood naked, facing each other, at the entrance to the Modern Art Museum in Bologna. The opening was narrow, so people entering the museum not only had to squeeze between the two artists, they had to decide which naked artist to face as they sidled by. The performance lasted ninety minutes before the police stopped it.

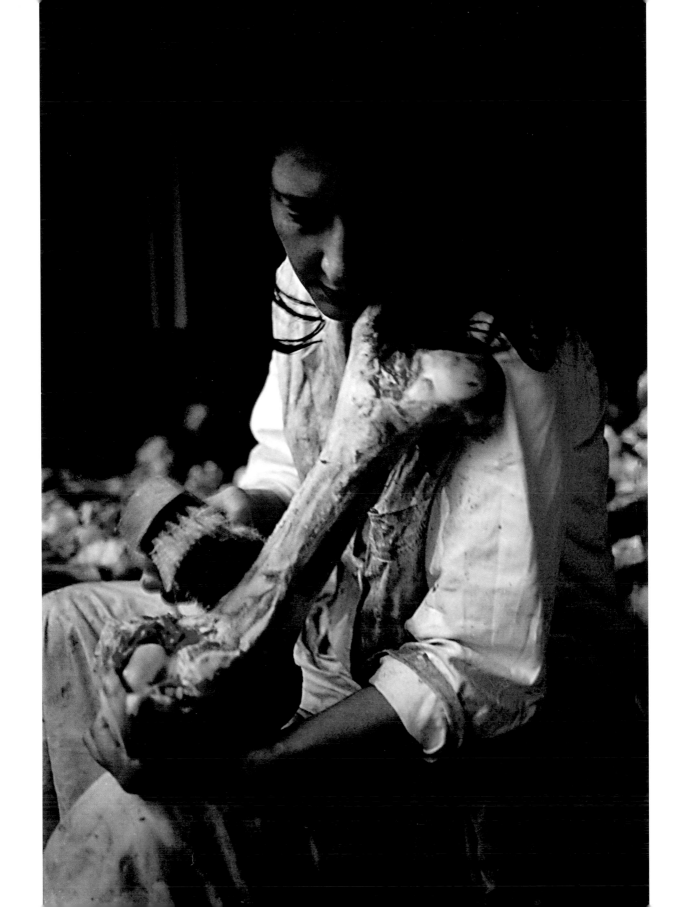

Ulay and Abramović performed together for more than a decade, with most of their work revolving around their connection–literally, in *Relation in Time*, 1977, for which they sat back to back tied together by their hair, without an audience, for sixteen hours. In *Light/Dark* (p. 110), performed only once, in 1977, Abramović and Ulay knelt and slapped each other in turn for twenty minutes. The ongoing series NightSea Crossing was performed at locations all around the world, including Documenta VII in Kassel, Townhall in Toronto, the Stedelijk Museum in Amsterdam, and the Art Gallery of New South Wales in Australia. They sat across a table from each other, with an object between them that would change with each location–one time a snake and a boomerang, another time a pair of Chinese scissors. Ulay and Abramović remained silent for the duration (which could last for days), looked only at each other and abstained from food, with the intention of transcending through presence. In 1987, after twelve years together as partners and lovers, the artists realized that had come to a place that was more defined by differences than similarities, and they parted. A staged walk along the Great Wall of China symbolized the end of their love and collaboration (p. 111). They walked the entire length of the Great Wall from opposite ends, eventually meeting in the middle to say goodbye. Over a period of 90 days, each artist walked a grueling 2,000 kilometers–Ulay started in the west in the Gobi Desert and Abramović started at the eastern terminus at the Yellow Sea.

Abramović's first solo performance after her breakup with Ulay in 1988 was inspired by her walk along the Great Wall, when she learned it had been built along the earth's energy lines and was referred to as a dragon or snake. While researching the piece, Abramović discovered that snakes and other reptiles move along magnetic energy lines of the earth. In the first performance of *Dragon Heads*, Abramović sat in a red chair surrounded by a large circle of ice (p. 112). Five large, hungry pythons were placed on her body and allowed to follow her own energy lines. The artist remained stationary regardless of the movements of the snakes. The performance, in 1990 at the Edge Festival 90 in New Castle, Great Britain, lasted sixty minutes. Abramović performed numerous other times with the snakes, sometimes naked and sometimes wearing a conservative blue dress, stockings, and pumps. The python is not poisonous, but kills its prey by constriction. Typically, its prey are not larger than a rabbit or a chicken and although the viewer understands Abramović is probably not in danger, everyone has a natural horror of the notion of snakes crawling around one's body. The mythology of snakes often symbolizes female power and fecundity, as well as evil.

In 1983, while at a residency in Florence, Abramović collaborated with Michael Laub in telling the story of her life in a fifteen-minute performance using one sentence for each year she had lived, a work eventually also performed at the Stedelijk Museum in Amsterdam. Working with Charles Atlas, she made a four-minute version of it for Spanish television and has performed it several times since, varying each performance with added "chapters" and slides, video, monologues,

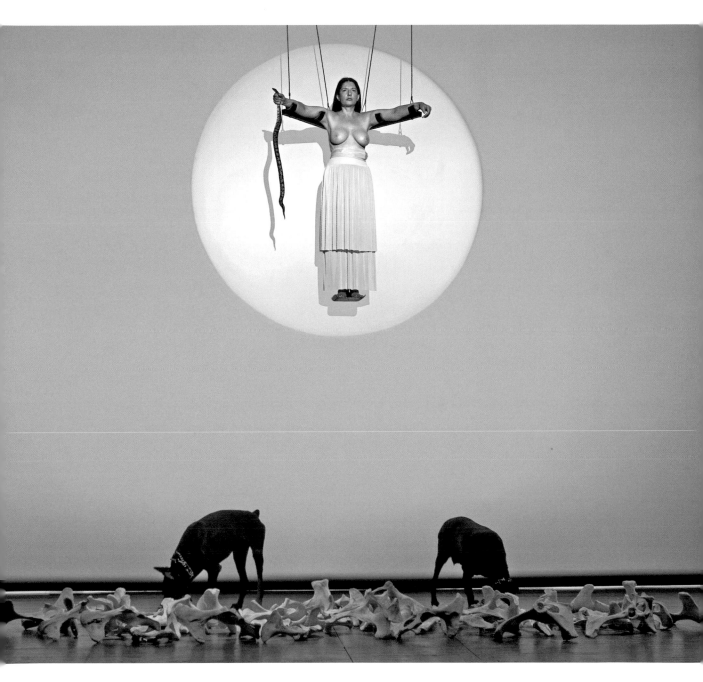

*The Biography Remix
(Snakes)*. Performance,
Avignon, France, 2005.
Photo: Christoph Raynaud de Lage

115

singing, dancing, and interaction with the public. Abramović used objects of danger—knives and whips—as well as the more mystical minerals and crystals, which for her are about energy and light—"simplified computers of the planet."[11] From 1989 to 1992 she visited mines in Brazil that held great caches of crystals. In places where she found extremely large ones, she would request permission to spend the night near the crystals. Numerous performances during this time period involved meditating or sleeping near crystals. In *Shoes for Departure*, 1994 (below), two large amethyst crystals were carved to resemble rocket ships or medieval peasant shoes, implying a journey, perhaps to another world.

At the 1997 Venice Biennale, Abramović performed *Balkan Baroque* (p. 113), for which she won the Golden Lion Award for Best Artist. In the performance, she was surrounded by 1,500 pounds of fresh cattle bones, which she cleaned with disinfectant as she sang. The bones were covered with blood; the stench filled the gallery. Behind her were three video screens, two with images of her parents, who fought for the unification of Yugoslavia, and the other showing the artist herself in a white lab coat explaining how Balkans rid themselves of rats by turning them against each other. This was her attempt to come to grips with a life lived under communism and the recent Balkan war and as well as a comment on ethnic cleansing.

Shoes for Departure.
Amethyst, 1991

Abramović's influence is extensive, yet there are few artists who would go as far as she did to put themselves in such perilous and painful situations. Over the past thirty years, she has created a body of work singular for the depth, breadth, and extremes of performance. While her work can be associated more with certain strains of performance art of the 1970s, many of her underlying premises and motivations in fact share certain characteristics with some feminist artists whose work was a long-term response to various body issues and deep psychological wounds.

1. Marina Abramović, *The House with the Ocean View* (Milan: Edizioni Charta, 2003), n.p.
2. Marina Abramović and Germano Celant, *Public Body Installations and Objects 1965–2001* (Milan: Edizioni Charta, 2001), p. 17.
3. Stephen Henry Madoff, "Reflecting on an Ordeal that Was Also Art," *The New York Times*, November 28, 2002, p. E5.
4. Marina Abramović, *Artist Body Performances 1969–1998* (Milan: Edizioni Charta, 1998), p. 14.
5. Excerpts from these diaries are published in Marina Abramović, *The Biography of Biographies* (Milan: Edizioni Charta, 2004), pp. 105–11.
6. Ibid., p. 111.
7. Ibid.
8. Marina Abramović, *Artist Body Performances 1969–1998* (Milan: Edizioni Charta, 1998), p. 56.
9. Ibid., p. 15.
10. Interview by Janet A. Kaplan, *Art Journal* 58, no. 2 (Summer 1999), p. 15.
11. Marina Abramović and Germano Celant, *Public Body Installations and Objects 1965–2001* (Milan: Edizioni Charta, 2001), p. 24.

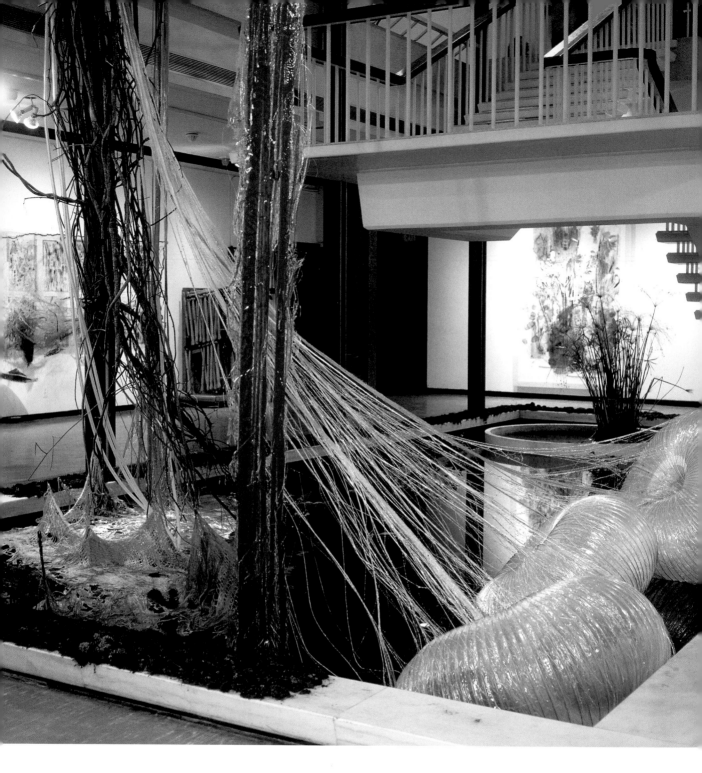

Elephant, 1995. Fiberglass, steel, wood, and
water, 50 x 50 x 50 ft. (15.2 x 15.2 x 15.2 m).
Brandeis University, Waltham, Massachusetts.
All reproductions of art by Judy Pfaff courtesy of the artist

Judy Pfaff:
Storming the White Cube

NANCY PRINCENTHAL

In the famous parable of the blind men and the elephant, seven sightless travelers encounter an elephant for the first time and are asked to describe it by touch. Each examines a different part of the big, oddly assorted animal—trunk, tusks, hide, feet—and each generates an account utterly at odds with the others'. It is a favorite tale for Judy Pfaff, who has cited it more than once in interviews, and who named one of her typically heterodox installations *Elephant*. Created in 1995 for the Rose Art Museum at Brandeis University, *Elephant* used organic, handcrafted, and industrial materials in a sprawling network of linear, planar, and volumetric forms that implicated every component of the space, from floor to ceiling and wall to wall (opposite). Pfaff brought copper wire, fiberglass resin, steel pipes, and plastic ductwork and piping to the gallery, along with vines, tree roots, and dried lily pads. Her working manuals included those used by carpenters, Tibetan botanists, and healers.

Some of the key elements for the installation, though, were found on site. There was a decorative pool in the gallery, drained and covered when Pfaff first visited, which she had restored to use. On the grounds of the campus, a forty-foot-tall birch was slated for culling, and Pfaff had her crew dig it up. Hung sideways from the ceiling in the gallery's light well, over the restored pool, it became one of the central elements of the installation. In the water itself, Pfaff floated grotesquely beautiful jellyfishlike forms made of coiled plastic ventilation tubes. Real plants also grew in the pool, and grape vines rose from it to the ceiling high above. Where the tree touched the wall, splashed paint made its roots seem to be hairs of a giant paintbrush.[1] Finally, there were Pfaff's framed, ineffably delicate collages on paper, decorous and richly detailed, their internal order as serene as it is complex.

As with the animal for which it's named, each small part of *Elephant* was a wonder, sufficient to itself and capable of generating, in isolation, a marvelous fictive beast. Its wealth of tactile information is a gift to the imagination. But, when the whole was regarded with both eyes open, it was clear that each part was also a necessary element of a living, breathing, majestic whole, utterly anomalous in the visual kingdom, richly endowed with memory, considered (and functional) in its finest details and its broadest musculature and skeleton.

Pfaff, whose work has been seen regularly ever since she completed an MFA at Yale in 1973, created her first large-scale installation in 1975, at the pioneering nonprofit Artists Space in New York. It is recalled by founding co-director Irving Sandler, in the opening words of a deeply admiring monograph on Pfaff, as a "near-

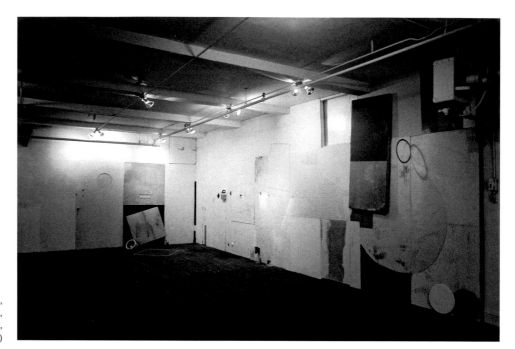

J.A.S.O.N.—J.A.S.O.N.,
1973. Installation,
Artists Space, New York,
11 x 60 ft. (3.4 x 18.3 m)

disaster." Scarcely two years out of school, she arrived at the (admittedly then slightly rough-and-ready) exhibition center with a truckload of unpromising material, including plaster, concrete, wire, wood, and light bulbs, and promptly began chopping holes in the walls. "The process was improvisational," Sandler writes, "and the work in progress looked," he repeats, "like a disaster area almost to the opening day."[2] Indeed the finished installation preserved a sense of minimal coherence balanced precariously—recklessly—on the verge of irredeemable chaos. Plywood, sheet metal, wire, and paint were variously applied to the walls; light was controlled to further modulate shifting experiences of texture and scale. There were passages that approximated geometric abstraction and others that more closely resembled an unfinished office renovation. The overall impression was impromptu, contingent, and liable to change. But its title, *J.A.S.O.N.–J.A.S.O.N.*, the acronym containing the first letters of the months during which Pfaff had lived (for the first time) in New York City, suggests that in concept and logistics, material for this show had been assembled with care and over time (above). In turn, this first major work's title speaks for an essential, and enduring, aspect of Pfaff's process, the apparently cavalier randomness of which conceals months (and sometimes longer) of exacting planning. While serendipity is welcomed, the working method is based on planning, skill, and, as in any successfully improvisatory practice, a keen sense of discipline.

Pfaff didn't invent installation art, but Sandler's response (and he was hardly an unsophisticated observer) indicates how unfamiliar and disconcerting it

was in the mid-1970s. At Yale, where she studied painting, Pfaff's mentor was Al Held; it was in fact he who chose Pfaff for the show at Artists Space, which in its early years relied on artists for all curatorial decisions. Held's investigations of space took place on the plane of the canvas, but many of Pfaff's peers were carrying their experiments into the third and, arguably, fourth dimensions of experiential space. Gordon Matta-Clark, a friend and fellow member of the Holly Solomon Gallery, where Pfaff began exhibiting in 1979, had coined the term "Anarchitecture" for his anarchic disruptions of the built environment. Among other artists then represented by Solomon, Robert Kushner's embrace of visual luxury (he, like several other Holly Solomon artists, was then identified with the "Pattern and Decoration" movement), and Laurie Anderson's integration of visual and performance art, were both very important to the development—and reception—of Pfaff's work. Other artists creating work that insinuated itself between image and object, object and act, including Robert Smithson, Barry LeVa, Richard Serra, and Alan Saret, were pursuing investigations closely related to Pfaff's at roughly the same time. And Held's painting, the spatial antics of which increasingly anticipated the landscape of cyberspace (though he steadfastly declined the tools of electronic design), was of sustained significance to Pfaff.

Held, who remained a close friend of Pfaff's until his death in 2005, had other important affinities with her. As Pfaff describes him, Held "didn't finish high school and went into the Navy when he was seventeen. He went to Paris on the G.I. Bill. So all the education I had at Yale was from someone who learned through life, on the street, and through other artists. He doesn't talk 'that talk' at all. So we got on very well. He was a straight-shooter, and could *really* look at painting."[3] Pfaff too came from a working class background, in a country where social station was considerably more constraining than in the U.S. Born in 1946 in London, a city then still reeling from the war, she never met her father, a pilot with the Royal Air Force; her mother moved to Detroit soon after Pfaff's birth. With her bother, Pfaff was raised in her early years by grandparents. An auspicious childhood pastime involved scavenging bombed and abandoned buildings for the raw materials of "never-never land" fantasy dwellings. In 1956, Pfaff and her brother joined their mother in Detroit, expecting to enjoy the material abundance that the U.S. seemed to promise all. They were disappointed. At 15, Pfaff left home and soon thereafter married an officer of the U.S. Air Force. The union lasted four years. In 1965 Pfaff entered Wayne State University in Detroit, attended Southern Illinois University in Edwardsville in 1968, and ultimately completed a B.F.A. at Washington University in St. Louis in 1971.

When she began a master's degree at Yale that fall, after having spent the summer of 1970 in Yale's Norfolk program, Pfaff was, in short, a couple of years older, and perhaps considerably more experienced, than many of her classmates. As evidence, her work ethic was well-established. Impatient with dawdling academics, she celebrated—and still does—the wisdom of skilled craftsmen and laborers, and

then as now wasted no time in filling an empty studio with art. She was not daunted by heavy equipment, hard work, or recalcitrant and unpromising materials. "I have never associated real thinking with making. I was just a compulsive maker,"[4] she recalls. Pfaff's inclinations did not leave her altogether alone. One consequence of the booming economy and newly commercialized art scene of the sixties was an impulse, among many artists in the following decade, to turn away from its excesses by identifying themselves not as esthetes but as workers; rather than ateliers, they chose to work in industrial loft spaces; instead of oil paint, or wood or stone, they used steel, or plastic. Though some of these distinctions are tricks of language, and though the shift was long and slow, with origins in prewar conditions, it gained critical mass, and new meaning, in the art production and politics of the seventies. And the very spaces in which the new work was taking shape became, not infrequently, subjects in themselves. The raw brick walls, exposed infrastructure, and disused relics of heavy manufacturing were crucial to the development of installation art. So was an eagerness to twist those spaces' Euclidian coordinates. Smithson, LeVa, Saret, and Serra all shared a preference for industrial materials and processes, and also an eagerness to see them warp and bend.

An exceptionally alert artist with insatiable curiosity about the world, Pfaff paid close attention to the work of her peers. That is not to say she disdained the lessons of history. The First International Dada fair of 1920, with its provocatively dense and anarchic disposition of work; El Lissitzky's *Proun Room* (1923), a spare, lucid transformation of space through geometric interventions, and, at diametrical opposition, Kurt Schwitters' *Merzbau* (also begun in 1923), the legendary, apartment-engulfing assemblages of miscellaneous construction material; the similarly room-swallowing installations made by Marcel Duchamp in 1938, hanging 1,200 burlap coal sacks from the ceiling as part of the First International Exhibition of Surrealism in Paris, and in 1942, entangling the First Papers of Surrealism Exhibition at Art of this Century in New York with sixteen miles of string; and Frederick Kiesler's equally aggressive manipulations of the same gallery space in the same year are all important elements of Pfaff's inherited legacy.[5] So is a great deal of painting. Particularly when she was just starting, Pfaff's work was often compared to Jackson Pollock's, as if she had literally undertaken to prove that Abstract Expressionist painting had indeed created an arena in which to act. Add to these influences her appetite for a variety of extra-curricular disciplines, from physics, medicine, zoology, and astronomy to Eastern and Western spiritual systems, and the network of references for Pfaff's work seems more than complete. As she has said herself, "I bump into an awful lot of people when I make a work."[6]

In its gender bias, the history thus far outlined is more than a little misleading. Though industrial materials, processes, and workspaces tend to be associated with the men among Pfaff's peers, the women artists of her generation were from the outset strongly identified with the advent and development of installation art as a major—some would now say a predominant—form. Early on, Pfaff's attention to

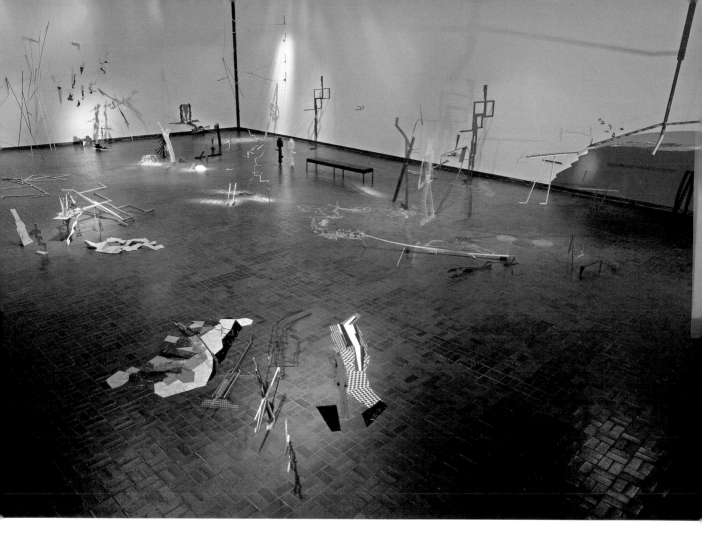

Reinventing the Wheel,
1979. Neuberger Museum,
Purchase, New York

detail, her rejection of the authoritative pronouncements of Minimalism, and, most of all, her occupation of a space in a kind of domesticating process, however forceful and untidy, struck some observers[7] as characteristically feminine. In fact, formlessness was itself considered a signatory mark, and even a cardinal virtue, of feminist artmaking. Notables in installation art's lineage include, prominently, Louise Bourgeois, who by the late 1940s was exhibiting totemic sculptures in arrangements sufficiently dense and dramatically fraught to constitute integrated environments, and Louise Nevelson, whose first installation, *Moon Garden + One*, a dimly lit, closely packed theatrical environment of black-painted wood, was made in 1958. Among Pfaff's peers and near contemporaries, Eva Hesse's sculptures, which resisted the reigning imperative to divest abstraction of personal meaning, and which invaded the rooms they occupied with particular energy, were key for many artists of the sixties and after. And the poured, knotted and spangled sculptures made by Lynda Benglis in the late sixties and early seventies intersected with Pfaff's work in many ways.

To establish this family tree is to assume Pfaff's work has been a fixed entity. But in the late seventies and early eighties in particular, she was a very restless artist. By the end of the seventies, having had ten solo exhibitions across the country and been included in the 1975 Whitney Biennial, she was, as she wryly put it in the title of an installation at the Neuberger Museum in Purchase, New York, *Reinventing the Wheel* (1979) (p. 123). Taking to its limits the implication that installation work is inherently theatrical (as argued by Michael Fried in a famous 1967 essay[8]), Pfaff not only created a lively ensemble of objects, but populated it with surrogate actors, in the form of stick figures fashioned from Plexiglas, Styrofoam, Contact paper, and wood. Disposed in carefree abandon throughout the large space, they consorted cheerfully, in a distinctly unsentimental figurative drama closely related to the paintings of the so-called New Image artists, with some of whom Pfaff had become friends, including especially Elizabeth Murray. The deadpan, reductively figurative sculpture of Jonathan Borofsky and (particularly) Joel Shapiro, and the simple, iconic figurative paintings that Susan Rothenberg was beginning to make are part of the context for this body of work. Despite all this good company, Pfaff's approach to the very old problem of representational sculpture was (as her title suggests) to solve it as if for the first time, an exercise she undertook with more humor than bravado. Hence the rudimentary quality of the figures, their sketchy forms and tentative postures, and their tendency to tumble and sprawl and knock their heads against the walls, to upend and prostrate themselves and hurl themselves into corners, all in the good-natured spirit of robots in training—emergent, potent, but still in helpless, goofy embryo.

Though it was a fertile source of visual play, Pfaff didn't linger in this mode. With work like the widely acclaimed *Deepwater* (opposite), made in 1980 at the Holly Solomon Gallery, Pfaff returned decisively to a more abstract vocabulary. As she did so, her range of materials expanded, in a centrifugal, omnivorous way that

Opposite: *Deepwater*,
1980.
Holly Solomon Gallery,
New York

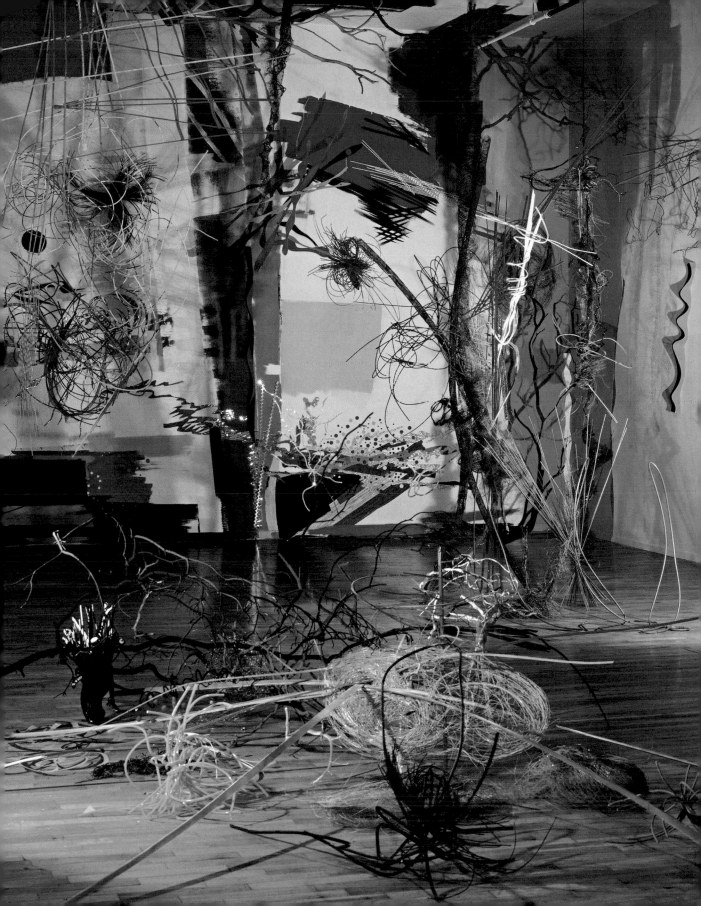

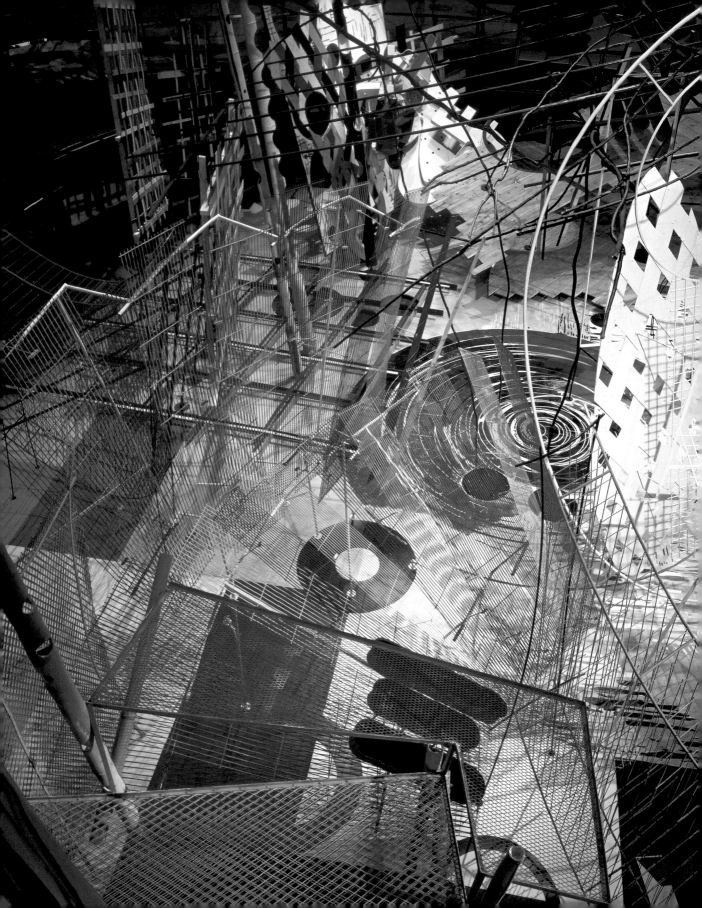

has continued to the present. As the title suggests, *Deepwater* is meant to suggest the visual experience, which can be extravagant, of being undersea (specifically, it was conceived on a trip to the Caribbean, where Pfaff had the opportunity to snorkel). Paint in aqueous shades of blue and green was stroked and splashed on walls, ceiling, and floor. Coils of wire, wicker, and rattan pooled and eddied; tree roots branched upward like coral; wire mesh flashed like schools of fish. But being undersea (as the title implies as well) can also be an occasion of considerable anxiety, even terror. Describing *Deepwater*, Pfaff cites the underwater antiphonies of "weightlessness with mass, beauty with desolation, and volume with emptiness."

Not for the last time, many observers looked only to its exuberance. And though this limited kind of response has been an ongoing source of disquiet,[9] Pfaff's work proceeded, in the 1980s, toward an increasingly high-keyed kind of energy. Linda Nochlin wrote of *Deepwater* that it was "a kind of three-dimensional *dérèglement des sens*,"[10] and indeed it was toward an increasing sensual disorder that her work developed. As always, the apparent chaos belied premeditation both conceptual and logistical. Among the coordinates within which her work unfolded, two key references stand out, both involving time and movement. One is the frenetic life of a big city, the other the pace and fluidity of film. She has said she is for "sculpture that would act on you ... the way the city acts on you," and also, "I structure my work the way films are put together."[11] Perhaps most to the point, she has pursued an expression of spontaneity and vivacity immediate enough to discourage analysis—to so engross the senses that intellectual responses are preempted. "Do you know the way ... at the beginning of Disney films, where they take a single paintbrush and with a single stroke create a full-color, sparkling scene? That's what I'm after," she has said. "My whole life is about the labor but I want my work to seem magical."[12] And, as a caution to over-interpretive viewers, "Looking at anything long enough gives it meaning it doesn't deserve."[13]

Both filmic and urban energy are evident in the installations of the mid-1980s, as is an increasingly acute sensitivity to the particulars of context. *Gu, choki, pa* (1985) (opposite), commissioned by the Wacoal Art Center in Tokyo, included bonsai trees, ikebana, kimonos, images of Mount Fuji, and other Japanese references. It also reflected the notoriously overloaded visual landscape of downtown Tokyo. There was no less agitation or speed in *NYC-BQE*, though in this installation, made for the 1987 Whitney Biennial, the associations were to Pfaff's adopted hometown (p. 128). Decidedly American in its brash color and bold patterns, *NYC-BQE*, with its blooming, buzzing profusion of reverberant circles and stripes, garden furniture and faux-brick walls (all related to Pfaff's then daily commute from home to studio along the Brooklyn-Queens Expressway of the work's title), is characteristic of the installations of the later 1980s, which had grown increasingly jangly and bright. Primary and day-glo colors, plastics and other synthetic materials cut into big, simple geometric shapes, and also into forms associated with youthful revelry, from flower-power petals to beach-ball globes, proliferated.

Opposite: *Gu, choki, pa*, 1985. Installation, Wacoal Art Center "Spiral", Tokyo. Steel, wood, plastic, formica, and organic material, 20 x 40 ft. (6.1 x 12.2 m)

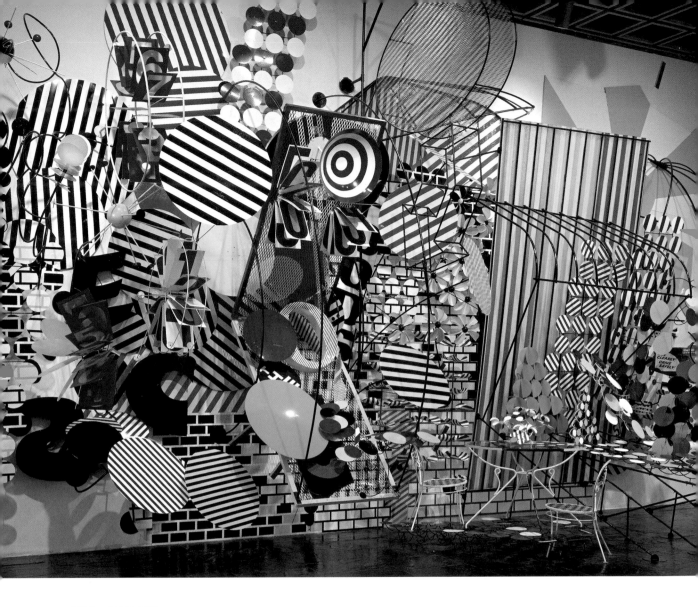

N.Y.C.—B.Q.E., 1987.
Painted steel, plastic
laminates, fiberglass, and
wood, 15 x 35 x 5 ft.
(4.6 x 10.7 x 1.5 m).
"Whitney Biennial 1987,"
Whitney Museum of Ameri-
can Art, New York.
Courtesy of Max Protetch
Gallery

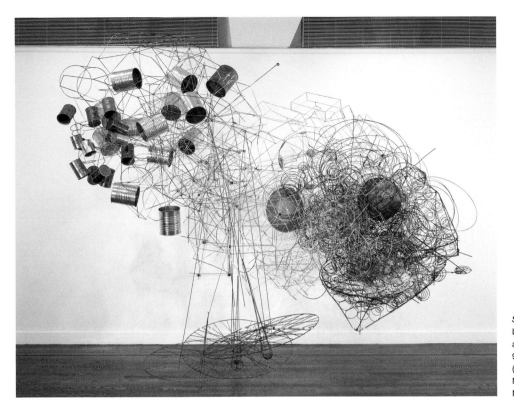

Straw into Gold, 1990.
Lacquered steel, glass,
and tin cans,
98 x 116 x 93 in.
(248.9 x 294.6 x 236.2 cm).
Max Protech Gallery,
New York

The work's density and aggression built on a strong alternative current in the art world of the 1980s, in which the Neo-Expressionist painting that dominated the galleries was opposed by artists working in noncommercial modes and venues. The collaborative undertakings that produced, in New York, the *Times Square Show* and the exhibitions of Group Material, and the widespread use of nontraditional spaces such as the anchorage of the Brooklyn Bridge—where Pfaff installed work in 1987—all provided opportunities for the development of installation work, and for the coinage of terms by which some of it came to be identified, from Energism to (in a telling linkage with the music of the era) Punk. Glitz and trash, Mylar and metal, and, especially, materials purchased at the odd-lot office supply stores along Manhattan's Canal Street, were fashioned, in Pfaff's work of this time, into raunchily exuberant installations that teetered, typically, on the brink of saturnalia's darker side.

By the end of the 1980s, Pfaff was making freestanding wall works that go furthest, in her career to date, toward engagement with the aesthetics of street signage and commercial graphics. The bold colors and swooping geometries of this work gave way, by the early 1990s, to more irregular forms in which linear elements grew finer, more profuse and unconstrained, and to the subtler colors of both nature and (in a return to first principles) unfinished industrial materials. Pfaff made her first visit to the world-famous Pilchuck glassmaking center outside of Seattle,

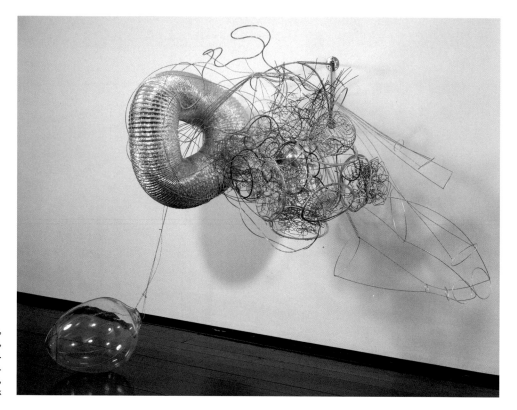

Milagro, 1991. Glass, wire,
and aluminum,
78 x 60 x 102 in.
(198.1 x 152.4 x 259.1 cm).
Max Protech Gallery,
New York

Washington, in the summer of 1989. In addition to learning to work in a new medium, she was deeply affected there by the natural environment, including its tide pools, changeable gray skies, and, generally, the mutability of a watery environment. Having spent her formative years in London, Detroit, and New York, Pfaff describes herself as a city kid, and said as late as 1998, sounding a little like Woody Allen, "I've actually been frightened about nature. I don't go hiking."[14] The occasion for the remark was a weeklong visit to Maine during which she stayed right on the ocean, "and all of a sudden it dawned on me that literally *everything* was moving,"[15] an incessant mobility that has increasingly been reflected in her work. But as far back as *Deepwater*, nature has been at issue, and not only when it is the nominal subject.

Witness, for instance, *Straw into Gold* (1990) (p. 129) and *Compulsory Figures* (1991), freestanding works made almost entirely of metal, the first using

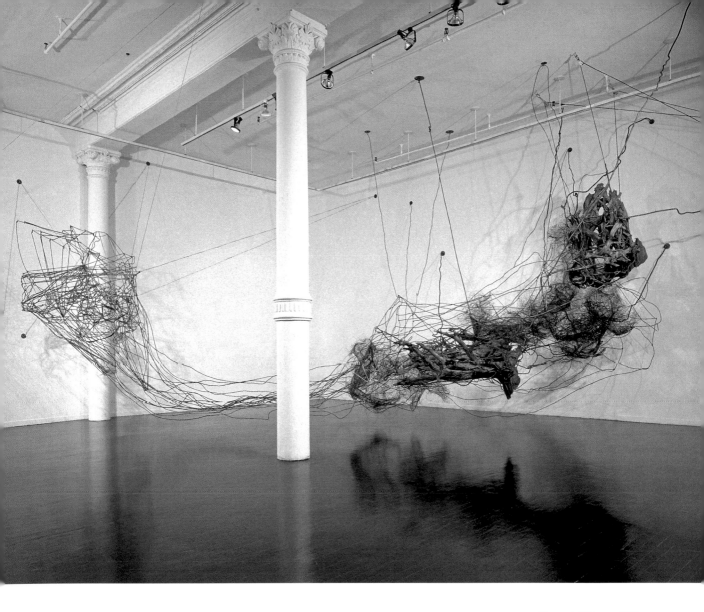

Flusso é Riflusso, 1992.
Steel, wire, wood, and
paint, 12 x 25 x 20 ft.
(3.7 x 7.6 x 6.1 m).
Max Protech Gallery,
New York

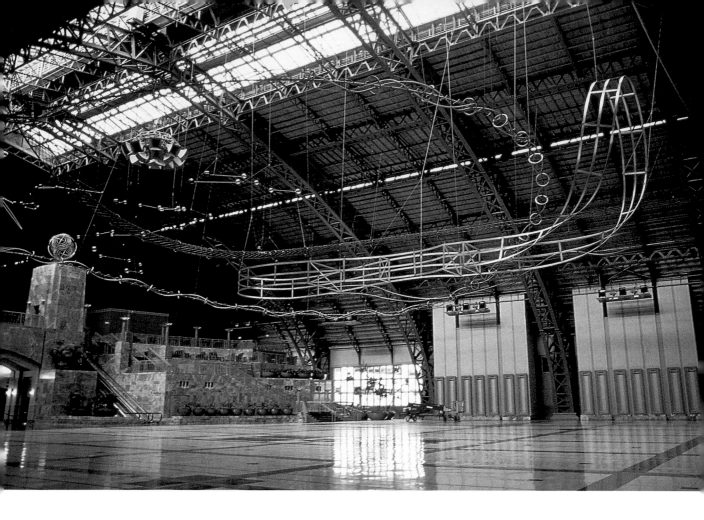

Cirque, Cirque, 1994.
Steel, aluminum, glass, and
cable, 205 x 210 x 40 ft.
(62.5 x 64 x 12.2 m).
Pennsylvania Convention
Center, Philadelphia

bedsprings and unlabeled, unpainted tin cans, the second woven wire and a big coil of accordion-folded aluminum duct. Despite their mass-produced, inert, and nearly colorless constituent parts, both these sculptures express the delicacy and unrestrained energy of burgeoning organic activity, of life springing forth in gloriously messy abundance—an apparent chaos within which precise order can, just barely, be discerned. Thus the welter of wires in *Straw into Gold* gives way to spinning concentric circles, spoked wheels and nascent cones and cubes. This sculpture also harbors several blown glass orbs, though they are less evident than the tin cans suspended at the work's apex. Working with fragile, luminous, and often gemlike glass was a break with the past in many ways, and Pfaff undertook it with as much caution as excitement. "Glass is an extravagant, luxurious material—it is deluxe as opposed to most of the materials I work with, which are base metals,"[16] she noted in 1995. Even when, as in *Milagro* (1991) (p. 130) and *Mattarello* (1992), the blown glass forms have a more prominent, independent existence, they are leashed and netted by wire, as if to constrain their beauty. In *Milagro*, a big, egg-shaped clear class form that rests on the floor is tethered like an anchor to a weightless scribble of wires on the wall; in *Mattarello*, a glass form also rests on the floor, held in a net of wire that leads to a ballooning wire disk, thence to an tangled arabesque of further linear involvement; in both, the vulnerability of glass becomes both burden and ballast.

By the middle 1990s, Pfaff's repertory of form and materials had grown even more diverse. In a review of *Flusso é Riflusso* (1992) (p. 131), dominated by a witchy, sweeping hammock-like form made of gnarled wood and knotted wire, the artist and critic Stephen Westfall wrote, "It spilled toward the viewer in a flash flood of wires, cables, geometric asterisks and two large spidery wooden forms. The supporting cables and bolts were incorporated into the work as gestural anecdotes, like strands of sidewalk-hot chewing gum."[17] Even more exuberant, *Moxibustion* (1994), a gallery-engulfing installation at the not-for-profit Exit Art in New York was (as the title implies) a combustible mix of moxie and frailty, a perilously balanced, creepy-gorgeous visual ecosystem.

Having helped shape a form of art that bridges the ephemeral and the permanent, the site-specific and the freestanding, Pfaff was a dark-horse contender for the enormous commission that she was awarded in 1993 for a work to permanently occupy the interior of the former Reading Terminal in Philadelphia, which was being converted to a convention center. *Cirque, Cirque* (opposite) was installed in 1994 in the 70,000-square-foot shed; with ceilings nearly ninety feet high, it was said to be the biggest single room in the world when it was built in 1892. The volume of materials that Pfaff employed was duly colossal: nine miles of metal tubing, for instance, which begs for comparison with Duchamp's 1942 installation *16 Miles of String*. But whereas Duchamp aimed to entangle viewers (and other artworks) in his tricky spider's web, Pfaff undertook to direct attention upward, using as a starting reference the constellation of lights famously set into the vaulted ceiling of Grand Central Station in New York. In Philadelphia, the celestial and the

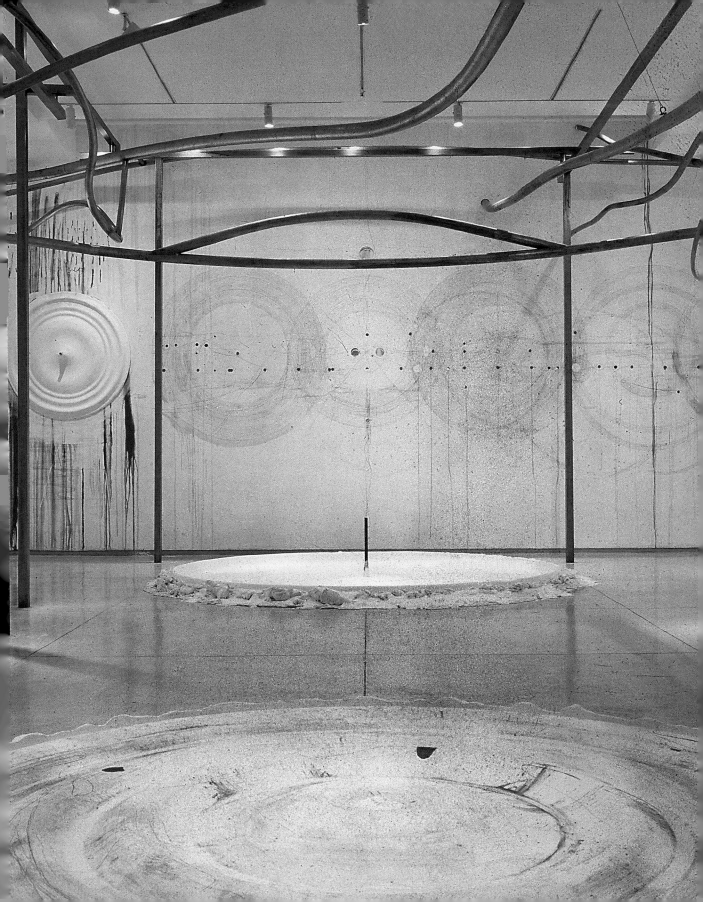

marine intermingle in a soaring, glittering, shimmering network of gold, blue, and silvery aluminum helixes, spirals, arabesques, and orbs. Swimming together along the walls and near the roof, they form patterns suggesting the sinuous contours of underwater animals, or the crystalline structures of protein molecules, or distant stars, all defying gravity with the grace and bravado of a trapeze artist.

This enormous—and enormously time-consuming—installation, anomalous in Pfaff's career (indeed it would be a chartbuster for almost any artist of our time), provided a kind of interregnum. When she was able to return to work of more human scale, it was with obvious relish for impermanence and spontaneity, which resulted in a dizzying profusion of vanishingly subtle details. *Elephant* was among the works that followed, and its heterogeneity typifies the work of the later nineties. By the end of the decade, Pfaff was also experimenting more freely with the architectural elements of the spaces in which her installations were made. *Round Hole, Square Peg* (opposite), installed in 1997 at the André Emmerich Gallery in New York, involved tubing coursing overhead through the several interconnected rooms of the gallery, as well as plaster mounded on the floor and walls and bundled tree limbs suspended horizontally. Some of the plaster forms rose into curvilinear towers resembling stupas, and while Asian references had been visible in Pfaff's work for years—this exhibition included drawings executed on pages from Indian Sanksrit ledgers, on which, Pfaff said, "I could fill the paper with timed responses"[18]—the temple-like forms were also drawn from nature, in particular from observations of raindrops. In 1995, Pfaff was named co-chair of the art department at Bard College, in rural upstate New York, and her new studio and home were on a creek near the Hudson, where, she said with particular reference to the imagery in *Round Hole, Square Peg*, she likes to watch rain on the water's surface. But her sources were diverse as ever; several big plaster discs on the floor were grooved with concentric rings, impelled in part, Pfaff says, by Howard Edgerton's famous stop-action photograph of a falling drop of milk.

Also useful were WPA plasterers' manuals describing sweep molds for chandeliers, which were made with rods that extended from floor to ceiling; the turning template—like a reverse potter's wheel, Pfaff has said—directs the patterning of the plaster below. Evidence of experimentation with novel (for her) processes was clear in the completed installation; Pfaff admits that "The mess we made was unbelievable."[19] Perhaps most irreverently, she drilled holes, in level lines but otherwise random patterns, right through the gallery's several sheetrock walls, including one that stood in front of a large window facing a busy street. Sightlines were thus provided from room to room and from quiet interior to visually cacophonous cityscape. A simple gesture, it was profoundly provocative, and perceptually rewarding. As Pfaff put it, "Penetrating something is a fabulous way of communicating."[20]

Pfaff has said of *Round Peg, Square Hole*, with its dazzlingly polyglot vocabulary, "It becomes a model for the universe, a cosmology."[21] But the work's

Opposite:
Round Hole, Square Peg,
1997. Installation.
André Emmerich Gallery

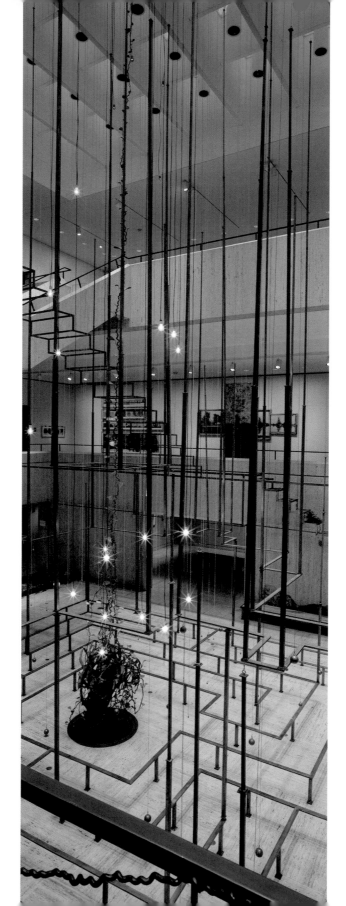

If I Had a Boat, 2000.
Steel, cable, plant matter,
expanded foam, wood
plaster, lighting, dyes, and
lead weights,
40 x 65 x 38 ft.
(12.2 x 19.8 x 11.6 m).
Elvehjem Museum

Imperial Hotel, 2005.
Print, 37 x 85 in.
(94 x 215.9 cm).
Elena Zang Gallery,
Woodstock, New York

title names a discordance that is also at the heart of the installation, a nonconformity between constituent parts altogether at odds with the seamless integration of elements that typifies traditional cosmologies. Internal friction, a primary energy source for Pfaff's work from the beginning, continues to be a generating force, even when she refrains from overt challenges to the work's context. In 1998 Pfaff represented the U.S. at the São Paulo biennial with an installation called *Corona (Coroa) de Espinhos* (Crown of thorns). As has been the case whenever she was invited to create work for distant sites, she immersed herself in its physical particulars, which in Brazil included indigenous plantlife and the lucid modernist architecture of the exhibition space, designed by Oscar Niemeyer. *Corona de Espinhos* incorporated actual (fallen) trees from nearby Ibirapuera Park, as well as expanded-foam casts of organic matter. There was also a massive quantity of material shipped from home, assembled onsite in a process that took six weeks of eighteen-hour days. "By the time I get out of a space," Pfaff said to curator Miranda McClintick, "I have touched every part of it physically—like a child crawling."[22]

 While remaining responsive, as in São Paulo, to contextual specifics, Pfaff no longer treats each installation as a set of obstacles to be overcome. "With the early installations there was a lot of problem solving," she said in 1998. She has also

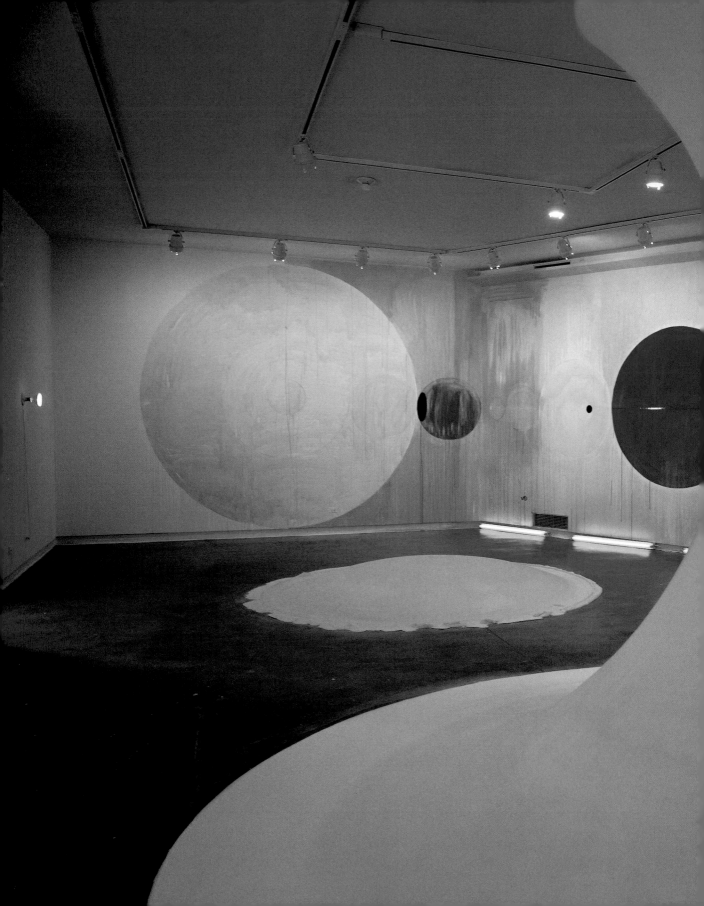

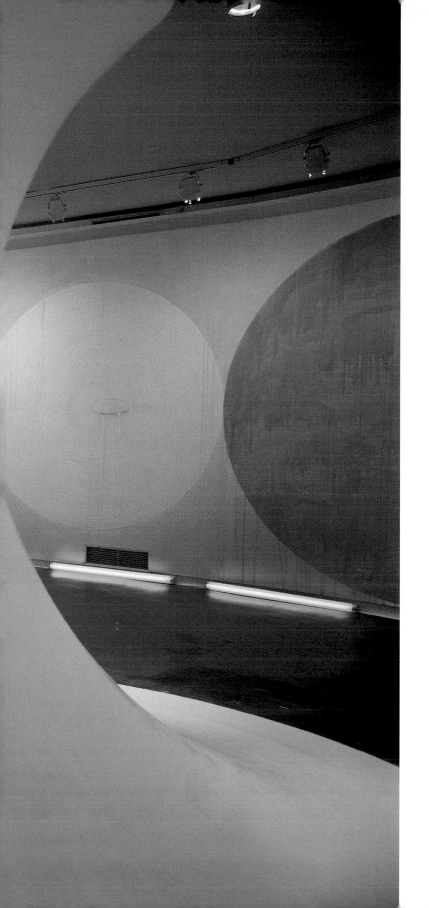

Notes on Light and Color, 2000. Plaster, dye, contact paper, and glass, 70 x 30 x 11.5 ft. (21.3 x 9.1 x 3.5 m). Dartmouth College, Hanover, New Hampshire.
Photo: Rob van Erve

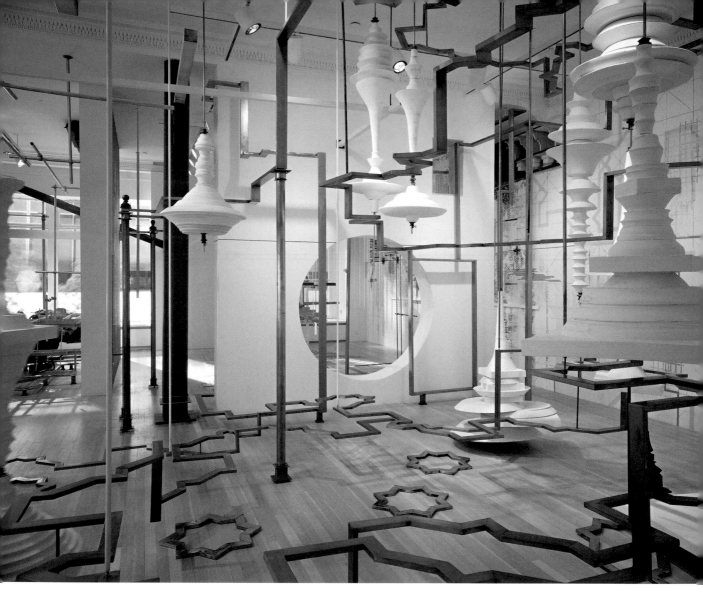

Neither Here Nor There,
2003. Ameringer/Yohe
Gallery, New York

increasingly acknowledged their reflective, personal qualities. "Up until about five or six years ago, I thought all the work was about exterior things—noticing how the light falls, or a tree grows. ... Then suddenly, I saw it was really an interior landscape."[23] That is true even of such majestic installations as *If I Had a Boat* (p. 136), made for the soaring atrium of the Elvehjem Museum at the University of Wisconsin, Madison, in 2000. Deep water and night skies were woven into an installation that had at its heart—indeed, it nearly seemed to pulse—the knotted mass of a tree's roots. Pfaff's use of trees finds kinship in sculpture by a range of contemporaries, including Robert Lobe, Mel Kendrick, Rona Pondick, and Anya Gallacio. Though their work varies widely, all have found in trees an imposing expression of endurance, and of temporal and physical registers that are larger and grander than the human. In Pfaff's work in particular, trees represent a deceptively routine form of transcendence, a kind of everyday sublime.

A similar quality of ordinary sublimity characterizes Pfaff's abundant work on paper. As intimate, delicate, and graceful as the three-dimensional works are bold and even aggressive, the drawings, prints (in several processes), photographs and collages that she has made throughout her career are assembled from many of the same sources as her other work: the natural world, non-Western texts and manuals, and all manner of evocative miscellaneous printed matter (p. 137). The atmosphere of the works on paper is often aqueous and dreamlike, and when, as is frequently the case, they are shown alongside the installations, the two-dimensional works paradoxically deepen their dimensions.

Though it has proved (so far) a singular detour, Pfaff marked the new millennium with an installation that departed quite radically from previous work. *Notes on Light and Color* (2000) (p. 139), made for the Jaffe Friede & Strauss Galleries at Dartmouth College while she was in residency there, was coolly futuristic. Its parade of preternaturally luminous circles, painted on a curved wall in mostly pastel shades of yellow, green, pink and red, served as backdrop for a trio of regular curvilinear plaster forms, one hourglass-shaped, one a sharply truncated cone, and the last a humble mound. Black circles and ovals were painted on a glass window wall; they reappeared in smaller versions amid the frieze of colored circles, where they formed links of kiss-like delicacy and impertinence. Though it recalled the trippy, mind-blowing atmospherics of some of the work of the 1980s, *Notes on Light and Color* was as serene as the earlier work was hot-headed, and occasioned Pfaff to recall that she had, early in her career, worked in a shop that printed Joseph Albers' famous serigraphs.[24]

In subsequent installations, considerations of color have been secondary. *Squares of Savannah*, commissioned by the Savannah College of Art and Design in 2002, actively engaged the neoclassical architecture of the gallery and the cultural history it reflects. Centered around the cap of a dome that floated on slender columns were further fragmentary columns and pilasters, a big grooved plaster disc (as in *Round Hole Square Peg*), and hybrid turned legs, urns, and finials.

Some were intact, while others were tumbled into heaps on the floor, their mostly plaster forms shattered and slathered with further plaster. Despite this melancholic evidence of an irretrievable past, a sense of dignity and even celebration prevailed; the gallery's curator, Judith von Baron, compared building a Pfaff installation to a barn raising, and that spirit of communal determination—and historical reverie—is evident in the result. Similarly, in *Neither Here Nor There* (2003) (p. 140), at the Ameringer and Yohe Gallery in New York, Pfaff's interests were largely architectural. This riotously active installation brought together Victorian denticulated cornices, Mediterranean tile patterns, Asian pagoda plans, nineteenth-century decorative stenciling, and a Chinese moon gate in the form of a six-foot-diameter hole cut into a wall separating two rooms. Opposed circulatory systems, on the one hand biological, on the other man-made—plumbing or heating; electronics—were expressed in plaster and metal. Stupas rose from floor, plaster pendants dangled, stamped tin ceiling tiles covered parts of walls, as did a Tibetan sand mandala. Pfaff's first installation in New York in six years, *Neither Here Nor There* demonstrated that her visual appetite was as hearty as ever, and her energy unabated.

The follow year, Pfaff was awarded a prestigious MacArthur Foundation Fellowship, an honor that acknowledged her importance to peers and younger artists. It came more than two decades after *Artnews* featured her on its cover (in 1981) as an "artist to watch"—as indeed she has been. Her presence in major cities' galleries and museums has, perhaps, not been as regular as other artists of her stature, partly because her work is hard to show and to sell, but her influence has been immense. Irving Sandler cites Nancy Rubins, Cornelia Parker, Jessica Stockholder, Jason Rhoades, and Sarah Sze as among those artists whose work reflects Pfaff's. Diverse as their work is, these artists share an inclination to activate entire physical environments rather than discrete objects, and to engage the audience in a viewing process that takes place over time and in real space. This inclination, combined with a willingness to absorb a universe of materials and processes into the business of artmaking, are Pfaff trademarks. She doesn't have exclusive rights to them—they reflect forms of resistance to conventions of medium and of presentation that arose in the first part of the twentieth century in Europe. And the inclination toward heterodox installation work has now been fully absorbed into the mainstream of visual art, in a process that has accelerated in the past two decades. But, arguably, Pfaff has done more than anyone else to demonstrate the form's possibilities, and to invite further experimentation.

1. Anachronistic though it is, it is hard not to think of Komar and Melamid's only half-facetious experiments, starting in 1998, with elephants employed as painters, their prehensile trunks wielding the brushes.
2. Irving Sandler, (New York: Hudson Hills Press, 2003), p. 1.

3. Richard Whittaker, "Conversations …," in *Works + Conversations* 1 (1998): 4.

4. Ibid., p. 4.

5. For a prehistory of installation work in alternative exhibition practice of the twentieth century, see Bruce Altshuler, *The Avant-Garde in Exhibition: New Art in the Twentieth Century* (New York: Harry N. Abrams, 1994).

6. Sandler, *Judy Pfaff*, p. 3.

7. In a 1973 discussion with Linda Nochlin, already undertaken as a kind of retrospective look at feminist art, Lucy Lippard said that in preference to "female imagery," understood as explicitly sexual, "It's more interesting to think about fragments, which imply a certain antilogical, antilinear approach also common to many women's work. I like fragments, networks, everything about everything. Men's work isn't so cliché-aggressive, all angles and phallic, as it's closed–the this is my image number. Women are, for all kinds of reasons, more open, into themselves in a very different way." ("What is Female Imagery," Lucy Lippard, *From the Center: Feminist Essays on Women's Art* [New York: E. P. Dutton, 1976], p. 83.) Writing about Pfaff's work sixteen years later, Nochlin reflected, "There has always been a tendency to equate artistic 'formlessness' in the sense of a rejection of rigid structure with femininity. … As though the woman artist qua woman artist were incapable of order, of imposing a strict–i.e., intellectual–formal discipline on the inchoate fancies of her mind," and cites the theoretical support, in French theory, for this notion. (Linda Nochlin, "Judy Pfaff, or the Persistence of Chaos," in *Judy Pfaff* (New York: Holly Solomon Gallery, and Washington, DC: National Museum of Women in the Arts, 1989), p. 9.

8. Michael Fried, "Art and Objecthood," in Gregory Battcock, *Minimal Art: A Critical Anthology* (New York: E. Dutton, 1968), pp. 116–47.

9. Pfaff was uncomfortable with terms like energism, and thought of even her boldest early work as "tumultuous, and dark," in Nancy Princenthal, *Art in America*, October 1998, p. 94.

10. Nochlin, *Judy Pfaff*, p. __.

11. Sandler, *Judy Pfaff*, p. 13.

12. In Kristin Tennant, "Working Wonders," *Wash University Alumni Newsletter*, Fall 2005, p. 30.

13. Princenthal, "Judy Pfaff: Life and Limb," p. 100.

14. Whittaker, "Conversations," p. 8.

15. Ibid., p. 8.

16. In Sylvia Netzer, "Three New York Artists Use Glass," *Neues Glas*, February 1995, p. 27.

17. Stephen Westfall, "Judy Pfaff at Max Protetch," (review), *Art in America*, January 1993, p. 97.

18. Jan Garden Castro, "Poetry out of Chaos: A Conversation with Judy Pfaff," *Sculpture*, February 1998, p. 27.

19. Ibid., p. 25.

20. Ibid., p. 23.

21. Ibid., p. 25.

22. Miranda McClintick, *Outside/Inside Landscapes* (New York: Independent Curators Incorporated, 1998), unpaged.

23. Whittaker, "Conversations . . . ," p. 3.

24. Castro, "Poetry out of Chaos" p. 25.

Jenny Holzer: Language Lessons

NANCY PRINCENTHAL

Jenny Holzer has a hard time with words. "I hate to write. I really hate to write," she told an interviewer in 1992,[1] and returned to the theme ("I can barely write") in another interview some ten years later.[2] And yet since the 1970s Holzer's primary medium has been written language, presented in formats and materials that have ranged from cheaply offset posters wheat-pasted onto storefronts throughout Manhattan, to electric signboards at major sports stadiums, to giant light projections on the facades of buildings in cities around the world. Holzer has carved texts into marble and written them in blood-red ink on flesh. Often the phrases hurtle by with ferocious speed, sometimes too fast to read. But the resistance that Holzer encounters in choosing them remains central to the challenging experience of reading them, and to her contentious engagement with subjects that are themselves of surpassing difficulty: injustice and deprivation, political and sexual violence, death, rage, grief. Though at times her work has edged close to autobiography, the voices in which she speaks have never been securely associated with her own. In the past decade she has increasingly relied on texts borrowed from others, including poets, politicians, and anonymous functionaries of state security forces. Whatever its source or mode of expression, it is never less than powerfully resonant in the broadest political sense, and the most intimately personal one as well. "My work takes you in and out of advocacy, through bad sex, murder, paralysis, poor government, lunacy and aimlessness," Holzer summarized in 1990. "I hope," she concluded, "that my work is useful."[3]

Born in Gallipolis, Ohio, in 1950—with almost absurd precision, these coordinates mark the precise middle of the century in a mid-sized town in the Midwest—Holzer grew up in nearby Lancaster, Ohio. Her father's family had come to the United States in the mid-nineteenth century from Germany; on her mother's side, she is descended from Scot/English settlers who began arriving in the United States in the 1600s. In Lancaster there were farms and horses (which her mother trained; Jenny joined her briefly after college, teaching riding classes). Her father was a Ford dealer. In 1966 Holzer entered the Pine Crest Preparatory School in Fort Lauderdale, Florida. Restless during her college years, she enrolled at Duke University in 1968, and then went to the University of Chicago, where she first understood that art might be her career. But she left Chicago for Ohio University at Athens, where she earned a BFA in 1972. Holzer's education continued at the Rhode Island School of Design, where she enrolled in the summer program in 1974; she completed an MFA there, in painting, in 1977.

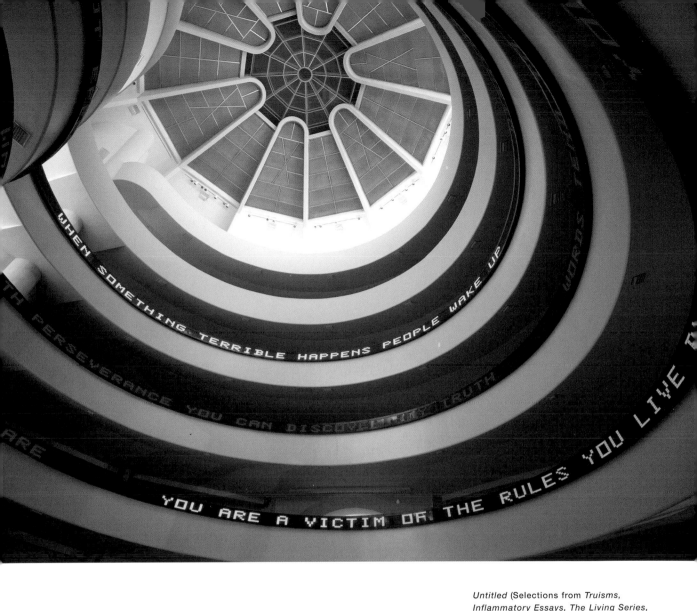

Untitled (Selections from *Truisms,
Inflammatory Essays, The Living Series,
The Survival Series, Under a Rock,
Laments*, and *Child Text*), 1989. Extended
helical tricolor L.E.D. electronic-display
signboard, 16$^{1}/_{2}$ in. x 162 ft. x 6 in.
(41.9 x 4900 x 15.2 cm). Solomon R.
Guggenheim Museum, New York; partial gift
of the artist, 1989.
© The Solomon R. Guggenheim Foundation, New
York. Photo: David Heald

Painted Room, 1978.
Acrylic wash over latex
paint. Institute for
Art and Urban Resources,
P.S. 1, New York.
All reproductions of art by
Jenny Holzer © 2007 Jenny
Holzer, member Artist Rights
Society (ARS), New York

Holzer's most notable student project was her 1976 *Blue Room*, in which every surface, including windows and floors, was painted first in white, then a washy Thalo blue, creating what she recalls as a profoundly disorienting environment.[4] It was the basis for a 1978 installation she made soon after moving down to New York, at P.S. 1, a then-new (it was launched in 1977) alternative art space in Long Island City, where Holzer painted each wall of a project room a different color; small mirrors introduced notes of cross-room color exchange (above). Both projects reflected her training in painting (early favorites were Mark Rothko and Morris Louis), her growing interest in Conceptualism (she has cited Joseph Kosuth), and also an attraction to things transcendent; she has always, she says, been a fan of William Blake.[5] When asked about her family's involvement with art, Holzer mentions that her grandmother's sister was a Sunday painter and also, perhaps more significantly, a dowser, able to divine the presence of underground water. Holzer's own childhood inclination toward the rapturous and hard-to-explain was expressed in epic drawings—"shelf-paper scrolls," she called them in an interview with Joan Simon—and precocious fiction. "I wanted to write ecstatic, fantastic things," she has said. "I tried to write as if I were mad, in some exalted state." When she first studied art, she told Bruce Ferguson, she thought artists could make "miraculous things—things that were really special and absolutely sublime."[6]

But it was probably her post-graduate experience at the Whitney Museum of American Art's Independent Study Program—where painting was frowned upon and where instructor Ron Clark's notorious reading list, on which the authors

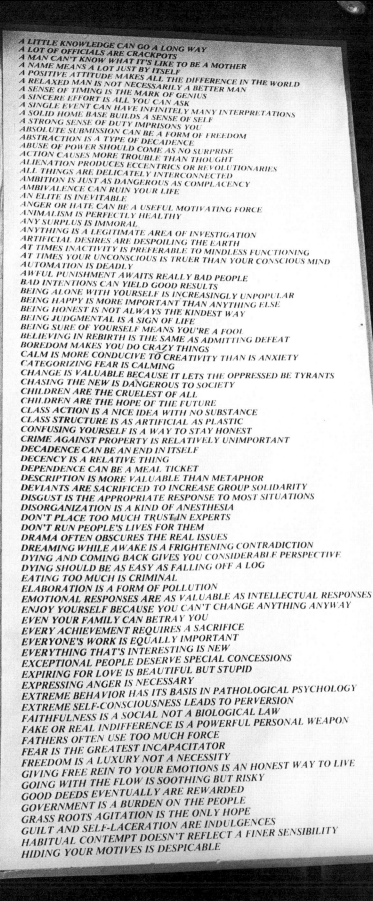

Truisms, 1977–1979.
Poster

ranged from Bertolt Brecht to Jacques Derrida,[7] was the core of a course of study that included weekly guest speakers ranging from Vito Acconci to Dan Graham to Alice Neel—which most directly provoked what perhaps remain Holzer's best-known texts. Called the *Truisms*, they first appeared in public in 1977, on posters covering the windows of Franklin Furnace (p. 147), which was another new art space, in this case dedicated to artists' publications and, especially later, performances. Aphoristic statements arranged alphabetically by the first word's first letter, the *Truisms* were, Holzer has said, "almost a table of contents"[8] for what came later. Printed cheaply and without emphasis on visual style, they were pasted by night on walls and windows in SoHo and less art-friendly Manhattan neighborhoods. The *Truisms* have had a long afterlife—in books and posters, on baseball caps and T-shirts, on electric signboards and marquees; they even formed the basis of a dance by Bill T. Jones, performed by Harry Goldhuber, in 1985.

The language of the *Truisms*, obdurate and internally consistent, heralded a voice that is striking not least for its paradoxical anonymity. Holzer has said that her early work was not so much written as blurted,[9] but the *Truisms*, as their title suggests, seem to reflect wisdom long since received. Of course, that seeming is the result of exacting craftsmanship. Beginning (in one of many versions of the list) with "A little knowledge goes a long way" and ending with "Your oldest fears are the worst ones," the statements Holzer produced, each an irreducible nugget of presumption, include many that reflect the experience of a young professional ("You don't know what's what until you support yourself"; "It's better to be naïve than jaded"). Several could only be considered self-evident—that is, actual truisms—at a stretch (e.g., "Murder has its sexual side"). A little guardedly, Holzer has explained their syntax by saying, "Midwesterners are impatient ... They want to get things done ... fast and right. That's reflected in the [*Truisms'*] speech patterns."[10] Also like proverbial Midwesterners, the *Truisms* pull no punches. Writing in 1998, David Joselit described them, and later texts, as creating a "version of what the world looks like when your internal censor stops functioning,"[11] admitting contradictory notions. (See, for example, "Selfishness is the most basic motivation"; but note also that that truism is followed, and not contradictorily, by "Selflessness is the highest achievement.") But the quality of these statements that has most attracted critical attention is how difficult they make it for readers to determine their author's position. "I wanted to highlight those thoughts and topics that polarize people, but not choose sides," Holzer told Michael Auping in 1990,[12] and indeed their insistent neutrality as to tone, grammar, and vocabulary—their avoidance of any kind of emotional coloration—supports Holzer's claim of non-partisanship.

On the other hand, it is possible to view her very refusal of identity as a form of violence against business as usual. One way of thinking about the flat affect of Holzer's early language is as a kind of verbal minimalism consistent with visual production well into the seventies, and also with such literature as the *nouveaux romans* of Alain Robbe-Grillet, whose ruthlessly dispassionate fiction had been

much read in the sixties. It is also possible to view Holzer's laconic prose style as still more pointedly political. Hal Foster, writing in 1982, called the *Truisms* "verbal anarchy in the streets." In an article that linked Holzer with Barbara Kruger, Foster cited Roland Barthes (who at the time was relatively new to American readers) several times: both artists, Foster said, follow Barthesian precepts to the extent that they "accept the status of art as a social sign engaged with other such signs." And they both embody Barthes's notion of the writer, which, as Barthes described, is "not the possessor of a function or the servant of an art, but the subject of a praxis," someone who "must have the persistence of the watcher who stands at the crossroads of all other discourses."[13] Suggestive as this self-effacing mediator is as a paragon for Holzer, her practice, as Foster's analysis goes on to note, is considerably less peaceable than Barthes's stationary "watcher" suggests. "For Holzer, language is the site of pure conflict," Foster writes; "actually, the *Truisms* as a whole express a simple truth: that truth is created through contradiction."[14]

Whether the *Truisms*' truths have to do with the world or with the language that describes it is a question Holzer's early work refuses to answer. From the start, she focused on both the way words work, in the most basic and far-reaching sense, and also on the particular, usually painful realities that the individual texts address. The two aspects of this investigation of language correspond to her double-tracked exploration of publics and how they are best reached, in which she has been partly concerned with the institutions of art, and partly with broader responsibilities of civic life. With the *Truisms*, Holzer not only launched herself as an aesthetic contrarian, but also as someone whose first work would be shown outside the commercial gallery circuit, with which she would maintain a wary relationship. And as with the choice of words as medium, the choice of posters as a first format is easily linked to sources near and far. Holzer herself genially admits she "stole" the idea of posters from the painter Mike Glier, whom she met while at RISD; they came to New York together (and remain partners). But the use of posters was widespread at the time, as she also freely concedes. Holzer says the idea came partly from a man "who went around plastering Times Square with posters that warned other men to stay away from the vice in the area";[15] also, she notes, "there were tons of great New Wave music posters around that drew lots of attention." The ubiquity and diversity of these posters framed Holzer's in a way that enhanced their ambiguity, and also lent them a not unwelcome radical chic. "I wanted them to seem like a radical basement workshop production," she recalls.[16] At the same time, she drew upon a tradition of art activism that goes back at least a century: "My predecessors," Holzer says, "include everyone from the conceptualists to the Dadaists and even some Utopian social theorists."[17]

In addition to historical models, the guerilla-style presentation of the *Truisms* had precedents in Holzer's own fledgling work, which had included setting out crumbs of bread in abstract, geometric patterns so pigeons would replicate the shapes when they ate, and leaving paintings out on the beach for sunbathers to dis-

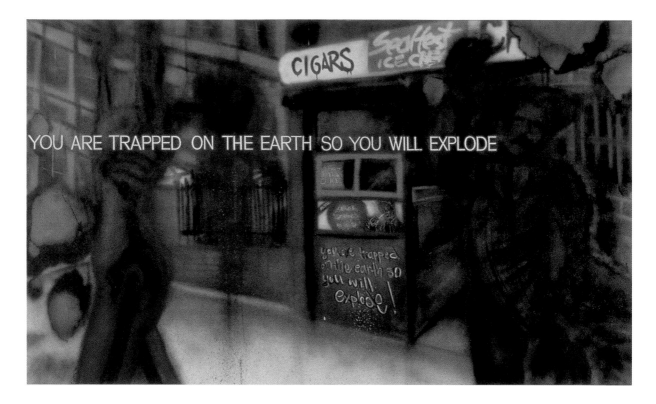

cover. Considerably evolved, the same impulse was behind the "Manifesto Show," which Holzer organized in 1979 with Colen Fitzgibbon for a storefront in the East Village. An open admission that the vaulting idealism represented by early twentieth-century modernism's successive manifestos had lost its credibility, the Manifesto show brought together tracts by 150 artists, some of whom belonged to the loose collective Collaborative Projects (Colab); the profusion itself ensured an anti-utopian, or at least anarchic, cacophony of ideas. On the other hand, the logistics of the show reflected a spirit of community and political opposition–to the institutions of culture and commerce, if not the state–that was deeply (if only implicitly) optimistic. The same impulses were expressed in other choices Holzer made at this time. In 1979 she showed the *Truisms* in Spanish as well as English in the community-bridging art space Fashion Moda, in the then deeply troubled South Bronx. That year she also showed the *Truisms* in the windows of Printed Matter, an important nonprofit distributor and publisher of artists' books (a form of low-priced original art then being energetically explored); the next year she contributed to several artists' books. Also in 1980, she participated in the "Times Square Show," the best-known of Colab's undertakings.

Some of Holzer's decisions in the early 1980s bore on issues of identity politics, such as the paintings she produced in 1983 with the graffiti artist Lady Pink (opposite). "I collaborated with Lady Pink because I was curious about her," Holzer has recalled. "She was one of the few girl graffiti artists, and I ... figured she was probably a pretty tough, interesting girl—which she is."[18] Like many of Holzer's decisions, this one involved risk. Rather recklessly, it overlooked the radically different purposes for which she and Lady Pink made art; it even more boldly forced her to cede a degree of control over her own work. At the same time, their high-keyed, spray-painted canvases were a forum for a kind of female voice that was then (as now) seldom heard. Holzer was sometimes linked in the eighties with other women artists concerned with social politics and/or an examination of the mass media, including Martha Rosler, Lyn Blumenthal, Adrian Piper, and Louise Lawler.[19] And though Holzer's work was not generally understood, especially in the early years, to be primarily feminist, from the start it was concerned with female experience. David Joselit has argued that Holzer's very choice of using language, and particularly, as she has often done, the language of authority, is boldly feminist. "Because of the coincidence of language and patriarchy, the feminine is, metaphorically, set on the side of the heterogeneous, the unnamable, the unsaid," he wrote. Hence its powers of subversion, when operating within written language, are all the more potent.[20]

In a similar critique of the mostly masculine assumptions implicit in the language of the mass media, Majorie Perloff writes that in popular culture as in advertising, personal expression and heightened affect have become basic tools of persuasion. "Authenticity is itself no more than a relational term, a conscious staging,"[21] Perloff claims, observing that by midcentury an explosion of photo-based or otherwise realist commercial imagery had led to wariness about its unconsidered use in both the visual and literary arts. "The current suspicion of 'imageful' language, on the part of the more radical poetries, has a good deal to do with the actual production and dissemination of images in our culture,"[22] she writes. Holzer's preference for ostensibly neutral language; her refusal to speak from an uncomplicated first-person position, or to choose between the rhetoric of power or abasement; even the opacity of her language and its refusal of graceful realism all reflect a widespread wariness of the mass media. And they frame a feminist awareness that became increasingly explicit in Holzer's work.

At the same time that she was working by choice at the margins of cultural power, in subject matter and in practice, Holzer also strode right into its center. In 1982 she was offered use of the Spectacolor electric signboard in New York's Times Square (under the sponsorship of the Public Art Fund) to project a selection of *Truisms* (subsequently, she used the sign for other texts) (see p. 6). Enormous as was its range of broadcast, the Spectacolor board represented more than a way of reaching a different audience. It was also new way of linking the viewing experience with the work's contents, one that she has exploited ever since. The propulsive energy of the

> HAVING TWO OR THREE PEOPLE IN LOVE WITH YOU IS LIKE MONEY IN THE BANK.

Living sign, 1980–82

electronic signboard, the way it can change speed, keeping pace with reading—with thought—and even exceed it; the way that it allows for words to be perceived as images when flashed, and as text when scrolled; the degree to which such words can seem percussive, like music, and explosive, like gunfire; and even decorative, but with a kind of festivity that is on the edge of danger, like fireworks; and, though perhaps this is too obvious to need stating, the way using the signboards makes art analogous to both advertising and mainstream news broadcasts (which exploits the above-mentioned associations, as Holzer helps us see)—all these things recommended the medium to Holzer.

During this period, several new series of texts were developed. *The Inflammatory Essays* (1979–82), which, like the *Truisms*, first appeared as posters, were aptly named. Incendiary little harangues, each one a hundred words (twenty lines) long, they were inspired, Holzer says, by Emma Goldman, Rosa Luxembourg, Mao, and Lenin, as well as Futurist essays and other radical art tracts. Some of the statements reflect on the evils of unchallenged political power. ("A charismatic leader is imperative. He can subordinate the small wills to the great one.") Some are squarely focused on a smug citizenry. ("You have lived off the fat of the land. Now you are the pig who is ready for slaughter. Look over your shoulder.") Others suggest the ranting of cult leaders. ("Starve the flesh, shave the hair, expose the bone … ") To the extent that their energy is entirely provocative, the *Inflammatory Essays* are less sympathetic than any other of Holzer's writings. Their righteous fervor inhibits the comforts of introspection, and their unremitting belligerence discourages critical engagement. Joselit characterized this body of writing as having a "seamless but nonetheless jarring mobility in tone"; using an unidentifiable voice, he says, is Holzer's way of evaporating not just object but (speaking) subject.[23] In fact, with statements like "Scorn liberty, scorn hope, scorn the light" and "Kill the vermin," Holzer assumed a voice that is

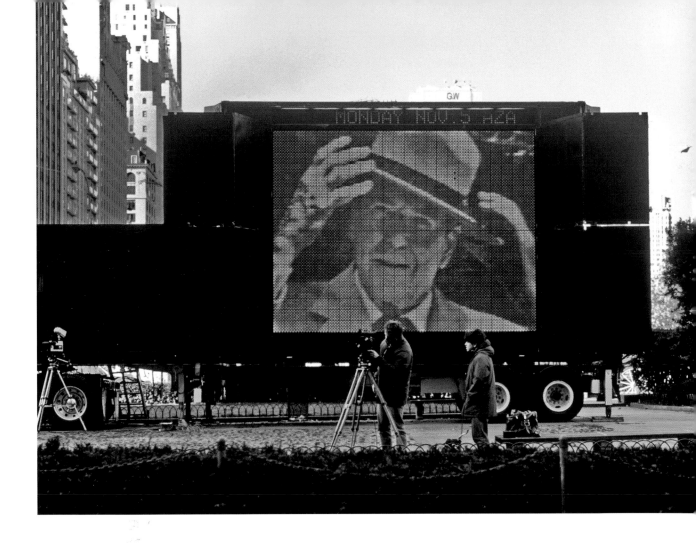

not just slippery but also nearly incomprehensible as social discourse, a voice very close to the edge of recognizable humanity.

Sign On a Truck, 1984

It was a position from which she soon withdrew, beginning an indirect approach to more personal material. Holzer says, "Starting with the *Living* series, which I began in 1980 [and completed in 1982], there was a switch from ... many viewpoints to a single voice in a more neutral or institutional format. ... I became ostensibly 'upper-anonymous' instead of 'lower anonymous.'"[24] As those texts remind us, the 1980s were the decade that introduced the term *yuppies*, when Republicans gained the White House and then Congress, and fevered economic growth helped support a sharp right turn in the social values marketed by popular culture. The *Living* texts, each a short sentence, mused on the benefits and responsibilities of the privileged class: exercise breaks, gifted children, maintaining sexual appeal, and getting on with one's life in the face of troubles suffered by remote, less advantaged others (opposite). "It takes awhile before you can step over inert bodies and go ahead

with what you were trying to do," one *Living* text reads. This series, its messages hardly more appealing than those of the *Inflammatory Essays*, was quickly followed by a further inward spiral, retreating from *Living* to a series called *Survival*.

The works in the latter series, in a marked departure, approach first-person speech, though with tremendous caution. Holzer has said, "With the *Survival* series [1983–85] I thought it would be interesting to take … a line that would be closer to my own. … I switched from being everybody to being myself."[25] The simplicity of that statement is a little misleading. The *Survival* texts, each again a simple declarative statement, hardly indicate a securely integrated personality. In fact what they express most strongly is the speaker's lack of emotional center—a circuit failure between basic knowledge and psychological reality that results in a breakdown of instinctual understanding and behavior. "Tear ducts seem to be a grief provision," reads one *Survival* text. "Turn soft & lovely anytime you have a chance," says another, and a third, "Remember to react." The same distortions of affect govern the *Survival* texts' politics: "If you had behaved nicely the communists wouldn't exist," while arguably true, is just as lacking in animus, and as bluntly unhelpful, as "Dance on down to the government and tell them you're eager to rule because you know what's good for you."

It's possible to read the *Living* and, especially, the *Survival* series as Holzer's most despairing, so haunting is the disjunction between belief and feeling. Their emotional opacity is supported by the formats in which they were presented, which included, for the *Living* series, bronze plaques like the ones that mark sites of historic interest. *Survival* appeared in the form of enameled metal signs like those used to designate parking restrictions, both elements of the New York streetscape common enough to be nearly invisible. At the same time, Holzer was experimenting widely with electronic signs, using the *Truisms* and *Survival* texts in displays that exploited the technology's fast-growing range of typefaces, pacing, rhythm and even simple imagery. These too appeared in various public places—stadiums, plazas, marquees—as well as in gallery and museum exhibitions. In other words, while the direction of the writing was, at least in part, toward introversion, the means of presentation reached for an ever broader public. In the mid-eighties, for instance, Holzer became interested in using public service spots on television. And during the 1984 presidential election campaign, she undertook her most direct involvement in the political process with *Sign on a Truck* (p. 153). For this project, Holzer invited twenty-one other artists to submit videos that were projected from a 13-by-18-foot mobile screen (deliberately, it was "just like the kind of electronic screen used at the Republican convention").[26] The screen was mounted on the flatbed of a truck and driven to two well-trafficked New York locations, one at the corner of Central Park and the other at Bowling Green, where it served as an invitation to an open-mike forum.

In 1985 Holzer and Mike Glier moved out of the city to rural Hoosick, in upstate New York. Three years later their daughter Lili was born. Both events had

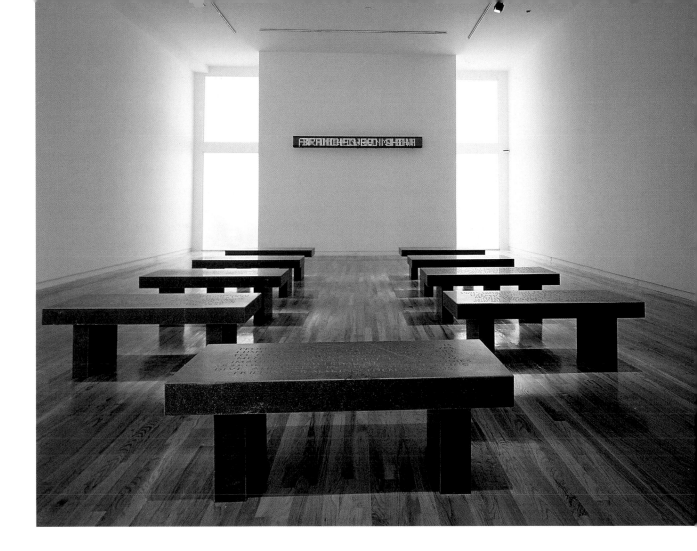

a profound influence on Holzer's work. The series *Under a Rock* (1986) (above) was the first to be carved in stone, an appealingly natural material whose obduracy and durability could hardly contrast more strongly with electric signboards, on the one hand, or disposable paper posters, on the other. But another primary association of the carved granite was to mortality. Engraving words into stone benches that have the visual (and physical) gravity of mausoleum furniture, Holzer considerably deepened, and complicated, the emotional range of her work. The neoclassical Scottish garden called Little Sparta that was Ian Hamilton Finlay's nearly lifelong project, in which fragments of classical and modern poetry and prose, often on martial themes, were carved into miscellaneous architectural fragments, comes closest to the visual aspect of Holzer's work in stone. But Finlay's vexingly murky politics and sometimes alienating displays of erudition are very different from Holzer's urgent candor. In any case when *Under a Rock* was shown, both initially (at the Barbara

Under a Rock, 1986.
Misty granite bench.
Barbara Gladstone Gallery,
New York

Gladstone gallery in 1986) and later, the stone benches were accompanied by racing LED signs. The effect, as Holzer described it, was "a combination of a church, a space station, a Greyhound bus stop, and a high school auditorium."[27]

As important as the cross-talk between the mobile, chattering lines of electronic text and the static, implacable carved benches is the changed quality of the writing in *Under a Rock*. Its short texts were the first to be frankly narrative, and the first to be largely concerned with violence against women. Though in several cases the actions described are unclear, rape surely seems at issue in "Crack the pelvis so she lies right. This is a mistake. When she dies you cannot repeat the act" and "Blood goes in the tube because you want to fuck. Pumping does not murder but feels like it. ... You want to die and kill and wake like silk to do it again." Only a little more ambiguously, one text reads, "You spit on them because the taste left on your teeth excites. You showed hope all over your face for years and then killed them in the interest of time." If in previous writings Holzer had aimed, by her simple syntax, spare vocabulary, and general asperity, to project anonymity even while the content grew more personal, with *Under a Rock* it became clear that her odd, lurching, vehement staccato was inescapably her own. And for all its syntactical clarity, the semantic logic of Holzer's writing actually became harder to discern. In fact, the very simplicity of the grammar helps disguise the complexities of its meaning. That, too proves retrospectively illuminating: the contradictions among the *Truisms*, or between *Living* and *Survival*, speak not only for an irreparably fractured society but for disjunctions within a single individual, of a different order but not altogether unrelated to the kind that separate thought from feeling. Holzer has said of the *Under a Rock* texts, "I didn't want to be didactic ... I try to give people room to fumble around until they get their own footing."[28] But they read like the forcefully unitary expression of an individual deeply at odds with herself.

The permeability of bodies and the difficulty of establishing their boundaries had come up before *Under a Rock*, where these issues figure prominently. One of the more memorable of the *Living* texts reads, "The mouth is interesting because it is one of those places where the dry outside moves toward the slippery inside." For the better part of a decade, starting in the mid-eighties, the body's vulnerability was brought into ever tighter focus. *The Laments* (1988–89) were precipitated, in part, by the then-accelerating AIDS crisis, and also by Holzer's new motherhood, a fraught conjunction. In a 1989–90 exhibition at the Dia Foundation in New York City, the *Laments* (opposite), which range up to a paragraph in length, were engraved on the tops of stone sarcophagi and programmed into vertical LED signs. Some of this writing has the bluntness of raw fear ("The new disease came. I learn that time does not heal." "If the process starts I will kill this baby a good way."). But there are equally stark, and moving, paeans to altogether different kinds of physical experience ("No record of joy can be like the juice that jumps through your skull when you are perfect in sex.") The *Laments* were followed by *Mother and Child* (1990), a short series that is among Holzer's most personal and direct. "I am indif-

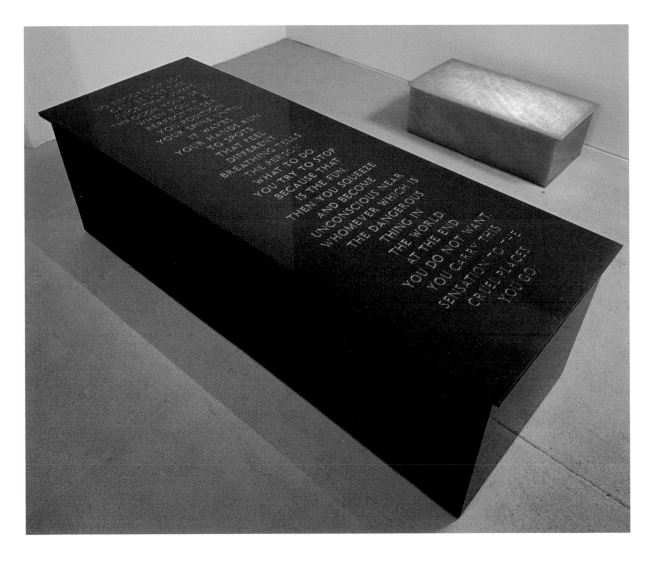

Laments, 1988–1989.
Nubian black granite
sarcophagus,
82 x 30 x 24³/₈ in.
(208.3 x 76.2 x 61.9 cm).
Dia Art Foundation

ferent to myself but not to my child," she wrote. "I am sullen and then frantic when I cannot be wholly within the zone of my infant." Bulletins from the strange land of early parenthood, these statements are as shocking in their tenderness as their rigor. To read them is to find Holzer stunned into shameless poignancy by her own quite ordinary experience.

Also in 1989, Holzer's work was featured at the Guggenheim Museum in New York. Within the year, she represented the United States at the 1990 Venice Biennale (see p. 158), with a series of installations that won her the Leone d'Oro (grand prize for best pavilion). At the Guggenheim, LED signs spiraled up the museum's famous ramp, filling the soaring atrium with pulsing light; a circle of engraved stone benches provided for viewing from below. In Venice, she used the

Above: *Microwave Room*,
44th Venice Biennale, 1990

airport, rail station, vaporetti, and streets and alleys for posters; hats and T-shirts were sold at tourist retail stands. One chamber of the U.S. pavilion was illuminated with a dozen nearly thirteen-foot-high vertical LED signs programmed with *Mother and Child* texts that alternately ascended and descended, sometimes running upside down so they could only be read in their reflections on the polished floor. In another room, eleven nearly fifteen-foot-long flashing horizontal signs were flanked by two sets of five twenty-foot-long signs, on all of which the seven series of texts written to date ran in three colors and five languages. This "firestorm of electronic light and language," in Auping's words,[29] led to that installation being nicknamed the "microwave room" (above). In still other rooms, diamond-patterned marble floors and stone benches, engraved with *Truisms*, *Inflammatory Essays*, and *Mother and Child* texts, produced a sober, elegiac effect. Separately and especially cumulatively, the ambitious projects of 1989–90 pro-

Opposite: *Black Garden*,
1995

158

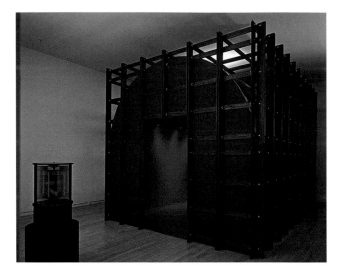

vided what Holzer had sought, as a young student, in Blake and Rothko—access to a kind of visual/textual rapture.

These momentous exhibitions were followed in the early 1990s by a series of projects in which Holzer again turned outward, away from personal experience and toward global politics. Twice she was invited to create memorial gardens at troubled sites in Europe. For the town of Nordhorn, where a World War I monument had served as a Nazi rallying ground in World War II, Holzer created *Black Garden* (1995) (p. 159), in which the foliage was chosen for its deep-colored leaves and blooms; sandstone benches were engraved with a series of texts written in 1992, during the first U.S. incursion in the Persian Gulf, and called, simply, *War*. A small white garden was also planted at Nordhorn, to commemorate Nazi victims. The *Erlauf Peace Monument* (1995) marks the site in Erlauf, Austria, of the German surrender in World War II. Here Holzer also created a garden of white plantings and, for a row of white paving stones, a series of truncated phrases invoking isolated moments of wartime experience, all sharp as shrapnel.

Lustmord (1993–94) (above), a project that also originated in Germany, was drawn in part from reports of atrocities committed in the war in the former Yugoslavia. From three perspectives—victim, perpetrator, and observer—it reflects, with gut-clenching intimacy and vividness, on the sexual violence that was a favored tactic in the Bosnian conflict. Holzer's presentation of this material was unusually elaborate. The texts were stamped on the walls of a small barrel-vaulted enclosure lined in quilted red leather. They also appeared in two Plexiglas canisters, seemingly written in spiraling red light on air—as if going up in smoke, a counterpart to the leather-stamped words that were, literally, branded on flesh. More graphically still, Holzer displayed small bleached human bones circled with small metal bands incised

Lustmord, 1993. Ink on skin

with fragments of text. In Germany (*Lustmord* was also later shown in New York and elsewhere), the texts first appeared as an insert in the Sunday magazine of the *Süddeutsche Zeitung*, a major daily newspaper. There they took the form of words written in ink on human skin (above). Most provocatively of all, a white card on the front of the magazine bore two lines of text, including "Da wo Frauen sterben bin ich hellwach" (I am wide awake in the place where women die), printed with ink containing a small amount of actual blood, donated by German and Bosnian women for the purpose. Unsurprisingly, the entire project generated not only fervent praise but also a storm of protest.

The outrage that *Lustmord* caused is perhaps commensurate with the depth of experience on which it drew. Over the years, Holzer had alluded to rape many times. With *Oh* (2001) (p. 162), the references became considerably more intimate. Much of *Oh* is an unblinking, worried, ardent catalogue of the perfect parts—arms, ribcage, genitals, fingers—of a child fast becoming a young woman. But some of *Oh* is the artist's own family history: "I have not raped you although this would be familiar enough if I remember the family habit," Holzer writes. She names the perpetrator as a grandfather, "lover of any woman he could catch then rapist of children and grandchildren got from the women." *Oh* was composed for a spring 2001 exhibition at the Neue Nationalgalerie in Berlin, a museum designed by Mies van der Rohe. The texts Holzer used there—a compendium of which *Oh* was the newest—ran on LED signs mounted on the ceiling, so viewers had to crane their necks or, ideally, lie on the floor or on benches, to read them clearly. Mies's famously spare design involves glass window walls, and in many light conditions the texts reflected on the glass and seemed to continue beyond, soaring out over the adjacent plaza and nearby rooftops.

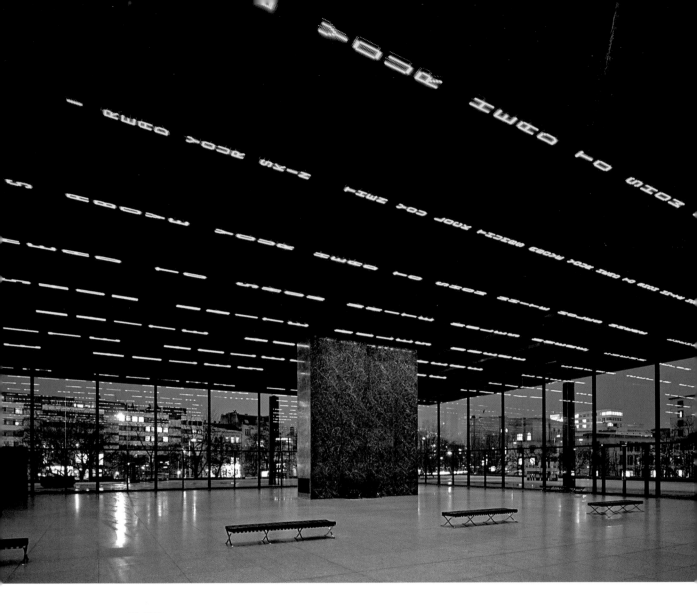

Oh, 2001
Neue Nationalgalerie,
Berlin

Holzer has not written any original material since *Oh*. Starting in 1996, she had begun to use light projections, which throw huge white letters at night over the façades of buildings and certain landscape elements, including dense stands of trees and even water. Monumental and ghostly, the scrolling projections pick out architectural details, or leaves, or curls of foam from the obscurity of darkness, while broadcasting enormous words that have an oracular presence tremendously potent even in the photographs that are their only lasting document. Holzer's xenon projections have appeared in countries from Argentina to Norway, and including France, Germany, and England; they've been seen on the Spanish Steps in Rome and the Arno River in Florence. The texts have been both Holzer's own and, starting in 2001, words written for a variety of purposes by others. At the Jüdisches Museum Berlin that year, documents from the museum's archive, along with poetry by Yehuda Amichai and others, were projected on the building. At several locations in Bregenz, Austria the following year, she used (in addition to selections from her own writing going back to the *Truisms*) a poem by Henri Cole directed in sorrowful rage at George W. Bush. Among the texts programmed into electronic signs shown at the Bregenz Kunsthaus at the same time, some laid like verbal landmines across the floor, were excepts from correspondence between government officials in the United States and the Middle East, and also the Cole poem, which appeared as well in the form of letters burnt in spiraling lines up the peeled trunks of two trees, one at the Kunsthaus and the other at a church just outside Bregenz.

Shortly before the 2004 presidential election in the United States, Holzer projected the contents of formerly classified government documents on the façade of the Gelman Library at George Washington University in Washington, D.C., which houses the National Security Archive, a collection of declassified documents established two decades earlier by journalists and scholars, and maintained as a way of supporting public access to governmental information. Also in the fall of 2004, poetry by Wisława Szymborska, Amichai, Cole, and others was projected on several New York City monuments (St. John the Divine on the Upper West Side, Bethesda Fountain in Central Park) (p. 164). These nighttime projections, supported by the nonprofit Creative Time, were accompanied in the daytime by text-bearing banners pulled aloft by small airplanes. The following fall, government documents as well as poetry were projected on New York City landmarks, this time including the New York Public Library and 30 Rockefeller Center. Sliding silently across these august buildings, the massive illuminated words were quietly spellbinding. "There's something about light that's right for these terrible subjects," Holzer said at the time. "It's a way of having beauty let you come closer than you might otherwise."[30]

In the spring of 2006, at the Cheim and Read Gallery in New York, Holzer exhibited her first paintings in more than twenty years. Executed in oil on linen, the elegant *Redaction Paintings* are enlarged facsimiles, on variously colored backgrounds, of declassified government documents, all of them heavily censored.

...NO FACE IN THE MIRROR R
...REFLECTING MORE
DARKNESS THAN LIGHT,
MORE STRIFE THAN LOVE,
NO MORE STRIFE
THAN IN MY HANDS NOW,
AS I SIT ON A ROCK,
TEARING UP BREAD FOR

NYC Series—Cole, 2004.
Bethseda Fountain, Central
Park, New York City

Patches of black conceal parts—and in many cases almost the entirety—of memos and letters circulated within the U.S. government, most dealing with such sensitive issues as assessment of terrorism risks and treatment of detainees. Sometimes oddly satisfying in formal terms, the *Redaction Paintings* speak eloquently not just about the prevalence of state censorship and the abuses it vainly tries to hide, but also about the assaults it commits against language, as well as bodies and minds (p. 166). In a catalogue essay, Robert Storr notes the work's demonstration that "In the interface between official and unofficial practices, codes and euphemisms are necessary." Holzer traces, Storr says, "a verbal maze of specialized terminology, acronyms, abbreviations, rote salutations and initials," a series of layered abstractions "of which the censor's markings are the last in line."[31] If Theodor Adorno's famous pronouncement that poetry is not possible after Auschwitz is brought to mind by Holzer's turn away from original composition and toward exposure of the real language of power, Hannah Arendt's argument that the Nazi regime's abuse of language was among its most egregious offenses is brought even more forcefully to mind. In her *Eichmann in Jerusalem*, which indicted the chief administrator of the "final solution" for, above all, a failure of imagination—"an inability to *think*, namely, to think from the standpoint of somebody else"[32]—Arendt wrote, "The net effect of this language system [the *Sprachregelungen*, essentially a code of official euphemisms] was not to keep these people ignorant of what they were doing, but to prevent them from equating it with their old, 'normal' knowledge of murder and lies."[33] Clearly, Holzer shows, this omnidirectional kind of linguistic repression—directed equally inward and at others—still thrives.

Both insofar as she has exposed the way power corrupts language, and in her practiced ability to think from the standpoint of others, Holzer powerfully illuminates the dangers of what Arendt so unforgettably described as the banality of evil. Considered as a whole, Holzer's work has refreshed written language as a medium for visual artists, while ensuring that politics retains a seat in the institutions of high culture. It now seems clear that she keeps closer company with such politically engaged artists as Nancy Spero, Hans Haacke, and Krzysztof Wodiczko than with those whose primary concern is the conventions of the mass media or the institutions of high culture (Barbara Kruger, Louise Lawler). Above all, Holzer has retained faith in the belief—one not much in vogue at the moment—that difficulty, for artist and viewer alike, bodes well for significant achievement.

1. Michael Auping, "Interview with Jenny Holzer," in *Jenny Holzer* (New York: Universe, 1992), p. 95.
2. "Jenny Holzer in Conversation with Henri Cole," *Jenny Holzer* (Berlin: The American Academy in Berlin and the Nationalgalerie Berlin, 2001), p. 114.
3. Auping, "Interview with Jenny Holzer," p. 110.
4. Joan Simon in conversation with Jenny Holzer, in David Joselit, *Jenny Holzer* (London: Phaidon, 1998), p. 19.
5. Ibid., p. 33.

SWORN STATEMENT

b(6), b(3)

For use of this form, see AR 190 45; the proponent agency is ODCSOPS

PRIVACY ACT STATEMENT

AUTHORITY: Title 10 USC Section 301; Title 5 USC Section 2951; E.O. 9397 dated November 22, 1943 (SSN).
PRINCIPAL PURPOSE: To provide commanders and law enforcement officials with means by which information may be accurately identified
ROUTINE USES: Your social security number is used as an additional/alternate means of identification to facilitate filing and retrieval.
DISCLOSURE: Disclosure of your social security number is voluntary.

1. LOCATION	2. DATE (YYYYMMDD)	3. TIME	4. FILE NUMBER
1/502 I.P. AO Glory	2003/12/25	11:50	

5. LAST NAME, FIRST NAME, MIDDLE NAME	6. SSN	7. GRADE/STATUS
████████████████		████████

8. ORGANIZATION OR ADDRESS
████████████████

9. ████████████████ _____ WANT TO MAKE THE FOLLOWING STATEMENT UNDER OATH:

I WAS ON GUARD WHEN the guy had his JAW BROKEN. THE
what I RECALL IS, WE WERE ASKED TO STAND THEM UP IN A
FORMATION so they could FIND ONE of the DETAINEE'S A SOLDIER
AND I WAS STANDING SOME up ON ONE SIDE of the ROOM ALONG
with 4 or 5 others on the other side WHEN I HEARD ONE
of the DETAINEE'S CRYING. So I WENT to SEE WHAT WAS WRONG.
HE WAS CRYING AND HOLDING HIS HAND'S to HIS FACE WHEN the soldier
who WAS WITH ME CAME OVER AND PULLED HIS MASK OFF. HIS FACE WAS
FULL of BLOOD. THEY then ASK ME to TAKE HIM to ANOTHER ROOM
WHERE I WAS THEN ASKED to go AHEAD AND go.

Questions + Answers Follow on next page (2/3). ████

10. EXHIBIT	11. INITIALS OF PERSON MAKING STATEMENT		PAGE 1 OF ____ PAGES
	████		
	____ TAKEN AT ____ DATED		

ADDITIONAL PAGES MUST CONTAIN THE HEADING "STATEMENT OF _____

THE BOTTOM OF EACH ADDITIONAL PAGE MUST BEAR THE INITIALS OF THE PERSON MAKING THE STATEMENT, AND PAGE NUMBER MUST BE BE INDICATED.

DA FORM 2823, DEC 1998 DA FORM 2823, JUL 72, IS OBSOLETE USAPA V1

001236

10. Ferguson, "Wordsmith," p. 109.
11. David Joselit, in Simon et al., *Jenny Holzer*, p. 48.
12. Auping, "Interview with Jenny Holzer," p. 85.
13. Roland Barthes, as quoted in Hal Foster, "Subversive Signs," *Art in America*, November 1982, p. 88.
14. Foster, p. 91.
15. Ferguson, "Wordsmith," p. 111.
16. Auping, "Interview with Jenny Holzer," p. 82.
17. Ferguson, "Wordsmith," p. 111.
18. Ibid., p. 112.
19. The list is Ferguson's, see "Wordsmith," p. 113.
20. Joselit "Various Bodies and Spaces," p. 47.
21. Marjorie Perloff, *Radical Artifice: Writing Poetry in the Age of Media* (Chicago and London: The University of Chicago Press, 1991), p. 11.
22. Ibid., p. 57.
23. Joselit, "Various Bodies and Spaces," p. 44.
24. Ferguson, "Wordsmith," pp. 112–13.
25. Ibid., p. 113.
26. Ibid., p. 152.
27. Auping, "Interview with Jenny Holzer," p. 92.
28. Ferguson, "Wordsmith," p. 152.
29. Auping, "Jenny Holzer," in *Jenny Holzer* (Universe), p. 62.
30. In Amei Wallach, "New 'Truisms' in Words and Light," *The New York Times*, September 28, 2005, p. E 7.
31. Robert Storr, "Paper Trail," in *Jenny Holzer: Redaction Paintings* (New York: Cheim & Read, 2006), pp. 5, 8.
32. Hannah Arendt, *Eichmann in Jerusalem* (New York: Viking Press, 1963), p. 49.
33. Arendt, *Eichmann in Jerusalem*, p. 86. By way of illustration, Arendt wrote, "None of the various 'language rules,' carefully contrived to deceive and to camouflage, had a more decisive effect on the mentality of the killers than this first [1939] war decree of Hitler, in which the word for 'murder' was replaced by the phrase 'to grant a mercy death.'" (p. 108).

Opposite:
Broken Jaw—A Redaction Painting, 2006

Cindy Sherman:
The Polemics of Play

ELEANOR HEARTNEY

It is a rare discussion of postmodernism that does not invoke the work of Cindy Sherman. Since 1977, when she began creating her groundbreaking Untitled Film Stills, Sherman has been the indispensable reference for studies of the decentered self, the mass media's reconstruction of reality, the inescapablilty of the male gaze, the seductions of abjection, and any number of related philosophical issues.

However, despite the heavy lifting that her work tends to inspire among theoretically inclined critics, Sherman is also among the most accessible and durable artists of her generation. Her work uses the visual language of genres familiar to anyone versed in popular culture, among them B-movies, horror films, fairy tales, soft- and hardcore porn, and fashion photography. These become the basis for photographic tableaux in which, for the most part, Sherman herself plays the protagonist in open-ended narratives that alternately evoke pathos, fear, disgust, and empathy. For followers of French theorists like Roland Barthes, Jacques Lacan, and Jacques Derrida, these works are full of markers of artifice and inauthenticity that undermine the authoritarian messages of their sources in mass culture. For those unschooled in the ways of poststructuralism and critical theory, they tap into cultural wellsprings of fantasy, imaginative play, and the guilty pleasures of cultural transgression. These differences of outlook add grist to the ever-present question: Just who is Cindy Sherman?

Sherman was born on January 19, 1954, in Glen Ridge, New Jersey, to an engineer father and schoolteacher mother. Much of her suburban childhood was spent playing dress up by herself or with friends. She haunted thrift shops, using her finds to recreate herself up before the mirror. This is an activity that did not cease when she entered art school at State University College at Buffalo in 1972. Occasionally she even stepped out on the town in her alternate personas.

In art school she made a number of forays into painting, and had a failed encounter with the technical aspects of photography, before she discovered the conceptual approach, which was just then gaining currency. She also made friends with a number of like-minded students, including Robert Longo, who became her close friend. Her breakthrough as an artist came soon after she moved from Buffalo to New York City following her graduation from art school. Longo, with whom she was then living, suggested that she might as well make art out of the elaborate characters she was creating. She shot the first of what would be her Untitled Film Still series in their apartment before branching out to locations around the city, in Long

Island and out West during vacations with her family. An NEA grant in 1976 allowed her to pursue this project, leading to her first exhibition of the Film Stills in 1977 at Metro Pictures Gallery in New York.

Sherman emerged on the art scene in the late 1970s in the company of a group of young artists whose work deliberately eschewed the bombast of neoexpressionism, then making a splash as a latter-day version of the macho emotionalism of Abstract Expressionism. In contrast, the works of Sherman and her colleagues were modest in scale, photographically based, and indebted to images from advertising, movies, and glossy magazines. Along with Longo, who created blackand-white drawings of isolated, writhing figures in evening dress who might have been derived from film stills, Sherman's contemporaries included Sarah Charlesworth, who isolated details of glamorized images borrowed from glossy fashion magazines against lustrous monochrome backdrops; Richard Prince, known for cropped and reconfigured images of cowboys appropriated from ads for Marlboro cigarettes; and Sherrie Levine, who gained fame for rephotographing pre-existing photographs.

The meaning of such works, according to then pervasive theories of postmodernism, resides not in the image as such, but rather in the conventions by which their sources in popular culture contribute to the construction of our sense of reality. In a prescient 1979 essay that examined Sherman and her colleagues, critic Douglas Crimp suggested that the practice of mining quotations and excerpts from media images and then reframing and restaging them in patently artificial ways provided artists with the means for interrogating the invisible understructure of representation. "We are not in search of sources or origins," he wrote, "but structures of signification: underneath each picture there is always another picture."[1]

Over the years, Sherman's work has colonized ever greater swaths of pop and high culture, and has in the process served as raw material for ever more complex theoretical interpretations. The untitled Film Stills that launched her career consist of small black-and-white photographs in which the artist assumes the role of various female types of the sort who populate European films and B-movies of the fifties and sixties. They consist of librarians, hillbillies, seductresses, waifs, and urban sophisticates captured amid equally typecast settings. These photographs so convincingly evoke vintage film stills that some early critics were convinced they referred to specific movies. In fact, these works, for which Sherman donned various wigs and costumes and rearranged parts of her home and studio, evoke the mood and details of films that never existed.

Though the photographs suggest a variety of scenarios, they differ from conventional film stills that tend to focus on moments of dramatic action between two or more characters. Sherman's heroines are always alone, nearly expressionless, and caught up in very private emotions. They seem to be women with impenetrable interior lives, caught in a moment of quiet contemplation.

Thus, they are fantasy objects of a peculiar type. There is almost always an undercurrent of anxiety, which may have something to do with the idea that they are outsiders, and even seductresses are oddly out of sync with one's expectations. The dark-haired vixen of Untitled, 1978 (p. 172), wields her evening bag like a weapon as she casts a guarded glance in the direction of a male visitor whose presence is suggested by wafting cigarette smoke and a coat flung over a chair that is visible in the reflection of a mirror. In another Film Still a woman in a lacy dress lies diagonally across a bed, but rather than seduction, her pose and attitude suggest shock or grief as she grips a handkerchief in one hand and a clump of bedspread in the other.

The Film Stills have a built-in aura of nostalgia. The film still itself was already becoming a relic of a bygone era during Sherman's childhood and the generic female types she recreates here are icons of the fifties and sixties, thus already historical by the time she started creating these works. Sherman has noted that she was consciously going for a more mysterious ambiance, which lead her to mime the look of films by Hitchcock or European directors like Antonioni or Fellini. In terms of types, she chose women who, in her words, "don't follow the accepted order of marriage and family, who are strong, rebellious characters [and] are either killed off in the script or see the light and become tamed, joining a nunnery or something." [2]

This characterization of the types in the Film Stills is curiously at odds with the vast critical literature that has grown up around them, which tends to regard the women in these photographs as common prototypes or media clichés constructed out of male fantasies. Sherman's Film Stills are frequently cited as quintessential examples of postmodern strategy. They are often used to illustrate the notion of the simulacra, formulated by French theorist Jean Baudrillard to describe the fictional nature of our apparent reality. Baudrillard suggested that our sense of the world is formed, not by interaction with any actual or concrete "real," but by the interplay of empty signifiers. As a result, according to Baudrillard, we are surrounded by "the generation by models of a real without origin or reality," [3] or as others put it, by copies without originals. Sherman's stills of fictional films seem to fit this bill perfectly.

Related to the theory of the simulacra is another idea that gained enormous currency in the art debates of the early 1980s and also became attached to Sherman's work. This is the argument that our very sense of self has been created by the unreal media images that bombard us from the worlds of Hollywood, fashion, and advertising. In this light, Sherman's Film Stills present a disparate assortment of female types, but in the end tell us nothing about the woman who is enacting them. As feminist critic Judith Williamson argued in a 1983 article, Sherman's Untitled Film Stills are simultaneously "a witty parody of media images of women" and "a search for identity." [4]

This interpretation leads to perhaps the most common theoretical explanation of Sherman's Film Stills. As formulated by critic Craig Owens in an influential 1983 article, Sherman presents us with the idea of femininity as masquerade. [5] This converged with feminist theories about the male gaze that observed how Western

art, and more recently the popular culture of film and advertising, have traditionally been organized around the satisfaction of the male viewer.[6] The voluptuous nudes of Ingres and Titian, provocative damsels selling cars, and Hollywood's seductive screen sirens all share in the perpetuation of male fantasies about women as pliable, passive, and ever-available. Thus they tell us nothing about woman in herself. Certain proponents of a psychoanalytic approach to art have extrapolated from this idea to make the argument that the very idea of woman in herself is a fantasy. From this perspective, Sherman's masquerade reveals our culture's vision of woman as an empty signifier, whose necessarily fractured being is defined by a phallic lack. She serves patriarchal culture as a fetish that can never be possessed because it doesn't really exist.[7]

All of these explanations seem to define Sherman as a postmodern feminist, skillfully manipulating media imagery to reveal the phallogocentric basis of a male-dominated society. However, despite its centrality to postmodern debates, something about Sherman's work always seemed to escape these characterizations. Critics wondered: Was she really challenging the status quo or was she actually perpetuating it? Was she or was she not really a feminist? How were viewers expected to respond to these reductive clichés of femininity?

On one side of this debate were critics like Craig Owens, who argued that Sherman's work deliberately subverts the male gaze by challenging prevailing stereotypes and by refusing to offer the illusion of an apparently stable identity.[8] On the other were feminist critics like Mira Shor who held that Sherman's work simply perpetuates clichés of femininity while feeding into pervasive myths about female beauty and vulnerability.[9]

Sherman's next body of work greatly complicated the matter. In 1981, she created a series of photographs that suggest the poses and vulnerability, though not the state of undress, of girlie magazine pin-ups. These untitled Centerfolds borrow the horizontal format of the girlie magazine pin-up to depict women of various sorts lying prone beneath the camera's eye. However, though the poses and layout are suggestive of centerfolds, the characters were quite unlike those normally found in the pages of *Playboy*. Instead her characters wear school-girl sweater sets or terry cloth bathrobes which underscore their uneasy innocence. Completely absent are such common centerfold props as corsets and high heels. Instead, these women suggest awkward adolescents or young women as yet uncomfortable with their sexuality.

These works were commissioned by *Artforum* for a photo spread but were ultimately rejected by the editors, who feared they simply reinforced existing stereotypes about women's victimhood or submissiveness. The most controversial was a photograph of a disheveled blonde woman, bathed in morning light, who is drawing black sheets up to her neck (p. 174). Some critics saw this as a depiction of the aftermath of a rape. Sherman counters that she was thinking of a woman who had partied until dawn and was now trying to fall asleep in the early morning light.

Opposite:
Untitled, 1978. Black and white photograph, 10 x 8 in. (25.4 x 20.3 cm)

Untitled, 1981.
Color photograph,
24 x 48 in. (61 x 121.9 cm)

Countering the reading of this work as a surrender to oppressive fantasies are critical commentaries that see this series as an effort to undermine the controlling male gaze. Curator Lisa Phillips argues that, because she is both creator and subject of these images, Sherman wrests control from the voyeuristic male gaze of the pinup's usual consumer.[10] Craig Owens puts it another way, noting, "Sherman's photographs themselves function as mirror-masks that reflect back to the viewer his own desire ... but while Sherman may pose as a pin-up, she still cannot be pinned down."[11]

Sherman followed these photographs with works that pursued another aspect of female objectification. In the mid-eighties and then again in the nineties, she created several series based on fashion photography. However, despite the fact that these works were commissions from fashion magazines and fashion houses, they again deliberately eschew the conventions of the genre, instead suggesting Sherman's love/hate relationship to the female quest for beauty. Clothes provided by fashion designers became the inspiration for characters of the sort rarely if ever encountered in fashion magazines. In Untitled, 1983 (opposite), posing against what appears to be a cheap flowered bed sheet, she protectively clutches at her crotch and looks at the camera with a startled, school-girlish expression, which is much at odds with the seductress implied by her trussed, form-altering lingerie. Frequently in these works, one can barely make out the contours of the garment being featured. In several she wears a large fake nose and deliberately unattractive wigs. One of the most anti-glamorous, Untitled, 1983 (p. 176), features a standing Sherman in a bleach-blonde wig that all but obscures her face. She wears a severe black suit and stands against the wall clenching her fists like a cornered animal.

Untitled, 1983.
Color photograph,
94³/₄ x 45¹/₄ in.
(240.7 x 114.9 cm)

While French *Vogue* was not pleased with Sherman's approach, other fashion editors and designers, including Comme des Garçons, Issey Miyake, and Dianne B were enthusiastic about Sherman's reenactments of their clothes. Their willingness to embrace even the most extreme efforts to subvert the fashion industry's code of glamour and seduction casts light on charges that the fashion industry is simply a system for the subjugation of women. Instead, it suggests that fashion can also embrace an attitude of play and self-mockery not unlike Sherman's own.

With these fashion images, Sherman's personas began to shift from images of vulnerability to images that were overtly threatening, grotesque, or disturbing. This became even more pronounced in the photographs that followed the fashion images. These works originated in an invitation by *Vanity Fair* to create a series based on fairy tales. Using theatrical makeup, fake appendages, masks, and dramatic nocturnal lighting, Sherman recreated herself as a pantheon of monsters, hags, and misshapen creatures of the sort who inhabit the margins of fairy tales. Though many (but by no means all) of these monstrosities were apparently female, it was clear that Sherman had moved far beyond any conventional commentary on female roles. Again there were a variety of critical interpretations. Some critics saw a connection to feminist discussions about Western culture's suppression of female magic and shamanism that considered women with unusual powers to be witches. Others connected the work to Bruno Bettelheim's theories about the function of fairy tales as repositories of primal fears that children must overcome to successfully enter adulthood. Psychoanalytic interpretations dwelt on the stage of adolescent development when sexuality inspires anxiety and dread, but is also inescapably alluring.

Works in this series found Sherman sprouting horns, pointed ears, and an enormous warty chin; bathed in deep purple shadows and transformed into a snout-nosed human/animal hybrid; lying corpse-like on the ground with blotchy, dirt-covered skin (Untitled, 1985) (p. 178); and leering at the viewer as a half naked, demonic gypsy (Untitled, 1985) (p. 179).

With these works Sherman seemed to have come full circle from the Film Stills' exploration of women's conformity to social roles. Here she exaggerates the outsider status hinted at in those personas with a set of characters who exist only in the world of fantasy and nightmare. Sherman has suggested that these works are in part about dealing with fears of death.[12] But despite their darkness, these works are not simply repellant. They are leavened with humor and a sense of the absurd. Like traditional fairy tales, they invoke evil and irrationality in order to bolster our ability to master these frightening forces.

Sherman ventured further into the territory of disgust with her Disaster photographs. In many of these works, Sherman as protagonist begins to disappear, leaving only unpleasant traces behind. One depicts a recently disturbed field of dirt out of which poke a scattering of body parts—a nose, lips, teeth, an ear and some stiffened fingers. The mirror of a discarded makeup compact oddly reflects part of a

Untitled, 1983.
Color photograph,
$74^1/_2$ x $45^3/_4$ in.
(189.2 x 116.2 cm)

Untitled, 1985.
Color photograph,
72¹/₂ x 49¹/₄ in.
(184.2 x 125.1 cm)

face—is it a memory of the victim or a glimpse of the murder? Arguably the most repulsive image in this series presents a field of half-eaten candy covered with sand and a pile of vomit. A pair of sunglasses in the distance reflects back the face of the apparent author of this scene (Untitled, 1987) (p. 180).

These works are the antithesis of Sherman's earlier exploration of cinematic representations of women. While the untitled Film Stills, Centerfolds, and Fashion photos are about surface images and social masks, the Disaster series instead focuses on the body at its most corporeal. Though equally fictional, they suggest the idea of the body as a set of physical processes and discrete parts that, once blasted apart, can never be satisfactorily reassembled.

Over time, as Sherman's work has moved away from standard female types and toward increasingly bizarre and at times repellant personas, a new set of theo-

Untitled, 1985.
Color photograph,
72^1/$_2$ x 49^3/$_8$ in.
(184.2 x 125.4 cm)

retical interpretations has sprung up around her work. These link her focus on dis-
gust with the notion of abjection. As articulated by French feminist Julia Kristeva,
the use by contemporary artists and writers of taboo materials like dirt, hair, excre-
ment, dead animals, menstrual blood, and rotting food, and references to taboo sub-
jects like castration and dismemberment, serve as means of confronting subjects
otherwise unmentionable in polite society. Kristeva describes the abject as "What
disturbs identity, system—order. What does not respect borders, positions and
rules, the in between, the ambiguous, the composite."[12] From this perspective,
Sherman's work undermines an oppressive social order by breaking down conven-
tions about cleanliness, hierarchy, and propriety.

 After all but disappearing physically from her work, Sherman the sitter
returns in the next set of photographs, which present her reinvention of the histori-

Untitled, 1987.
Color photograph,
47½ x 71½ in.
(120.7 x 181.6 cm)

cal portrait. Though these works also use prostheses and bizarre makeup, they are less confrontational than the immediately preceding work. Here Sherman is working with Renaissance, Baroque, and nineteenth-century portraiture. We are made to understand that high art, no less than mass media, traffics in the construction of fantasy. Even the portrait, the painting genre that is supposedly the most realistic, is based on conventions of female beauty rooted in male desire; it reassembles the body to suit the illusion and relies on completely artificial means to create the appearance of naturalism.

A few of the works in this series are based on actual paintings, for instance, a reworking of Caravaggio's *Sick Bacchus* with an almost unrecognizable Sherman clutching a cluster of grapes. Most, however, simply evoke types familiar from art history. These include the Madonna nursing her child with a patently artificial breast (Untitled, 1990) (see p. 169), an absurd satin-swathed matron who seems to have stepped out of a painting by John Singer Sargent, or a Rembrandtesque old Jew poring over scripture.

After the monstrosities of the fairy tales and disasters, many critics felt that Sherman was pulling back into safer territory with the portrait photographs. However, they didn't have long to wait for the darker impulses to return to her work.

Sherman has noted that her 1992 Sex Pictures were a deliberate response to the upsurge in the culture war that pitted religious and political conservatives against artists like Andres Serrano, Robert Mapplethorpe, and Karen Finley. In the early 1990s, artists were in the cross hairs, held up by conservatives as exemplars of the depraved excesses of a liberal, secular humanist culture whose "pornographic" and "sacrilegious" art was presented as justification for eliminating government funding for the arts. Sherman's response was to create a series of photographs that deliberately mined the territory of hard core pornography. Using doll parts, masks and prosthetic genitalia, she conjured up horrific scenarios of degradation, mutilation, and sexual exploitation. Freed, for the most part, from the need to manipulate her own real human body, Sherman created weird amalgams of body parts that centered around body processes and activities rarely seen in respectable art works. She created an odalisque vaguely reminiscent of Manet's *Olympia* that seemed to reduce the female body to the elements most conducive to male fantasy. The face of this figure is obscured with a black mask while her body is made up of pendulous plastic breasts and a gaping plastic vagina propped onto a pair of mannequin legs. Another character assumes the come-hither pose of conventional centerfolds, but this female figure has a hag's head, truncated legs, and a prosthetic vagina exuding a long brown sausage. Other works recall the recombinatory dolls of mid-twentieth-century German photographer Hans Bellmer, in which dolls' legs, arms, and heads are combined in impossible configurations that are at once perversely sexual and repugnant. It is worth noting that Bellmer, working on his photographs from 1934 to 1949, also created his works against a backdrop of censorship and political conservatism.

Echoing Bellmer's use of art as a form of protest, Sherman's Sex Pictures were in part a protest against both the "political correctness" of the left and the censoriousness of the right during the most heated period of the Culture War. But they also were an extension of Sherman's interest in representations of the female body and the images injected into the culture by the mass media. While the Sex Pictures were first and foremost reworkings of the hardcore pornography represented by magazines like *Hustler* (whose cover image in 1978 of a woman being fed into a meat grinder became a cause célèbre among feminists), they also pointed beyond this narrow genre to wider cultural obsession with sex and violence as evidenced in ever more graphic Hollywood movies.

Sherman revisited this theme several years later in her first and, to date, only full-length film. *Office Killer* (1997) (p. 182) is a deliberate pastiche of the franchise of slasher films that include *Freddy*, *Scream*, and *Scary Movie*. The classics of this genre generally revolve around crazed killers unleashed on photogenic but feckless young people who are gleefully dispatched with the maximum of blood and gore. Sherman's version is set in a publishing office. Her killer, played by Carol Kane, is a mousy copy editor who was been downsized to work at home in the wake of an office shakeup. She gets her revenge by murdering her coworkers one by one and installing their decaying corpses in her basement where they become props for her fantasy of the ideal office.

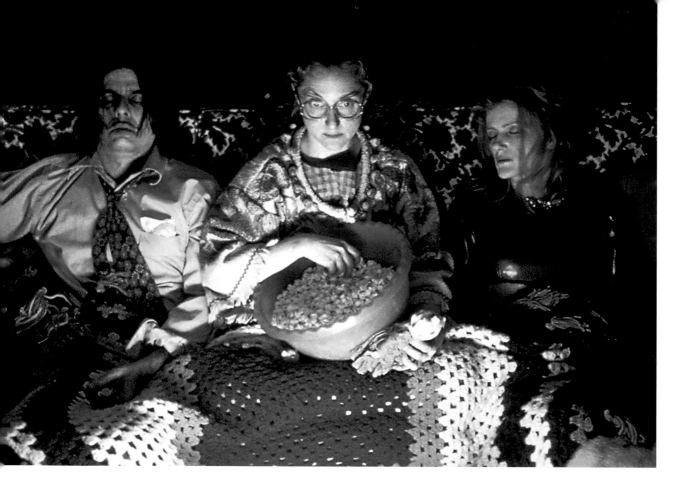

Office Killer, 1997.
Film still.
Courtesy of Miramax Films

Sherman plays this story for laughs, and her film stands out from the standard horror fare in its self-conscious absurdity and tweaking of the genre's clichés, and for the way certain visual vignettes deliberately echo some of Sherman's own still photographs. With *Office Killer*, Sherman comes full circle from the Film Stills, which presented characters in search of a story. Here such characters become the basis for a narrative that is in the end as strangely open ended as the fictive stills.

Following Sherman's directorial debut, she experimented with various ideas for new photography series, but it wasn't until after September 11, 2001, that she settled into a new theme. Her Clown series, which dates from 2004, presents a complex response to the catastrophe and to the way that it changed the political and cultural climate of the United States. The untitled Clowns draw on the ambiguous role played by these figures in the contemporary imagination. From one perspective, clowns suggest the innocence of childhood; from another they represent the exploitation of that innocence by adults (one recalls how convicted serial killer John Wayne Gacy was known for dressing up as a clown for children's parties). There is the cultural myth of the tragic clown, weeping beneath his gleeful makeup; the antic clown, deliberately tweaking authority figures and social order; and the murderous

clown, protagonist of countless horror flicks. There is also the tradition, enshrined in many of the plays of Shakespeare, of the clown as the wise fool, able to say things no one else can (Untitled, 2004) (below).

Sherman's clowns thus serve as icons of the widest range of human feeling and behavior. Beneath their red noses, yarn wigs, broadly painted faces, oversized jackets, and floppy shoes, they are vessels of unfathomable emotion. They suggest both the ultimate inaccessibility of others and the absurdity of our pretensions to reason, seriousness, and high moral virtue.

Any comprehensive survey of Sherman's work underscores the inadequacy of critical models that tie her to particular theoretical positions. Taken together, these critical models add up to a completely contradictory picture of Sherman's work.

On the other hand, her protean approach to art has made her one of the most influential artists in recent history. Her work is central to a raft of current discussions. For instance, the oddly open-ended stories that her photographs tell have everything to do with the ambiguous nature of postmodern narrative. Artists as diverse as Gregory Crewdson, Jeff Wall, Anna Gaskell, and Eleanor Antin also play on the necessary incompleteness of the still image (p. 184). Their photographs tell stories, but do

Untitled, 2004.
Color photograph,
70³/₄ x 89³/₄ in.
(179.7 x 228 cm)

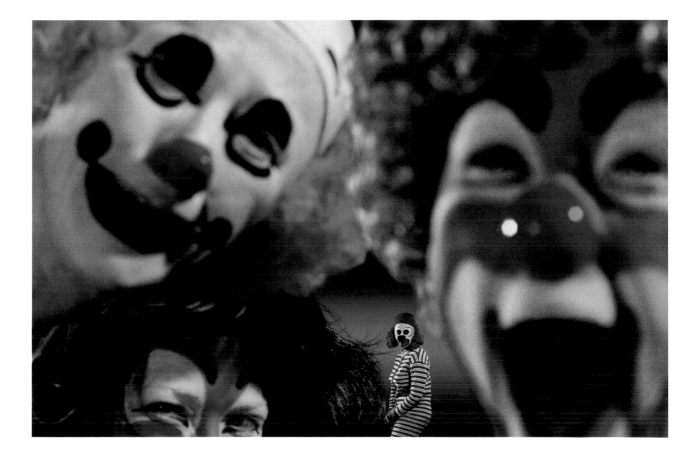

so in stop-action episodes that require the viewer to attempt to fill in the story, to imagine what happened before, what might happen next. By offering either too many or too few clues, these artists create a state of tension that keeps the viewer constantly aware of the fictitious nature of the illusion being created. This in turn, encourages the viewer to complete the story, in effect joining in partnership with the artist in a way that undermines conventional ideas about the artist's absolute authority.

Meanwhile, Sherman's unabashedly female preoccupation with the body links her to other artists like Kiki Smith, Petah Coyne, and Janine Antoni who attempt to get at the experience of physicality from the inside. Like Sherman, these artists traffic in real or represented body fluids, waste and internal viscera. However, unlike the more aggressively offensive work of male artists such as Mike Kelley and Paul McCarthy, they turn to these substances as a means of rethinking Western culture's traditional equation of woman and nature. Smith's work celebrates the body as flesh, employing mediums ranging from glass and paper to wax and bronze to explore the beauty of the purely physical aspects of the human body. Antoni uses lard and chocolate as stand-ins for fat and excrement, and her performance-based works are meditations on the interweavings of the physical and the spiritual. Coyne mixes attraction and repulsion in hanging sculptures of wax, plaster, or tar in which materials that evoke living flesh play off others that suggest cinders and ashes.

In her flirtations with soft- and hardcore pornography, Sherman also appears as a godmother of the more recent "bad girls," a group exemplified by Lisa Yuskavage, Ghada Amer, Cecily Brown, and Kara Walker, whose work also contains imagery that deals explicitly and often disturbingly with female sexuality. Yuskavage borrows from the soft-core pinup to create kitschy, lushly painted representations of doll-like women who seem to embody a mindless sexuality (opposite). Amer and Brown bury pornographic imagery under expressionistic brushstrokes or skeins of embroidery threads. Kara Walker deals with the violent legacy of slavery

with Victorian-style silhouettes that enact some of the most degrading practices of the master/slave relationship.

Like Sherman, they borrow from pornography in the service of larger questions about social values, sexual mores, and the essential nature of desire and pleasure. While acknowledging that pornography may reinforce unsavory and degrading stereotypes, they argue that it also contains the potential to destabilize social conventions that have become rigid and oppressive.

Finally, Sherman's work reaches out to non-Western artists Yasumasa Morimura and Nikki S. Lee, who also assume characters and theatrical personas to examine the cultural and social aspects of identity. Morimura, in particular, works in a mode strikingly similar to Sherman's (p. 186)—Western critics sometimes refer to him as the Japanese Cindy Sherman, a moniker that slights the culturally specific nature of his work. A slender Japanese man with fine features, Morimura poses in photographic recreations of famous iconic Hollywood film stars and the subjects of Western art masterpieces. Despite obvious similarities, his work differs from Sherman's in a number of important ways. He is, first of all, a Japanese man drawing on the Western pop culture image bank, giving his work an extra layer of cultural translation. And second, he mainly portrays female characters, playing on all the complexities that come from crossing gender lines. Lee, meanwhile, shares Sherman's interest in the performance aspect of identity, but takes it a step further by actually infiltrating various subcultures in various disguises. She has impersonated such characters as a southern redneck, a Japanese office lady, a biker chick, and a club denizen, all apparently convincingly enough to fool members of these groups.

So, who is Cindy Sherman? However widely they differ in other aspects, critical interpretations of her work share the notion of Sherman as the standard bearer for a stern polemic, whether it be a statement against patriarchy, consumerism, social order, or the false consciousness of contemporary society. The artist herself has tended to distance herself from such theoretical approaches to her

LISA YUSKAVAGE, *Day*, 1999–2000. Oil on linen, 77 x 62 in. (195.6 x 157.5 cm). Courtesy of David Zwirner, New York

work. In her rare interviews, she confesses that she often doesn't understand the fine points of theoretical exegeses. She also admits that some of the critical polemics have actually influenced her to change the direction of her work, noting, "The only time critical writing really affected my work was when it seemed like someone was trying to second guess where I was going next: I would use that to go somewhere else."[13]

On the other hand, she willingly acknowledges the female basis of her vision. In a 1997 interview, she noted, "Even though I've never actively thought of my work as feminist or as a political statement, certainly everything in it was drawn from my observations as a woman in this culture. And a part of that is a love-hate thing—being infatuated with make-up and glamour and detesting it at the same time. It comes from trying to look like a proper young lady or look as sexy or as beautiful as you can make yourself, and also feeling like a prisoner of that structure. That's certainly something I don't think men would relate to."[14]

While theory-based approaches bring out interesting aspects of Sherman's work, they downplay the element of pleasure that the viewer feels in looking at the work, and that Sherman obviously feels in making it. Sherman notes that the work

grows out of the notion of play. This goes back to her early fascination with dressing up and extends to her profligate mixing and subversion of established genres.

In the end, Sherman's most important legacy may be her reintroduction of the pleasures of fantasy into an art world that often rejects pleasure as politically and ideologically suspect. The playful perversity of her work, ever more visible in recent years, serves as a reminder that the imagination thrives on fantasies that would be unacceptable if transferred to the real world. We are able to enjoy horror films and tales of mass destruction exactly because we know they are not real. And contrary to postmodern declarations that the "real" is simply an illusion, the imagination knows the difference.

Fantasy, at least the variety purveyed by Sherman, is potentially subversive today. She moves us far from the acceptably family-friendly fantasies of Disney or the newly refurbished Times Square. In their place Sherman brings forward fears and desires that we tend to suppress or ignore. She urges us to stop being uncomfortable about guilty pleasures, and to be unafraid to examine the dark side of human nature.

"My biggest fear," she has said, "is a horrible, horrible death, and I think this fascination with the grotesque and with horror is a way to prepare yourself psychically if, God forbid, you have to experience something like that. That's why it's very important for me to show the artificiality of it all, because the real horrors of the world are unwatchable, and they're too profound. It's much easier to absorb—to be entertained by it, but also to let it affect you psychically—if it's done in a fake, humorous, artificial way. It's similar to the way I love being terrified by roller-coaster rides, where you're really scared that you could die, and the adrenaline is rushing, but at the same time you know that you're safe."[15]

1. Douglas Crimp, "Pictures," *October* 8 (Spring 1979), reprinted in Brian Wallis, ed., *Art after Modernism: Rethinking Representation* (New York: New Museum of Contemporary Art in association with David R. Godine, Publisher, Boston, 1984), p.186.
2. Cindy Sherman, "The Making of Untitled," in *Cindy Sherman: The Complete Untitled Film Stills* (New York: Museum of Modern Art, 2003), p. 8.
3. Jean Baudrillard, *Simulations*, trans. Paul Foss and Paul Patton (New York: Semiotext(e), 1983), reprinted in ibid., p. 253.
4. Judith Williamson, "Images of Woman: The Photographs of Cindy Sherman," *Screen* 24, no. 6 (Nov.–Dec. 1983): 102–16.
5. Craig Owens, "The Discourse of Others: Feminists and Postmodernism," in Hal Foster, ed., *The Anti-Aesthetic: Essays on Postmodern Culture* (Seattle: Bay Press, 1983).
6. See for instance, John Berger, *Ways of Seeing* (London: Viking Press, 1972).
7. This is a position articulated by Laura Mulvey, "Visual Pleasure and Narrative Cinema," *Screen* 16 (Autumn 1975), reprinted in Wallis, ed., *Art after Modernism*, pp. 361–73.
8. Owens, "The Discourse of Others."
9. Mira Shor, "From Liberation to Lack," *Heresies* 6, no. 4 (1989): 15–21.
10. Lisa Phillips, "Cindy Sherman's Cindy Shermans" in *Cindy Sherman* (New York: Whitney Museum of Art, 1987).
11. Owens, "The Discourse of Others," p. 75.
12. Julia Kristeva, *Powers of Horror: An Essay on Abjection*, trans. Leon S. Roudiez (New York: Columbia University Press, 1982).
13. "Cindy Sherman Talks to David Frankel," *Artforum* 41, no. 7 (March 2003): 55.
14. Interview with Noriko Fuku, "A Woman of Parts," *Art in America* 85 (June 1997): 80.
15. Ibid.

Kiki Smith:
A View from the Inside Out

ELEANOR HEARTNEY

On June 23, 2003, New York's Museum of Modern Art celebrated its temporary move from Manhattan to the borough of Queens with a procession. A horse, several dogs, and hundreds of celebrants marched across the Queensboro Bridge holding aloft replicas of three modern masterworks from the MoMA collection. Others carried a palanquin bearing the artist Kiki Smith. Dressed in black, with her long salt-and-pepper hair flowing in the wind, Smith presided silently over the proceedings like a medieval queen or pagan deity as uniformed participants spread rose petals in her path.

Why Smith? Organizers noted that she was chosen as "a living icon." Critic John Perreault confirmed this judgment, describing her as "the current patron saint of the art bohemia." [1] Smith's credentials for this honor are many. As the daughter of famed minimalist Tony Smith, she has lived her entire life cheek by jowl with contemporary art. During her childhood, frequent family visitors included Jackson Pollock, Mark Rothko, Barnett Newman, Mark de Suvero, and Richard Tuttle. Today she is one of the most exhibited artists in the world.

But one suspects that the quality that earned Smith a place in the procession, along with reproductions of Picasso's *Les Demoiselles d'Avignon*, Duchamp's readymade *Bicycle Wheel*, and Giacometti's *Standing Woman*, is her status as the art world's embodiment of the nature principle. MoMA's celebration demanded something more earthy than the usual postmodern anxieties over the inauthenticity

Opposite:
Rapture, 2001. Bronze, 67¼ x 62 x 26¼ in. (170.8 x 157.5 x 66.7 cm). Collection of the artist. All reproductions of art by Kiki Smith © Kiki Smith, courtesy PaceWildenstein, New York

FRANCIS ALŸS, *The Modern Procession*. Performance, New York City, 2002.

of experience and the hegemony of authoritarian institutions. Instead, one might read Smith's elevation as a vote for the primacy of the senses and an acknowledgment of the power of physical reality. In the midst of an art scene rife with hype, irony, and cynicism, she provided a reminder of art's historical capacity to move and pleasure us.

Commentators frequently remark on the contrast between the work of Smith and her father. Tony Smith was known for monumental polished steel arrangements of rectangular forms whose modular configurations suggest architectural structures like doors, arches, and windows. Kiki Smith's work is as maximalist as her father's is minimal; it makes constant reference to the human body and to a natural world and supernatural world inhabited by birds, fairies and fantastical creatures. While her father worked primarily with bronze, steel, and aluminum, her own sculptural materials tend toward the fragile and ephemeral—paper, plaster, beeswax, beads, glass, and ceramics, though she has made forays into more durable materials such as bronze and lead. She has been omnivorous in her choice of media, working as well in photography, printmaking, installation, drawing, and video.

Nevertheless, there are subtle connections between the two artists. Despite their grand size, Tony Smith's works were scaled to respond to the human body, and their forms were based on modular arrangements that often evoked crystalline growth patterns. Of all the works of artists who are now deemed "minimalists," Tony Smith's are the most organic and animated.[2]

Musing on her artistic debt to her father, Smith remarks, "In my work I have used images of small structures like cells or crystals to build a large whole ...Using individual parts to make a whole probably comes from my father's work, and also using paper as a sculptural medium."[3] A prophetic family snapshot shows Kiki and her sisters Seton and Beatrice sitting at the kitchen table, assisting their father by assembling models of his tetrahedrons in paper.

Kiki Smith was born in 1954 in Nuremburg, the first of three girls. The next year her family moved to South Orange, New Jersey, to live in the house where her father had been born. It was an artistic household: her mother, Jane, was an opera singer and actress and a close friend of Tennessee Williams. The family home served as a studio for Tony and a rehearsal space for Jane.

Surrounded by art and artists, it is not surprising that the next generation of Smiths should also exhibit an artistic bent. However, while her sister Seton knew from a young age that she would be an artist, Kiki followed a more desultory path. She experimented with crafts, made puppets and dolls, studied pottery, considered becoming a fashion designer. Following stints at various colleges, she also worked as a cook, an electrician's assistant, and a surveyor. Then, in the late 1970s she joined a loosely organized collective of artists who had come together under the name Collaborative Projects (Colab) to organize underground exhibitions, film screenings, performances, and concerts. Colab members were united by a sense of marginality and a preoccupation with the poetry of the urban streets and back alleys of the East

Hand in Jar, 1983.
Algae, latex, glass, and water,
12 x 6 in. (30.5 x 15.2 cm).
Collection of the artist

Village, where many of them lived, and they shared a resistance to the commercialism of the mainstream art world.

Smith created her first strictly "art" works in 1979 when she acquired a copy of *Gray's Anatomy* and used it as the basis for paintings of organs and body parts. She contributed work from this series to Colab's legendary Times Square Show in 1980. This sprawling exhibition in a decrepit former bus depot and massage parlor off Times Square, which featured the work of more than a hundred artists and performers, came to be seen as the clarion call of a new generation. Other participants included Jenny Holzer, David Hammons, Tom Otterness, Charlie and John Ahearn, Judy Rifka, Jean-Michel Basquiat, and Keith Haring, all of whom went on to shape the art discourse of the next decade.

Smith's contribution to the Times Square Show was a banner of chopped-up arms and legs. The morbidity of this work, with its intimations of death, violence, and mortality, became a leitmotif of her subsequent production, a tendency heightened by her father's sudden death from a heart attack later that year. Early works included her 1983 sculpture *Hand in Jar* (above), which consisted of a latex hand floating in a mason jar and sprouting live algae; scarves and fabrics silk-screened with microscopic images of the body and diseases (evidence of Smith's early interest in multiples); and a 1983 multimedia installation, *Life*

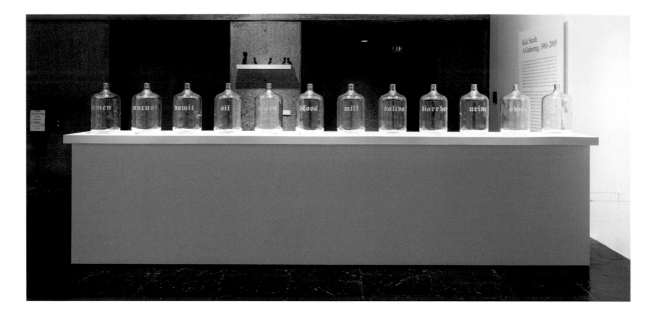

Untitled, 1986. Twelve clear glass bottles, dimensions variable, overall shelf: $^3/_4$ x 145 x 11$^1/_4$ in. (1.9 x 368.3 x 28.6 cm), each bottle: 20 x 10$^1/_2$ x 10$^1/_2$ in. (50.8 x 26.7 x 26.7 cm). Whitney Museum of American Art, New York; gift of The American Contemporary Art Foundation, Leonard A. Lauder, President, in honor of David W. Kiehl.
Photo: Sheldan C. Collins

Wants to Live, which included CAT scans, x-rays, reinscriptions of news reports on murders inspired by domestic violence, and projected images of a glowing skeleton.

Throughout the eighties, as she began to gain critical recognition for shows in alternative venues like Fashion Moda, ABC No Rio, and the Kitchen, Smith's work continued to revolve around the human body. She mingled clinically based replicas of human organs with more conceptual works that deal with body processes and substances. *Ribs* (1987) consists of a set of terracotta ribs loosely sewn together with thread. *Womb* (1986) is a hollow bronze replica of a womb hinged so that it lies open like a waiting vessel. An untitled work of 1987–90 (above) consists of twelve water-cooler bottles, silvered to present a mirror surface, and engraved in gothic letters with the name of a different bodily fluid—urine, sweat, tears, mucus, vomit, and so on. With such works, Smith revealed her interest in exposing aspects of our corporal existence normally hidden from view.

Smith's recreations of human organs, limbs, and fluids dovetailed with the renewed interest in the body among artists during the eighties. The body had been contested territory during the preceding decades; avant-garde artists of Tony Smith's generation had dismissed the representation of the body as a regression to the discredited practice of academic realism. In reaction to this marginalization by mainstream artists, the body reappeared as a central focus of feminist artists in the seventies. By the eighties, the body was a carrier for all manner of political and social content. Some feminists, drawing on poststructuralist theory, condemned any representation of the female body as implicated in the coercive conventions of a patriarchal society. Others argued that one could escape from these conventions by

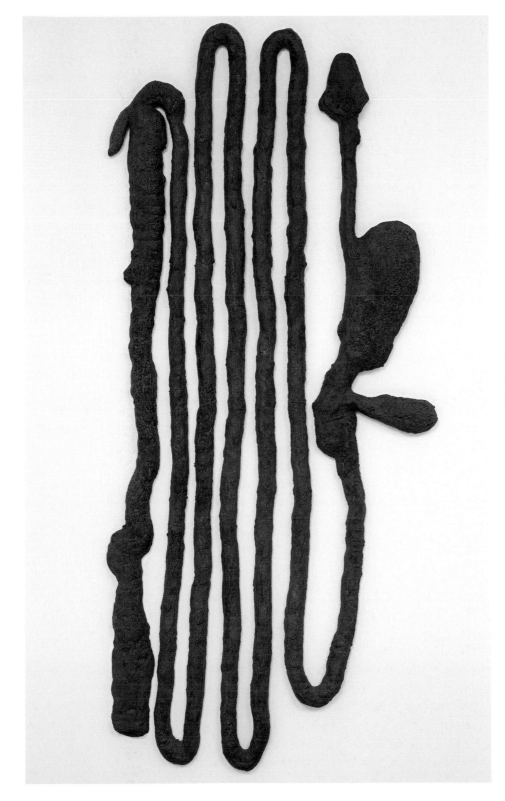

Digestive System,
1998–2004. Ductile iron,
62 x 27 x 1$^{1}/_{2}$ in.
(157.5 x 68.6 x 3.8 cm).
Collection of Tom
Otterness, New York

assuming control of them. Meanwhile, the increasingly devastating AIDS epidemic drew attention to issues of mortality and galvanized artists to consider the body in relation to social control, coercive ideologies, and homophobia.

In this context, Smith's focus on the body and her decision to work with materials more commonly associated with the "feminine" realm of craft and domesticity took on political implications. In particular, it intersected with debates over the notion of a woman's knowledge as arising through the body, a concept that found a middle way between the ancient identification of man with mind and woman with body. Smith took a more sympathetic approach to this dichotomy, which also split many feminists as they denied or redefined it. As she told Lynne Tillman, "When I was younger, my work was very much about trying to dismantle European hierarchical dualism, that women and nature were synonymous but inferior. But then people also tried to disassociate themselves from the belief that Woman is Nature, seeing that as too restrictive. But I decided I prefer to be identified with nature, with animals. Not to be separate from the universe. I prefer to have the universe at stake."[4]

In taking this approach, Smith aligns herself with women artists whose work is based on the premise that knowledge is not solely a matter of mind. There is also, they argue, a form of knowledge that is grounded in nature and comes through bodily experience. This idea lies behind Marina Abramović's endurance-oriented performances, Janine Antoni's use of lard and chocolate as surrogates for flesh and its excretions, or her employment of tanned cowhide as a second skin (below), and Helen Chadwick's celebrations of body processes normally shielded from public view.

In Smith's work this idea manifests itself through a focus on the body that travels from the inside out. She rejects the Western world's long-standing tendency to privilege vision over the other senses and to charge artists with the task of creating an objective representation of the visible realm. Instead, she expresses a corporeal sense of reality in which taste, touch, and smell are as important as sight. For

JANINE ANTONI,
Saddle, 2000.
Raw cowhide,
25.8 x 32.5 x 78.7 in.
(65.5 x 82.6 x 199.9 cm).
The Rachofsky Collection.
Courtesy of the artist and
Luhring Augustine.
Photo: Anders Norrsell

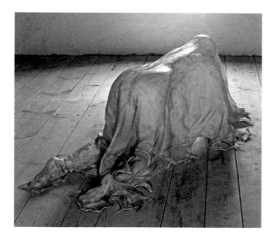

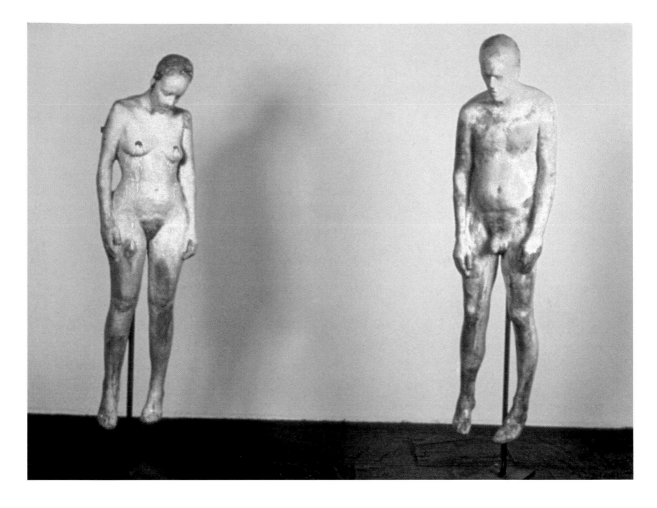

Smith, knowledge is subjective and cannot be separated from our sensate experience of the world.

 In keeping with this idea, Smith began her career deep inside the human body, creating representations of organs and the internal systems that make life possible. An untitled work from 1988 presents two hundred and thirty cut glass sperm that entwine on a black rubber sheet like living organisms caught in a microscope. *Digestive System* (1998) (p. 193), which offers a looping iron replica of the intestines and colon, came out of her desire to understand the scale of the system. *Nervous Giants* (1986–87) is a set of nine fabric panels embroidered with clinical diagrams of anatomical systems. *Mammary* (1988), composed of pink tinted plaster and string, is a starburst arrangement of the mammary glands and ducts.

 If Smith was challenging society's discomfort with body processes, she was also taking on the art world's discomfort with what has sometimes disparagingly been called "girlie art." She was blithely indifferent to issues of permanence and solidity that preoccupied more "serious" male artists, and moved easily between tra-

Untitled, 1990. Beeswax and microcrystalline wax, figures on metal stands; female figure: 64^1/$_2$ x 17^3/$_8$ x 15^1/$_4$ in; male figure: 69^7/$_{16}$ x 20^1/$_2$ x 17 in. Whitney Museum of American Art, New York

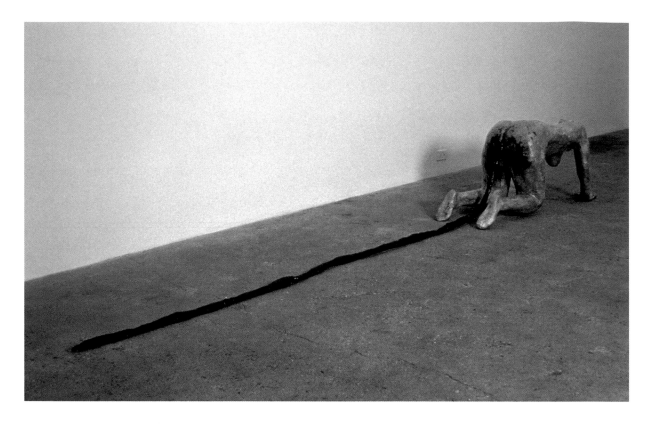

Tale, 1992. Wax, pigment, and papier-mâché, 160 x 23 x 23 in. (406.4 x 58.4 x 58.4 cm). Collection of Jeffrey Deitch

ditional sculptural approaches and techniques and materials more commonly deemed to be in the feminine realm. She employed embroidery and textiles, she shaped forms out of papier-mâché and plaster, and she sculpted crushed paper, rolling tendrils to create veins or hair. These ephemeral materials, in particular, imparted fragile and vulnerable qualities to her organs and biological systems.

By the end of the decade Smith had begun to move to the surface of the body, though in a way very different from the conventional approach to the figure, in which skin encases a mysterious and unknowable interior. Instead, in works like her 1988 paper sculpture of red-soaked body fragments that simulated human skin, Smith focused on skin itself, a membrane that allows access between inside and outside. As she remarked to Carlo McCormick, "You're really very penetrable on the surface, you just have the illusion of a wall between your insides and the outside."[5]

Smith related the pathos in her limp and empty husks to the death in 1988 of her sister Beatrice from AIDS. In an installation at Tyler School of Art in 1990 she presented a company of white paper effigies suspended from the ceiling like flayed skins. Describing the genesis of this work, she noted, "I hung one of them up in the corner of my studio, just to get it out of the way, but it was shortly after my sister Bebe died, when I saw it suspended there and thought that it is like a spirit. With all these people we know dying from AIDS, you have this hovering of people's pres-

ence who you don't have physical access to anymore but are still quite vital to your life. Having this body hanging in the corner reminded me of that, so I made a whole installation of them about that."[6]

From there it was a short step to the representation of complete human bodies. Smith's first full figural work comprises a pair of sagging wax male and female figures hung on metal stands like discarded coats, slumping downward as fluids ooze from their orifices. The woman's breasts leak milk, the man's penis leaks semen (p. 195). But there is no potency to these representations. Instead, as Smith notes, "[H]er milk nurtures nothing, his seed seeds nothing. So it was about being thwarted—having life inside you, but the life isn't going anywhere, it's just falling down."[7]

At this point, commentators began to link Smith's work to the notion of abjection then gaining ascendancy in the art world. As defined by French theorist Julia Kristeva, abjection is about crossing borders and mingling supposedly distinct orders of nature. The term covers a wide swath of contemporary art, encompassing contemporary artists' fascination with impurity, border states, mutations, hybridity, and the irrational. In practice it ranges from Cindy Sherman's wart-covered hags to Joel Peter Witkin's still-life arrangements of rotting corpses and body parts to Paul McCarthy's embrace of chocolate syrup and mayonnaise as substitutes for scatological processes.

In Smith's hands, abjection is a way to deal with socially suppressed attitudes toward sexuality, death, and vulnerability. Because her works in this vein often dealt with female figures placed in compromised positions, they were sometimes linked to the then-current preoccupation with woman as victim. But in fact, Smith had much more existential concerns in mind. For her, these images of abjection revealed human frailty and fragility. She has remarked, "But the things I'm deeply attracted to always have a cut in them, they're always somewhat scarred and mangled, and the damage or the scarring is evident. You can see the vulnerability."[8]

One work that gained particular notoriety was *Tale* (1994) (opposite). At the height of a controversy over the inclusion of a work involving elephant dung in a show at the Brooklyn Museum, Philippe de Montebello, director of the Metropolitan Museum of Art, widened the attack on "offensive" art to include Smith's work, pronouncing it "simply disgusting and devoid of any craft or aesthetic merit."[9]

Tale consists of a wax sculpture of a naked woman crawling on the floor. Her buttocks are smeared with a brown substance and trailing behind her is a long brown coil of what appears to be feces. Smith describes this sculpture as a representation of the feeling of being burdened with one's own inescapable history. As she notes, it is as if "the figure trailing shit were carrying around a physical manifestation of the past, a story she can't let go of, or suffering the humiliation of having her insides, her past, out in public."

Related works include *Pee Body* (1992), which presents a flesh-colored female figure crouching on the floor and surrounded by loops of yellow glass beads that suggest a trail of urine (see p. 75). *Train*, from the following year, presents a

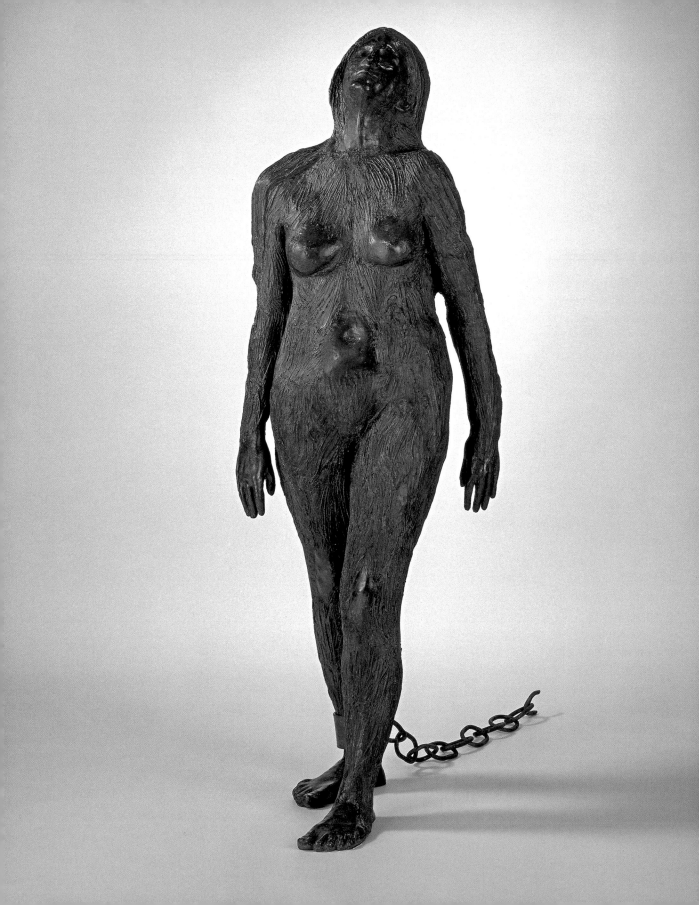

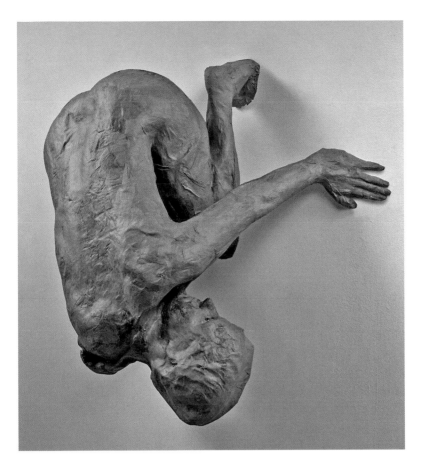

Lilith, 1994.
Papier-mâché and glass,
17 x 31¹/₂ x 32 in.
(43.2 x 80 x 81.3 cm).
The Israel Museum,
Jerusalem.
Photo: Ellen Page Wilson

white female nude looking over her shoulder at a stream of red beads emerging like menstrual blood from her vagina.

During this period Smith also began to create figures inspired by biblical and mythological characters. However, as with her other representations of the body, they veered far from conventional approaches. She was particularly interested in figures who represent the ambiguous and contradictory condition of women throughout history. In her depictions of biblical heroines, Smith's manner of presentation reflects her own religious training. Raised as a Catholic (her father was trained by Jesuits and her mother was a convert), she was instilled with the mixed messages embodied by the Virgin Mary and the female saints that could both celebrate Mary's submission to God's will as she abandoned her own life and desires to become the mother of Jesus and, with the saints, be a mediator in the grand narrative of redemption. Encouraged to model themselves on such characters, Catholic girls were urged to be pure and maternal, acquiescent and empowered.

Smith suggested these contradictions in a number of powerful works. Her Virgin Mary, created both in bronze and wax, presents this icon as a flayed figure

Opposite: *Mary Magdalene*,
1994. Cast silicon bronze
and forged steel,
60 x 20¹/₂ x 21¹/₂ in.
(152.4 x 52.1 x 54.6 cm).
Collection of the artist.
Photo: Herbert Lotz

with exposed viscera. In this way, Smith expresses Mary's loss of autonomy in the face of God's command. A related idea is explored in an untitled work, also in wax and bronze, that presents a female figure crouching on the ground with her unnaturally long arms extended before her. Ruminating on the sense of defenselessness suggested here, Smith has noted, "The Virgin Mary always extends her arms, making the body vulnerable. Vulnerable and compassionate, but to be vulnerable is to lose insight. It makes you exposed. For me, to be that vulnerable, I think you could lose all your insides, losing your self. ... I am angry that the Virgin Mary pays for her compassion by being neutered. ... The position of the Virgin robs you of your femininity and sex."[10] In other works, Smith turned to the hidden power embedded in these figures. Her *Mary Magdalene* of 1994 (p. 198) is neither the early Renaissance emaciated repentant hermit of Donatello's 1453 statue nor the voluptuous harlot

200

favored by later painters. Instead, though Smith pays homage to this earlier work, she refuses to depict the saint as a sexless wraith. Her Magdalene is full-bodied and confident. Having divested herself of the ragged animal skins clothing Donatello's version, she reveals a body covered with fine hair. In this she looks ahead to the blending of animal and human natures that would reappear in Smith's later fairy tale–based works.

Smith similarly reworked *Lilith* (1994) (p. 199), named, according to Talmudic legends, for the first wife of Adam. Traditionally she is a demonic creature, accused of being a vampire, child stealer, and paramour of Satan. Smith incorporates these intimations of supernatural power, but suggests that Lilith might also be seen as a feminist icon. Her Lilith clings to the wall, turning her head to survey the world out of startlingly realistic glass eyes. Lilith's expression is less depraved than wary, as she joins the mythical and historical lineage of forceful females who have been punished for their assertiveness by being accused of sorcery.

At this time, Smith also explored various non-western goddess figures, again presenting them as generative and empowered creatures. These included the Egyptian sky goddess Nuit, whom Smith presented in 1993 as as a set of disembodied limbs entangled in a skein of stars, and *Shela na Gig*, a Celtic fertility goddess who bends over provocatively to expose her vagina.

By the mid-1990s Smith's work shifted again. Reviewing her career, she remarked to an interviewer in 1994, "For three years my work was about birth. Then for four years it was about fluids and the body and the nervous system. My work has evolved from minute particles within the body, up through the body, and landed outside the body. In the last few years it's been inside and outside. Now I want to roam around the landscape."[11] Smith found herself moving away from the overtly visceral and disturbing images of the early 1990s toward a more delicate and poetic approach. Figures now were entwined with chains sprouting birds and butterflies, or surrounded by bronze stars and miniaturized, or outfitted with fairy wings to hang in clusters on the wall. The darker aspects of Smith's work remained present but were transformed. A news report of the pesticide poisoning of birds inspired Smith to create a scattering of bronze crow carcasses, transforming traditional symbols of warning and threat into emblems of pathos in *Jersey Crows* (1995) (opposite). Her 1996 installation *Stars and Scat* mingles glass stars and tiny sculpted animal scat across a field of brilliant blue paper whose beauty overwhelmed any negative connotations.

During this period Smith increasingly turned to traditionally feminine motifs and materials, most notably in a series of works that were based on lace doilies. These appeared in multiple guises—as etchings that highlight their weblike character, as lacey bronze sculptures, or as cut paper. She describes these doilies as "cosmic mandalas sort of trickling down onto the coffee table, into daily life. ... I cast some in bronze, and they become orifices. ... In another one, they turn into eyes, and in others they become moons or cells or snowflakes."[12]

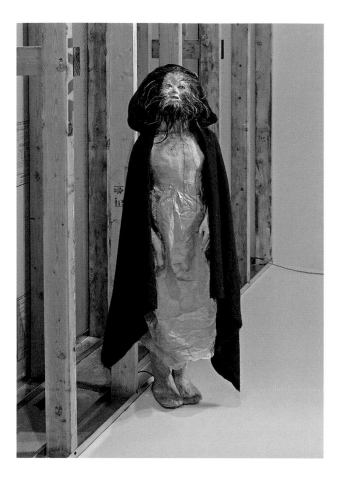

Daughter, 1999, in collaboration with Margaret Dewys. Nepal paper, bubble wrap, methyl cellulose, and hair, 48 x 15 x 10 in. (121.9 x 38.1 x 25.4 cm). The Ann and Mel Schaffer Family Collection

It became clear that the issue of beauty, always latent in discussions of her work, was coming to the fore in a much more persistent way. Earlier works often deliberately flouted conventional standards of beauty, eschewing classical perfection and presenting the body as a flawed and fragmented container for life and soul. As Smith became increasingly experimental in her media, her works began to be explicitly decorative. She found herself drawing on elements often associated with Victorian ornament and popular sentiment; stars, butterflies, beads, lace, feathers, and teardrops began to make frequent appearances in her installations, sculptures, and paper works. Smith relates this tendency as part of her interest in rehabilitating discredited aesthetics and subject matters. Just as the body and its processes were once forbidden themes for art, she argues that there remained something transgressive about an appeal to sentimentality and kitsch.

In recent years Smith's outward drift has led her to an exploration of the meanings hidden in children's stories and fairy tales. The unsanitized versions of traditional tales are full of violence, mayhem, and black magic, reflecting the underside of the orderly world promoted by religious and political authorities. Smith was

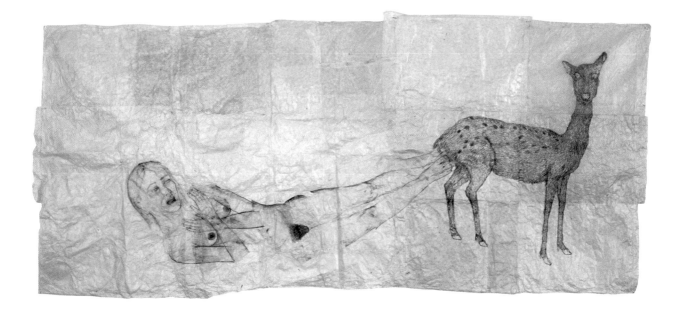

Born, 2001. Ink on Nepal paper. 56 x 123 in. (142 x 312 cm).
Photo: Frank Kleinbach

especially taken with the relationships between humans and animals in the tales of Little Red Riding Hood, Alice in Wonderland, or the legend of Geneviève, the patron Saint of Paris, envisioned as a female version of Francis of Assisi, communicating with animals and pacifying savage beasts.

Smith's take on these tales recalls the theories of psychologist Bruno Bettelheim, who maintained that violent fairy tales provide children and adults with a cathartic release of primitive fears and psychological traumas. Her Red Riding Hood for instance, is at once a vulnerable little girl and the embodiment of primitive impulses. *Born*, a lithograph, depicts *Riding Hood* and her grandmother apparently being reborn out of the belly of a wolf. One of the most provocative considerations of this theme is *Daughter* (1999) (opposite), in which a paper figure outfitted with Red Riding Hood's signature cloak is given a half-human, half-wolf face. When Smith first exhibited this work she placed it behind a wall where this hybrid creature seems less fearsome than fearful of her reception by the world.

Alice, meanwhile, appears in the lithograph *Pool of Tears 2 (After Lewis Carroll)* of 2001 as one of a company of unlikely creatures swept away by a river of her

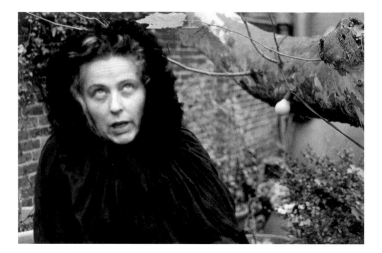

Sleeping Witch, 2000.
Ektacolor print

own tears. Geneviève appears in the sculpture *Rapture* (2001) (see p. 188), in which a woman steps from a wolf carcass, as if shedding her previous skin, and in *Born* (2002) (p. 203), where she emerges from the birth canal of a deer. As Marina Warner has noted, such works reference the idea posed by many traditional fairy tales that passage through animal states bestows wisdom and strength.[13]

In yet other works, animals appear alone, as stand-ins for human consciousness and subliminal desires. In the installation *Night*, done at Washington's Hirshhorn Museum in 1998, she combined a mural-size etching of a deer, peacock, and wolf against plinths containing small black sculptures of all manner of creatures and entities, ranging from rabbits and mice to bats, owls, stars, snowflakes, and eggs (opposite). The whole was an almost ghostly homage to the mysterious spirit of the natural world.

Smith's work has always had a strongly personal aspect. Even when they are clearly not autobiographical, one senses her strong identification with her fragmented and freestanding bodies. Over the last decade and a half she has increasingly incorporated her own features into her works. The photo series *Sleeping Witch* (2000) (above) shows the artist as a crone, dressed in a black Victorian cloak and walking in the woods, lying in autumn leaves, or carrying a basket of apples in a deliberate reference to Sleeping Beauty's evil stepmother. A photogravure from 1995, *My Blue Lake*, offers a panoramic mapping of her face stretched out so it begins to resemble a lake or expanse of sky. *Pieta* (1999) is a large lithograph in which Smith depicts herself as a series of seated figures tenderly nestling her dead cat in her arms. Such works suggest Smith's identification with the forces of nature, either literally or via witches, crones, and other representatives of the realm of instinct and the irrational.

One also senses that many of the animals and hybrid creatures in her recent works serve as alter egos. Along with the persistent motif of the wolf, she has cre-

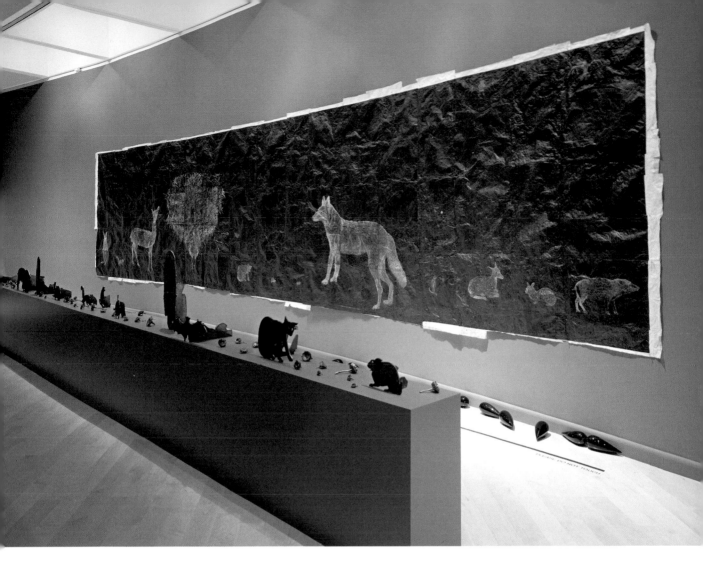

ated series of Sirens, composed of women's heads on pigeons' bodies, and of Harpies, whose female heads are attached to chicken feet. Such mythological creatures are personifications of evil in conventional narratives, but in Smith's hands they also seem to represent our untamed emotions.

Accompanying the outward drift of Smith's recent subject matter has been a growing willingness to turn to art historical and folkloric models for her work. Echoes of the stylized figures of Eli Nadelman and Paul Manship appear in small figure sculptures like *Alice*, 2005, which presents the Lewis Carroll's heroine in an unusually subdued and introspective mode (p. 207). Other works draw on American folk art or eighteenth-century porcelain figurines. While earlier works often tended to exhibit rough surfaces and raw edges, Smith now seems drawn to finer finishes as she translates her long-term interests in the language of art history. The focus on finish extends to her two-dimensional media as well. *Six Girls*, 2004, is a delicate

Directions: Kiki Smith, 1998. Installation view with *Black Animal Drawing* (1996–1998; etching on Nepal Paper). Hirshhorn Museum and Sculpture Garden, Washington, D.C. Courtesy Hirshhorn Museum and Sculpture Garden

collage and ink drawing which presents a sextet of nearly identical young women, two of whom are surrounded by rose bushes. The mood is serene and has something of the quality of a Victorian valentine.

Smith has reflected, with some truth, that with her recent turn to landscape and fable, her trajectory as an artist has become less linear and coherent: her earlier focus on the body moved from an almost clinical interest in hidden processes to a consideration of the body as a carrier of psychic meaning, while her more recent work pulls almost promiscuously from art history, legend, anthropology, and literature. It presents landscape in its the broadest definition—as the whole complex of forces outside the self that make us what we are.

Nevertheless, this work remains consistent with Smith's life-long interest in the view of reality from the inside out. In her work, nature, no less than the body, is experienced subjectively. When Smith depicts animals, be they deer, birds, wolves, or butterflies, or when she envisions hybrid half-human monsters, it is clear that they are expressions of internal conflicts and emotions. They reflect a world in which there is no comfortable division between mind and body or between the human and natural worlds. Smith's animals are avatars of primitive forces that occupy both realms, as she acknowledges that we are all hybrids of a sort—like Little Red Riding Hood, the Harpies, or Sirens—a mix of primitive and civilized impulses. In Smith's universe even stars, trees, and stones are anthropomorphized, exuding a mysterious life spirit; as she recently explained: "I want my work to represent the conflicted complexity of an inner existence, which is holistic and ... problematic. I don't want to be a shining star. I want to be a big black mass flying through space filled with stars."[14]

1. *Artopia: John Perreault's Art Diary*, January 25, 2004.
 http://www.artsjournal.com/artopia/archives20040101.shtml .
2. The term was never embraced by the artists most closely associated with this tendency.
3. Gilbert Brownstone, "There Was a Family Named Smith" in *The Smiths*, exh. cat. 2006 (Palm Beach: Palm Beach Institute of Contemporary Art, 2006), p. 48.
4. "Lynne Tillman in Conversation with Kiki Smith," interview in Siri Engberg, *Kiki Smith: A Gathering*, 1980–2005 (Minneapolis: Walker Art Center, 2005), p. 39.
5. Carlo McCormick, "Kiki Smith," *Journal of Contemporary Art*, Summer 1991, p. 84.
6. Ibid.
7. David Frankel, "In Her Own Words," interview in Helaine Posner, *Kiki Smith* (Boston: Bulfinch Press, 1998), pp. 38–39.
8. "Lynne Tillman in Conversation with Kiki Smith," p. 40.
9. Philippe de Montebello, "Making a Cause Out of Bad Art," *New York Times*, October 5, 1999, Section A.
10. Claudia Gould, interview with Kiki Smith in Kiki Smith, exh. cat. (Williamstown, Mass.: Williams College Museum of Art, 1992), p. 3.
11. Michael Boodro, "Blood Spit and Beauty," *Artnews* 93, no. 3 (March 1994): p. 129.
12. Frankel, "In Her Own Words," p. 41.
13. Marina Warner "Wolf-girl, Soul-bird: The Mortal Art of Kiki Smith," in Engberg, *Kiki Smith*, p. 51.
14. "Lynne Tillman in Conversation with Kiki Smith," p. 41.

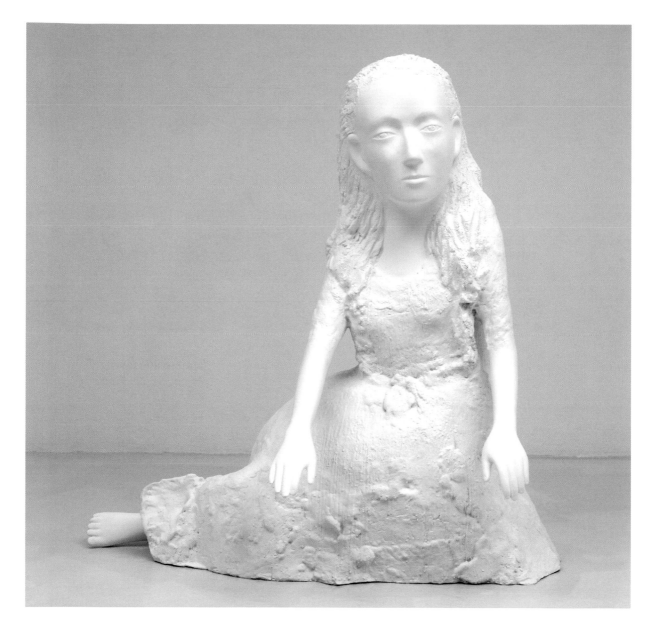

Seer (Alice II), 2005.
White auto body paint on
bronze, 63¹/₂ x 72 x 41 in.
(161.3 x 182.9 x 104.1 cm).
Galerie Lelong, Paris
Courtesy PaceWildenstein

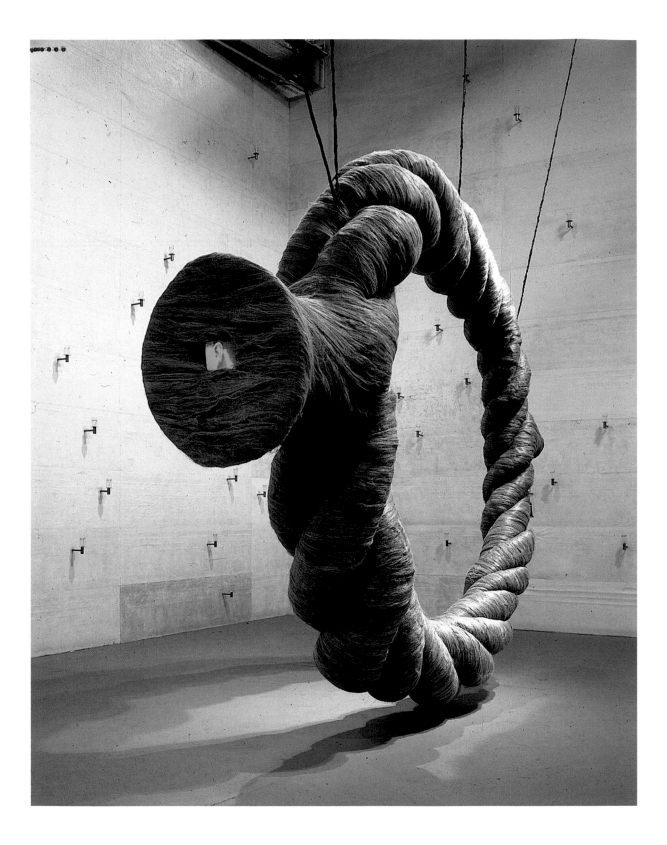

Ann Hamilton:
The Poetics of Place

Helaine Posner

In a body of work that includes objects, photographs, video, performance, and complex, materially rich, enveloping environments, Ann Hamilton engages our senses of sight, sound, smell, and touch, and invites us to trust unmediated somatic experience as a vital source of knowledge. Hamilton's intuitive and intellectual responses to the installation spaces trigger streams of ideas that take tangible form in her large-scale, site-specific installations. Her creative process often begins with an exploration of the history, economy, and culture of the locale through repeated site visits; extended conversations; and readings on subjects as varied as sociology, anthropology, cultural theory, literature, and poetry. The viewer, however, needs no such specialized information. Upon crossing the threshold to a Hamilton installation we discover an immersive environment of great material abundance evidencing the touch of innumerable handmade marks and acts. The artist's typically wide array of non-art materials includes organic substances such as beeswax, honey, and horsehair; man-made objects like pennies, clothing, and books; and animal and human presences; these trigger personal associations and visceral responses. She simultaneously activates multiple means of perception, encouraging us to experience ways of knowing through the body as well as the mind, potentially gaining access to a deeper sense of our humanity. In recent years her approach has evolved into one with more subtle and spare gestures and increasingly archetypal and spiritual imagery.

A native of Columbus, Ohio, Hamilton received a BFA in textile design from the University of Kansas in 1979 and went on to earn an MFA in sculpture from the Yale School of Art and Architecture six years later. She originated a series of innovative studio tableaux while in graduate school, followed by several sensory, conceptually based installation/performance works created mainly for alternative spaces in New York and California. In 1988, just three years after graduating from Yale, the Museum of Contemporary Art in Los Angeles asked Hamilton to make a new work for her first solo exhibition at a major museum. Although she had already produced a number of critically acclaimed installations, the breadth of vision, imaginative scope, and tremendous scale of her project for MOCA was unprecedented. In *the capacity of absorption* (1988–89) (opposite and pp. 210 and 211), the visitor became immersed in a spectacular accumulation of diverse substances and materials arranged in a sequence of three distinct yet related spaces. Passage through these galleries was an encounter with the unexpected, the organic, the sensual, the mechanical, and the linguistic—a journey that induced an initial sense of awe leading

Opposite: *the capacity of absorption*, 1988. Installation, Temporary Contemporary, Museum of Contemporary Art, Los Angeles.
All reproductions of art by Ann Hamilton courtesy of the artist. Photo: Wayne McCall

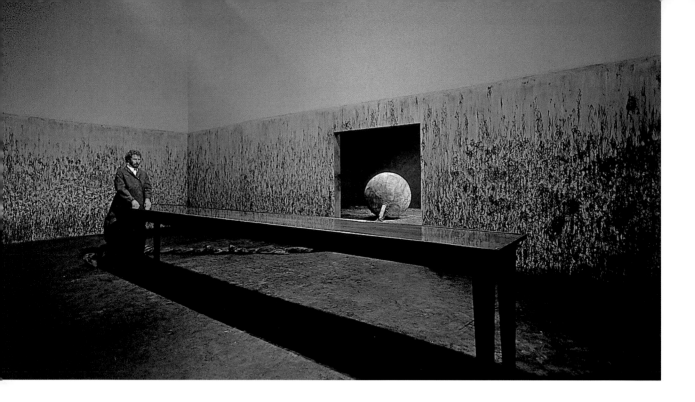

to "a state of suspended reverie, in which a multitude of possibilities and realities can exist."[1]

A golden glow pervaded the first room, whose walls and floor were surfaced with sheets of beeswax and paraffin-covered paper, emitting a sweet smell. The walls were punctuated by a hundred and fifty glasses set on copper shelves, each containing a whirling vortex of water (achieved through the use of spinning magnets) that produced a soothing sound. At the center of this large, high-ceilinged room the artist suspended a fifteen-foot-high circular form covered with thick, twisted flax fibers, that functioned as a megaphone. A small mouthpiece was attached to one end of this object, however it did not amplify the sound. Instead, the louder one spoke, the quieter the room became, as the voice had the surprising effect of slowing the whirling vortexes until the room became silent. A tiny video monitor embedded in the opposite end of this form displayed the image of an ear perpetually overflowing with water, filled perhaps to *the capacity of absorption*.

The warm, bright atmosphere of the first room gave way to darkness and damp in the second. The walls of this space, up to a height of almost eight feet, as well as the floor, were hand-coated with deep green algae, suggesting a site that recently had been inundated by flood waters. This impression was underscored by the smell of the algae, the chirping of live crickets, and the sound of water gently flowing along the top of a long, narrow wooden table. At this "water-table" stood a silent, self-contained attendant in a heavy canvas coat with fingers placed in a set of

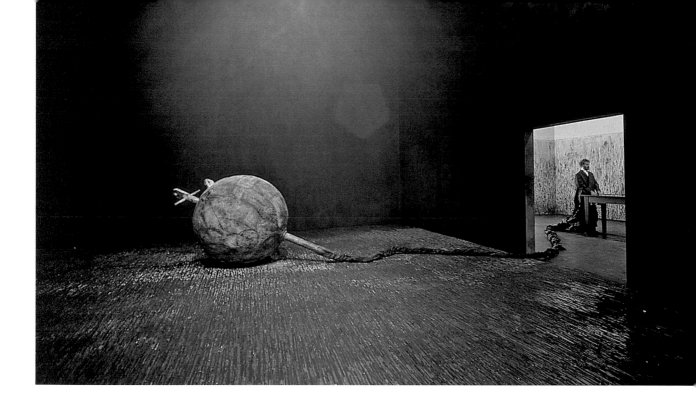

holes cut into its surface. Across its length, a similar set of holes awaited the visitor who could choose to share this sensation. Together with the sensory stimulus of the organic substances, the unexpected presence of the attendant heightened an awareness of one's physical self, and offered the pleasure of sharing the quiet company of a fellow human being.

The long, twisted end of the attendant's coat trailed into the third gallery, where it was tied to a massive metal buoy covered in wax and etched with phrenology diagrams, a pseudo-scientific system based on the nineteenth-century notion that different areas of cognition in the brain could be charted to reveal mental capacity. The buoy, metaphorically transformed into a brain, rested on a floor loosely laid with ten tons of lead linotype, used in typesetting. In navigating the space, viewers could feel the weight of the metal type subtly shift beneath their feet. To complete the room, the artist rubbed a layer of nearly black powdered graphite into the gallery walls, setting a somber tone. The graphite, customarily used in lead pencils, and linotype, once employed to print books, referred to the constructions of language (as the buoy alluded to the mind), however each did so through essentially outmoded means that suggest the inadequacy of our culture's most highly valued source of knowledge.

In *the capacity of absorption* one experienced a clear progression from the sensual to the cerebral, from the spoken to the written word, and from the light to a mysterious darkness, primarily through our sensory and intuitive faculties, as a

number of the artist's ongoing themes began to emerge. Hamilton explored such issues as, how do we know what we know and what eludes us? What is the relationship between the corporeal and the cognitive? What is lost or gained in communication through the word instead of the voice? How do we reconcile our need for solitude with the simultaneous desire to be part of a larger social group? She has always framed her practice as range of questions to be asked rather than conclusively answered, and she trusts the viewer to approach the work in a similar spirit.

In a career spanning more than twenty years, Hamilton has created over sixty temporary installations in locations throughout North and South America, Europe, Australia, and Asia. Because this body of work is so widespread, few people have had the opportunity to view it in its entirety. Though she came of age as an artist in the mid-1980s, her work might be best understood in the context of the installation and performance art movements that emerged in the 1960s and gained increasing importance in the decades that followed. In this period, progressive artists were moving away from the notion of the art object as a precious, enduring commodity and were experimenting with ephemeral forms such as large-scale envi-

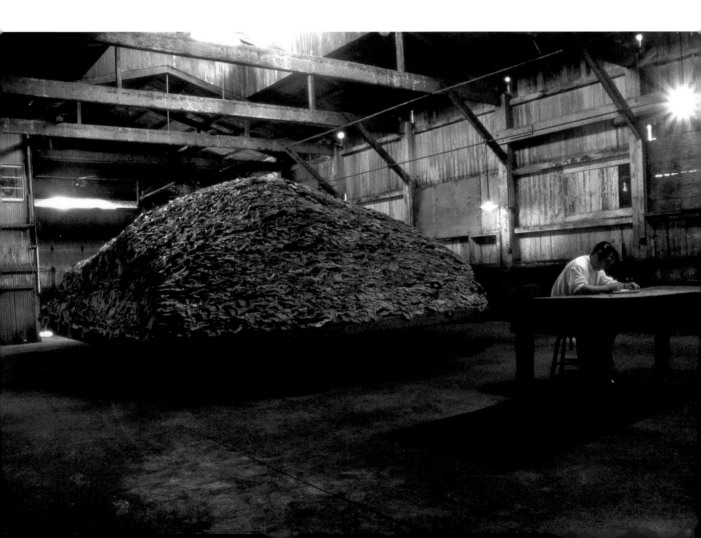

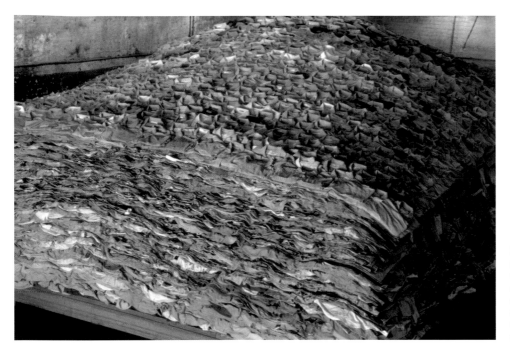

left and opposite: *indigo blue*, 1991. Installation, *Places with a Past: New Site-Specific Art at Charleston's Spoleto Festival,* Charleston, South Carolina.
Photo: John Williams

ronmental and performance work, which often included the artist and, at times, the audience. A diverse group of visual artists—Vito Acconci, Alice Aycock, Daniel Buren, and Robert Smithson, among others—became well known for creating temporary, conceptually based, experiential installations that surrounded the viewer and responded to the physical characteristics of a particular site. The artist's inhabited installations were also informed by the field of performance. Rich sources include Marina Abramović and Ulay's psychologically charged, poetic endurance works; more directly, the experimental theater tableaux of Robert Wilson, a visiting professor at Yale in 1985; and the interdisciplinary performances of Meredith Monk, a pioneering artist who brought together music, voice, movement, and image, and with whom Hamilton later collaborated on a theater piece titled *mercy* (2002).[2]

A correspondence also exists between Hamilton's work and that of the influential German sculptor and installation and performance artist Joseph Beuys (1921–1986), whose work also included both human and animal presences and evocative, non-art materials. As Hamilton has aptly observed, "Beuys's thinking is on a heroic scale and based in a belief that society can be transformed through art. My ambitions are perhaps different, but I share with his work a belief that art can connect us to something that is lost. ... he becomes a person not to be compared to, but someone who enlarged and changed the arena for work."[3] Although Hamilton rightly resists a direct comparison with Beuy's art and his utopian political philosophy, there are parallels in their approaches. Each has broadened the boundaries of

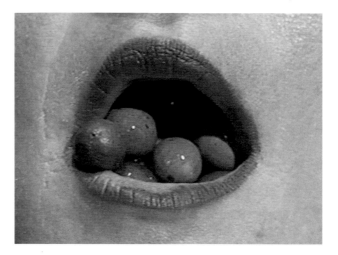

art making, creating profound, conceptually based installations that draw upon human experience as they also explore our connections with nature, culture, and broader social systems.

In 1991 Hamilton was asked to participate in an innovative, city-wide exhibition, *Places with a Past: New Site-Specific Art at Charleston's Spoleto Festival*. She was one of eighteen international artists who were invited to select a site in Charleston, South Carolina, in which to create a temporary work that addressed the history of a city known as the "Capital of the Old South." Hamilton made a preliminary visit in February 1991 to take in the city's atmosphere, and she read American labor history for more than a year, notably Howard Zinn's *A People's History of the United States* (1980), in preparation for this project. She chose as her site a plain brick structure that was formerly an automotive repair shop to create an installation that exhibition curator Mary Jane Jacob has described as "an ode to the worker and to hand labor."[4] The title of the work, *indigo blue* (p. 213), referred to the natural dye obtained from the indigo plant, a valued part of Charleston's early economy and now most closely associated with the uniforms of blue-collar workers. She collected over 14,000 pounds of worn work shirts and pants and amassed them in the center of this large industrial space to create a single spectacular accumulation.

In this installation, 48,000 articles of blue clothing were carefully folded and laid onto a seventeen-by-twenty-four-foot platform to form an enormous accretion that spoke of time, repetition, and the touch of numerous hands. From a distance, the physical presence of this enormous mound of layered shirts and pants suggested a large body, while up close the discretely folded items brought to mind the individual lives of their unknown owners. The many acts of folding by unseen hands further suggested the repetitive yet necessary tasks regularly and anonymously performed by blue-collar workers. Hamilton's *indigo blue* was a respectful attempt to

acknowledge the efforts of those who spend their days engaged in manual labor and whose names and deeds will never appear in history books.

Walking around this massive pile, the viewer came upon an attendant seated at a wooden work table quietly and continuously performing a curious task. He or she was slowly erasing the pages of old blue-cloth-covered military manuals, first moistening a Pink Pearl eraser with spit then neatly rubbing away the text line-by-line. It was the first of several of the artist's installations in which altered books would play a significant role. Erasing these texts was not meant as an act of negation, as might be assumed, but rather an attempt to lessen the weight of conventional history to make way for another forgotten story, one of common everyday experience, to be told. The action of erasing, according to the artist, was a means of "using the body to re-mark history—taking the mechanically reproduced text and replacing it with the mark of the body," essentially telling an alternate tale through the touch of

Opposite and below:
aleph, 1992. Installation,
MIT List Visual Arts Center,
Cambridge, Massachusetts.
Photo: Charles Mayer

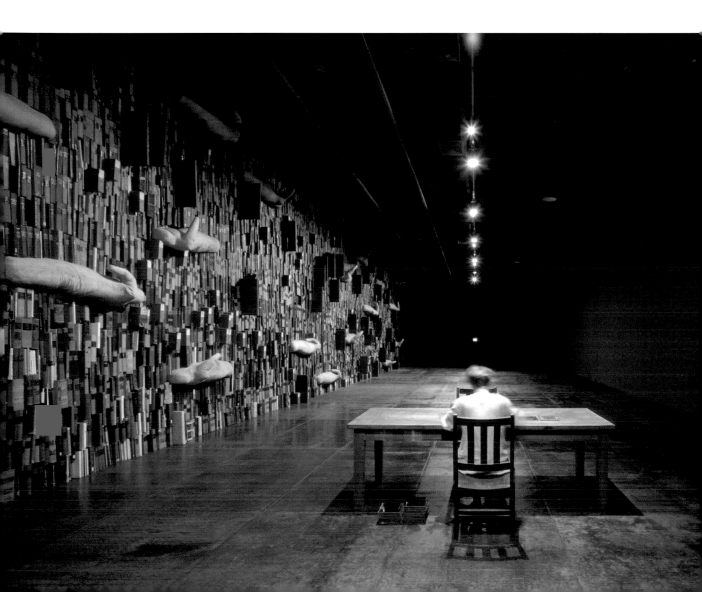

the hand.[5] Finally, in a small, second-story office space, overlooking the enormous cloth mound, hung sixty rounded, pendulous sacks filled with soybeans. Over the course of the installation, the soybeans rotted and filled the office with a decaying stench which, like the evidence of seemingly countless folded shirts and pants, subtly evoked the passage of time.

The process of thinking, feeling, and making that goes into a large-scale installation is of fundamental importance to Hamilton. The hands-on process of making involves a dedicated team of professionals—the artist herself and a number of skilled individuals, either employed by the organizing institution or hired for their specific expertise—and typically expands to include a committed group of volunteers, often women. Hamilton has found that the simple, time-absorbing, and repetitive acts required to create a work, often based on accumulation, were best accomplished as a social or communal activity. She is mindful that the satisfaction derived from working together on shared tasks, and "slowing down to the pace of the body, [and] the rhythm of handwork," is increasingly rare in contemporary life.[6] For Hamilton and her various teams it is a significant part of the installation experience, and linger as a palpable presence in the completed work.

Like *indigo blue*, the installation *aleph* (p. 215), presented the following year at the MIT List Visual Arts Center in Cambridge, Massachusetts, was a sensitive and astute response to the culture represented by its particular site, a gallery on campus at one of the country's leading institutes of science and technology. Once again the artist made use of copious found materials and innumerable handmade acts, in this case, creating an installation that explored her deep interest "in the implications of shifting technologies" and "expressed the tensions of tangible loss and incalculable emergence during paradigmatic change."[7]

In a darkened, cavernous ninety-by-thirty-foot gallery with twenty-two-foot-high ceilings, Hamilton laid a floor of steel sheets that reverberated with the sound of footsteps, heightening one's awareness of movement through the space. She covered one of the long walls with 35,000 outdated technology and patent texts and embedded a group of bulbous "bodies," resembling wrestling dummies, within the towering, densely textured stack. This immense collection of books represented the authority of knowledge codified in the written word, while their apparent wear suggested the fugitive nature of certain scientific systems over time. The bodies encased in the strata of books were more ambiguous entities. Were they trapped by or did they float within this vast field of information? As Hamilton put it, "Our physical empathy with these mute, unarticulated forms raised questions about our own ability to register sensual experience, and about the limitations of language as expressing our relationship to the world."[8] "It's like the McLuhan idea that every advance in technology is a step away from the body."[9]

The wall of books and bodies formed the context for the two actions that took place within the installation. A small videotaped image set into the far wall, and appearing as a distant flicker of light, showed images of stones slowly rolling around

in the artist's open mouth. This focus on the mouth—border between the external and internal body and the site of ingestion, sensual pleasure, language, as well as vomiting—was both compelling and repellent, as the viewer witnessed a border being transgressed. In its place next to the wall of books, the mouth implied oral traditions, whereby the values of a community are passed from person to person, as opposed to written ones, which here would be obscured and made "marble-mouthed" because of the presence of the stones. This image also paradoxically evoked eloquence, as in the famous story of Demosthenes, who overcame a speech impediment by practicing elocution with stones in his mouth and became Athens' greatest orator.

Near the gallery entrance, an attendant seated at an old library table slowly erased the reflective surface of a stack of head-sized mirrors with a circular motion. The mirrors may symbolize the highly self-conscious nature of contemporary life and the tendency to partially construct one's identity as a two-dimensional image rather than a corporeal body. Hamilton believes this can have a paralyzing effect "physically, emotionally, and imaginatively" and that by erasing the reflected image we may effectively free ourselves of its grip (not wipe ourselves away), potentially attaining a fuller, more present, sense of self. Named for the first character of the Hebrew alphabet, *aleph*, suggests the origins of language. At MIT Hamilton attempted to address the process from oral traditions to written language to our current mode of disembodied communication, each of those steps representing a further separation of the word from the body.

In 1993 Hamilton married artist Michael Mercil and two years later the couple had a son, Emmett. It proved to be an eventful year for the artist both personally and professionally. At age thirty-seven she became one of the youngest artists to be awarded the highly prestigious MacArthur Foundation Fellowship and she completed one of her most ambitious installations to date at the Dia Center for the Arts in New York. The work *tropos* (p. 218), whose title refers to the tendency of an organism to turn toward external stimuli, also explored such issues as the fragility of language, its connection to the body, and the relationship between oral and written culture, using more minimal yet more visceral means than those seen in aleph. The artist began by making subtle changes to the architecture of the Dia Center; replacing the windowpanes with a translucent glass that permitted the space to be bathed in a soft, natural light, and gently grading the gallery's concrete floor. The most dramatic feature of this installation was the enormous horsehair carpet that covered the 8,000-square-foot space. "Stitched together in slowly undulating, often interrupted, swirls," according to curator Lynne Cooke, "this epic 'hide' starts to resemble an endlessly surging ground, an oceanic topography."[10] Negotiating a path through this swelling sea of horsehair was a tactile and seductive experience that also had an element of revulsion, both from the work's overwhelming scale and the fear that one's feet could become caught or entangled in the web of hair.

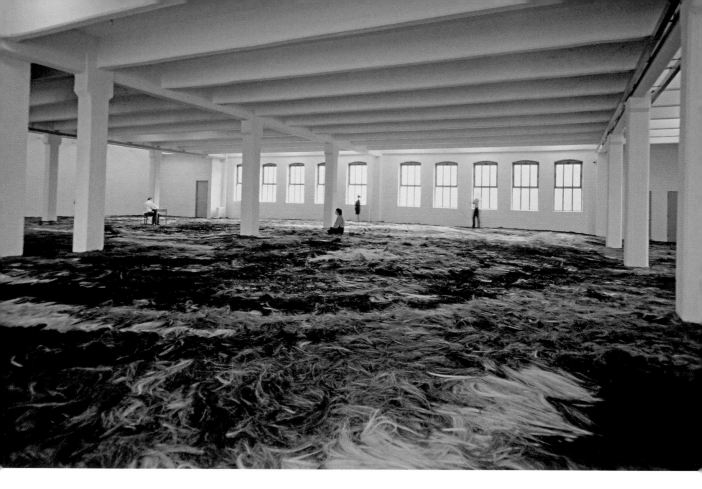

In the midst of this space an attendant sat at a small metal desk reading a book and then methodically singed each line of text with a heated instrument as puffs of smoke filled the air. This faint burning odor was accompanied by a recording of a barely audible voice struggling to read. Those incomplete words, long hesitations, and stuttering sounds were uttered by a man with aphasia, an impaired ability to articulate ideas or comprehend spoken or written language resulting from brain damage. *tropos* was a powerfully demanding work as Hamilton disturbed many of our basic assumptions about our abilities—movement, communication, and comprehension—showing the unraveling of fragile connections between thoughts and speech, writing and understanding, and thwarting our expectations of firm ground.

Around 1994 Hamilton confronted new questions: "I was very aware that the installations were increasingly structured by the material environment as a context for a live gesture. I kept wondering, how could I make the gesture of the person the piece itself? How necessary is all that material?"[11] These questions prompted a transition in the artist's work first seen in the installation *seam*, presented as part of

the Museum of Modern Art's Projects series in 1994–95 (below). In this work the artist greatly reduced her emphasis on material abundance and eliminated the presence of an attendant, instead featuring an enormous video projection that filled the viewer's field of vision with an image intended to convey "how touch feels." In this darkened space Hamilton projected a a gigantic fingertip continually spreading thick honey over a glass surface. Although not immediately identifiable, the moving image registered as something occurring either inside the body or on the surface of the skin. The rhythmic motion of the enlarged fingerprint, seen in reddish tones, provided a visceral and visual expression of the significance of touch, long a theme in Hamilton's work. This piece marked a number of tangible and conceptual changes in her work. There was a shift from material density to a gradual emptying of space, a greater focus on gesture despite the absence of a live attendant, and a departure from the marked horizontality of her previous work and its allusion to the landscape, in favor of an insistent verticality.

This change of direction became apparent upon entering the spare, pristine environment of *bounden* (1997), a work commissioned for a mid-career survey of the artist's work organized by the Musée d'art contemporain in Lyons (p. 221). In a

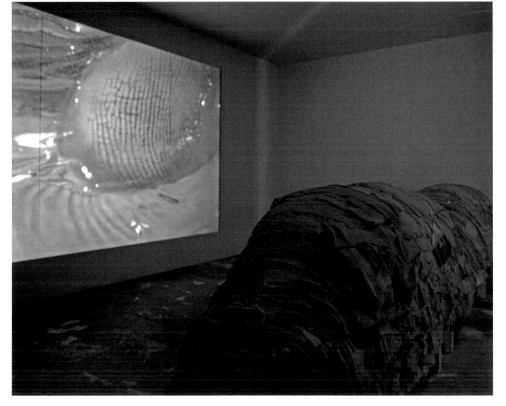

seam, 1994. Installation, *Projects 48*, The Museum of Modern Art, New York.
Photo: D. James Dee

gallery measuring 72 feet wide and 16¹/₂ feet high, and seemingly filled only with light and embroidered lengths of silk, an entire shimmering white wall "wept." The poignant discovery of tears slowly welling up and trickling down this broad expanse, and steadily puddling on the floor, evoked deep feelings of anguish that might be personal or collective. The mass of material and signs of production so essential to her earlier installations were nowhere in sight. In their place, a system of PVC tubing hidden behind the gallery walls, fed droplets of water through hundreds of infinitesimal holes randomly arrayed across its surface. The weeping, oozing, sweating wall was a mysterious, ever-changing entity that traced a path of descent to thoughts of transience and loss.

On the opposite wall Hamilton draped nine sixteen-foot-high windows in white silk organza, with a selection of texts hand embroidered in large, looping script. The readings were mainly from works by women writers that spoke of the body in pain, and included a poem by Susan Stewart, "Lamentations"; a text by Shaker author Rebecca Cox Jackson, "A Dream of Slaughter"; and excerpts from Angela Carter's "The Company of Wolves." The embellished fabric flowed down

the windows to the floor, where the artist stretched each panel across the gallery space, laying each on the back of a *prie-dieu*, a smaller support used for kneeling while at prayer. Within this glowing white space, these elegant and sacred items displayed terrible tales of violence and death that resonated with the instinctive evocations of sweat and tears seen on the opposing wall. The solemn and sacramental environment of *bounden* lamented the fragility and helplessness of women whose only recourse might seem to be prayer.

In 1999 Hamilton was selected as the official United States representative for the 48th Venice Biennale, one of the oldest and most prestigious international exhibitions of contemporary art.[12] She created a work that responded to the physical and symbolic qualities of the American Pavilion, a neoclassical structure designed in 1929, whose central courtyard, domed rotunda, and symmetrically flanking galleries evoke a body with embracing arms. The building also suggests a scaled-down Monticello, with symbolic ties to Thomas Jefferson's philosophy of democratic social space. The installation, titled *myein*, a Greek word meaning both mystery and an abnormal contraction of the pupil of the eye, was the artist's most abstract, reserved, and multilayered work to date. In it she attempted the elusive

Opposite and below: *bounden*, 1997. Installation, *Ann Hamilton: Present-Past, 1984–1997*, Musée d'art contemporain de Lyon, France.
Photo: Blaise Adilon

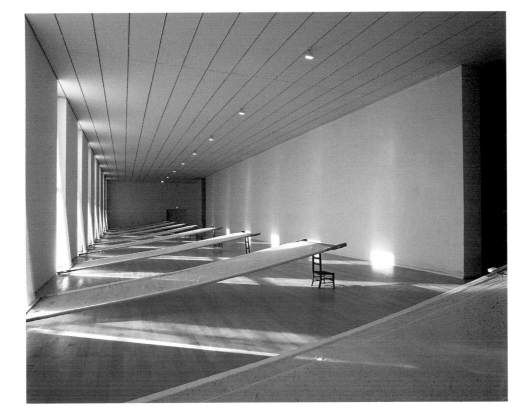

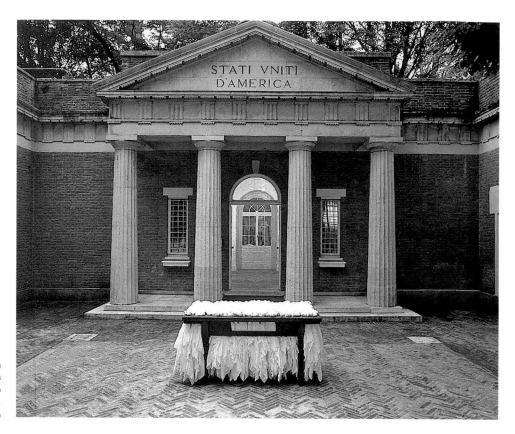

myein, 1999. Installation views, The United States Pavilion, 48th Venice Biennale, 1999.
Photo: Thibault Jeanson

task of "making the invisible visible," employing such intangibles as daylight, dust, the movement of air currents, empty space, and a whisper, as her tools.

In *myein* Hamilton engaged the exterior and interior of the pavilion through several unifying gestures that alternately revealed and veiled the structure and rendered it as both image and object. The approach to the building was distorted and impeded by a steel-and-glass grid that spanned its ninety-foot width. From the exterior the rippling of the transparent glass dissolved the view of the pavilion, transforming its façade into a virtual mirage. The view from inside the courtyard, looking out toward the Giardini Park, was liquefied by the distortions of the glass, transforming the garden into an impressionistic vision (opposite). Once again she incorporated a wooden table—here with thick white cloths knotted across its surface, pulled through its top, and draped to the ground—providing a site for pause and reflection within this ethereal space.

That version of a Jeffersonian ideal, veiled and somewhat skewed, came up against the painful realities of everyday life in the building's interior, where the walls of each of the four galleries were encrusted with an enlarged Braille text of Charles Reznikoff's *Testimony: The United States* (1885–1915): *Recitative*, a col-

lection of spare, dark poems drawn from actual court records that constitute a litany for a multitude of past lives (p. 225). A bright pink powder mysteriously drifted down the gallery walls, collected on the texture of the Braille dots, and accumulated on the gallery floors over the course of each day. The perpetual flow of the sifting powder, punctuated by random bursts of color, had a mesmerizing effect. In addition, the pavilion's four skylights, covered for more than a decade, were revealed, allowing natural light to illuminate the surfaces and volumes of the space. The final unifying element was the sound of the artist's whispering voice, spelling out in international phonetic code Abraham Lincoln's deeply moving Second Inaugural Address calling for healing the nation's wounds following the shame of slavery and the destruction of the Civil War.

myein, 1999. Installation, The United States Pavilion, 48th Venice Biennale, 1999.
Photo: Thibault Jeanson

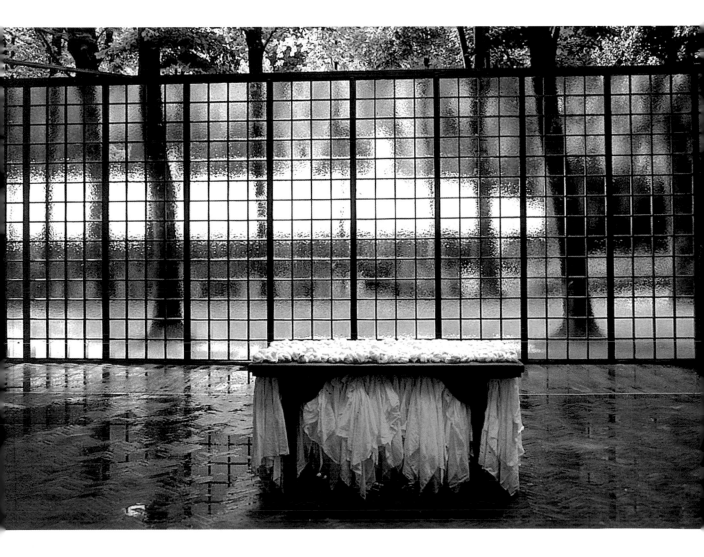

This dispassionate chronicle of industrial accidents, domestic violence, racism, bank failures, religious disputes, murder, mob rule, and other destructive calamities seemed to call into question whether America's promise of "life, liberty, and the pursuit of happiness" was true for all its citizens. The artist's use of Braille, a tactile, basically obsolete system, shrouded by falling dust, and the obscure individual coded characters of Lincoln's address, with its whispered yet elusive intimacy, epitomized Hamilton's ongoing preoccupation with the limitations of language. Like the tears of *bounden*, the artificially colored dust in *myein* filled the mostly empty spaces with a gravity of loss. In Hamilton's work red tones, including the pink powder, refer to the corporal body, its passions, rituals, sacrifices, and blood. Like autumn leaves, the artist's descent imagery evoked an absence, time, and the ever-presence of death. The installation *myein* was a solemn, complex and cerebral work that challenged the visitor to become an active participant in the construction of meaning.

The artist further explored some of these ideas and images in a major installation commissioned by the Massachusetts Museum of Contemporary Art (MASS MoCA) for an enormous gallery the size of a football field, as other themes also began to emerge. In *corpus* (2003–4), a warm natural light, the sound of multiple voices often speaking in unison, and the flutter and drift of falling sheets of onionskin combined to infuse this vast, nearly empty volume with an aura of beauty and grace (pp. 226–27). Hamilton achieved this effect through the introduction of three elements, including 40 pneumatic devices placed in the gallery's rafters that released single sheets of paper in a breathing rhythm; 24 cone-shaped speakers, each reproducing a single voice, that continuously rose and descended almost to the floor to create a central aisle; and a layer of magenta silk organza covering each of the gallery's 120 extremely tall windows, suffusing the space with an ever-changing, rose-colored light. The meditative and absorbing atmosphere of corpus encouraged the visitor to linger, as the light, choir of voices, and central nave evoked the transcendent spaces of a cathedral.[13]

The work *corpus* was organized as a sequence of galleries and experiences. After crossing the vast, luminous main hall, the viewer entered a small darkened room in which four speakers, emitting a serene vocal work by Meredith Monk titled *Liquid Air*, spun slightly overhead. The third and final space, a balcony overlooking the main gallery, also suffused in deep-pink light, contained three rows of heavy white wooden benches resembling church pews. The simplicity of these forms, made from old wood factory beams, and their arrangement, suggested the site of a modest congregation while preserving the luminosity of the space below. The last element was a small video image that circled the balcony projecting a single line of text that read "in the beginning was the was beginning the in the beginning was beginning …"–fragmented words of Genesis.

The word and the voice, the body and the light—all plays on the title *corpus*— were present in real and symbolic form in this contemplative work addressing the

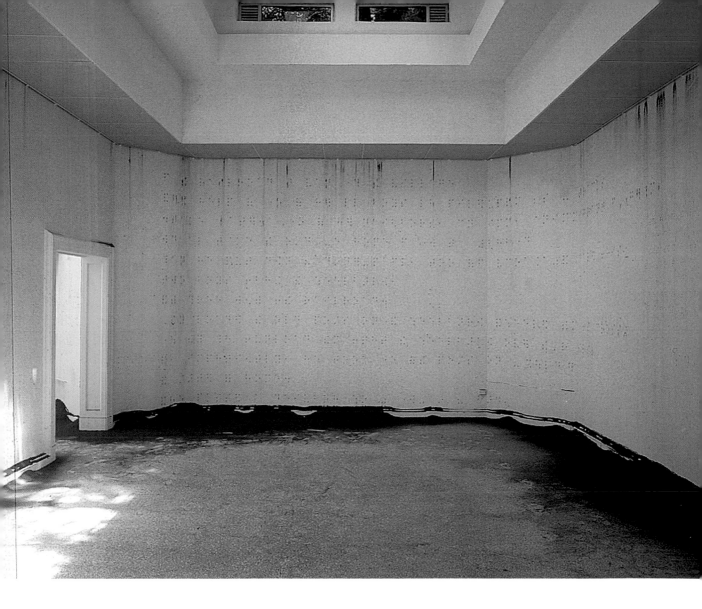

myein, 1999. Installation,
The United States Pavilion,
48th Venice Biennale, 1999.

Photo: Thibault Jeanson

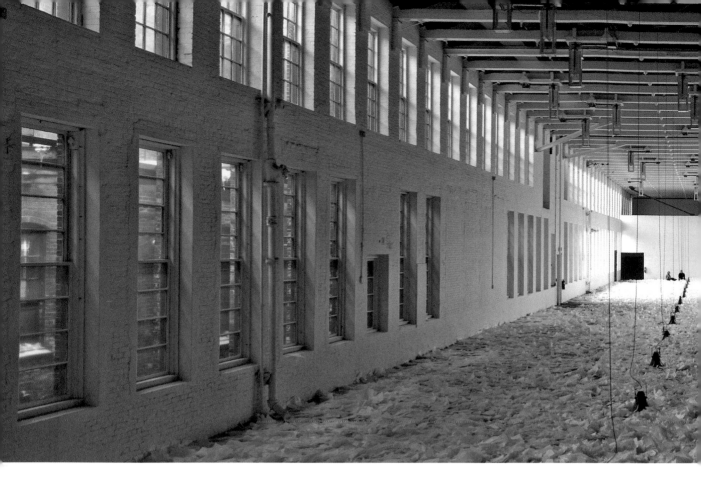

corpus, 2003. Installation
views, MASS MoCA, North
Adams, Massachusetts.
Photo: Thibault Jeanson

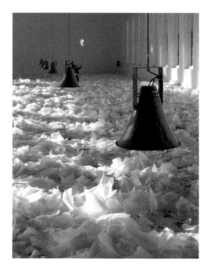

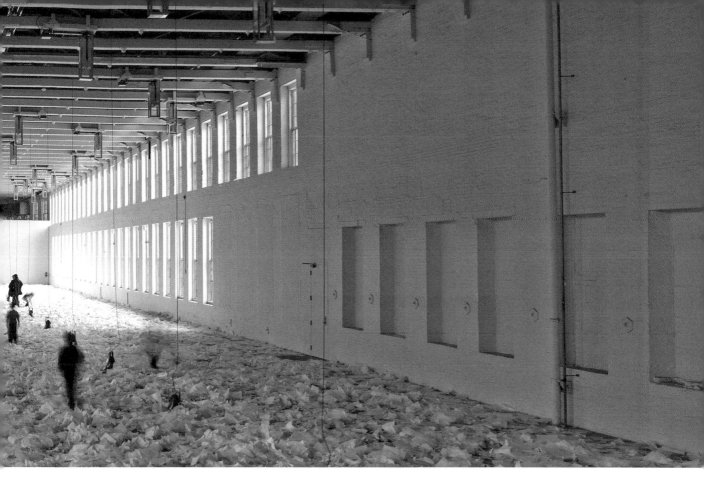

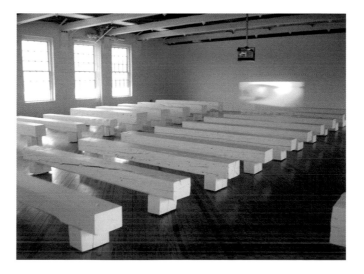

227

subjects of spiritual longing and the search for meaning in the contemporary, secular world. In the first gallery, the individual sheets of white paper that gently fluttered from the ceiling and accumulated on the floor continued the pattern of descent that structured both *bounden* and *myein*. As Hamilton has said, "we are in a perpetual state of descent—that is our bodily purpose" and in this work she evoked a body that is never represented or described, while also calling attention to its finitude. In the face of this somber reality, the artist suggested that some solace may be found in the sound and gathering of voices, in the potential fellowship of the congregation, and in the pleasure to be derived from being part of something greater than ourselves. In recent years she has addressed issues of our finitude, the potential for spirituality in our lives, coping with feelings of emptiness and attempt to find community, and, as always, the condition and experience of being a body.

At age fifty, Hamilton has created a body of work of tremendous scope and ambition, and has received broad attention and great critical acclaim, while pursuing an unusually independent and eclectic course. Her career has thrived on the support of the many museums, university galleries, alternative spaces, grant-making foundations, and fellowship organizations that have recognized and encouraged her vision. Her work often comes out of a process of reading, mainly the work of writers and thinkers from fields outside the visual arts. Although she most often generates her own projects, she is as likely to collaborate with a choreographer, an avant-garde composer, an architect, or a landscape architect, as she is with another artist. Over the past twenty years she has created more than sixty installations of great formal clarity and intellectual and intuitive depth. And though she may share some common ground with such international installation artists as Rebecca Horn, Marina Abramović, and Ilya Kabakov, she is essentially without peer. At middle age she has come to a point of increased introspection and is unafraid to explore life's big questions in her poetic and expansive body of work.

1. Mary Jane Jacob, *Ann Hamilton: The Capacity of Absorption* (Los Angeles: The Museum of Contemporary Art, 1989), unpaginated brochure.

2. Joan Simon, *Ann Hamilton* (New York: Harry N. Abrams, 2002). I am grateful to Joan Simon for her insights on the context and sources of Ann Hamilton's work.

3. Quoted in Simon, *Ann Hamilton*, p. 48.

4. Mary Jane Jacob, *Places with a Past: New Site-Specific Art at Charleston's Spoleto Festival* (New York: Rizzoli, Inc., 1991), pp. 73–74.

5. Quoted in Simon, *Ann Hamilton*, p. 107.

6. Quoted in "Ann Hamilton *aleph*," Interviewed by Helaine Posner, in *19 Projects: Artists in Residence at the MIT List Visual Arts Center* (Cambridge, MA: MIT List Visual Arts Center, 1996), p. 199.

7. Patricia C. Phillips, "Ineffable Dimensions: Passages of Syntax and Scale," in *Ann Hamilton: Present-Past, 1984–1997* (Milan: Skira, 1998), p. 116.

8. "Ann Hamilton *aleph*," p. 191. This quote and the discussion of aleph that follows is drawn from the introduction and interview with the artist that accompanied a residency project I organized at the List Art Center in 1992.

9. Ibid., p. 196. Hamilton is referring to communications theorist Marshall McLuhan (1911–1980), whose best-known work is *Understanding Media: The Extensions of Man* (1964).

10. Lynne Cooke, *Ann Hamilton* (New York: Dia Center for the Arts, 1993), unpaginated brochure.

11. Quoted in Simon, *Ann Hamilton*, p. 155.

12. In 1999, Katy Kline and I were United States Co-commissioners for the 48th Venice Biennale. This discussion of *myein* is based on the essay originally published to accompany the installation and some later thoughts.

13. Lawrence Raab, "Acts of Finding" in *Ann Hamilton corpus* (North Adams, Mass.: MASS MoCA Publications, 2004). The observation about the main gallery seeming like a town square is Raab's. His essay on *corpus* is quite illuminating.

Shirin Neshat: Living between Cultures

ELEANOR HEARTNEY

"I'm not satisfied with just explaining my culture. I don't want to be an ethnographic artist." SHIRIN NESHAT[1]

In the early 1990s, when Shirin Neshat was emerging as an artist, the art world was caught up in a fascination with the "other." After decades in which an "international" exhibition meant one confined almost exclusively to American and European artists, with the occasional Japanese thrown in for spice, artists from every corner of the globe began to be seen and celebrated. This was the consequence of several factors—the end of the Cold War, which opened up previously closed borders to trade and tourism; the acceleration of technological discoveries that made travel and communication infinitely easier; and, in the art world, the collapse of various paradigms valorizing straight white European or American males over all other groups.

Neshat, an Iranian woman whose early work deliberately employed symbols associated with her culture, was swept up into this embrace of otherness. During most of the 1990s her photographs, videos, and films centered around images of women in black chadors, the enveloping garment worn (sometimes voluntarily, sometimes under duress) by women in Islamic societies throughout the world. From the perspective of a Western audience (and due to the political situation, her work could not be seen in her native country), Neshat was viewed as a messenger from an exotic world. But in fact, critiques that situated her within what would later, post-9/11, be dubbed "the clash of civilizations" and acclaimed her as a symbol of resistance to Iranian repression, miss much of the complexity of her work. Instead, over the years, it has become clear that she uses her position as an Iranian woman artist to speak to a wide range of personal and social issues and to express her point of view from the intersection of many overlapping identities.

It has been Neshat's fate to live a life inextricably bound up with politics and geopolitical upheaval. She was born in 1957, just four years after the CIA-assisted coup that replaced Iran's first democratically elected government with Shah Reza Pahlavi, a leader more sympathetic to Western interests. While the Shah's regime was beneficial to the class of educated, Western-leaning Iranians to which her family belonged, the manner of its instatement left a festering resentment, especially among those who were not sharing the fruits of the country's alignment with the West. In 1975 Neshat left Iran to go to art school at the University of California at Berkeley. She found herself stranded in America in 1977 when the Iranian revo-

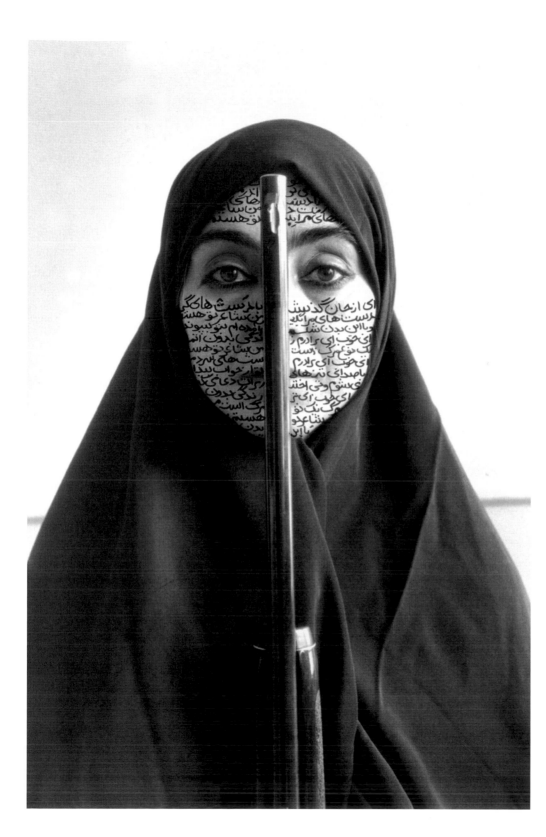

Rebellious Silence,
1994. Black and white
RC print and ink, 11 x
14 in. (27.9 x 35.6 cm).
All reproductions of art
by Shirin Neshat © Shirin
Neshat, courtesy
Gladstone Gallery.
Photo: Cynthia Preston

lution replaced the Shah with an Islamic fundamentalist government headed by the Ayatollah Khomeini.

For the next thirteen years Neshat was not able to return home. From distant America she received news about further upheavals and conflicts involving her native country. These included the seizure of the U.S. Embassy in Tehran in 1979 by Islamic militants and the fourteen-month-long hostage crisis that followed, resolved just after Ronald Reagan took office as president. From 1980 to 1988 Iran was engaged in a war with neighboring Iraq. The U.S. covertly funded Iraq, hoping to create a bulwark against the spread of Islamic fundamentalism in the region. The 1989 death of Khomeini ushered in an era of relative liberalization in Iran, which, though still an Islamic state, seemed to be growing more amenable to outside influences.

During these years, Neshat finished school, moved to New York, and married a Korean curator, Kyong Park, who was director and founder of an alternative space called the Storefront for Art and Architecture. The Storefront, located in downtown Manhattan, was a laboratory for innovative art projects involving politics, architecture, art, and progressive notions about public space. It was a place of intellectual ferment and experimentation and served Neshat well as a kind of second education in contemporary art. During this period, she became a mother, helped Park run the space, and worked closely with numerous artists, architects, theorists, and curators. However, for over a decade, she put aside the idea that she herself might become an artist.

In 1990 Neshat returned to Iran for the first time since the revolution and found the country greatly changed. The cosmopolitan, Westernized Iran she remembered had been transformed into a thoroughly Islamicized culture in which women were required to wear chadors, the old Persian street names had been changed to Muslim and Arabic ones, and the once-open mixing of the sexes was forbidden. The distance between her memories and the current realities had an enormous impact on Neshat, and when she returned to the U.S. she began to make art. Instead of painting, the medium she had studied at Berkeley, she turned to photography. This lead to her first widely acclaimed body of work, Women of Allah, a series of black-and-white photographs that depict Neshat, clad in a chador. She covered the parts of the photograph that expose parts of her body (which by Islamic law were confined to feet, hands and face) with inscriptions of Farsi poetry written by Iranian women poets such as Forough Farokhzad and Tahereh Saffarzadeh. The poems range in content from explorations of female desires and fears to militant calls for women's participation in the Iranian revolution. In photographs from the Women of Allah series, the focus is on Neshat's text-covered face or hands, while in others she assumes more provocative stances, brandishing a rifle as in *Rebellious Silence* (see p. 231), and even, in one photo, using her bare feet as a support as she aims the gun barrel at the viewer.

These works were Neshat's reactions to the changed status of women in Iran's Islamic society. They make note, on one hand, of the mandated female uni-

form, and on the other, of the role played by women in the revolution and the war against Iraq. Neshat was particularly interested in women's part in the perpetuation of the ideal of politically motivated martyrdom in a religious state. In retrospect, Neshat criticizes these works for what she sees as their neutral and even romanticized view of women's place in a revolutionary society. Western commentators, however, were more inclined to read into them a critique of Iranian society's violence and repression of women. In such readings, Neshat became a champion of Western ideals of individuality, secularism, and sexual equality.

These works entered the American art scene in 1993, and their appearance coincided with a growing interest in multiculturalism and globalism. Critics and curators focused on notions of cultural difference, seeking voices from outside the art mainstream to better represent a decentered world. From this perspective, Women of Allah seemed to offer a glimpse of unassimilatable "otherness," and the series' focus on the veil underscored the Muslim world's apparent distance from the West.

For Western observers Neshat's work pulled back a curtain on a hidden world. She focused attention on the desires and ambitions of the otherwise invisible category of Muslim women, placing them in both a personal and political context. At the same time, her apparent critique of female oppression in Iran seemed to reinforce Western values of freedom, autonomy, and individuality. Hence much of the early commentary on her work emphasized its feminist and political underpinnings.

However, as a number of more perceptive commentators began to point out, this interpretation depended on the reduction of the Islamic veil to a emblem of repression. In fact, as writers such as Hamid Dabashi have pointed out, the Islamic veil is a supple and multilayered artifact.[2] The Arabic word for *veil* is *hijab*, or curtain, pointing to the fact that it marks the border between different realms. In Islamic cultures these borders include the boundaries between public and private space, between sacred or secular realms, and between Islamic culture and the outside world.

As a result, the *hijab*'s meanings shift by context. Prior to the Iranian revolution in 1977, the *hijab* had all but disappeared, even in rural areas, where it made work in the fields impractical. When women in Tehran began to don the *hijab* in 1977, it initially served as a revolutionary emblem, signifying the solidarity of these urban and often highly educated women with the ideals of the revolution. It was only after wearing of the *hijab* became mandatory under Khomeini that Iranian women began to chafe at their increasingly restricted lifestyles. After the Iranian revolution, the imposition of the veil was just one of a number of laws that mandated the separation of men and women and limited women's ability to move freely in public. However, in the Western world, the wearing of the veil often retains its symbolic meaning as a statement of resistance to Western hegemony. This is evident in the furor that resulted in France in 2003 when the government banned the wearing of the *hijab* in schools, and in 2000 in Turkey, when an elected member of Parliament was expelled for refusing to remove her *hijab*.

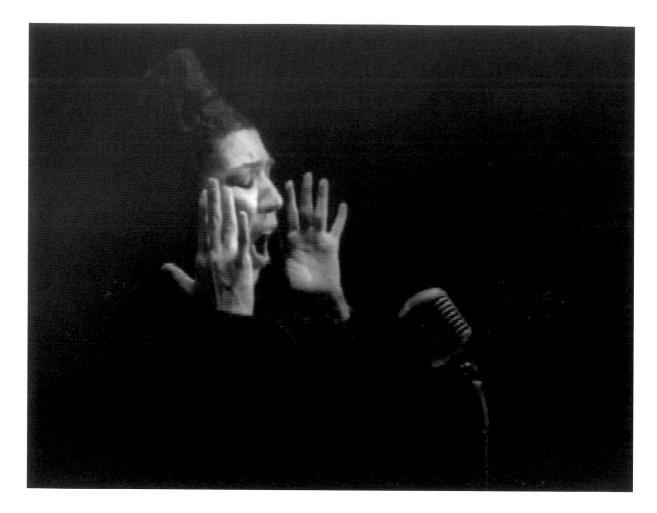

Turbulent, 1998. Film still.
Photo: Larry Barns

In Neshat's next series of works, these complexities became more evident. In 1996, on one of her trips to Iran, she was detained and questioned at the airport, after which she felt it was no longer safe for her to return. This experience helped erode the neutrality that she had been attempting to maintain in her works and turned her toward a more nuanced study of the meaning of her Islamic heritage. Around this time, her marriage was also ending, another circumstance that forced her to reexamine her relationship with her past. Turning to video, she began to explore issues of authority, power, and masculine prerogative as embedded in the social structure and even the architectural spaces of Iran.

The first such work was *Shadow under the Web* (1997), which she filmed in Istanbul—this and subsequent videos were all filmed outside Iran, in landscapes that evoked the native country from which she felt exiled. Neshat filmed herself wearing a black chador and running across four screens through spaces that represented the private, public, sacred, and natural realms. To the sound of heavy breathing, we see

her traverse sites ranging from mosques and plazas to city streets, marketplaces, and urban gardens. The work expressed the Islamic world's gendering of spaces, which are divided into the territories dominated by men or women.

This is an idea that receives fuller articulation in the three video works that followed. These works, *Turbulent*, *Rapture*, and *Fervor*, form a remarkable trilogy. Completed between 1998 and 2000, they represent Neshat's first fully mature work. In these video installations Neshat uses multiple screens to draw the viewer into the work. *Turbulent* (1998), which is presented as a ten-minute loop, comprises two separate but synchronized video narratives presented on opposite sides of a darkened gallery (opposite). One is a black-and-white video of an Iranian man in Western dress who sings an ancient Persian love song to a packed auditorium; Iranian viewers would recognize the words as a love poem by the great thirteenth-century mystic Rumi. (The performer is Shoja Youssefi Azari, who has been Neshat's companion and continuing collaborator on all subsequent projects.) At the end of the performance the all-male audience explodes into applause. Facing this is a screen depicting an Iranian woman dressed in the traditional chador and singing a strange, wordless song to an empty auditorium (she is played by composer and singer Sussan Deyhim, creator of the song and another continuing collaborator). Her song, full of cries, wails, and guttural utterances, is deeply affecting, and the absence of an audience is heartbreaking. The contrast between the two scenes is enhanced by a device that creates a visual bridge between them. The two videotapes are coordinated so that each singer, after completing the performance, pauses and watches silently as the other sings.

Turbulent contrasts the very different realms inhabited by men and women in Iranian society. It suggests a world in which men are empowered with language, while women are speechless, though not without voice. Yet, despite the woman's apparently inferior status, it is clear that her song is the more powerful. Her isolation gives her a freedom of expression that the man, as he respectfully watches her perform, seems to envy. In an interview with *Time*, Neshat noted, "It [*Turbulent*] was inspired by the fact that women are forbidden from performing or recording music [in Iran]... If music is an expression of mysticism and spirituality, how interesting that the man could have that experience but the woman could not. The woman [in *Turbulent*] breaks all the rules, first by appearing in a theater where she's not supposed to be. But then her music breaks all the norms of classical music. It's not tied to language. It's improvised. So we create a sense of opposites... but we also speak about how women reach a certain kind of freedom, how women become incredibly rebellious and unpredictable in this society whereas men end up staying within the conformed way of living."[3]

Rapture, a thirteen-minute video installation completed the next year, is also presented on two facing screens presenting male and female perspectives and edited so the two groups seem to be reacting to each other (pp. 236–237). Here the interplay is more complex, as the protagonists on each side line up to face each other

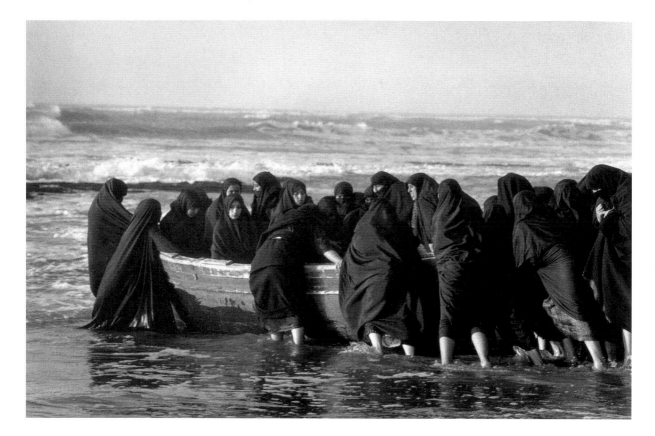

at the onset of the videos and throughout periodically interrupt their activities to watch the other's activities on the facing screen.

On one screen, a large group of men wearing an identical uniform of Western white shirt and black pants move through the corridors and ramparts of an ancient fortress by the sea. On the other, an equally large group of women in black chadors move over a desert landscape to the sea. The men march purposefully through the fortress, engage in wrestling matches and wash their hands in preparation for ritual prayer. The women stride through the desert and line up before the camera to hold out tattooed hands, the only part of their body besides the face which Islamic law allows them to expose. Toward the end of the narrative, they pull a small wooden boat across the beach. Several women get in and push off to the open sea. At this moment, the men line the parapet and communally wave goodbye.

What might be a schematic representation of Islamic gender roles—with men identified with culture, authority, and modernity and the women associated with nature, isolation, and tradition—is deepened by the mournful beauty of the images. The women in black chadors, faceless and fleshless from a distance, fan out across

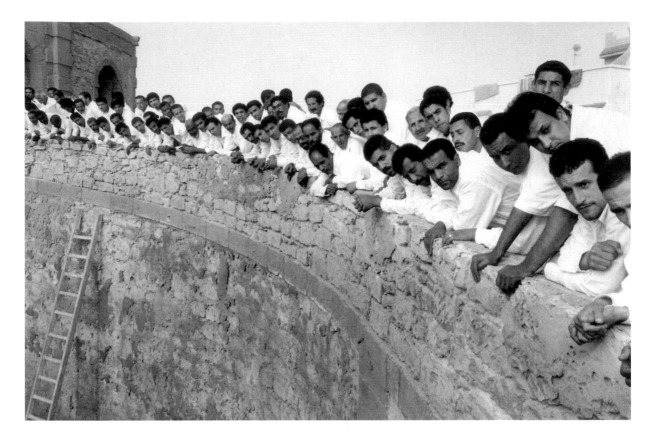

the desolate landscape or pull back together like a flock of birds. The men surge like a river through the ancient battlements, mutely line the parapet, or crouch in a circle for ritual hand washing, their gently undulating movements recalling the rustle of the petals of a giant blossom.

The message of the work is ambiguous. As in *Turbulent*, the apparently superior status of the male world is undercut by the anarchic freedom of the females. Nor is the outcome clear. The women's ultimate gesture of liberation—the launch of a tiny dingy crowded with a small coterie of their number, seems less an outright act of defiance than a symbol of sorrowful desperation. As the tiny craft sails out to the horizon, dwarfed by the ocean vastness, it is hard to say whether it is floating forward toward an uncertain secular future or back to the never-never land of the golden past.

The third work in this trilogy, *Fervor* (2000), is a ten-minute video installation (pp. 238, 239). Here split screens are lined up side by side so we view the male and female realms simultaneously. The action centers around a man and a woman who eye each other in passing on the street before ending up sitting on either side of

a large meeting room that has been partitioned by a curtain dividing male and female congregants from each other. In the front of the room, situated so he is visible to the men and women who cannot see each other, is an man preaching a sermon about sexual transgression. Though the Western viewer is given no translation, it is clear from his angry words and gestures, as well as from the discomfited reaction of the women, that his target is female wickedness. Like the speaker, the viewer is able to follow events on either side of the partition. We see that the man and woman seem to be communicating wordlessly, casting glances at each other that somehow penetrate the thick curtain. Suddenly the woman rises and flees the room. The man soon follows. Back on the street, they pass each other, but again are prevented by law and social custom from communicating.

Below and opposite:
Fervor, 2000. Film still.
Photo: Larry Barns

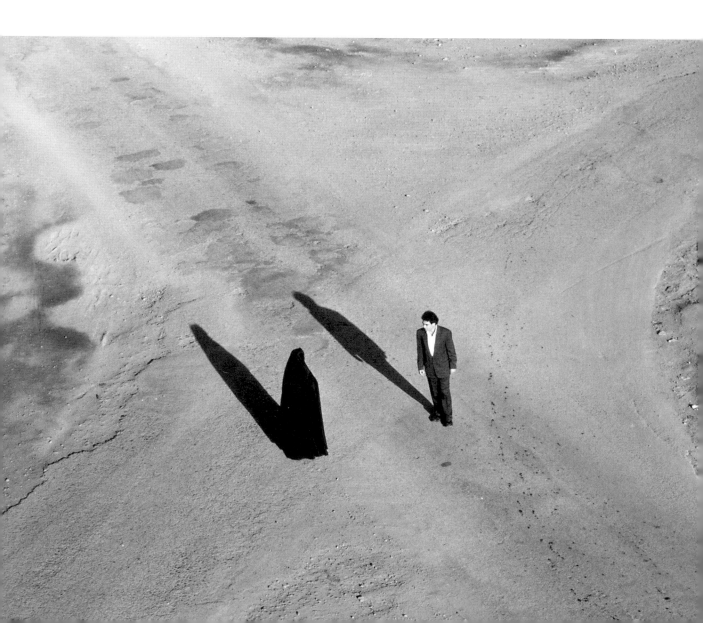

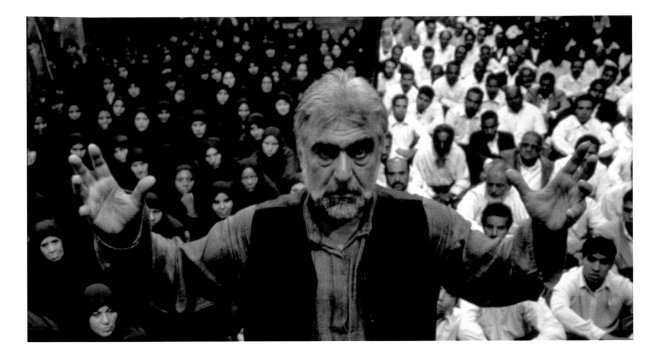

Fervor is marked by an undercurrent of sexual desire, made more intense by the way the narrative unfolds in a society in which the interactions of men and women are strictly regulated. This work, more than *Turbulent* or *Rapture*, also underlines the role that religion plays in defining these interactions. As Neshat notes, "In Iran, you can't separate religion from anything else. Everything is controlled by religion. It defines space, the relationship between men and women, the nature of sexuality, changes in human behavior and the way you are supposed to think about other races."[4]

These three works gained Neshat a huge international reputation; *Turbulent* was awarded the prestigious Golden Lion prize at the 1999 Venice Biennale. They also made it more difficult for commentators to peg her simply as a purveyor of identity politics. It was increasingly clear that Neshat was using her experiences as an Iranian woman exiled to the West in deeply original ways, drawing on her experiences to explore larger personal and social issues. After all, as an exile who left her country as a student, her vision of Iran was anything but documentary. Instead, Neshat's Iran is as much a creation of her imagination and memory as it is of any concrete, verifiable reality. As she explained to one interviewer, "I'm interested in juxtaposing the traditional with the modern, but there are other more philosophical aspects that interest me as well—the desire of all human beings to be free, to escape conditioning, be it social, cultural, or political, and how we're trapped by all kinds of iconographies and social codes."[5]

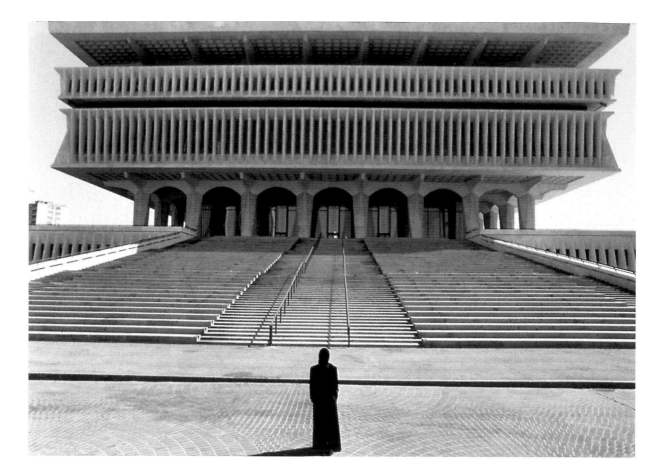

Soliloquy, 1999. Film still.
Photo: Larry Barns

While working on this trilogy (which only emerged as a trilogy in retrospect), Neshat also created *Soliloquy* (1999) (above), a split-screen two-channel video intended to mirror her own increasingly divided sense of self. By immersing herself in narratives based on the post-revolutionary Iranian reality, she was increasingly aware of the ways her years in the West had made her a stranger to that world. In *Soliloquy*, she eschews actors, instead presenting herself in various landscapes that signify the contrasting and possibly irreconcilable worlds of Iran and the West. Also shot in Turkey (again a surrogate for Iran) and the United States, it highlights the distance between these two worlds. Neshat is a solitary wanderer through barren landscapes, crowded plazas, ancient architectural structures, modern highways, and postmodern buildings, apparently never at home anywhere. Thus the work becomes a metaphor not only for her own conflicted inner life, but also for the divisions between the Islamic and Western worlds. Neshat's reliance in these works on such dichotomies as Islam/West, male/female, and tradition/modernity led to

SHAHZIA SIKANDER,
Who's Veiled, Anyway?,
1997. Vegetable color,
watercolor, dry pigment,
and tea wash on wasli
paper,
14 x 11 in. (35.6 x 27.9 cm).
Courtesy of Sikkema Jenkins
& Co.

GHADA AMER,
Knotty but Nice, 2005.
Acrylic, embroidery, and
gel medium on canvas,
108 x 144 in.
(274.3 x 365.8 cm).
Photo: Rob McKeever/Ghada
Amer. Courtesy Gagosian
Gallery, New York

charges that she was simply perpetuating stereotypes about the exotic East. Such critiques frequently invoked the concept of Orientalism first proposed by Palestinian critic Edward Said, which analyzes the Western tendency to reduce the Orient to a set of clichés based on Near Eastern cultures' supposed femininity, irrationality, and authoritarianism.[6] This formulation, Said argued, made it easier for Western critics to dismiss non-Western cultures as inferior to those of the West.

But while Neshat was clearly working from a female perspective, she was less interested in political critiques or demonstrations of cultural superiority than in the complicated mix of spirituality, eroticism, and poetry at the heart of Islamic culture. The structure of her works, with their visual interplay between masculine and feminine perspectives, their use of poetry, music, and song, and their resort to complex visual and aural metaphors, reveals an ambition that goes far beyond ethnography or theory. She explains her aims thus: "Beauty has always been a major aspect of my work, partially because it is inherent in the nature of the Islamic tradition—it is an essential aspect of Islamic spirituality, particularly in the mysticism associated with Islam such as the Sufi tradition, in which beauty is a fundamental vehicle of meditation with God. We are told, 'God loves beauty' and therefore, so much focus is given to creating beauty. Beauty is a mediator between human and divine. I have always stressed this aspect of my culture to neutralize some other rather negative associations with the Islamic cultures, such as violence. I still use that tactic continuously in my work."[7]

Passage, 2001. Film still

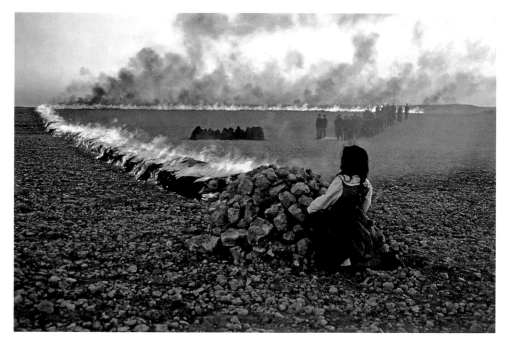

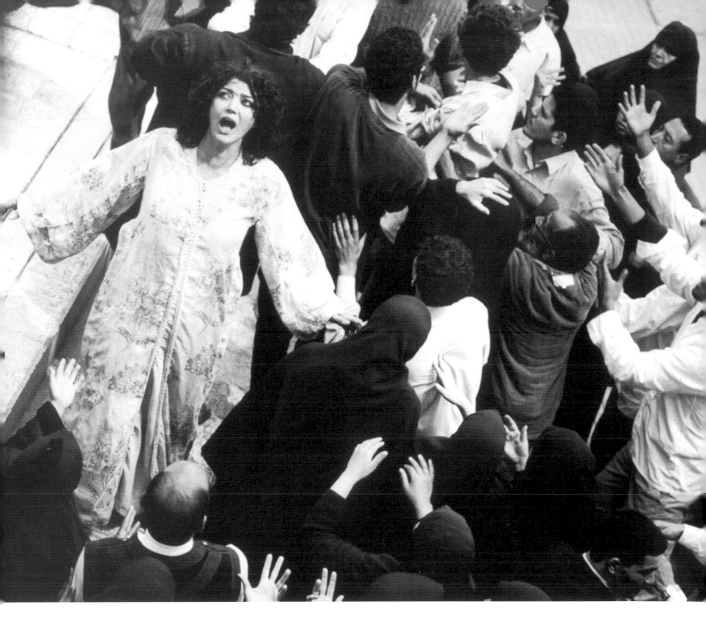

Neshat's focus on the sensual side of Islam mirrors that of several other women artists from Muslim backgrounds. Egyptian-born artist Ghada Amer creates apparently abstract embroidered canvases in which colorful fields of twisting thread only partially conceal delicately embroidered line drawings based on images from porn magazines. While these are in part a send up of the ejaculatory excesses of macho Abstract Expressionists such as Jackson Pollock, they are also related to the eroticism concealed behind the Muslim veil.

In a similar way, Shahzia Sikander, who was raised in Pakistan and lives now in the United States, takes on Western stereotypes about sexuality and Islam. She studied miniature painting techniques as an art student in Pakistan,

Possessed, 1998.
Film still.
Photo: Larry Barns

243

where she became adept at mingling the supposedly antithetical styles of Hindu Rajput painting with Muslim Mughal miniatures (p. 241). Mixing motifs from both these traditions along with images from Western art, she creates a representation of female beauty that crosses cultures. In her works the Muslim veil, which may serve as a diaphanous cover for a female nude, is as much about revealing as concealing. Instead of serving as a symbol of female oppression, it becomes a celebration of femininity.

With such works, Amer and Sikander join Neshat in looking beyond the specifics of the female role in Islamic culture. Instead, all three take aim at worldwide taboos against the expression of female sexual pleasure. Neshat's interest in beauty, eroticism, and mysticism become even more evident in her second trilogy—a set of videos created in 2000 that delve more closely into the inner lives of their protagonists and dispense with the formal and conceptual division of space into male and female realms. With the presentation of these works, it was no longer possible to interpret her work as a simple statement about female oppression in Iran or as a call for resistance to the authoritarian rule of the Imams.

Instead, these works create haunting, psychologically charged scenarios that deliberately eschew simple lessons. With *Passage* (2001) (p. 242), a single-channel, thirty-five-minute film, Neshat eschews her usual black and white palette for color. In this work a mesmerizing Philip Glass score commissioned for the piece accompanies a meandering narrative that alternates between the advance of a group of men carrying aloft a body dressed in white and depictions of a group of women in chadors gathered around a grave. The men wind across the desert (the work was filmed in Morocco) toward the women, who are digging in the sand. Eventually stopping not far from the women, the men lay the body on the ground. A third component enters as we see a small child in the foreground who plays at a distance from the women. She arranges stones in a circle and lays twigs as if to build a fire. finally, the camera pulls back to encompass men, women and child in a single shot. Fire erupts from the child's pyre and creates a ring of flames encircling the still separate groups of adults.

This work, created in part as a response to nightly news images of the escalating conflict between the Palestinians and the Israelis, is also a broader meditation on death and mourning, and was completed not long after the death of Neshat's father. The introduction of the child, who seems to stand outside the action and may represent the possibility of rebirth and renewal, presents a change from the dynamic of the works in the previous trilogy, with their call and response between the male and female realms. Here gender differences are less important than a sense of the continuity of life in the face of tragedy.

Possessed (2000) (p. 243), is a single-channel nine-and-a-half-minute video. This work, which returns to the stark contrast of black and white, focuses on a disturbed woman who wanders the streets of a notionally Iranian city. Unlike the properly veiled women on the street, her hair is uncovered and uncombed and she wears

an embroidered caftan rather than the mandated chador. The camera focuses first on her distraught face and then follows her through crowded streets to a crowded public square. Her screams and erratic behavior draw a crowd. As some bystanders attempt to subdue and others to protect her, her madness seems to transfer itself to the crowd. In the ensuing melee, she manages to slip away unnoticed, leaving the mob to rail loudly in her absence.

Issues that have long preoccupied Neshat return here, but in modified forms. Here the gender-based boundary between public and private space is breeched by the action of a woman who seems at home in neither sphere. In this, she serves as a symbol of exile, which has become increasingly important to Neshat as she finds herself excluded psychologically and physically from the world of her childhood. Her madness might also be seen, as Neshat herself has noted, as a metaphor

Pulse, 2001. Film still.
Photo: Larry Barns

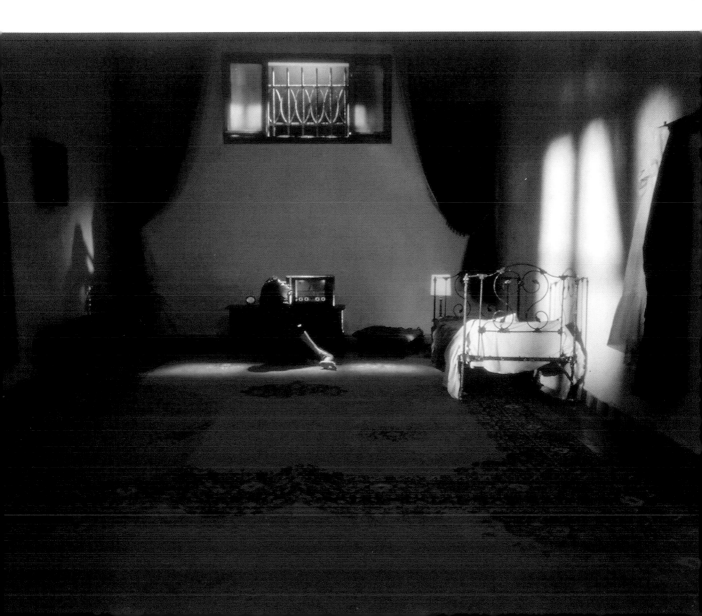

for the creative madness of the artists, whose expressions may be seen by unsympathetic observers as lunatic ravings.[8]

On the other hand, while the woman in *Possessed* exhibits aberrant behavior, it is not at all clear whether this behavior is voluntary. This distinguishes it from the actions in *Turbulent* and *Rapture*, where women push against the limits of their role with full consciousness of their transgressiveness. Instead, *Possessed* looks ahead to future works in which Neshat would return to the theme of female madness and the traps laid by social expectations.

The third work in this trilogy is *Pulse* (p. 245), an eight-and-a-half minute color film. Here, in place of a dialogue between public and private space, we find ourselves in the bedroom of a young woman as she dreamily sings along to the strains of a religious love song wafting from the radio. The male world enters only through the voice of the male singer, where it serves simply as backdrop. This single channel work has been filmed in a single take as the camera meanders through the shadows, finally resting on a view of the woman, sitting with her back to us in a shaft of light, her face unseen behind a cascade of black hair.

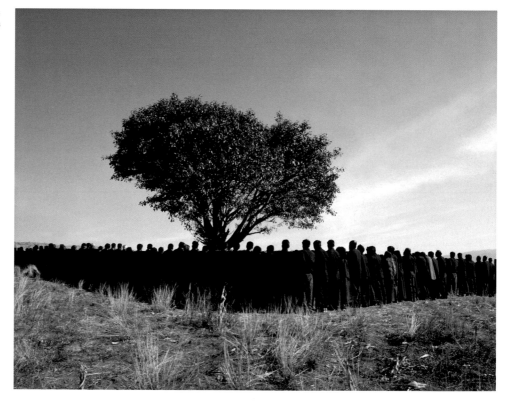

Tooba, 2002. Film still.
Photo: Larry Barns

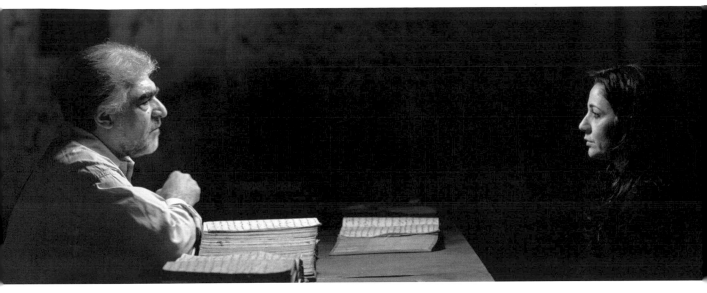

Taken together, the works in this second trilogy offer a meditation on the nature of freedom, which is achieved through death in *Passage*, through madness in *Possessed*, and through withdrawal in *Pulse*. By focusing on the possibility of individual freedom in a heavily controlled society, Neshat is able to move beyond the rigid dyads of East/West, male/female, and modern/traditional that formed an armature for her earlier work. As her characters become more fully rounded and begin to manifest interior lives, we begin to see the world through their eyes. In the process, they begin to suggest the commonality of human dreams and desires.

With the second trilogy, Neshat found herself coming closer to the to the mechanics of traditional cinema and its coherent narratives and more fully developed characters. Although, as she notes, she was never trained in filmmaking (or in photography or video art, for that matter) she closely follows Iranian cinema and in particular the work of Iranian filmmaker Abbas Kiarostami, who has gained an international reputation for his poetic, lyrical films about everyday life in contemporary Iran. As she has progressed more deeply into this terrain, Neshat's works have become increasingly collaborative, and she works frequently with a team that includes Sussan Deyhim, photographer Ghasem Ebrahimian, and, of course, her companion, co-writer and sometime performer, Shoja Youssefi Azari.

However, in an important departure from cinema, Neshat's films rarely use language, and when they do, as in *Fervor*, the actual meaning of the words is less important than the cadences of the singing or chanting. Instead, Neshat substitutes

The Last Word, 2003.
Film still

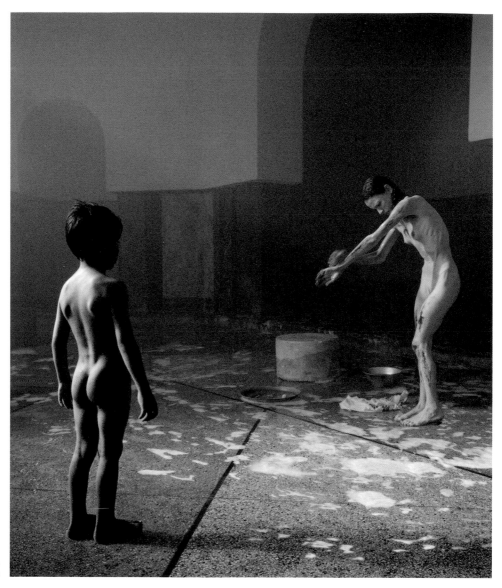

Zarin, 2005. Film still.
Photo: Larry Barns

music for the voices of her characters. Whether it is the mesmerizing Philip Glass score in *Passage*, the alternating musical performances in *Turbulent*, or the radio song in *Pulse*, music is crucial to the work's emotional effects. As Neshat told one interviewer, "The music is what is going on inside the characters' heads, we purposefully drop all speech, all realistic sounds. We see what's going on outside, we hear what happens inside." [9]

With *Tooba* (2002) (p. 246), Neshat moved even further from the cultural specificity of her earlier work. This two-channel color video, filmed in Mexico with

native Mexican actors, is in part a response to the horrors of September 11, 2001. It deals with the universal longing for a place of refuge, using the metaphor of the tree, or Tooba, as it is called in the Koran, which stands in paradise and provides sustenance and shelter for those in need. As in earlier works, there is a clash of realms here as a group of men mass and approach a giant tree, set off by a low adobe wall. Inside this boundary an old woman in black stands by the tree, her face and hands as lined as the ancient bark she leans against. The men line up along the outside of the wall and then leap over it, but the woman has already disappeared, apparently absorbed into the tree. In a magical way, this work dwells on the fragility of individuality threatened by the social mass, while also suggesting that there is, or should be, a necessary wall between the secular and sacred worlds.

Tooba is deliberately cross-cultural. Not only has Neshat abandoned any reference to the Muslim veil and for the first time used exclusively non-Muslim actors, the work also draws a connection between Koranic notions of paradise and the Mexican veneration of the Virgin of Guadalupe, who is also depicted and who serves as a symbol of Mexican liberation. As with Neshat's preceeding videos, the politics of *Tooba* are allusive rather than direct, though one may read into it various thoughts about the meanings of freedom.

Neshat followed this with her most overtly political work, *The Last Word* (2003) (p. 247), which deals with the suppression of writers in her native country. Even with its political subtext, this video maintains a sense of mystery and poetry. It is a narrative about a woman who is evidently being interrogated and condemned by a group of men in a disheveled library/courtroom. The woman, who is free of the traditional chador, sits on one side of a wooden table while the men leaf through books and present open volumes as evidence of her turpitude. Dressed in white shirts, the men bustle about like busy ants while the woman sits silent and almost motionless before them. Then the chief interrogator unleashes a tirade in Farsi, after which the woman recites in her defense a poem, "The Window," by Iranian writer Forough Farokhzad, about the power of love. Even for those unacquainted with Farsi, the contrast between the music of her recitation and the angry diatribe of the man is obvious. She then stands up and silently departs.

This work, which was inspired in part by Neshat's own frightening interrogation seven years earlier, underscores the importance of poetry in Neshat's work. A feature of her early photographs, in which poetic texts were inscribed across her face and arms, it reappears at various moments (the love songs in *Turbulent* and *Pulse*, for instance) as a symbol of eroticism and mystery which no social or religious order can erase.

Neshat's most ambitious project, unfinished as of this writing, is a feature-length film based on the novel *Women Without Men* by the Iranian novelist Shahrnush Parsipur. This story takes place in Iran in the 1950s, during the U.S.-assisted coup d'etat that replaced Iran's first democratically elected government with the Shah. The book follows five Iranian women from different classes, illumi-

nating personal dilemmas that intersect only marginally with the larger political upheaval. Nevertheless, a sense of strife dominates the film, as each woman deals with her individual brand of madness. Finally, their very different conflicts bring them all together in a paradisiacal garden, where, it is suggested, redemption may be possible. Because of its outspoken treatment of the lives of women and the explicit treatment of sex and desire, this book was banned in Iran, and Parsipur was imprisoned for five years.

Neshat has been shooting each woman's story separately, and presenting them individually as narratives that offer fascinating character studies. The final film will integrate all the stories by intercutting back and forth between them. Among the stories is the tale of Mahdokht, a woman in her forties who is deeply sexually repressed, yet consumed by an obsession with fertility. She escapes to her family garden, and, in an echo of *Tooba*. attempts to transform herself into a tree. Finally, in an image that deliberately recalls John Everett Millais's *Death of Ophelia*, she is seen floating motionless in a pond, overlaid with fragmented images of her past and feverish mental state.

Contrasting to this is the story of Zarin, a prostitute who one day descends into madness and is unable to distinguish the faces of her male clients, whose features fade and become an empty blur. In horror she flees to a bathhouse, where she attempts to scrub herself clean of her physical and mental transgressions (p. 248). In a frenzy watched with disgust by the other patrons of the bathhouse, she finally rubs until her skin is bloody, then wraps herself in a black robe. She then stumbles on to a mosque, only to discover that even there, the male worshippers have also been wiped clean of facial features.

This focus on madness is not entirely new in Neshat's work, having also been the theme of *Possessed*. Nor is she alone in this interest, and in fact, there is an interesting kinship between her work and that of Finnish artist Eija-Liisa Ahtila, who also explores the interior landscape of madness. Both artists focus on female characters, bringing us inside their heads, where both the terror and the beauty of their visions is evident. Neshat differs from Athila, however, in the way she suggests there are exterior social sources for the descent into irrationality. In her narratives, madness seems connected to a rigid and uncompromising social structure.

As a result, one has the sense that in Neshat's work, madness is not entirely a negative thing, aligned as it is with imagination, freedom, and creativity. Neshat draws a parallel between these extreme mental states and the effects of social, political, and mental restrictions. The madwoman becomes a metaphor both for the artist and for the exile, who like the lunatic, is an outsider who will not and cannot fit in. She remarks, "Living in your imagination, you develop an internal world based on the power of the imagination. When all else is controlled, the poverty of your possibilities becomes a source of creativity."[10]

Neshat's development as an artist has paralleled the evolution of art world ideas about identity and globalism. From an early focus on cultural and ethnic iden-

tity, she has moved outward toward more universal themes and toward a recognition that all identities are necessarily hybrid.

Neshat's work reflects her multiple worlds, offering a powerful mix of personal, cultural, and cross-cultural references. She makes art through her identities as an Iranian and as a woman, but reshapes them to speak to larger issues of freedom, individuality, societal oppression, the pain of exile, and the power of the erotic. Mingling the personal with the political and expressions of identity based on gender with expressions of identity based on ethnicity—suggesting the tensions and convergences between East and West—she presents the experience of coexisting in many spheres. In this she offers a powerful model for the complexity of life in a global reality.

1. Leslie Camhi, "Lifting the Veil: Shirin Neshat Uses Video and Photographs to Explore the Status of Women in Islam," *Artnews* 99 (February 2000): 151.
2. Hamid Dabashi, "Border Crossings: Shirin Neshat's Body of Evidence," in Dabashi, RoseLee Goldberg and Giorgio Verzotti, *Shirin Neshat* (Turin and Milan: Castello di Rivoli Museo d'Arte Contemporanea/Charta 2002).
3. Susan Horsburgh, "The Great Divide: An Interview with Shirin Neshat," *Time* 56, no. 9 (August 28, 2000).
4. *Shirin Neshat*, interview with the author, July 2006.
5. "Shirin Neshat," interview with Octavio Zaya, *Interview*, September 1999.
6. Edward Said, *Orientalism: Western Conceptions of the Orient* (New York: Pantheon Books, 1978).
7. Shirin Neshat, interview with David Shapiro, *Artkrush*, September 2002.
8. "*Shirin Neshat*: Where Madness is the Greatest Freedom," interview with Adrian Dannatt, *The Art Newspaper* 12, no. 115 (June 2001): 76.
9. Ibid.
10. *Shirin Neshat*, interview with the author, July 2006.

Ellen Gallagher: Mapping the Unmentionable

ELEANOR HEARTNEY

It has been a long time since the champions of modernism have been able to argue that narrative and content were the enemy of quality, as Clement Greenberg did in 1940 when he proselytized for an art whose purity was not defiled by reference to any external reality.[1] In a similar vein, forty years later, Rosalind Krauss could still celebrate the widespread use of the grid by artists with the pronouncement: "The grid announces, among other things, modern art's will to silence, its hostility to literature, to narrative, to discourse." The grid, she added, "states the autonomy of the realm of art."[2]

But many artists today see supposedly neutral modernist formulas like minimalist geometry, the grid, and the archive as empty shells to be filled with subversive content. When Haim Steinbach equates art and commodity by placing high-end running shoes and lava lamps on shelves derived from the minimalist sculptures of Donald Judd, when Peter Halley takes Mondrian's geometry and makes it reference electronic circuitry and prison bars, and when Charles Ray homogenizes and serializes the family unit, presenting all members, from father to baby, as elements of equal size, they all make a mockery of modernism's formalist pretenses by using them for quite other purposes.

But few subversions of the modernist faith have been as unexpected or as transformative as Ellen Gallagher's injection of issues of race, class, and gender into Krauss's once impregnable grid. Gallagher, who is half Irish and half African American, mingles modernist devices with images drawn from ugly racial stereotypes and advertisements culled from pre- and postwar magazines directed at African American women. Her work is full of deliberate impurities. Apparently abstract paintings are composed of lines and bars created of cartoonishly Negroid lips and eyes. Monumental grid works are made up of found images of African American wig models altered with fantastical headdresses and helmets applied with molded yellow Plasticine. Her monochrome black paintings are covered with delicate raised rubber marks that create almost imperceptible black filigree images. Such works turn modernism's neutrality inside out, transforming it into a vehicle for reminders of the uneasy assimilation of African Americans into the country's larger culture.

Gallagher's white Irish mother hailed from Rhode Island, while her black father was a native of Cape Verde, an archipelago off the west coast of Africa. She was born in Providence, Rhode Island, in 1965 and attended Oberlin College, where she studied creative writing. Following a summer on an Alaskan fishing boat and a

semester in a study program conducted on a ship, she decided she wanted to be an artist and enrolled in the School of the Museum of Fine Arts, Boston.

As a person of mixed race, Gallagher avoids the essentialist approach to racial identity, preferring instead to see it through the lens of history. In her work, blackness operates as a mask that can be assumed and manipulated for a variety of purposes. She references the minstrel shows of the nineteenth and early twentieth centuries that revolved around stereotypes of blacks as lazy, comic buffoons. She dramatizes the demands placed on women, particularly black women, to conform to various ideals of beauty, and she excavates the changing meanings of race through literature, history and music.

Gallagher's first mature body of work appeared in early nineties. It consisted of minimalist paintings created over sheets of penmanship paper, those ruled

Oh! Susanna, 1993.
Oil, pencil, and paper on canvas, 60 x 36 in.
All reproductions of art by Ellen Gallagher courtesy of Gagosian Gallery

Blubber, 2000. Ink, pencil, and paper on linen, 120 x 192 in. The Art Museum at Princeton University, Princeton, New Jersey.
Photo: Tom Powel

sheets used by grammar-school children for handwriting practice. Gallagher glued these to canvases and used them as the guide for strings of marks which revealed themselves, at close range, to be the exaggerated facial features and vaudeville bow ties that were the signature of minstrel performers. The minstrel show was a form of entertainment in which actors made themselves up in blackface, with huge white lips and bug eyes meant to be read as a comic caricature of African American features. In the beginning, minstrel performers were exclusively white, but after the Civil War, African Americans like Bert Williams also emerged as popular minstrel entertainers, painting their faces to conform to the expected format. In these cases, questions of identity and identification became complex, as real African Americans turned themselves into caricatures of caricatures, a feat which in turn highlighted the stereotype's artificiality.

Explaining her fascination with this idea, Gallagher has noted, "Blackface minstrel is a ghost story. It's about loss: there's a black mask and sublimation ... Like Melville, blackface minstrel was the first great American abstraction, even before jazz. It's the literal recording of the African body into American public culture. Disembodied eyes and lips float, hostage, in the electric black of the minstrel stage, distorting the African body into American blackface."[3]

Gallagher has orchestrated these signs of blackness in a variety of ways. In *Oh! Susanna* (1993) (see p. 253), tiny eyes and lips alternate in wavy bands, periodically interrupted by little blonde wig shapes and white faces that hint at the more desirable ideal that owners of the eyes and lips can never attain. From a distance the work becomes a tapestry-like overall pattern, seductive as the abstract marks on a peacock's tail. In *Afro Mountain* (1994) the lower half of a ground of yellowed lined paper is filled with rows of tiny drawn lips. They undulate slightly and vary in darkness, so once again, from a distance, the work suggests a finely etched weave.

Gradually Gallagher began to free her motifs, setting them into swirls and curlicues, or inscribing them in curving lines snaking across empty grounds. She also began to widen her repertoire, adding commalike shapes which suggested the smooth flip wigs adopted by black women to cover their unruly hair, along with dots to suggest their faces. And she began to treat the penmanship paper as a compositional device, cutting it into strips and piecing it together into forms that mimicked the arabesques of the comma-wigs. Gallagher has noted her interest in jazz syncopation and these works clearly aspire to a musical rhythm. In *Blubber* of 2000 (opposite), for instance, the commalike shapes are scattered unevenly like a flock of crows over the lightly gridded painting surface. Tiny black dots turn them into faces. Tumbling across the lower third are several graceful curves pieced together like marquetry from bits of penmanship paper.

Beginning in 1998, Gallagher also began to create a number of black paintings in which a flat black ground became host to accretions of shiny raised black rubber. Again these tiny elements were based on her signature motifs. They came together to suggest images like a tree, a string of seaweed, an African sculpture, or the back of a scarified head. These representations are nearly invisible, and always seem on the verge of dissolving back into their black ground. They are most apparent when viewed in raking light slightly from the side. Their frailty serves as a metaphor for the disappearance of the black body into the morass of contemporary consciousness.

The adoption of pernicious racial stereotypes is a tactic that has been used by a number of African American artists to defuse their sting. Artists as diverse as Robert Colescott, Michael Ray Charles, Kara Walker, Renee Cox, and Fred Wilson have incorporated representations of demeaning characters such as Sambo, Mammy, Aunt Jemima, and Uncle Remus into their work, using humor and irony to unearth and undermine the larger cultural attitudes which they embody (p. 256).

Gallagher's use of these motifs differs from theirs in its subtlety and its dependence on the strategies of modernist painting. She notes that she is less interested in the minstrel performers than in the ephemera that surround them and become characters in their own right. Fat lips and bulging eyes are sublimated within nearly abstract works that a number of commentators have likened to the restrained poetic geometry found in the paintings of Agnes Martin. The use of the ruled penmanship paper underscores the formal rigor of these works, while

KARA WALKER,
*Freedom Fighters for the
Society of Forgotten
Knowledge, Northern
Domestic Scene*, 2005. Cut
paper and adhesive on wall,
120 in. x 40 ft.
(304.8 x 1219.2 cm).
Photograph courtesy of Sikkema
Jenkins & Co.

providing a metaphor for the ordering principles by which society enforces roles and behaviors.

Gradually, Gallagher's works began to take on more gender-specific forms. This was spurred by her growing fascination with the images in the advertising sections of midcentury black culture magazines. In publications like *Ebony*, *Black Digest*, and *Our World*, Gallagher discovered another lost world, this time relating to the efforts of fashion-conscious black women to conform to socially acceptable norms of beauty. The pages of these publications are full of advertisements for skin whiteners, hair straighteners, hair extensions, and wigs. The latter either overruled the naturally hued kinkiness of black hair or allowed the wearer to go "natural" by donning a realistic-looking Afro. Other products offered solutions to various physical problems, among them acne, corns, bunions, and asthma. Or they promised to mitigate the embarrassment of skin that was too dark. They attested to the anxiety felt by the magazines' readers about the inadequacy of their physical bodies.

Explaining her interest in these ads, Gallagher comments, "These women are not just trying to be beautiful; they had to have these prosthetics. It's about what you needed to go out the door, like you weren't even reasonable until you put these on. You need to be transformed, constricted by the humiliation of your own hair or these things all over your skin. Nothing's right! Your skin needs to be whitened, or

you have acne or bunions. ... So overwhelming. Everything needs to be transformed just to be acceptable."4

Gallagher's first artistic forays into this territory involved alterations made to the pages of such magazines. A number of works in this vein were part of the exhibition *Preserve* at the Des Moines Art Center in 2002. Using Wite-Out, she erased the eyes of wig models or gave them the bulging eyes characteristic of minstrel performers. Often she exaggerated this effect by attaching stick-on toy eyes. She used black ink to exaggerate or block out their wigs, or to cover them with her signature "nigger lips." In other works she cut out features and wigs. She also began to cover parts of the images with Plasticine and pomade. The result was to transform these symbols of the aspiration to beauty into weird aliens or monsters.

The works in this series have titles like *Falls and Flips*, *Glow,* or *Power Falls*, which suggest the wigs and hairpieces that inspired them. Generally they adhere to the grid structure, reflecting the way that these advertisements were originally presented on the magazine page. On occasion Gallagher deliberately upsets the grid, collaging the wig heads in a more irregular pattern. Taken together, these works make playful reference to the idea of the archive, simultaneously celebrating and undermining modernist notions of order expressed by adherence to abstract structures.

While Gallagher was initially drawn to the wigs themselves as signs of identity, she gradually grew equally interested in the surrounding texts. She notes that the names given to products become ways of charting midcentury attitudes toward race and beauty—the wigs were created our of synthetic fibers with names like Afrilon and Afrylic, while the wigs themselves had names like Nu-Nile, Kongolene, and Freedom Puff.

The Des Moines show included *Ugly Itching Skin* (p. 258), a collage that takes its name from a small ad offering to solve this problem. Surrounding this block of text, Gallagher has collaged a scattering of various altered wigs, setting them over blocks of text cut from articles in the magazines referring to romantic travails. *A ha o girl oo* (p. 259) takes its name from a caption swathed across a page advertising "real" hairpieces. Gallagher rendered this come-on unintelligible by blacking out certain letters. The phrase then becomes like the abstract croon of R & B backup singers. Gallagher further accentuated the slippage between intended and created meanings by cutting up the faces of the wig models and reassembling them slightly off kilter.

Yellow, also included in this show, looks ahead to Gallagher's next body of work. Here a regular grid of small collaged faces of the sort that beam from collage year book pages have each been altered by cutout hair shapes. These turn bright yellow when placed against the work's yellow ground. The color has social significance, denoting American society's supposed ideal of blondness. The faces' dark eyes have also been whited out, suggesting a further desire to conform to Caucasian standards of beauty.

Ugly Itching Skin (Preserve), 2001.
Oil, pencil, paper, and plasticine with text
on magazine page, 13¼ x 9½ in.
(33.6 x 24.1 cm). Photo: Tom Powel

A ha o girl oo (Preserve), 2001. Oil, pencil, paper, and plasticine on magazine page, 13 x 10 in. Photo: Tom Powel

Preserve, 2001. Rubber and
enamel on wood with
metal screws, 10 x 12 x 32 ft.
Photo: Cameron Campbell

Also included in *Preserve* was a sculptural work of the same name (opposite). It takes the form of a child's jungle gym, painted porcelain white and covered with raised reliefs. From a distance they resemble stylized foliage, while close up it becomes clear that the relief forms recapitulate Gallagher's signature motifs—eyes, lips, tongues, and comma-wigs.

Preserve is unusual for Gallagher in being a three-dimensional work, but its adherence to the grid format is in keeping with her formal interests. The white geometrical structure inevitably brings to mind the grid sculptures of Sol LeWitt, but again here, rigorous order coexists with subversive content. Like the penmanship paper of Gallagher's earlier works, the jungle gym speaks of the coercive aspects of childhood training. Meanwhile, as some observers have pointed out, the name of this piece of playground equipment has potentially racist connotations, conjuring racial epithets like "jungle bunny" or "porch monkey."

In subsequent works, Gallagher began to play the images culled from magazine pages off the texts in ever more elaborate ways. *Pomp-Bang*, from 2003 (pp. 262–263), consists of 396 individual pages laid across an eight-by-sixteen-foot canvas in a grid format. Each page represented a different ad, digitally scanned and scaled up or down so that each was the same size. On each page, Gallagher altered the image with built-up bright yellow or orange Plasticine, turning ordinary people into strange hybrid creatures with head gear drawn from every corner of the worlds of nature, architecture, science fiction, and history. One character seems to have been transformed into an octopus;, another, above the caption "the Lioness," sports an orange mane. Yet another has headgear that is literally woven together from strips of yellow Plasticine. In these works the yellow color of the Plasticine begins to refer, not only to the fantasy of blondness, but also to a bizarre and unnatural reality in which animals, humans, and machines seem to have melded.

Plasticine is a putty-like modeling material made from calcium salts, petroleum jelly, and aliphatic acids. Gallagher notes that she chose this material because of its formal qualities. She describes it as skin-like and adds, "The Plasticine is meant to allude to that idea of mutability and shifting, because Plasticine is used in animations and Claymation. Much the same way that penmanship paper is not a fixed material, the Plasticine will always continue to be vulnerable."[5]

Taken together, the individual pages of *Pomp-Bang* (the name is taken from a caption on one of the ads) form a map of the strange world that the artist was beginning to inhabit. Certain characters emerge and recur. One of these is Peg-Leg, who was actually a black entertainer at a hotel in the Catskills. Gallagher outfits him with a yellow Plasticine leg and notes that she associates him with Captain Ahab from *Moby Dick*, whose nemesis, after all, was the Great White Whale.

Another recurring character is the Nurse, a figure who is frequently presented in these pages as a viable model for ambitious black girls. Her presence in this work is also inspired by the story of Eunice Rivers, the black nurse who recruited a

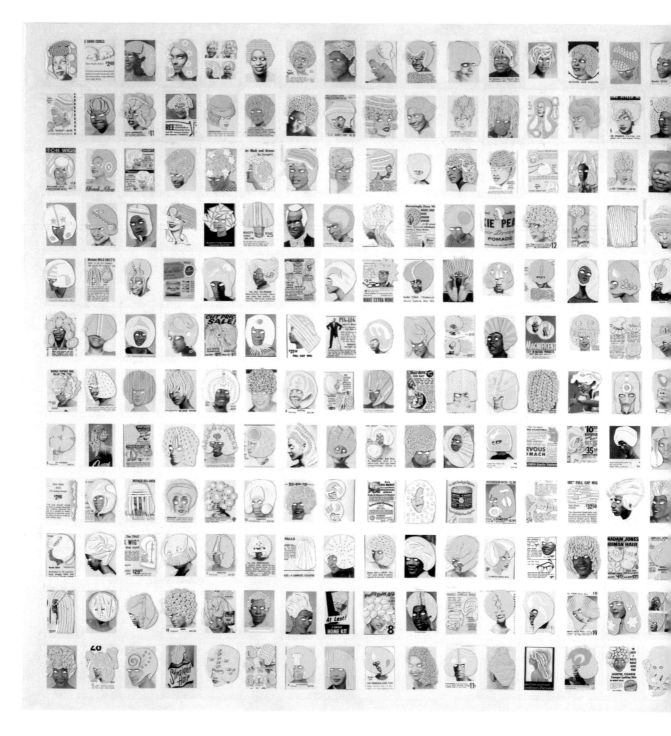

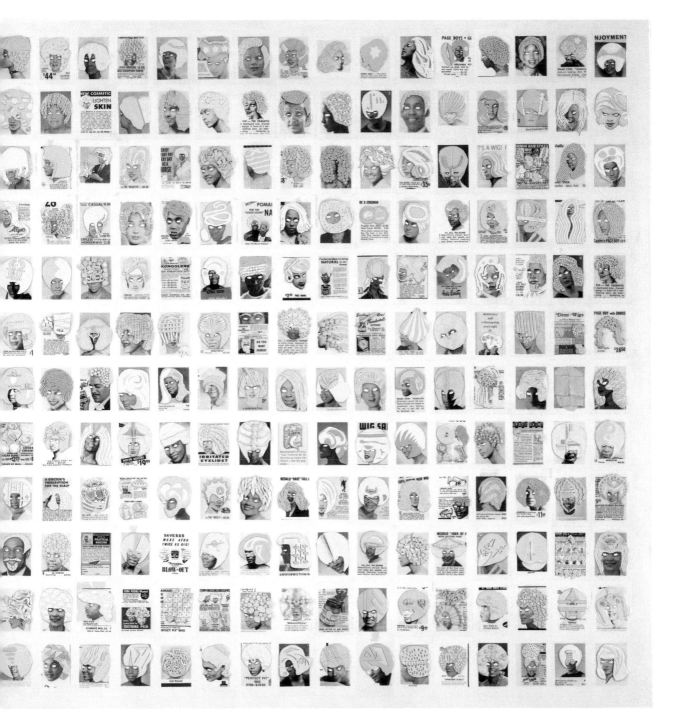

Pomp-Bang, 2003. Plasticine, ink, and paper mounted on canvas, 96 in. x 16 ft. (244 x 488 cm). Collection of the Museum of Contemporary Art, Chicago, Joseph and Jory Shapiro Fund by exchange and restricted gift of Sara Szold.
Photo: Tom Powel

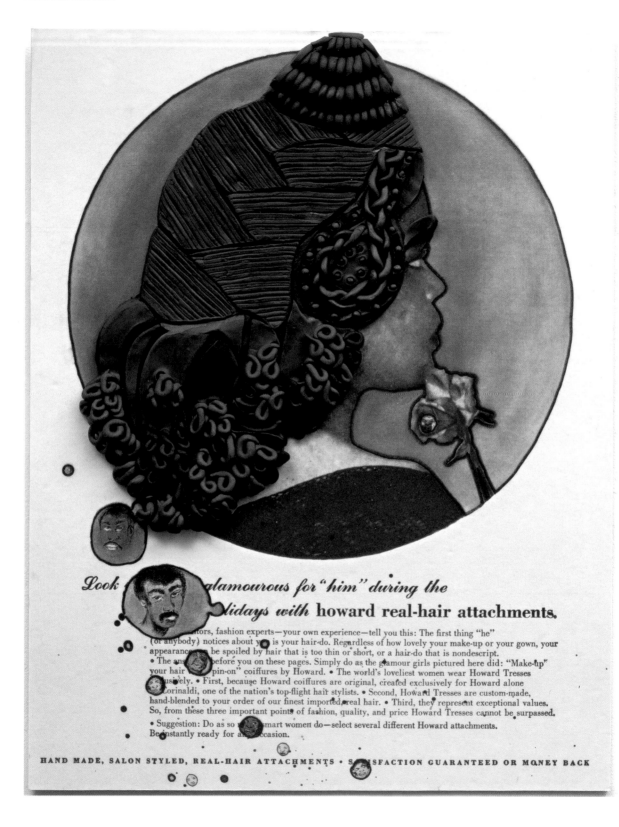

group of impoverished black men to participate in the notorious Tuskegee experiment. Rivers felt she was helping them because they were receiving medical care for the first time in their lives; but the point of the experiment was to follow the course of their untreated syphilis until they died. Both Ahab and Rivers are ambiguous figures who hover somewhere between hero and villain, suggesting a world where simple binaries are no longer sufficient.

Gallagher continued these explorations in *eXelento* of 2004 and *DeLuxe* of 2004–5 (opposite), in which grids of wigs and beauty products are reinvented with ever more elaborate and fanciful additions. In these works, the cultural references get broader, as when Gallagher plays off a vintage news report on the Tuskegee experiment; incorporates a photograph of Lloyd Sealy, the first African American to command a precinct in Harlem; or surrounds musician Isaac Hayes with a swirling mandala of velvet cutouts. They began to encompass the whole of a little-known history of African American life in the mid-twentieth century.

DeLuxe is Gallagher's most ambitious work to date. It is a suite of sixty prints, joined together to make a large-scale work. Each panel offers a little world unto itself and employs a remarkable array of printmaking techniques including photogravure, digital imaging, lasers, direct etching, photo etching, and screenprinting. Sections began as collages, were then made into photogravures, a mid-nineteenth-century printmaking technique that here renders all the images in the collage flat and uniform. These became the base for myriad transformations. Along with Plasticine additions, Gallagher also attached rhinestones, brown felt, or gold leaf, layering cutouts over them and applying drawings of lips, stockings, sea creatures, eyes, and even hamsters to the works. She explored a wide range of compositional devices—some focus on a single figure while others contain neat rows or scattered clusters of small heads. The colors are more diverse as well, with flashes of pink, red, blue, and green joining the bright yellow of earlier works.

In *Pomp-Bang*, *eXelento*, and *DeLuxe*, Gallagher plays with the idea of otherness, turning her black wig models, entertainers, and historical characters into newly minted androids, aliens, and chimeras that exist between the worlds of fact and fantasy. Their sense of displacement reminds us of the uncertain position of African Americans in American society. This is particularly the case for women, who remain the central figures in Gallagher's work. Subjects of a double oppression, they must deal both with the inferior position of women in a male-dominated society and the oppressions of race in a white world. Further complicating the situation are the lingering effects of white fantasies about the voracious sexuality of African women, a mythology born in the slave era when black women both threatened and titillated their more "civilized" white owners. All these mixed messages find their way into Gallagher's works.

Critics have connected Gallagher's wig imagery to a larger cultural dialogue about the importance of hair in black society. For African American women during the 1940s and fifties, hair was a symbol of their otherness—it could only be coerced

American Beauty (DeLuxe), 2004–5. Photogravure, aquatint, spitbite, and plasticine, 13 x 10 inches (33 x 25.4 cm). Photo: D. James Dee/Two Palms Press, New York

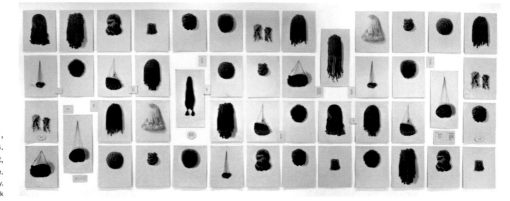

into the acceptable hair styles of the day through elaborate chemical processes. By the sixties and seventies the natural coiled hair of the Afro became a badge of honor for men and women who took pride in their otherness. At the same time, scholars and artists began to investigate the meanings of hair in African tribal life, noting that bodily ornament in the form of elaborate coiffures, scarification, and tattoos were ways of indicating tribal identity and status.

Drawing on such ideas, a number of contemporary African American artists have created work that deals with the significance of black hair. Alison Saar has created sculptures in which hair becomes a ritual object of sorts, attaching a woman to other elements of her ancestral past and personal history. Lorna Simpson shares Gallagher's fascination with wigs, creating her own *Wigs (portfolio)* (above), a lithographic inventory of various black hair styles created through braiding, dying, and weaving.

Nor is the fascination with hair limited to African American women. Petah Coyne has created a number of sculptures in which thick shanks of horsehair entangle Madonna figures, while Kiki Smith produced a sculpture of a nude Mary Magdalene covered by a thick fur of hair. In such works, hair expresses sexuality, animal nature, and ethnic and racial identity.

Gallagher takes a more sociological approach—seeing hair as a way to access otherwise inaccessible histories. She says of her wig works, "The wigs themselves have information embedded within them. They start from the 1930s and go until about 1978, but here they are neither really chronological nor wholly arbitrary. The wigs admit an anxiety about identity and loss; they map integration, the civil rights movement right through to Vietnam and women's rights. And they chart an emerging Afro-urban aesthetic where the Afro becomes this important way of taking up space in the city."[6]

Recently Gallagher has turned her attention to other lost worlds. Due perhaps to her own ancestral ties, by way of her father, to the Cape Verde Islands, she

Untitled (Watery Ecstatic Series), 2004. Watercolor and cut paper, 16 x 19³/₄ in.
Photo: Tom Powel

has recently begun to incorporate imagery that deals with the sea, the Middle Passage (the leg of the slave trade that brought African captives to the Americas, generally under horrific conditions) and Drexciya, the mythical underwater country said to be populated by the children of pregnant African women thrown off of slave ships.

Drexciya and the utopian fantasies it nurtured appear in Gallagher's work in a variety of forms. Her Watery Ecstatic series drawings, begun in 2001 (above), include images of imagined sea creatures carved out of thick watercolor paper. Gallagher deliberately mimics the process of scrimshaw, the bone carving done by sailors on whaling ships to pass the time. She notes that scrimshaw images traditionally took three forms: images of home, naked ladies, and whaling. She has taken this idea and applied it to home in a more mythical sense as the place of both origin and return for the troubled souls of the Middle Passage.

In her drawings, tendrils of drifting sea creatures are lined with tiny faces or tentacles composed of her signature eyes. Among the denizens of her deep are

ELLEN GALLAGHER
AND EDGAR CLEIJNE,
Monster (Murmur), 2003.
16mm film still.
Courtesy of the artist and
Gagosian Gallery

fantastical sea creatures, crustaceans, exotic seaweed, and jellyfish. Colors are rich and evocative—sea greens, berry reds, and rich browns. Other drawings are white-on-white works on paper, in which great fishes appear to be attacked by creatures with tiny black faces in their tentacles. These works are more freeform and lyrical than previous works, creating a dreamlike world where beauty contains the promise of freedom.

Dreams of Drexciya also underlie Gallagher's *Murmur*, which is a series of five 16mm film projections made in collaboration with Edgar Cleijne. In one, bits of white Plasticine shaped to resemble sea creatures descend down into Drexciya. In another, heads treated to Gallagher's collage alterations bob up and down in the waves. In yet another a shoal of bewigged heads move and twist like fish in a downward spiral. As with her drawings and prints, the films exhibit Gallagher's promiscuous embrace of techniques ranging from Claymation to stop-frame and scratch animation, which involves working directly on the filmstrip by scratching into the emulsion layer.

The films also reference Gallagher's ongoing interest in science fiction–like transformations. One segment, *Monster* (above), involves alterations worked upon

the footage from a 1950s film, *It Came from Outer Space*. Speeded up, slowed down, scratched, and overlaid with drawn imagery, it remakes this bit of Cold War paranoia for a new generation.

In 2005 Gallagher was invited to create an installation in the Freud Museum in London, in the building where Sigmund Freud spent his last days. The invitation threw Gallagher back to her student days when she spent a semester aboard an oceanographic research vessel researching the migratory patterns of a species of wing-footed snails. She discovered that as a young man, Freud was also fascinated by marine biology; his first scientific paper, published in 1877, dealt with the nervous system of the Petromyzon, a species of lamprey, and provided support for Darwin's theory of evolution. Freud created a number of beautiful drawings of this organism in the course of his research.

Sensing a kindred spirit, Gallagher proposed an intervention in Freud's study. She placed specimen jars containing her own fantasy sea creatures alongside Freud's collection of antiquities and installed both his research drawings and works from her own Watery Ecstatic series. She also found a place for projection of a pair of her films dealing with the documentation of ocean specimens.

Abu Simbel, 2005. Photogravure, watercolor, color pencil, varnish, pomade, plasticine, blue fur, gold leaf, and crystals, 24^{1}/$_{2}$ x 35^{1}/$_{2}$ in. (62.2 x 90.2 cm)

The biggest intervention, and one which caused some controversy, involved a photogravure of the Egyptian temple of Abu Simbel that hung over Freud's desk. Its prominence reveals Freud's fascination with Egypt, while also underscoring the pervasiveness of Orientalist thinking in the early twentieth century. Initially Gallagher wanted to remove it, allowing it to act as a psychic absence. When the museum directors objected, she proposed instead to simply alter a replica, and replace the original with her new version. This met with the director's approval.

Gallagher's alterations bring this work into line with her earlier wig transformations. She collaged images of nurses, faces, eyes, and lips from her store of vintage "race" magazines over a reproduction of the awe-inspiring effigies of Rameses II. The most striking alteration involves the addition of a spaceship from the jazz musician Sun Ra's film *Space is the Place*. Thus she provided an imaginative continuity between the ancient mysteries of the Egyptian pharaohs, their place in the thinking of the founder of psychoanalysis, and their impact on our contemporary fascination with cosmic travel and transformation (p. 269). As Gallagher described it, this work creates "a tricked-out, multi-directional flow from Freud to ancient Egypt to Sun Ra to George Clinton."[7]

Gallagher's work continues to deepen as she elaborates upon longtime motifs and themes in increasingly narrative scenarios. A 2006 painting *Bird in Hand* (opposite), for instance, takes her old friend Peg-Leg and turns him into a fantastical aquatic creature, entangled in mangrove roots, whose legs sprout tentacles while his head explodes in an elaborate headdress of undulating amoebic forms. He is linked as well to the Freud project in that Gallagher relates him as well to Sun Ra's astronaut and the idea of the voyage to the unknown.

Gallagher has moved far from her early efforts to reconcile minimalism and message. But even as her works have become increasingly maximalist, she has

ORLAN, *Self Hybridization Precolumbian No. 4*, 1999. Aluminum-backed Cibachrome. Collection Walker Art Center, T. B. Walker Acquisition Fund, 1995.

Bird in Hand, 2006.
Oil, pencil, gold, plasticine,
gold leaf, and paper on
canvas, 93³/₄ x 120⁷/₈ in.
(238 x 307 cm)

retained her fascination with the tropes of race, the contingency of history, and the mutability of identity. As she is quick to point out, she was never involved in a simple critique of racial attitudes. In an 2001 interview with curator Jessica Morgan, she noted, "These are not corrective works. They are much more about building something from this given. It was about taking a given literal fact and then expanding on it."[8]

As her work has evolved, this has become ever more clear. Her works play with the signs of race, identity, and history, not the things themselves. More recently, she has remarked, "I'm interested in signs not as static but as moving, as things that start with something that has already been discarded. And I try to make my images through that—the unruly cracks in the edifice, underneath which there is something to be protected."[9]

This allows her to loosen the rigid categories that are used to define identity and to look beyond them to the hybrid reality of contemporary American society. In this her work has much in common with that of Adrian Piper, an African American artist whose films, installations, and performances exploit confusions created by her own light skin to undermine racial distinctions.

Meanwhile, Gallagher's delight in melding different categories of being recalls the work of the French artist Orlan, who uses digital imaging to alter images of her own face, allowing her features to meld with the (to Western eyes) distorted features of pre-Columbian and African sculptures (p. 270). In these works, Orlan's unmistakable eyes peer from faces sporting elongated necks and noses, strange protuberances, flattened foreheads, elaborate ornamental markings, and helmetlike hair arrangements. Like the strange characters who peer with empty eyes at us from Gallagher's *DeLuxe*, *eXelento*, and *Pomp-Bang*, these creatures are both futuristic and primitivist, suggesting the possibility of some new breed of human drawn from the whole of mankind's genetic store.

Taken as a whole, Gallagher's work points us toward a strange new world where fusion, rather than purity, is the order of the day, and identity is a matter of self-construction. From her early penmanship drawings to her work relating to Freud and Darwin, one constant has been her adherence to the principle of adaptation and mutability. Thus her work shares much with the modernist art that she has used as a touchstone throughout her career, as it looks beyond the world as it is to various utopian possibilities, and draws a map to suggest how we might attempt to get there.

1. Clement Greenberg, "Towards a Newer Laocoon," *Partisan Review* 7 (July–August 1940): 296–310.
2. Rosalind Krauss, "Grids," reprinted in *The Originality of the Avant-Garde and Other Myths* (Cambridge, Mass.: MIT Press, 1985), p. 9.
3. "'History and Drag,' Ellen Gallagher in Conversation with Cheryl Kaplan," *DB Artmag* 33, Jan. 2006, db-art.info .

4. "1000 Words: Ellen Gallagher," *Artforum* 42, no. 8 (April 2004): 131.

5. Interview with Ellen Gallagher, *Art 21: Art in the 21st Century*. Season three ([Alexandria. Va.]: Art 21, Inc.; distributed by PBS Home Video, 2005; www.pbs.org/art21/artists/Gallagher).

6. "1000 Words," p. 131.

7. Quoted in press release for *Ichthyosaurus*, exhibition at the Freud Museum. Curated by James Putnam, July 28–September 25, 2005.

8. Jessica Morgan, "Ellen Gallagher," interview, in *Ellen Gallagher* (Boston: The Institute of Contemporary Art, Boston, 2000), p. 23.

9. "1000 Words," p. 131.

Dana Schutz: The Elephant in the Living Room

SUE SCOTT

Dana Schutz was fifteen when she began painting seriously in the basement of her mother's house in Lavonia, Michigan. Vocational tests in school at that time revealed she would make an excellent bricklayer. For the artist, painting is in itself the act of building. The first painting she remembers is a van Gogh self-portrait and her "mom telling me that if the painting were laying flat on the ground you could pick it up by the nose."[1] That love of surface texture has stayed with her from her early

Frank as a Proboscis Monkey, 2002. Oil on canvas, 36 x 32 in. (91.4 x 81.3 cm).

teens. Little more than a decade later, and the same year she graduated with an MFA from Columbia University, Schutz rose to prominence with her first solo exhibition at LFL Gallery in New York. Entitled *Frank from Observation*, the exhibition included twelve paintings that built a world for a hypothetical character named Frank, with paint application so thick that the log or nose or leg leaps into the viewer's space. "The paintings are premised on the imaginary situation that the man and I are the last people on earth," Schutz explained in the press release issued with the show. "The man is the last subject and the last audience and, because the man isn't making any paintings, I am the last painter."[2]

Over the next four years Schutz had solo exhibitions in Paris, Berlin, and Boston galleries and in museums around the United States.[3] She was included in prestigious international group shows, including biennials in Venice (2003), Prague (2003), and at the Corcoran Gallery of Art in Washington, D.C. (2005), and impor-

Self-Portrait as a Pachyderm, 2005. Oil on canvas, 23 x 18 in. (58.4 x 45.7 cm)

All reproductions of art by Dana Schutz courtesy of Zach Feuer Gallery (LFL)

Reclining Nude, 2002.
Oil on canvas, 48 x 66 in.
(121.9 x 167.6 cm)

tant group shows in London and New York. Critics and viewers responded to her offbeat hypothetical situations (she once said she would rather paint the wrinkle on a man's forehead than the opening of the Olympics); primitive settings; her uninhibited view of what a painting can be (she once painted a brushstroke jumping over a wall); and her bold use of high-key color and aggressive, raw brushstrokes. Her work is an amalgamation of memory, biography, current experience, history, art history, popular culture, music, television reality shows, and quirky humor.

Her subject in *Frank from Observation* may have had his genesis years before when, working in a restaurant in Southfield, Michigan, Schutz waited on Dr. Jack Kevorkian, the pathologist known for his advocacy of and participation in euthanasia, who ordered everything "burned to a crisp"—as she remembers it a "charred, sort of cremated breakfast."[4] He looked at her name tag, commented that she had a boy's name, and joked that her parents could have done better by naming her Frank.

Schutz records Frank's activities with detached humor. He is an aging surfer type with a stringy bleached comb-over and a scraggly blond beard who faces his viewers with unblinking blue eyes and a big nose. Usually he is naked, though he sometimes wears a blue work shirt, perhaps referencing his life before the rest of the population disappeared. Frank is shown lounging naked on a rock, on the beach, and even as a devolved primate with apelike features in *Frank as a Proboscis Monkey* (2002) (p. 274); his loneliness is accentuated in the night scenes *Frank at Night*

(2002) and *Chicken and Egg* (2003), in which he stands at an abstract sculptural telescope and the moon is a giant fried egg reflected in a pond below.

Painting a nonexistent man in an undetermined environment is a comment on the act of painting: an artist is before a blank canvas with the power to create a new world. If creating metaphorical situations is Schutz's point of departure, exploring the use of space in painting is an important formal concern. For example, in *Frank as a Proboscis Monkey*, the foliage allows for a fractured, cubist space; in *Reclining Nude* (2002) (opposite) he lounges as an odalisque on the sand, his penis slightly erect, presented across his leg in a nod to the long-venerated tradition of passive recumbent women subjects. One thinks of Sylvia Sleigh's pinup men from the

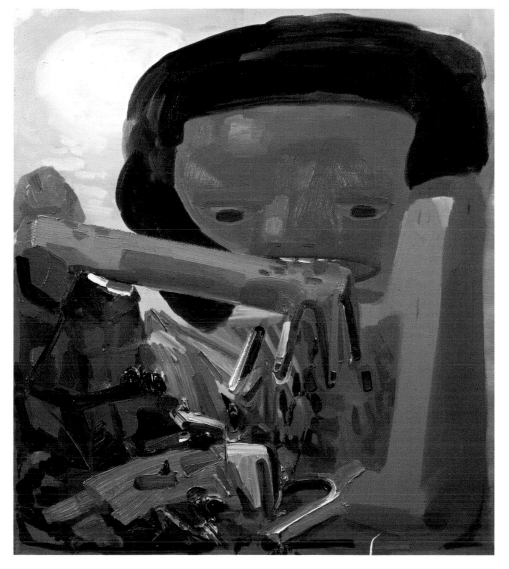

Self-Eater 3, 2003.
Oil on canvas,
43 x 29 in. (109.2 x 73.7 cm)

1970s or, especially, Alice Neel's reclining nude *John Perreault* (1972), which shares many spatial similarities. Frank's pink play-dough body floats on a precarious middle ground, an imagined space that he could almost fall out of if the picture were tipped. In Neel's male version of the odalisque, the art critic reclines nude on a white sheet, his head resting on his arm and one knee bent over the other, jutting out into the viewer's space.

It was in *Frank from Observation* that Schutz began to explore the possibilities of expressive color: "I wanted the palette to operate in a more subjective manner. I think of color in a bodily or physical way and tend to make decisions about it when I am visualizing what I am about to paint. If I make a painting of a sick man I want the color to describe how sick he is and in what way he is sick."[5] Schutz recycled some of Frank's body parts to make two women in *The Breeders* (2002), named for the all-girl band: "Although he is configured into a musical group, it is impossible for him to make music, seeing as how he is dismembered, and, in any case, in painting you can only make an allusion to music."[6]

In subsequent exhibitions Schutz built on what she calls metanarratives. Her scenarios went on to include a series of "what ifs"; rock stars as monuments; self-eaters; ungrounded phobias such as fear of gravity; or mundane and thoughtless activities that have no form, such as sneezing or staring. *Stare* (2004), for instance, was based on a David Sedaris short story in which a girl spends four hours staring at her hands; both writer and artist were able to build a portrait from a non-event. *Sneeze* 2 (2001) (opposite) depicts the distorted face of a dark-haired balding man, whose powerful sneeze seems to have blown apart the lower half of the painting. Paint extruded from the tube becomes a line of snot. Comparisons of bodily functions to the process of painting, in this case the viscosities of mucous and paint, appear throughout Schutz's work in both coded (like Jackson Pollock's drips) and unmediated paint strokes.

Many of the paintings in the 2004 exhibitions *Self-Eaters and the People Who Love Them* at Galerie Emmanuel Perrotin in Paris and *Panic*, her second solo show at Zach Feuer (LFL) in New York were based on the bizarre notion of a group of people who regenerate by consuming their own flesh. Schutz expanded the concept to include a community of self-eaters who could rejuvenate not just themselves but their world. Like *Frank from Observation*, the idea was a metaphor for painting, for the dependence of contemporary art on its own history. Though some critics and observers had problems with Schutz's "bad painting" and overt historical references, others saw in her expressive brushwork and art historical quotations a fresh approach to representational narrative painting. Roberta Smith praised *Panic* in *The New York Times*: "Ms. Schutz's second solo exhibition is outstanding. It shows her attempting, if not always mastering, her own kind of history painting, while cultivating the strange home alone figures that are her hallmark."[7]

The small, beautifully realized *Self-Eater 3* (2003) (p. 277) is German Expressionist in both palette and the way the young girl's face and upper torso

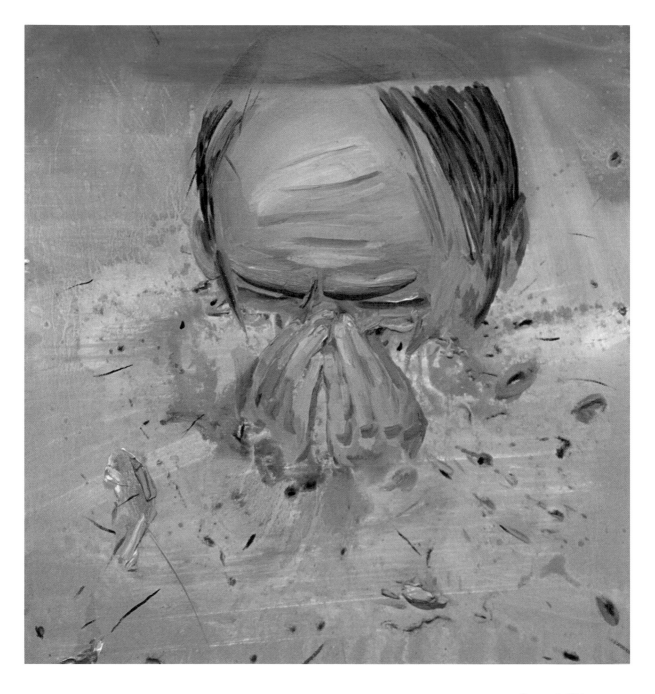

Sneeze 2, 2001.
Oil on canvas, 20 x 19 in.
(50.8 x 48.3 cm)

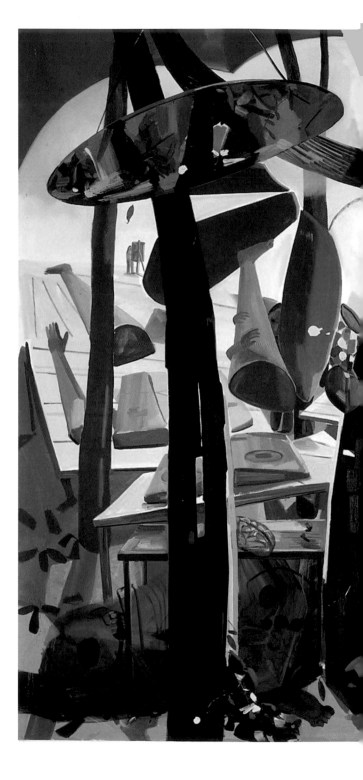

Civil Planning, 2004.
Oil on canvas,
114 x 168 in.
(289.6 x 426.7 cm)

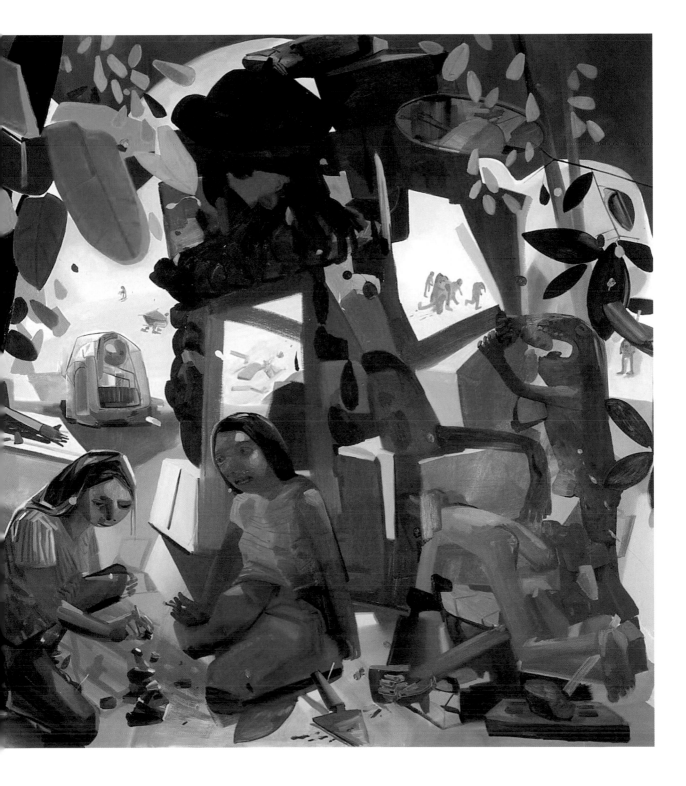

crowd the frame. Even as the girl eats her pink and brown plank of an arm, the fingers fall into a claylike pile, presumably the raw material, straight from creation myths, from which she can rebuild herself; the lower left section is a small abstract composition framed by the girl's two arms. In *Twin Parts* (2004) a half-completed cubist monster selects body parts—noses, the back of the head, toes, legs—from shelves and tables that surround her. The horizon line splits the canvas where the girl stands on a carpet of flowers and plants, the sky with yellow and white clouds in the background. As with a number of Schutz's scenarios, the outdoor setting is primeval and futuristic, a future restored after destruction.

The fourteen-foot painting *Civil Planning* (2004) (pp. 280–81) is an ambitious and complex layering of space, structure, and meaning. Two girls kneel in the center of the picture, one beginning a small structure as the other girl looks on, an unused trowel at her feet. Schutz's idea was to paint loiterers, but even that idea is enigmatic. "As a painter who is advancing on the sheer force of ecstatic imagination, ideation, and subject color," critic Meghan Daily wrote in *Artforum*, "Dana Schutz just might be our finest contemporary symbolist."[8] In fact, the artist was thinking about the narrative space, contemporary anxieties, and ambiguous meanings in Gauguin's *Where Do We Come From? What Are We? Where Are We Going?* when she painted *Civil Planning*. Is the one girl listening? Or is she off in her own world? Mirrors are mounted on banana trees and body parts in all shapes, sizes, and colors are strewn about on tables, or stacked in the clearing and the woods. A reptilian self-eater munches on the structure that surrounds the girls, sacrificing himself to continue the process. There is a struggle of some sort in the background, and people are dragging off an inert body. A tiny figure at the back left—presumably the artist herself—stands before an easel, recording the activities on canvas. By placing the action between herself and the viewer, Schutz gives her audience a role in realizing the artwork.

Though they may read as narratives, none of Schutz's paintings or series can be reduced to a simple story. Instead, she sets up situations that trigger outcomes that fuel oblique and loosely connected narratives. Critics and art historians have suggested a wide array of artists and movements they consider influential to Schutz, mostly gestural, figurative work such as Philip Guston's late paintings, fifties Bay Area figuration, and the more expressionistic work of Malcolm Morley. Some point to historic paintings, for example the ethereal Tahitian settings of Paul Gauguin or the Fauves and German Expressionists. Certainly there are remnants, two decades later, of the neoexpressionists and New Image painters. Schutz admires Ernst Ludwig Kirchner's unexpected use of color, Laura Owens's poetic subjects and the distinctive use of space and her shifts between abstraction and the pictorial, Cecily Brown's unapologetic use of gesture, Philip Guston's reinventions of himself, as well as Alice Neel, Cindy Sherman, and Charles Ray. The artist Peter Halley once noted in an interview that Schutz seemed to be "carving form out of space."[9]

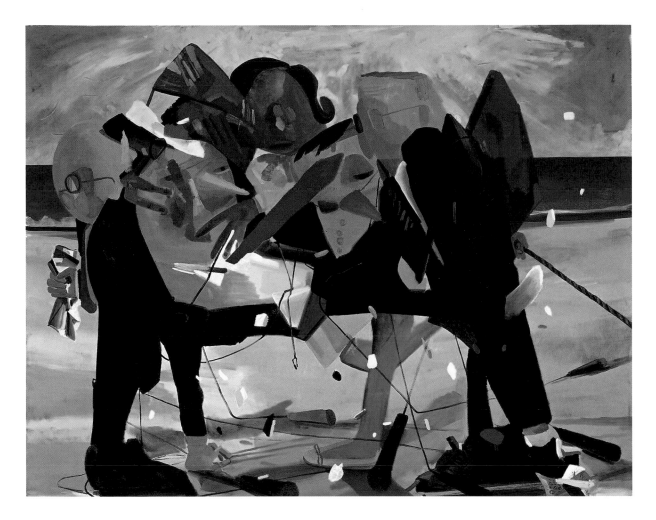

Roberta Smith has connected her portraits to the early reliefs of Eva Hesse, from a series of about seven odd, almost monstrous self-portraits from 1960—girls with gray skin and yellow eyes, sitting uncomfortably in the space. Though Hesse's palette is more muted, the impact is equally as expressive and emotional. There is an odd similarity between Hesse's self-portraits and Schutz's *Self-Portrait as a Pachyderm* (2005) (p. 275), particularly in the willingness to portray the self as monstrous. Schutz's portrait is closely cropped from the shoulders up, showing the artist with thick gray elephant skin and clown-orange hair. The skin, made from thickly applied, almost uniform strokes of paint built up like small blocks, is the skin of both the painting and the artist. She takes this a step further in *Happy* (2004), presumably a self-portrait because the figure holds paintbrushes in both hands. The composition of black latticework containing blocks of pure color brings to mind the

Party, 2004.
Oil on canvas, 72 x 90 in.
(182.9 x 228.6 cm)

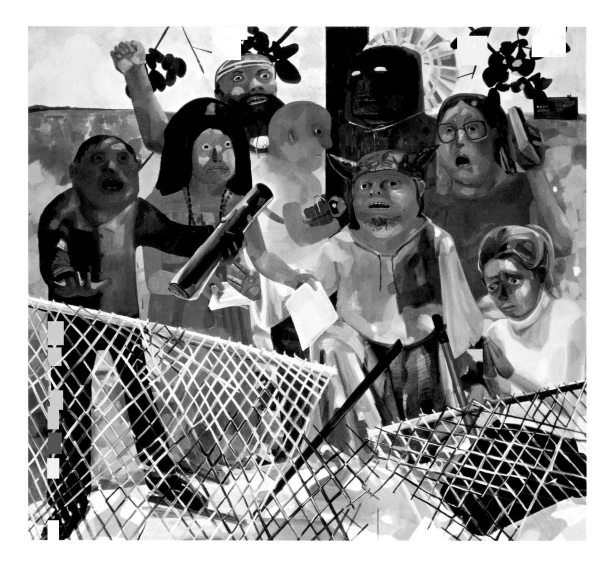

Fanatics, 2005.
Oil on canvas, 90 x 96 in.
(228.6 x 243.8 cm)

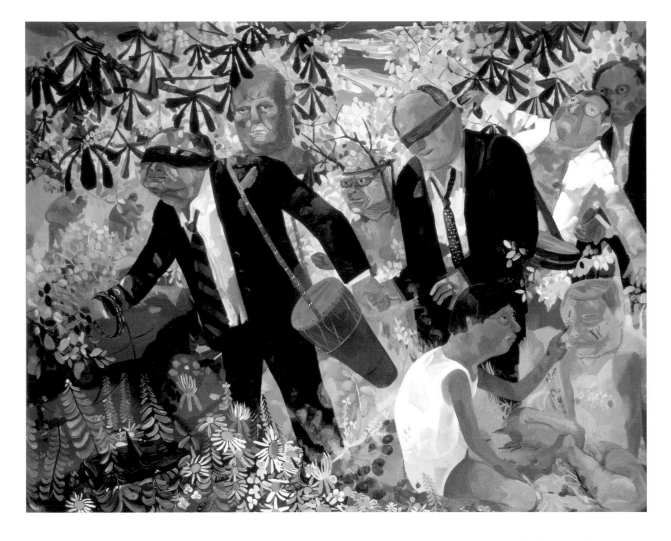

Men's Retreat, 2005.
Oil on canvas, 96 x 120 in.
(243.8 x 304.8 cm)

stained-glass window paintings of Georges Rouault. Here the figure is subsumed into the overall pattern of color and form with the background. Schutz seems to be saying, "I am the painting."

Contrast Schutz's self-portrait with Lee Krasner's self-portrait of about 1930, works separated by more than seventy-five years. Krasner's self-portrait tells as much about the times as it does its maker: she purposely de-feminizes herself, sporting cropped hair and wearing a short-sleeved masculine work shirt and a shapeless painter's apron. The artist stares directly out from the canvas, casting the viewer in the dual role of spectator and mirror. Though not exactly defiant, Krasner appears assured in her role at a time when it was an act of defiance for a woman to portray herself as a real artist.

Schutz shows herself engaged in the act of painting, at the moment the brush touches the canvas. The imagery, rendered in brushy strokes of bright color, is more cartoon than realistic. Trees and bushes surround her and the sunny expanse of the sky unfolds behind. Two large theatrical lights shine down on her, like giant caricatures of egg yolks or watchful eyes. In this post-feminist scenario Schutz acknowledges that she is scrutinized as if on stage but it is the portrait, not the artist, that confronts the viewer. Is the painting about rendering the prop in the room or can it be a vehicle to convey other ideas? Schutz's answer is to paint the elephant in the living room.

In paintings such as *Party* (2004) (p. 283), *Fanatics* (2005) (p. 284), and *Men's Retreat* (2005) (p. 285), Schutz addressed current events. With *Party* she entered the political arena, depicting members of George W. Bush's cabinet, with cartoon images of Dick Cheney, John Ashcroft, Condoleezza Rice, and Donald Rumsfeld supporting a slumping president, who seems in a state between dead and drunk. A dark-skinned man, presumably Colin Powell, stands at the back of the group, wearing a pink hood or party hat, his hand covering his mouth as if he will not or cannot speak. Flecks of falling confetti and party hats akimbo indicate the party is over. Discarded microphones dangle on the floor and their long cords entangle the group, binding them together. Their message seems no longer relevant or perhaps no longer heard. Rice holds a rope, which goes off stage to the right; maybe a reference to humiliating prisoners by leading them around on leashes at Abu Ghraib prison or perhaps the idea that the group is hanging themselves. The direct connection to the current administration brings to mind Philip Guston's Poor Richard series of cartoons lampooning Richard Nixon or Nancy Spero's reactions to the Vietnam war.

Party was painted just before the presidential election of 2004, before the outcome was known. The title could have a double meaning—the GOP celebrating their victory or a group being removed from the scene, the end of their party. As with most of her work, Schutz successfully combined tradition with originality. The classic triangular composition and the overt reference to the Deposition could easily be seen as analogous to the president's messianic vision. Schutz sacrifices realism for

composition, creating a triangular structure in which there are not enough legs to match the number of people in the mass, which is supported by struts provided by Cheney and Rumsfeld and balanced in the center by Rice's dancing legs.

Fanatics is particularly relevant today, when a fanatic can be as benign as a woman praying on her knees or as destructive as a suicide bomber. Schutz convenes many types of fanatics, but separates them from the viewer by a broken chain link fence. *Vertical Life Support* (2005), featuring a woman with a feeding tube in her neck, is clearly a reference to the plight of Terri Schiavo, the subject of a national controversy when her husband decided to terminate her life support. *Men's Retreat* shows corporate magnates cavorting at a men's camp, a response to the trend for high-powered men trying to connect with their primitive states by acting out certain games and performances. Set against dense foliage, a scantily clad Bill Gates applies war paint on a nude Ted Turner's face. Dennis Kozlowski's head float ominously from dense foliage as men in suits parade by blindfolded and holding hands. Other naked figures ride piggyback in the background.

In P.S. 1's 2005 *Greater New York* exhibition, Schutz exhibited *Presentation* (2005) (pp. 288–89), her largest painting to date. Later acquired by the Museum of Modern Art in New York, *Presentation* is a ten-by-fourteen-foot mural depicting a bizarre autopsy, a surreal rendition in a brilliant palette of red, pink, blue, and green expressionist colors in a composition and theme that might remind us of Rembrandt's well-known *Anatomy Lesson of Dr. Tulp* (1632), although Schutz's audience of hundreds is so large it disappears far into the background, bringing to mind James Ensor's Christ's *Entry into Brussels*. For this work Schutz looked to medieval paintings and "the relationship that spectacle had to reality in that time."[10] In *Presentation*, Schutz tilted the table and her subject forward, establishing a spatial hierarchy where the main character occupies the middle ground, with the audience (which includes faces of her friends) further crowding space by its close proximity to the main character, a convention seen in many late medieval and early Renaissance compositions. The bottom quarter of *Presentation* is a band of flowers, foliage, and spare body parts. A grottolike opening of brown and gray brush marks creates a deeper space, heightening the imbalance of the scene. Schutz collapses and pushes the space toward the viewer, implicating her or him as a participant in the event.

But what is the event? A man reclines on a pink plywood operating table. He is rendered with raw brushstrokes, his head and trunk a sickly yellow, other areas of his body arranged from a patchwork of paint. A smaller body, face down and apparently legless, rests next to him, totally inert and flattened into the board. There is no consideration of scale and the victim is monumental in relation to his audience. His hand and arm are in traction, his torso gapes open, and his left leg is not connected. It seems the artist herself doesn't know and can only speculate: "Maybe it's about pain in public," Schutz observed, "or maybe these people are just trying to make sense of this overwhelming mess of a man on the table."[11]

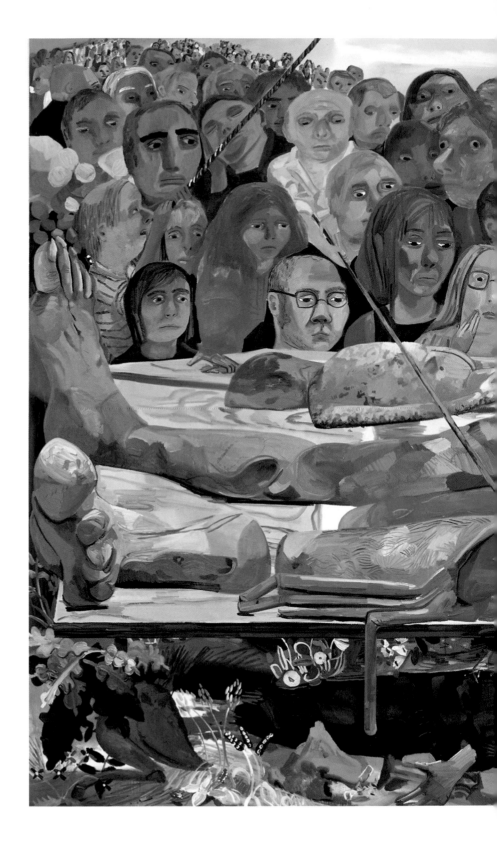

Presentation, 2005.
Oil on canvas,
120 x 168 in.
(304.8 x 426.7 cm)

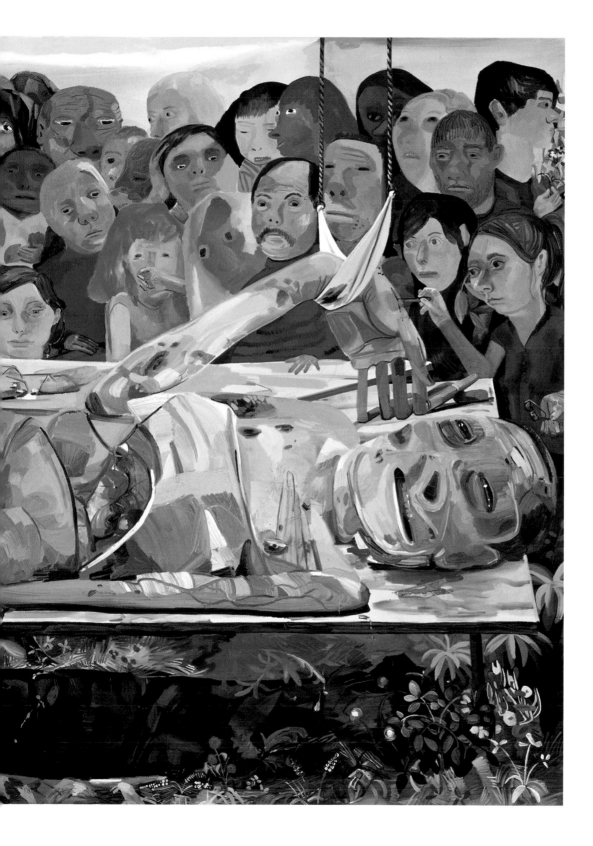

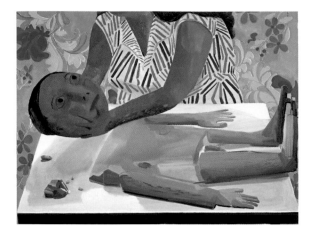

Boy, 2004.
Oil on canvas, 42 x 54 in.
(106.7 x 137.2 cm)

Boy and *Surgery* (both 2004) (above and opposite) further explore themes of body parts and creation. In *Boy*, a woman—her own head truncated by the top of the picture—places a head on the body of a young child, perhaps a metaphor for the final moment in the creation of a painting before it goes before an audience. *Surgery* shows a group of rubber-gloved girls around a table, creating another girl just like themselves. One works on the brain, another uses tweezers on the abdomen, while a third girl sews on a limb. The table is surrounded by foliage and covered with a checked tablecloth, like a picnic table. The adolescent playfulness is combined with an intensity of teamwork and purpose. "The figures in these paintings," Schutz explained, "are in the state of being built and recreated. They also mirror the creative act of construction and transformation and, to a certain extent, collaboration. I feel that they could have had a hand in making their own picture."[12]

As an artist who is only thirty years old, who has experienced a meteoric rise in popularity and who has exhibited publicly for less than five years, it is difficult to judge the impact Schutz will have. She is part of a generation of artists including Barnaby Furnas, Marc Handelman, and Tom McGrath, who are reinvestigating figuration and abstraction within the context of art history. Like those artists, Schutz makes her viewer acutely aware of the materiality of paint and invites them to share in the fiction of viewing. What sets Schutz apart are her investigations of the nature of creating and painting. As one critic observed, it is the "captivating relationship between the maker and the made that sits at the center of Schutz's achievement."[13]

1. Katy Siegel, "The Beginning or the End," *Dana Schutz: Paintings 2002–2005*, exh. cat., Rose Art Museum, Brandeis University, Waltham, Mass. (2006), p. 12.

2. LFL Gallery press release, November 2002.

3. These shows were at JCCC/Nerman Museum of Contemporary Art, Overland Park, Kansas (2004);

SITE Santa Fe, New Mexico (2005); and the Rose Art Museum, Brandeis University, Waltham, Mass. (2006).

4. Interview with Maurizio Cattelan, in *Dana Schutz*, exh. cat., Johnson County Community College Gallery of Art, Nerman Museum of Contemporary Art, 2004, n.p.

5. Interview with Raphaela Plataow, in *Dana Schutz: Paintings 2002–2005*, p. 83.

6. Ibid., p. 86.

7. Roberta Smith, "Dismemberment as Motif in Study of Mayhem," *The New York Times*, December 6, 2004, p. B9.

8. Megan Daily, "Laying it On Thick," *Artforum*, April 2004, p. 138.

9. Peter Halley, "Dana Schutz Paints Like You Wanted to in High School," *Index Magazine*, February/March, 2004, p. 30.

10. Interview with Raphaela Plataow, in *Dana Schutz: Paintings 2002–2005*, p. 88.

11. Maurizio Cattelan, "Dana Schutz: Me, Frank and My Studio," *Flash Art*, October 2005, p. 85.

12. Ibid., p. 88.

13. Robert Enright, "Death Defier: The Art of Dana Schutz," *Border Crossings* 92, (2004): 45.

Surgery, 2004.
Oil on canvas, 75 x 91 in.
(190.5 x 231.1 cm)

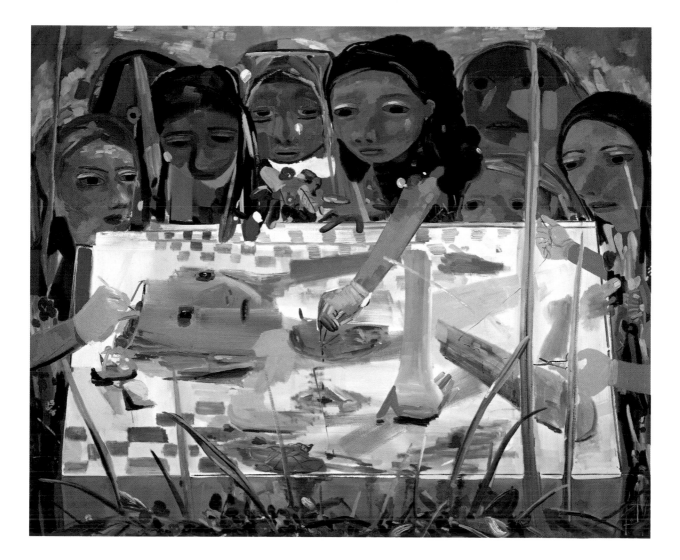

Bibliography

General reference: Books & Exhibition Catalogues; Journals

Books and Exhibition Catalogues

About Time: Video, Performance, and Installation by 21 Women Artists. London: Institute of Contemporary Arts, 1980.

American Women Artists. New York: Sidney Janis Gallery, 1984.

American Women Artists, the 20th Century. Knoxville, Tenn.: Knoxville Museum of Art, [1989]

AUKEMAN, ANASTASIA, ed. *Division of Labor: "Women's Work" in Contemporary Art*. New York: Bronx Museum of the Arts, 1995.

Bad Girls. London: Insitute of Contemporary Arts; Glasgow: Centre for Contemporary Arts, [1993]

Bearing Witness: Contemporary Works by African American Women Artists. New York: Spelman College and Rizzoli International Publications, 1996.

BECKETT, WENDY. *Contemporary Women Artists*. New York: Universe Books, 1988.

Beyond Power, a Celebration. San Francisco, Calif.: Southern Exposure Gallery, 1987.

BOHM-DUCHEN, MONICA, and VERA GRODZINSKI, eds. *Rubies & Rebels: Jewish Female Identity in Contemporary British Art*. London: Lund Humphries; Wappingers Falls, N.Y.: Antique Collectors' Club [distributor], 1996.

BROUDE, NORMA, and MARY D. GARRARD, eds. *The Power of Feminist Art: the American Movement of the 1970s, History and Impact*. New York: Harry N. Abrams, 1994.

———. *Reclaiming Female Agency: Feminist Art History after Postmodernism*. Berkeley: University of California Press, 2005.

BROWN, BETTY ANN. *Exposures: Women & Their Art*. Pasadena, Calif.: New Sage Press, 1989.

The Circular Dance: Sutapa Biswas, Chila Kumari Burman, Jagjit Chuhan, Nina Edge, Gurminder Sikand, Shanti Thomas. Bristol: Arnolfini, [1991]

CONKLIN, JO-ANN, ed. *The Louise Noun Collection: Art by Women*. [Iowa City]: University of Iowa Museum of Art, 1990.

Contemporaries, 17 Artists: Lita Albuquerque ... [et al.]. Los Angeles: Security Pacific Bank, [1980?]

CORTEZ, CONSTANCE, ed. *Imágenes e historias = Images and Histories: Chicana Altar-inspired Art*. Medford, Mass.: Tufts University Gallery; Santa Clara, Calif.: Santa Clara University, 1999.

DOUGHERTY, MARIJO, ed. *The State of Upstate: New York Women Artists*. [Albany?]: Upstate New York Committee, the National Museum of Women in the Arts, 1989.

DYSART, DINAH, and HANNAH FINK, eds. *Asian Women Artists*. Roseville East NSW, Australia: Craftsman House, 1996.

ELLIOTT, BRIDGET, and JANICE WILLIAMSON. *Dangerous Goods: Feminist Visual Art Practices*. Edmonton, Alberta, Canada: Edmonton Art Gallery, 1990.

Expressions from the Soul: Bay Area Korean American Women Artists. Santa Clara, Calif.: Triton Museum of Art, 1998.

FARRIS, PHOEBE, ed. *Women Artists of Color: A Bio-Critical Sourcebook to 20th Century Artists in the Americas*. Westport, Conn.: Greenwood Press, 1999.

Fiber and Form: The Woman's Legacy: Hannelore Baron, Lee Bontecou, Nancy Grossman, Eve Peri, Anne Ryan, Betye Saur, Lenore Tawney. New York: Michael Rosenfeld Gallery, [1996]

FIELD, RICHARD S., and RUTH E. FINE. *A Graphic Muse: Prints by Contemporary American Women*. New York: Hudson Hills Press in association with the Mount Holyoke College Art Museum, 1987.

Forces of Change: Artists of the Arab World. Lafayette, Calif.: International Council for Women in the Arts ; Washington, D.C.: National Museum of Women in the Arts, 1994.

From History to Action: An Exhibition in Celebration of the Tenth Anniversary of the Woman's Building. Los Angeles: Woman's Building, 1984.

Generation of Mentors. Los Angeles: Southern California Council of the California Committee of the National Museum of Women in the Arts, Washington, D.C., 1994.

GRINNELL, JENNIFER, and ALSTON CONLEY, eds. *Re/dressing Cathleen: Contemporary Works from Irish Women Artists*. Chestnut Hill, Mass.: McMullen Museum of Art, Boston College, 1997.

Growing Beyond: Women Artists from Puerto Rico. [Puerto Rico: Mujeres Artistas de Puerto Rico, Inc., 1988]

Gumbo Ya Ya: Anthology of Contemporary African-American Women Artists. New York: Midmarch Arts Press, 1995.

HASSAN, SALAH M., ed. *Gendered Visions: the Art of Contemporary Africana Women Artists*. Trenton, N.J.: Africa World Press, 1997.

HENKES, ROBERT. *The Art of Black American Women: Works of Twenty-Four Artists of the Twentieth Century.* Jefferson, N.C.: McFarland, 1993.

——. *Latin American Women Artists of the United States: the Works of 33 Twentieth-Century Women.* Jefferson, N.C.: McFarland, 1999.

Her Story: Narrative Art by Contemporary California Artists. Oakland, Calif: The Oakland Museum, [1991]

HILLSTROM, LAURIE COLLIER, and KEVIN HILLSTROM; with a preface by Lucy R. Lippard. *Contemporary Women Artists.* Detroit: St. James Press, 1999.

Illinois Women Artists: the New Millennium. Champaign, Ill.: Illinois Committee for the National Museum of Women in the Arts, 1999.

In the Lineage of Eva Hesse. Ridgefield, Conn.: The Aldrich Museum of Contemporary Art, 1994.

ISAAK, JO ANNA. *Feminism and Contemporary Art: The Revolutionary Power of Women's Laughter.* London; New York: Routledge, 1996.

——. *Laughter Ten Years After.* Geneva, N.Y.: Hobart and William Smith Colleges Press, 1995.

Issue: Social Strategies by Women Artists. London: Institute of Contemporary Arts, 1980.

JOBLING, PAUL. *Bodies of Experience: Gender and Identity in Women's Photography Since 1970.* London: Scarlet Press, 1997.

JONES, AMELIA, ed. *Sexual Politics: Judy Chicago's Dinner Party in Feminist Art History.* [Los Angeles, Calif.]: UCLA at the Armand Hammer Museum of Art and Cultural Center in association with University of California Press, Berkeley, 1996.

Just Like a Woman. [Greenville, S.C.]: Emrys Foundation: Greenville County Museum of Art, 1988.

Kindred Spirits: Nancy Brett, Shalvah Segal, Meg Webster. Brookville, N.Y.: Hillwood Art Gallery, 1987.

KINTANAR, THELMA B., and SYLVIA MENDEZ VENTURA. *Self-Portraits: Twelve Filipina Artists Speak.* Quezon City, Philippines: Ateneo de Manila University Press, 1999.

KORDICH, DIANE D. *Images of Commitment: 20th Century Women Artists.* Tucson, Ariz.: CRIZMAC, 1994.

LAHS-GONZALES, OLIVIA, and LUCY LIPPARD. *Defining Eye: Women Photographers of the 20th Century: Selections from the Helen Kornblum Collection.* St. Louis, Mo.: Saint Louis Art Museum, 1997.

LAMBTON, GUNDA. *Stealing the Show: Seven Women Artists in Canadian Public Art.* Montreal: McGill-Queen's University Press, 1994.

LIM, LUCY. *Six Contemporary Chinese Women Artists: Chou, Nie Ou, Nancy Chu Woo, Yang Yanping, Zhao Xiuhuan, Zhou Sicong.* San Francisco: Chinese Culture Foundation of San Francisco, 1991.

LLOYD, FRAN, ed. *Contemporary Arab Women's Art: Dialogues of the Present.* London: WAL, 1999.

MANSFIELD, ELIZABETH. *Power, Pleasure, Pain: Contemporary Women Artists and the Female Body.* [Cambridge, Mass.]: Harvard University Art Museum, 1994.

Matter Mind Spirit: 12 Contemporary Indiana Women Artists. Washington, D.C.: Indiana Committee, National Museum of Women in the Arts in association with Indiana University Press, Bloomington, 1999.

MESKIMMON, MARSHA. *The Art of Reflection: Women Artists' Self-Portraiture in the Twentieth Century.* New York: Columbia University Press, 1996.

MILLER, LYNN F., and SALLY S. SWENSON. *Lives and Works, Talks with Women Artists.* Metuchen, N.J.: Scarecrow Press, 1981.

MOORE, CATRIONA, ed. *Dissonance: Feminism and the Arts 1970–1990.* St. Leonards NSW, Australia: Allen & Unwin, 1994.

My Little Pretty: Images of Girls by Contemporary Women Artists: Kim Dingle, Judy Fox, Nicky Hoberman, Inez van Lamsweerde, Judith Raphael, and Lisa Yuskavage. Chicago: Museum of Contemporary Art, 1997.

My Magic Pours Secret Libations. [Tallahassee]: Museum of Fine Arts, Florida State University School of Visual Arts & Dance, [1996]

Nine from North Carolina: An Exhibition of Women Artists. Washington, D.C.: National Museum of Women in the Arts, 1989.

9 Women in Georgia: An Exhibition of Contemporary Art, organized by Gudmund Vigtel. Washington, D.C.: Georgia Committee of the National Museum of Women in the Arts, 1996.

NEUMAIER, DIANE, ed. *Reframings: New American Feminist Photographies.* Philadelphia: Temple University Press, 1995.

Original Visions: Shifting the Paradigm, Women's Art 1970–1996: Magdalena Abakanowicz, Mary Beth Edelson, Janet Fish, Agnes Martin, Pat Steir, Carrie

Mae Weems. [Chesnut Hill, Mass.: McMullen Museum of Art, Boston College, 1997]

PEREZ, PILAR, ed. *At the Curve of the World: Mariana Botey, E. V. Day, Anne Fishbein and Laurie Dahlberg, Diana López, Gertrudis Rivalta, Elena Del Rivero, Sandra Vivas*. Santa Monica, Calif.: Smart Art Press, [1999]

A Personal Statement: Arkansas Women Artists. [Arkansas]: Arkansas Committee of the National Museum of Women in the Arts, [1991]

Plastic Fantastic Lover (Object A). New York, N.Y.: Blum Helman Warehouse, 1991.

POSNER, HELAINE. *Domestic Tales*. Amherst: University Gallery, University of Massachusetts, 1984.

Presswork: the Art of Women Printmakers: Lang Communications Corporate Collection. [United States]: Lang Communications, 1991.

PUERTO, CECILIA. *Latin American Women Artists, Kahlo and Look Who Else: A Selective, Annotated Bibliography*. Westport, Conn.: Greenwood Press, 1996.

Reflections: Woman's Self-Image in Contemporary Art. Oxford, Ohio: Miami University Art Museum, 1988.

ROSEN, RANDY, and CATHERINE COLEMAN BRAWER, comps. *Making Their Mark: Women Artists Move into the Mainstream, 1970–85*. New York: Abbeville Press, 1989.

ROTH, MOIRA, ed. *The Amazing Decade: Women and Performance Art in America, 1970–1980*. Los Angeles: Astro Artz, 1983.

SCHNEIDER, REBECCA. *The Explicit Body in Performance*. London; New York: Routledge, 1997.

SEIGEL, JUDY, ed. *Mutiny and the Mainstream: Talk That Changed Art, 1975–1990*. New York: Midmarch Arts Press, 1992.

SEREBRJAKOVA, MARIA, NATALJA TURNOVA, and LARISA REZUN-ZVEZDOTSJOTOVA, *een kip is geen vogel* (a chicken is no bird). Amsterdam: Picaron Editions: CIRC, 1991.

Signs of Life: Rebecca Howland, Christy Rupp, Kiki Smith, Cara Perlman. Normal, Ill.: University Galleries, Illinois State University; New York, N.Y., 1993.

SINHA, GAYATRI, ed. *Expressions & Evocations: Contemporary Women Artists of India*. Bombay: Marga Publications on behalf of the National Centre for the Performing Arts, 1996.

STICH, SIDRA. *New World [Dis]Order*. [California]: Northern California Council of the National Museum of Women in the Arts, 1993.

TERR, LYNDIA, SANDRA WASKO-FLOOD, SUSAN BABAIE, eds. *1972 Retrospective 1982, the Washington, D.C., Chapter of the Women's Caucus for Art*. Alexandria, Va.: WCA/DC Business Office, [1983?]

Texas Women. [Midland, Tex.]: Texas State Committee of the National Museum of Women in the Arts, Washington, D.C., 1988.

26 Contemporary Women Artists, organized by Lucy R. Lippard. Ridgefield, Conn.: The Aldrich Museum of Contemporary Art, 1971

The Tyler Show: Working Women Artists from Tyler School of Art. Philadelphia: Samuel Paley Library, [1974?]

Visions of Ourselves: Women Artists' Heritage and Future. Visions of Ourselves: Women Artists' Heritage and Future. Orlando, Fla. Orlando: Women in Art, [1984]

VOIGT, ANNA. *New Visions, New Perspectives: Voices of Contemporary Australian Women Artists*. Roseville East NSW, Australia: Craftsman House, in association with G+B Arts International, 1996.

VON BLUM, PAUL. *Other Visions, Other Voices: Women Political Artists in Greater Los Angeles*. Lanham, Md.: University Press of America, 1994.

WALKER, CARYN FAURE. *Ecstasy, Ecstasy, Ecstasy, She Said: Women's Art in Britain, a Partial View*. Manchester [England]: Cornerhouse, 1994.

WARM: A Landmark Exhibition. Minneapolis, Minn.: Women's Art Registry of Minnesota, 1984.

WITZLING, MARA R., ed. *Voicing Today's Visions: Writings by Contemporary Women Artists*. New York: Universe, 1994.

Woman: Prints by 16 New Jersey Women Artists with Photographs by Arthur Dreeben. Princeton, N. J.: Queenston Press, 1978.

Women/Arizona '75. Tucson, Ariz.: Tucson Museum of Art, 1975.

Women Artists in the Vogel Collection. Gainesville, Ga.: Brenau University Galleries, 1998.

Women Artists, '78: Metropolitan Area: N. Y., N. J., Conn. New York: Women's Caucus for Art, [1978].

WOMEN ARTISTS SLIDE LIBRARY (London, England). *Contemporary Women Artists in the Women Artists Slide Library*. Haslemere, Surrey, U.K.: Emmett Pub., 1992.

WOMEN IN THE ARTS (organization). *Women Choose Women*. New York, N.Y.: New York Cultural Center [1973]

Women of the World: A Global Collection of Art. San Francisco: Pomegranate, 2000.

Women Photographers in America 1987. [Los Angeles]: Los Angeles Municipal Art Gallery, [1987]

Works on Paper: Women Artists. New York: The Brooklyn Museum, 1975.

WORTZ, MELINDA. *Diversity and Presence: Women Faculty Artists of the University of California*. Riverside: University of California, Riverside, 1987.

ZEGHER, M. CATHERINE DE, ed. and curator, *Inside the Visible: An Elliptical Traverse of 20th Century Art in, of, and from the Feminine*. Cambridge, Mass.: The MIT Press, [1996?]

ZELEVANSKY, LYNN. *Sense and Sensibility: Women Artists and Minimalism in the Nineties*. New York: The Museum of Modern Art, 1994.

Journals

Chomo-uri. Amherst, Mass.: Feminist Arts Program, Everywoman's Center, University of Massachusetts, [1974?–

Gallerie (North Vancouver, B.C., Canada). [North Vancouver, B.C.: Gallerie Publications, 1988]

Make (London). London: Women's Art Library, 1996–2002.

Warm Journal. Women's Art Registry of Minnesota. [Minneapolis, Minn.]: The Registry, 1980–[1987?]

Warm Newsletter. Women's Art Registry of Minnesota. [Minneapolis, Minn.]: The Registry, 1985–

WARM-ups. Women's Art Registry of Minnesota. Saint Paul, Minn.: The Registry, 1999–

Woman's Art Journal. [Knoxville, Tenn., Woman's Art], 1980–

Women Artists Slide Library Journal. London: The Library, –1990.

Women's Art Magazine. London: Women Artists Slide Library, 1990–1996.

Individual Artists

MARINA ABRAMOVIĆ

**Monographs, Solo Exhibition Catalogues
(with Ulay, 1976–1987), and Video Recordings**

ABRAMOVIĆ, MARINA. *Avant-Garde Walk a Venezia: Marina Abramović*. Italy: Edizioni d'arte Fr.lli Pozzo, 1995–96.

———. *Cleaning the Mirror I: Marina Abramović*. Oslo: Museet for samtidskunst, 2001.

———. *Foto cliché: Marina Abramović & Ulay*. London: Victoria Miro; Derry: Orchard Gallery, 1986.

———. *4 Performances by Marina Abramović, 1975–1976*. Amsterdam: Monte Video, 1996.

———. *Gold Found by the Artists / Marina Abramović/Ulay, Ulay/Marina Abramović*. Sydney: Art Gallery of New South Wales, 1981.

———. *Inbetween*. Kyoto, Japan: Korinsha Press, 1998.

———. *Marina Abramović*. Belgrade: Salon muzeja savremene umetnosti, 1975.

———. *Marina Abramović*. Ferrara: Comune di Ferrara, Assessorato Istituzioni Culturali, Centro Video Arte, Padiglione d'Arte Contemporanea, Palazzo dei Diamanti, 1993.

———. *Marina Abramović*. Milan: Charta; Como: Fondazione Antonio Ratti, 2002.

———. *Marina Abramović*. Paris: énsb-a, 1992.

———. *Marina Abramović*. Zagreb: Galerija suvremene umjetnosti, 1974.

———. *Marina Abramović: Artist Body: Performances 1969–1998*. Milan: Charta, 1998.

———. *Marina Abramović: Becoming Visible*. Montbéliard: Musées et Centre d'art contemporain de Montbéliard, 1993.

———. *Marina Abramović: Biography*. Ostfildern bei Stuttgart: Cantz, 1994.

———. *Marina Abramović: Boat Emptying Stream Entering (Part 1 and Part 2)*. Denton, Texas: University of North Texas Art Gallery, 1996.

———. *Marina Abramović: Balkan Epic*. Milan: Skira, 2006.

———. *Marina Abramović: The Biography of Biographies*. Milan: Charta, 2004.

———. *Marina Abramović: Cleaning the House*. London: Academy Editions; New York: Distributed in the U.S.A. by St. Martin's Press, 1995.

———. *Marina Abramović: Departure: Brasil Project 1990–91*. Paris: Galerie Enrico Navarra, 1991.

———. *Marina Abramović: Double Edge*. Sulgen, Switzerland: Niggli, 1996.

———. *Marina Abramović: El puente: exposición retrospectiva*. Valencia: Consorci de Museus de la Comunitat Valenciana; Milan: International distribution, Charta, 1998.

———. *Marina Abramović, Performing Body*. Milan: Charta, 1998.

———. *Marina Abramović: Student Body: Workshops, 1979–2003: Performances, 1993–2003*. Milan: Charta, 2003.

———. *Marina Abramović: Talon siivous: matkakaappi* [Cleaning the House: Traveling Cabinet]. Helsinki: Kiasma, Nykytaiteen museo, 1999.

———. *Marina Abramović: The House with the Ocean View*. Milan: Charta, 2003.

———. *Marina Abramović, The Star*. Japan: Marina Abramović (The Star) Executive Committee, 2003.

———. *Marina Abramović, Ulay*. Paris: Editions du Centre Pompidou, 1990.

———. *Marina Abramović, Ulay/Marina Abramović: Relation/Work and Detour*. Amsterdam, The Netherlands: International distributor, Idea Books, 1980.

———. *Marina Abramović/Ulay: Ulay/Marina Abramović: Relation/Work: 3 Performances*. Innsbruck: U. Krinzinger, [1978]

———. *Marking the Territory*. Dublin: Irish Museum of Modern Art, 2001.

———. *Modus vivendi: Ulay & Marina Abramović, 1980–1985*. Eindhoven: Stedelijk Van Abbemuseum, 1985.

———. *Der Schock des 11. September und das Geheimis des Anderen: eine Dokumentation*. Berlin: Haus am Lützowplatz; Lettre International, 2002.

———. *Spirit Cooking with Essential Aphrodisiac Recipes*. Santa Monica: Edition Jacob Samuel, 1996.

———. *Sur la voie / Marina Abramović*. Paris: Musée national d'art moderne, Centre Georges Pompidou, 1990.

ABRAMOVIĆ, MARINA, DORINE MIGNOT, and ULAY. *The Lovers*. Amsterdam: Stedelijk Museum, 1989.

BOND, ANTHONY, ed. Body: *Marina Abramović*. Melbourne, Victoria, Australia: Bookman Schwartz; Sydney, NSW, Australia: Art Gallery of New South Wales, 1997.

CELANT, GERMANO. *Marina Abramović: Public Body: Installations and Objects, 1965–2001*. Milan: Charta, 2001.

DANZKER, JO-ANNE BIRNIE, and CHRISSIE ILES, eds. *Marina Abramović*. Munich: Museum Villa Stuck, 1996.

ILES, CHRISSIE, ed. *Marina Abramović: Objects, Performance, Video, Sound*. Oxford: Museum of Modern Art Oxford, 1995.

MAHLER, HANNES M., ed. *Unfinished Business / Marina Abramović*. Cologne: Salon Verlag, 1999.

MESCHEDE, FRIEDRICH, ed. *Marina Abramović*. Stuttgart: Edition Cantz, 1993.

ROSENZWEIG, PHYLLIS D. *Marina Abramović: The Hero*. Washington, D.C.: Smithsonian Institution, Hirshhorn Museum and Sculpture Garden, 2001.

ŚLIZIŃSKA, MILADA, ed. *Marina Abramović*. Stockholm: Spirit House, Moderna Museet, 1998.

ULAY, *Ulay, Abramović: Performances 1976–1988*. Eindhoven: Stedelijk Van Abbemuseum, 1997.

Group Exhibition Catalogues

Art from Europe: Works by Ulay and Marina Abramović, René Daniels, Marlene Dumas, Astrid Klein…. London: Tate Gallery, 1987.

Biennale di Venezia (45th: 1993): La coesistenza dell'arte: un modello espositivo. Venice: Biennale di Venezia; Vienna: Museum moderner Kunst Stiftung Ludwig, 1993.

Collaboration: Marina Abramović, Ulay, Gwen Akin…. Los Angeles, Calif.: Security Pacific Corporation, 1988.

Dialogue with the Other. Odense, Denmark: Kunsthallen Brandts Klædefabrik, 1994.

Il diavolo del focolare: Marina Abramović, Chiho Aoshima, Vanessa Beecroft, Monica Bonvicini…. Milan: Electa, 2006.

Double Life: Identität und Transformation in der zeitgenössischen Kunst; Marina Abramović, Eleanor Antin, VALIE EXPORT, Dominique Gonzalez-Foerster, Ion Grigorescu, Lynn Hershman, Pierre Huyghe, Sanja Ivekovic, Elke Krystufek…. Vienna: Generali Foundation; Cologne: König, 2001.

Frischluft: Videokunst der 80er Jahre: Marina Abramović, FLATZ, Christian Boltanski, Cathérine Ikam, Bill Viola, Bruce Nauman. Duisburg: Wilhelm Lehmbruck Museum Duisburg, 1993.

Giganti: Marina Abramović, Domenico Bianchi, Joseph Kosuth, Maurizio Mochetti, Michelangelo Pistoletto. Milan: Charta, 2001.

Intervalli tra film, video, televisione: Yoko Ono, Alexander Kluge, Marina Abramović, Silvie & Chérif Defraoui. Palermo: Sellerio, 1989.

Longing and Belonging from the Faraway Nearby. Santa Fe: SITE Santa Fe, 1995.

Mystic: Marina Abramović, Jeremy Blake, Dorothy Cross, Nona Hershey, Arthur Jafa, Tony Oursler, Gustavo Romano, Arlene Shechet, C.A. Stigliano. Boston: Massachusetts College of Art, 2003.

19 Projects: Artists-In Residence at the MIT List Visual Arts Center. Cambridge, Mass.: Massachusetts Institute of Technology, 1996.

Noli me tangere: Marina Abramović, Cécile Bart, Silvie & Chérif Defraoui, Marianne Eigenheer, Kristjan Gudmundsson, Yves Klein, Thomas Kovachevich, Nils-Udo, Flavio Paolucci, Markus Raetz, Emmanuel Saulnier, Roman Signer…. Sion: Musée cantonal des beaux-arts, 1990.

Octobar 72: Galerija Studentskog kulturnog centra, Belgrade, Oktobar-novembar 1972 (October 72: Student Cultural Center Gallery, Beograd, October–November 1972) / Marina Abramović … [et al.]. Belgrade: Galerija Studentskog Kulturnog Centra, 1972.

Over de grens: James Lee Byars, Luciano Fabro, Cornelius Rogge, Richard Serra, Ulay—Marina Abramović, Hank Visch. Tilburg, The Netherlands: Textielmuseum, 1989.

PLATOW, RAPHAELA. *Dreaming Now: Sandra Cinto, William Kentridge, David Solow, Cai Guo-Qiang, Chiharu Shiota, Maria Magdalena Campos-Pons, Frans Jacobi, Marina Abramović*. Waltham, Mass.: Rose Art Museum, Brandeis University, 2005.

Remanence: Marina Abramović, Gordon Bennett, Daniel Buren…. Melbourne: Melbourne International Festival of the Arts Ltd., 1998.

Stanze e segreti. Milan: Skira, 2000.

Video Art 78: Abramović, Ambrosini, Atherton…. Coventry: Herbert Art Gallery and Museum, 1978.

Von Chaos und Ordnung der Seele: ein Austellungsprojekt zeitgenössischer Kunst der Psychiatrischen Klinik der Universität Mainz. Mainz: Die Klinik, 1987.

Wanås 1998: Marina Abramović, Janet Cardiff, Antony Gormley, Michael Joo, Allan McCollum, Kirsten Mosher, Monika Nyström…. Knislinge, Sweden: Wanås Foundation, 1998.

Witness: Theories of Seduction: Marina Abramović, Vanessa Beecroft, Carol Irving, David Levinthal, Bettina Rheims, Jenny Saville, Julia Scher, Carolee Schneemann, Cindy Sherman, Gillian Wearing, Hannah Wilke…. Long Island City, N.Y.: Dorsky Gallery, 2003.

LOUISE BOURGEOIS

Monographs and Solo Exhibition Catalogues

BAL, MIEKE. *Louise Bourgeois' Spider: The Architecture of Art-Writing*. Chicago, Ill.: University of Chicago Press, 2001.

BERNADAC, MARIE-LAURE. *Louise Bourgeois*. Paris: Flammarion, 1996.

BLUM, PETER. *Louise Bourgeois: The Red Rooms*. New York: Robert Miller Gallery, 1994.

BOURGEOIS, LOUISE. *Destruction of the Father Reconstruction of the Father: Writings and Interviews, 1923–1997*. Cambridge, Mass.: MIT Press in association with Violette Editions, London, 1998.

———. *Drawing Conclusions: An Exhibition of Drawings / Louise Bourgeois*. Rome, New York: Molica Guidarte, 1991.

———. *Escultura de Louise Bourgeois: La elegancia de la ironía*. Monterrey, Mexico: El Museo de Arte Contemoráneo, 1995.

———. *The Iconography of Louise Bourgeois*. New York: Max Hutchinson Gallery, 1980.

———. *Louise Bourgeois*. Barcelona: Fundació Antoni Tàpies, 1990.

———. *Louise Bourgeois*. Bourges, France: L'Ecole nationale des beaux-arts de Bourges, 1995.

———. *Louise Bourgeois*. Chicago: Arts Club of Chicago, 1997.

———. *Louise Bourgeois*. Cincinnati: Taft Museum, 1987.

———. *Louise Bourgeois*. Helsinki: Helsingin kaupungin taidemuseo, 1995.

———. *Louise Bourgeois*. London: Tate Gallery Publishing, 2000.

———. *Louise Bourgeois*. Lyon: Musée d'Art Contemporain de Lyon, 1990.

———. *Louise Bourgeois*. Madrid: Galería Soledad Lorenzo, 1997.

———. *Louise Bourgeois*. Milwaukee: Milwaukee Art Museum, 1992.

———. *Louise Bourgeois*. Monterrey, Mexico: Galería Ramis Barquet, 1993.

———. *Louise Bourgeois*. New York: Bellport Press, 1986.

———. *Louise Bourgeois*. New York, Bridgehampton, NY: Dia Art Foundation, 1990.

———. *Louise Bourgeois*. Otterlo: Rijksmuseum Kröller-Müller, 1991.

———. *Louise Bourgeois*. Rio de Janeiro: Centro Cultural Banco do Brasil; São Paulo: Fundacião Bienal de São Paulo, 1997.

———. *Louise Bourgeois, Album*. New York: P. Blum, 1994.

———. *Louise Bourgeois: Aller-retour: Zeichnungen und Skulpturen*. Nuremburg, Germany: Verlag für moderne Kunst Nuremburg, 2005.

———. *Louise Bourgeois: Les bienvenus à Choisy-le-Roi*. Paris: Direction régionale des affaires culturelles d'Ile-de-France, 1996.

———. *Louise Bourgeois chez Karsten Greve*. Cologne: Galerie Karsten Greve, 1999.

———. *Louise Bourgeois at Close Quarters*. West Long Branch, N.J.: Kultur, 1995.

———. *Louise Bourgeois: Desenhos*. Rio de Janeiro: Centro Cultural Light, 1997.

———. *Louise Bourgeois: Drawings and Sculpture*. Cologne: W. König, 2002.

———. *Louise Bourgeois: Estampes*. Paris: Bibliothèque Nationale de France, 1995.

———. *Louise Bourgeois: Femme maison*. Chicago: The Renaissance Society at the University of Chicago, 1981.

———. *Louise Bourgeois: Handkerchiefs*. Catania: Edizioni Gianluca Collica, 2000.

———. *Louise Bourgeois: Homesickness*. Yokohama: Yokohama Museum of Art, 1997.

———. *Louise Bourgeois: Illustrated Books*. New York: Miriam and Ira D. Wallach Art Gallery, Columbia University, 2001.

———. *Louise Bourgeois: "Infancia": gráfica reciente*. San José, Costa Rica: TEOR/éTica, 2003.

———. *Louise Bourgeois: The Insomnia Drawings*. Zurich: Daros, 2000.

———. *Louise Bourgeois: Life as Art*. Humlebaek, Denmark: Louisiana Museum of Modern Art, 2003.

———. *Louise Bourgeois: The Locus of Memory, Works 1982–1993*. New York: Harry N. Abrams, 1994.

———. *Louise Bourgeois: Maman*. Ottawa: National Gallery of Canada, 2005.

———. *Louise Bourgeois: Memoria y arquitectura*. Madrid: Museo Nacional Centro de Arte Reina Sofía, Aldeasa, 1999.

———. *Louise Bourgeois: L'Oeuvre gravée*. Zurich: Galerie Lelong, 1991.

———. *Louise Bourgeois: Oeuvres récentes*. London: Serpentine Gallery; Paris: Diffusion, Seuil, 1997.

——. *Louise Bourgeois, Pensées-plumes.* Paris: Éditions du Centre Pompidou, 1995.

——. *Louise Bourgeois: Present Tense.* Toronto: Art Gallery of Ontario, 1998.

——. *Louise Bourgeois: Prints: 1989–1998.* Lynchburg, Va.: Maier Museum of Art, 1999.

——. *Louise Bourgeois: Recent Work.* Brooklyn: The Brooklyn Museum, 1993.

——. *Louise Bourgeois: Recent Work 1984–89.* London: Riverside Studios, 1990.

——. *Louise Bourgeois: The Reticent Child.* New York: Cheim & Read, 2004.

——. *Louise Bourgeois, rétrospective, 1947–1984.* Paris: Galerie Maeght Lelong, 1985.

——. *Louise Bourgeois, Retrospektive 1947–1984.* Zurich: Galerie Maeght Lelong, 1985.

——. *Louise Bourgeois: Sculpture and Drawings.* Kansas City, Mo.: The Nelson-Atkins Museum of Art, 1994.

——. *Louise Bourgeois: Sculptures, environnements, dessins, 1938–1995.* Paris: Paris-Musées, Editions de la Tempête, 1995.

——. *Louise Bourgeois: Selected Prints, 1989–2005.* London: Marlborough Graphics, 2005.

——. *Louise Bourgeois: Unos y otros.* Havana: Centro de Arte Contemporaneo Wifredo Lam, 2005.

——. *Louise Bourgeois: Works in Marble.* Munich: Prestel, 2002.

——. *Luiz Burzhua v Ėrmitazhe.* St. Petersburg, Russia: Hermitage Museum, 2001.

——. *The Puritan / Louise Bourgeois.* New York: Osiris, 1990.

——. *Ode à ma mère: Neuf pointes sèches originales / Louise Bourgeois.* Paris: Editions du solstice, 1995.

——. *Tejiendo el tiempo.* Málaga: Gestión Cultural y Comunicacón, 2004.

——. *This Is the Show and the Show Is Many Things: Louise Bourgeois.* Ghent: Museum van Hedendaagse Kunst, 1994.

——. *La vie est une rancon / Louise Bourgeois.* Trois-Rivières, Québec: Éditions du Bien public, 1990.

BOURGEOIS, LOUISE, and THOMAS KELLEIN. *Louise Bourgeois:La Famille.* Cologne: Verlag der Buchhandlung Walter König; New York, 2006.

BOURGEOIS, LOUISE, and LAWRENCE RINDER. *Louise Bourgeois: Drawings & Observations.* Berkeley: University Art Museum and Pacific Film Archive, University of California, Berkeley; Boston: Bulfinch Press, 1995.

CAUX, JACQUELINE. *Tissée, tendue au fil des jours, la toile de Louise Bourgeois: Entretiens avec Louise Bourgeois.* Paris: Seuil, 2003.

CHEIM, JOHN, and JERRY GOROVOY, eds. *Louise Bourgeois Drawings.* New York: R. Miller, 1988.

CLAIR, JEAN. *Five Notes on the Work of Louise Bourgeois.* New York: Cheim & Read, 1998.

COLE, IAN, ed. LOUISE BOURGEOIS. Oxford: Museum of Modern Art Oxford, 1996.

CRONE, RAINER. *Louise Bourgeois, the Secret of the Cells.* Munich, New York: Prestel, 1998.

DARRIEUSSECQ, MARIE. *Dans la maison de Louise.* Bordeaux: Musée d'art contemporaine de Bordeaux, 1998.

GARDNER, PAUL. *Louise Bourgeois.* New York: Universe, 1994.

GOROVOY, JERRY. *Louise Bourgeois, Blue Days and Pink Days.* Milan: Fondazione Prada, 1997.

GREENBERG, JAN. *Runaway Girl: The Artist Louise Bourgeois.* New York: Harry N. Abrams, 2003.

HAENLEIN, CARL, ed. *Louise Bourgeois: Skulpturen und Installationen.* Hanover: Kestner-Gesellschaft, 1994.

HALL, DONALD. *Corporal Politics: Louise Bourgeois.* Cambridge, Mass.: MIT List Visual Arts Center; Boston: Beacon Press, 1992.

HELFENSTEIN, JOSEF. *Louise Bourgeois: The Early Works.* Champaign, Ill.: Krannert Art Museum, 2002.

JAHN, ANDREA. *Louise Bourgeois: Subversionen des Körpers: die Kunst der 40er bis 70er Jahre.* Berlin: Reimer, 1999.

KELLEIN, THOMAS. *Louise Bourgeois.* Bielefeld, Germany: Die Kunsthalle; Cologne: W. König, 1999.

KELLER, EVA, and REGULA MALIN, eds. *Louise Bourgeois: Emotions Abstracted: Werke 1941–2000.* Zurich: Daros, 2004.

KUSPIT, DONALD, and ELIZABETH AVEDON, ed. *Louise Bourgeois.* New York: Vintage Books, 1988.

MAYAYO, PATRICIA. *Louise Bourgeois.* Hondarribia: Nerea, 2002.

MEYER-THOSS, CHRISTIANE. *Louise Bourgeois: Konstruktionen für den freien Fall.* Zurich: Ammann, 1992.

MORGAN, STUART. *Louise Bourgeois: Nature Study: An Essay.* London: Arts Council of Great Britain, 1985.

MORRIS, FRANCES. *Louise Bourgeois: Stitches in Time*. London: August; Dublin: In collaboration with Irish Museum of Modern Art, 2003.

NIXON, MIGNON. *Fantastic Reality: Louise Bourgeois and a Story of Modern Art*. Cambridge, Mass.: MIT Press, 2005.

PINCUS-WITTEN, ROBERT. *Bourgeois Truth*. New York: R. Miller, 1982.

SMITH, JASON. *Louise Bourgeois*. Melbourne, Australia: National Gallery of Victoria, 1995.

STAMMER, BEATRICE E., ed. *Louise Bourgeois: Intime Abstraktionen*. Berlin: Akademie der Künste, 2003.

STORR, ROBERT. *Louise Bourgeois*. London; New York: Phaidon Press, 2003.

STRICK, JEREMY. *Louise Bourgeois, the Personages*. St. Louis: The St. Louis Art Museum, 1994.

WATERFALL, ANN, ed. *Sacred and Fatal: The Art of Louise Bourgeois*. Raleigh, N.C.: North Carolina Museum of Art, 1998.

WEIERMAIR, PETER. *Louise Bourgeois*. Zurich, Switzerland: Edition Stemmle, 1995.

WEIERMAIR, PETER, ed. *Louise Bourgeois*. Schaffhausen: Edition Stemmle, 1989.

WYE, DEBORAH. *Louise Bourgeois*. New York: The Museum of Modern Art, 1982.

——. *The Prints of Louise Bourgeois*. New York: Museum of Modern Art: Harry N. Abrams, 1994.

XENAKIS, MÂKHI. *LOUISE BOURGEOIS, l'aveugle guidant l'aveugle*. Arles: Actes Sud; Paris: Galerie Lelong, 1998.

Group Exhibition Catalogues

(In Search of) the Perfect Lover. Ostfildern-Ruit: Hatje Cantz, 2003.

KUNZ, STEPHAN, CHRISTIANE MEYER-THOSS, and BEAT WISMER, eds. *Louise Bourgeois, Meret Oppenheim, Ilse Weber: Drawings and Works on Paper*. Zurich: Edition Unikate, 1999.

Louise Bourgeois, Jenny Holzer, Helmut Lang. Vienna: Kunsthalle Wien, 1998.

RAMA, CAROL. *Un duo en solo: estampes 1942–1948, 1974–2000*. Vevey, Switzerland: Cabinet Cantonal des Estampes, Musée Jenisch, 2000.

True Grit: Lee Bontecou, Louise Bourgeois, Jay DeFeo, Claire Falkenstein, Nancy Grossman, Louise Nevelson, Nancy Spero. New York: Michael Rosenfeld Gallery, 2000.

Undercurrents: Rituals and Translations: Joseph Beuys, Louise Bourgeois, Robert Morris. Boston: School of the Museum of Fine Arts, 1987.

Archives

BOURGEOIS, LOUISE. *Louise Bourgeois Papers, 1922–1994*. Archives of American Art, Smithsonian Institution.

ELLEN GALLAGHER

Monographs and Solo Exhibition Catalogues

GALLAGHER, ELLEN. *The Astonishing Nose*. London: Anthony d'Offay, 1996.

——. *Blubber*. New York: Gagosian Gallery, 2001.

——. *Ellen Gallagher*. Birmingham, England: Ikon Gallery; Manchester, England: Distributed by Cornerhouse Publications, 1998.

——. *Ellen Gallagher*. Boston: Institute of Contemporary Art, 2001.

——. *Ellen Gallagher*. London: Anthony d'Offay Gallery, 2001.

——. *Ellen Gallagher*. New York: Gagosian Gallery, 1998.

——. *Ellen Gallagher*. Saint Louis: Saint Louis Art Museum, 2003.

——. *Ellen Gallagher: Preserve*. Des Moines: Des Moines Art Center, 2001.

——. *Exelento*. New York: Gagosian Gallery, 2004.

——. *Murmur: Ellen Gallagher*. Edinburgh: Fruitmarket Gallery, 2005.

——. *Pickling*. Berlin: Galerie Max Hetzler, 1999.

GALLAGHER, ELLEN, and HUBERT H. HARRISON. *The Preserver: Limited-Edition Artist Paper*. New York: The Drawing Center, 2002.

Group Exhibition Catalogues and Television Series

Art 21: Art in the 21st Century. Season three. Alexandria, Va.: Art 21, Inc.; distributed by PBS Home Video, 2005.

Ellen Gallagher, Anri Sala, Paul McCarthy. Zürich; New York: Parkett Verlag, 2005.

Fresh Talk, Daring Gazes: Conversations on Asian American Art. Berkeley: University of California Press, 2003.

GOETZ, INGVILD, and RAINALD SCHUMACHER, eds. *The Mystery of Painting: Ellen Gallagher* [et al.]. Munich: Kunstverlag Goetz, 2001.

KERTESS, KLAUS. *Fabulism: Carroll Dunham, Ellen Gallagher, Chris Ofili, Neo Rauch, Matthew Ritchie*. Omaha: Joslyn Art Museum, 2004.

Milena Dopitová in Context: Marnie Cardozo, Ellen Gallagher, Lillian Hsu-Flanders, Annette Lemieux, Denise Marika, Ellen Rothenberg. Boston: Institute of Contemporary Art, 1994.

Negotiating Small Truths. Austin: The Jack S. Blanton Museum of Art, The University of Texas at Austin, 1999.

Non toccare la donna bianca. Turin: Hopefulmonster, 2004.

Project Painting. New York: Basilico Fine Arts, Lehmann Maupin, 1997.

Projects: Ceal Floyer, Ellen Gallagher, Paul Ramirez Jonas, Wolfgang Tillmans, Gillian Wearing, Yukinori Yanagi. Dublin: Irish Museum of Modern Art, 1997.

Reflection: Seven Years in Print. New York: Miriam and Ira D. Wallach Art Gallery, Columbia University, 2003.

Vitamin D: New Perspectives in Drawing. London; New York: Phaidon, 2005.

ANN HAMILTON

Monographs and Solo Exhibition Catalogues

BRUCE, CHRIS. *Ann Hamilton*. Seattle: Henry Art Gallery, University of Washington, 1992.

COOKE, LYNNE and KAREN KELLY, eds. *Ann Hamilton: Tropos, 1993*. New York: The Dia Center for the Arts, 1995.

DOMPIERRE, LOUISE. *Ann Hamilton: A Round*. Toronto: Power Plant, 1993.

GAGNON, PAULETTE. *Ann Hamilton: Mattering*. Montreal: Le Musée d'art contemporain de Montréal, 1998.

HAMILTON, ANN. *Ann Hamilton*. Miami: Miami Art Museum, 1998.

——. *Ann Hamilton*. New York: The Dia Center for the Arts, 1993.

——. *Ann Hamilton*. San Diego: Museum of Contemporary Art, 1991.

——. *Ann Hamilton*. Seattle: Henry Art Gallery, University of Washington, 1991.

——. *Ann Hamilton: The Capacity of Absorption*. Los Angeles: The Museum of Contemporary Art, 1989.

——. *Ann Hamilton at Gemini 2003*. Los Angeles: Gemini G.E.L., 2003.

——. *Ann Hamilton: kaph*. Houston: Contemporary Arts Museum, 1998.

——. *Ann Hamilton, lignum*. Stockholm: Atlantis, 2005.

——. *Ann Hamilton: myein*: the United States Pavilion, 48th Venice Biennale. [Washington, D.C.?]: Katy Kline and Helaine Posner, 1999.

——. *Ann Hamilton: The Picture Is Still*. Yokosuka, Japan: Akira Ikeda Gallery/Taura; Ostfildern, Germany: Cantz, 2003.

——. *Ann Hamilton: Present-Past, 1984–1997*. Milan: Skira, 1998.

——. *Ann Hamilton: Whitecloth*. Ridgefield, Conn.: The Aldrich Museum of Contemporary Art, 1999.

——. *Awaken*. New York: Cypher Editions, 2000.

——. *The Body and the Object: Ann Hamilton 1984–1996*. Columbus, Ohio: Wexner Center for the Arts, Ohio State University, 1996.

——. *By Mouth and Hand*. Providence, R.I.: RISD Museum, 2001.

——. *Corpus*. North Adams, Mass.: MASS MoCA Publications, 2004.

——. *Projects 48*. New York: The Museum of Modern Art, 1994.

NESBITT, JUDITH, ed. *Mneme*. Liverpool: Tate Gallery Publications, 1994.

SIMON, JOAN. *Ann Hamilton*. New York: Harry N. Abrams, 2002.

——. *Ann Hamilton: An Inventory of Objects*. New York: Gregory R. Miller & Co., 2006.

Group Exhibition Catalogues and Television Series

Ann Hamilton, David Ireland. Minneapolis: The Walker Art Center, 1992.

Art 21: Art in the Twenty-First Century. Seasons one and two. [United States]: Art21, Inc.; [Alexandria, Va.]: Distributed by PBS Home Video, 2003.

Contemplation: Five Installations: Barbara Bloom, Ann Hamilton with Kathryn Clark, Nam June Paik, Robert Ryman, and James Turrell. Des Moines, Iowa: The Des Moines Art Center, 1996.

Elements, Five Installations: Petah Coyne, Mineko Grimmer, Ann Hamilton, Eric Orr, Peter Shelton. New York: Whitney Museum of American Art, 1987.

Five Artists: Phoebe Brunner, Dan Connally, Macduff Everton, Ann Hamilton, Cynthia Kelsey-Gordon. Santa Barbara, Calif.: Santa Barbara Museum of Art, 1988.

Increase: Ann Hamilton/Michael Mercil /Robert B. Silberman, Ann Hamilton, Michael Mercil, Laurel Reuter. Grand Forks, N.Dak.: North Dakota Museum of Art, 2003.

Wanås 2002: Anne Hamilton, Charlotte Gyllenhammar. Knislinge, Sweden: Wanås Foundation, 2002.

JENNY HOLZER

Monographs, Solo Exhibition Catalogues, and Video Recordings

AUPING, MICHAEL. *Jenny Holzer: The Venice Installation*. Buffalo: Albright-Knox Art Gallery, 1991.

HOLZER, JENNY. *Abuse of Power Comes as No Surprise*. New York: Barbara Gladstone Gallery, 1983.

——. *Diagrams: A Collection of Diagrams from Many Sources*. New York: 1977.

——. *Eating Friends*. Buffalo: Hallwalls, 1981.

——. *Eating Through Living*. New York: Tanam Press, 1981.

——. *The End of the U.S.A.* [Jenny Holzer, 1989].

——. *Inflammatory Essays*. New York: Jenny Holzer, 1982.

——. *Je lis ta peau: Jenny Holzer*. Paris: Editions du Regard, 2002.

——. *Jeni Horutsa, kotoba no mori de*. Tokyo: Tankosha, 1994.

——. *Jenny Holzer*. Basel: Kunsthalle, 1984.

——. *Jenny Holzer*. Cologne: DuMont, 2001.

——. *Jenny Holzer*. Dallas: Dallas Museum of Art, 1984.

——. *Jenny Holzer*. Mito, Ibaraki, Japan: Contemporary Art Center, Art Tower Mito, 1994.

——. *Jenny Holzer*. Monterrey: Museo de Arte Contemporaneo de Monterrey, 2001.

——. *Jenny Holzer*. Philadelphia: Institute of Contemporary Art, University of Pennsylvania, 1984.

——. *Jenny Holzer: Black Garden*. Nordhorn: Städtische Galerie Nordhorn, 1994.

——. *Jenny Holzer: Die Macht des Wortes; I can't tell you; Xenon for Duisburg*. Ostfildern-Ruit: Hatje Cantz, 2006.

——. *Jenny Holzer: For Paula Modersohn-Becker*. Bremen: KB, Paula Modersohn-Becker Museum, Kunstsammlungen Böttcherstrasse, 2005.

——. *Jenny Holzer: Im Gespräch mit Noemi Smolik*. Cologne: Kiepenheuer & Witsch, 1993.

——. *Jenny Holzer: Installation for the Hamburger Kunsthalle* (Ceiling Snake). Hamburg: Hamburger Kunsthalle, 1998.

——. *Jenny Holzer, KriegsZustand*. Leipzig: Klaus Werner für die Galerie für Zeitgenössische Kunst Leipzig, 1997.

——. *Jenny Holzer: The Living Series*. United States: Laura Carpenter Fine Art, in association with Barbara Gladstone Gallery, Tallgrass Press, 1992.

——. *Jenny Holzer, Lustmord*. Houston: Contemporary Arts Museum, 1997.

——. *Jenny Holzer OH*. Bordeaux: Le Musée, 2001.

——. *Jenny Holzer: Proteja-me do que quero*. Rio de Janeiro: Centro Cultural Banco do Brasil, 1999.

——. *Jenny Holzer: Redaction Paintings*. New York: Cheim & Read, 2006.

——. *Jenny Holzer: Signs*. Des Moines, Iowa: Des Moines Art Center, 1986.

——. *Jenny Holzer, Street Art*. Warsaw: Centrum Sztuki Wspólczesnej, 1993.

——. *Jenny Holzer: Writing*, ed. Noemi Smolik. Ostfildern-Ruit: Cantz, 1996.

——. *Jenny Holzer: Xenon*. Küsnacht: Ink-Tree Editions, 2001

——. *Laments*. New York: Dia Art Foundation, 1989.

——. *Laments* [video recording]. New York: Dia Art Foundation, 1989.

——. *A Little Knowledge Can Go a Long Way: Your Oldest Fears are the Worst Ones*. 1978.

——. *Living*. Paris: Yvon Lambert, 1998.

——. *Living—Daytime*. New York: 1980.

——. *Shriek When the Pain Hits During Interrogation....* Toronto: Art Metropole, 1989.

——. *Truisms and Essays*. Halifax: Press of the Nova Scotia College of Art and Design, 1983.

JOSELIT, DAVID. *Jenny Holzer*. London: Phaidon Press, 1998.

SCHNEIDER, ECKHARD, ed. *Jenny Holzer: Truth Before Power*. Austria: Kunsthaus Bregenz; Cologne: Walther König, 2004.

The Venice Installation. Buffalo: Buffalo Fine Arts Academy, 1990.

WALDMAN, DIANE. *Jenny Holzer*. New York: Solomon R. Guggenheim Museum, Harry N. Abrams, 1989; 2nd ed. 1997.

Group Exhibitions/Catalogues:

Artlight. Basel: Galerie Beyeler, 2000.

BEEBE, MARY LIVINGSTONE. *Landmarks: Sculpture Commissions for the Stuart Collection at the University of California, San Diego*. New York: Rizzoli, 2001.

Billboard: Art on the Road: A Retrospective Exhibition of Artists' Billboards of the Last 30 Years. Cambridge, Mass.: MIT Press, 1999.

Das Bild nach dem letzten Bild. Vienna: Galerie Metropol, 1991.

Doppelt Haut (Vanessa Beecroft, Jan Fabre, Sylvie Fleury, Gerlovina/Gerlovin, Carsten Höller, Jenny Holzer, George Lappas, Annette Messager, Bernhard Prinz). Kiel: Kunsthalle, 1996.

Energieen: Luciano Fabro, Gary Hill, Jenny Holzer.... Amsterdam: Stedelijk Museum, 1990.

Family Values: Amerikanische Kunst der achtziger und neunziger Jahre: die Sammlung Scharpff in der Hamburger Kunsthalle. Ostfildern-Ruit: Cantz, 1996.

In Other Words: Howard Finster, Jenny Holzer, Alfred Jensen, Barbara Kruger, Peter Rose, Ed Ruscha, Alexis Smith, Lawrence Weiner, James & Charles Wine. Washington, D.C.: The Corcoran Gallery of Art, 1986.

In Search of the Media Monster: Gretchen Bender, Joan Braderman, Nancy Buchanan, Jenny Holzer, Jerry Kearns. Cleveland: Art Gallery, Cleveland State University, 1988.

Investigations. Philadelphia: Institute of Contemporary Art, University of Pennsylvania, 1984.

Isla de esculturas Illa da Xunqueira do Lerez, Pontevedra: Giovanni Anselmo, Fernando Casás, José Pedro Croft, Dan Graham, Ian Hamilton Finlay, Jenny Holzer, Francisco Leiro, Richard Long, Robert Morris, Anne & Patrick Poirier.... Pontevedra: Deputación de Pontevedra; Concello de Pontevedra: Caixa Pontevedra, 2000.

Issue: Social Strategies by Women Artists. London: Institute of Contemporary Arts, 1980.

Jenny Holzer, Barbara Kruger. Jerusalem: The Israel Museum, 1986.

Jenny Holzer, Cindy Sherman: Personae. Cincinnati: Contemporary Arts Center, 1986.

KAISER, PHILIPP, ed. *Flashback: Eine Revision der Kunst der 80er Jahre*. Ostfildern-Ruit: Hatje Cantz, 2005.

KATZMAN, LAURA. *Contemporary American Artists in Print: Eric Fischl, Jenny Holzer, Barbara Kruger, Susan Rothenberg & David Salle*. New Haven, Conn.: The Yale University Art Gallery, 1987.

Keith Haring, Jenny Holzer: Schütz mich vor dem was ich will. Vienna: Wiener Festwochen, 1986.

The Kitchen Turns Twenty: A Retrospective Anthology. New York: Kitchen Center for Video, Music, Dance, Performance, Film and Literature, 1992.

Laughter Ten Years After. Geneva, N.Y.: Hobart and William Smith Colleges Press, 1995.

Louise Bourgeois, Jenny Holzer, Helmut Lang. Vienna: Kunsthalle Wien, 1998.

MARZONA, DANIEL. *Conceptual Art*. Cologne, Los Angeles: Taschen, 2005.

Mediascape. New York: Guggenheim Museum, 1996.

New York, ailleurs et autrement: Jenny Holzer, Barbara Kruger, Louise Lawler, Sherrie Levine, Allan McCollum, Richard Prince, Martha Rosler, James Welling. Paris: ARC, Musée d'art moderne de la ville de Paris, 1984.

OLANDER, WILLIAM. *Holzer, Kruger, Prince*. Charlotte, N.C.: Knight Gallery/Spirit Square Arts Center, 1984.

Pressplay: Contemporary Artists in Conversation. London; New York: Phaidon, 2005.

Read My Lips: Jenny Holzer, Barbara Kruger, Cindy Sherman. Canberra: National Gallery of Australia; New York: Distributed by Thames & Hudson, 1998.

RICHARDS, JUDITH OLCH, ed. *Inside the Studio: Two Decades of Talks with Artists in New York*. New York: Independent Curators International (ICI), 2004.

Rosebud: Jenny Holzer, Matt Mullican, Lawrence Weiner. Munich: Kunstbau Lenbachhaus Munich; Barcelona: Fundació Joan Miró, 1994.

SCHUMACHER, RAINALD and NOEMI SMOLIK, eds. *American Art from the Goetz Collection*. Prague: Galerie Rudolfinum, 2001.

SCHWEITZER, ROBERT. *Art and the Dialectic Process: Joseph Beuys, Hans Haacke, Jenny Holzer, Alfredo Jaar, Louise Lawler*. Scranton, Pa.: Everhart Museum, 1987.

Secret Spaces, Forbidden Places. New York: Berghahn Books, 2000.

Secular Attitudes: Jenny Holzer, Fred Lonidier, The Sisters of Survival. Los Angeles: Los Angeles Institute of Contemporary Art, 1985.

Time Span: Jenny Holzer, On Kawara, Bruce Nauman, Lawrence Weiner. Barcelona: Fundació Caixa de Pensions, 1990.

Walter Dahn, René Daniels, Isa Genzken, Jenny Holzer, Robert Longo, Henk Visch. Eindhoven: Stedelijk Van Abbemuseum, 1983.

ZURBRUGG, NICHOLAS, ed. *Art, Performance, Media: 31 Interviews*. Minneapolis: University of Minnesota Press, 2004.

Elizabeth Murray

Monographs, Solo Exhibition Catalogues, and Video Recordings

King, Elaine A. *Elizabeth Murray: Drawings, 1980–1986.* Pittsburgh: Carnegie Mellon University Art Gallery, Carnegie Mellon University Press; New York, 1986.

Murray, Elizabeth. *Notes for Fire and Rain.* New York: Lapp Princess Press, 1981.

——. *Popped Art.* Pop-ups designed by Bruce Foster. New York: Museum of Modern Art, 2005.

——. *Elizabeth Murray.* Berkeley: The University Art Museum, the University of California at Berkeley, 1987.

——. *Elizabeth Murray.* Overland Park, Kans.: Johnson County Community College, 1993.

——. *Elizabeth Murray.* Tokyo: Gallery Mukai, 1990.

——. *Elizabeth Murray* [video recording]. New York: Inner-Tube Video, 1989.

——. *Elizabeth Murray at Gemini 1994–2002.* Los Angeles: Gemini G.E.L., 2002.

——. *Elizabeth Murray, Drawings.* Long Beach: The University Art Museum, California State University, 1987.

——. *Elizabeth Murray Interview.* Chicago: Video Data Bank, School of the Art Institute of Chicago, 1978, 1982.

——. *Elizabeth Murray: Modern Women.* New York: The Museum of Modern Art, 1995.

——. *Elizabeth Murray: New Paintings.* Philadelphia: Locks Gallery, 1993.

——. *Elizabeth Murray: New Work.* San Francisco: The San Francisco Museum of Modern Art, 1988.

——. *Elizabeth Murray, Paintings and Drawings.* New York: Harry N. Abrams in association with the Dallas Museum of Art and the MIT Committee on the Visual Arts, 1987.

——. *Elizabeth Murray: Paintings and Works on Paper.* Hanover, N.H.: Dartmouth College, 2002.

——. *Elizabeth Murray, Prints, 1979–1990.* Boston: Barbara Krakow Gallery, 1990.

——. *Elizabeth Murray: Paintings 1999–2003.* New York: PaceWildenstein, 2003.

——. *Recent Work by Elizabeth Murray: Clarity and Complexity.* Columbus, Ohio: Wexner Center for the Arts, 1991.

Storr, Robert. *Elizabeth Murray.* New York: The Museum of Modern Art, 2005.

Group Exhibition Catalogues

Armstrong, Richard, and Richard Marshall. *Five Painters in New York: Brad Davis, Bill Jensen, Elizabeth Murray, Gary Stephan, John Torreano.* New York: Whitney Museum of American Art, 1984.

Coad, Robert James. *Between Painting and Sculpture [microform]: A Study of the Work and Working Process of Lynda Benglis, Elizabeth Murray, Judy Pfaff, and Gary Stephan.* Ann Arbor, Mich.: University Microfilms International, 1984.

Drawing Redux. San Jose, Calif.: The San Jose Museum of Art, 1992.

Early Works by Five Contemporary Artists: Ron Gorchov, Elizabeth Murray, Dennis Oppenheim, Dorothea Rockburne, Joel Shapiro. New York: The New Museum, 1977.

Eight Abstract Painters. Philadelphia: Institute of Contemporary Art, University of Pennsylvania, 1978.

The Elusive Surface: Painting in Three Dimensions. Albuquerque, N. Mex.: The Albuquerque Museum, 1989.

Jennifer Bartlett & Elizabeth Murray: Works from the Anderson Collection. Oakland, Calif.: Mills College, 1991.

Stachelberg, Cas. *Soho at Duke: Six Artists from the Paula Cooper Gallery.* Durham, N.C.: Duke University Museum of Art, 1988.

SHIRIN NESHAT

Monographs, Solo Exhibition Catalogues, and Video Recordings

AKBARNIA, LADAN. *Speaking Through the Veil: Reading Language and Culture in the Photographs of Shirin Neshat*. Los Angeles: University of California, Los Angeles, 1997.

DABASHI, HAMID. *Shirin Neshat*. Milan: Charta; London: Art Books International, 2002.

EDELSTEIN, SUSAN, ed. *Shirin Neshat "Women of Allah."* Vancouver: Artspeak Gallery, 1997.

GAGNON, PAULETTE. *Shirin Neshat*. Montreal: Musée d'art contemporain de Montréal, 2001.

JUNG, JÖRG, and RALF RAIMO JUNG. *Shirin Neshat: The Woman Moves*. Princeton: Films for the Humanities & Sciences, 2004.

MILANI, FARZANEH. *Shirin Neshat*. Milan: Charta; London: Art Books International, 2001.

NESHAT, SHIRIN. *Projects 70: Banners (Cycle 1)*. New York: The Museum of Modern Art, 1999.

———. *Shirin Nesatto Ten*. Hiroshima: Hiroshima-shi Gendai Bijutsukan, 2005.

———. *Shirin Neshat*. Aarhus, Denmark: Aarhus Kunstmuseum, 2002.

———. *Shirin Neshat*. Göttingen: Steidl, 2006.

———. *Shirin Neshat*. Høvikodden, Norway: Henie Onstad Kunstsenter; Oslo: in association with Riksutstillinger, 1999.

———. *Shirin Neshat*. Kanazawa: Contemporary Art Museum, 2001.

———. *Shirin Neshat*. Ljubljana: Moderna galerija, 1997.

———. *Shirin Neshat*. Milan: Edizioni Charta, 2002.

———. *Shirin Neshat*. New York: Annina Nosei Gallery, 1997.

———. *Shirin Neshat*. Vienna: Kunsthalle Wien; London: Serpentine Gallery, 2000.

———. *Shirin Neshat*. Warsaw: Centrum Sztuki Współczesnej, Zamek Ujazdowski, 2002.

———. *Shirin Neshat, Rapture*. Paris: Galerie Jerome de Noirmont, 1999.

———. *Shirin Neshat, Soliloquy*. Dallas: Dallas Museum of Art, 2000.

———. *Shirin Neshat, Turbulent*. New York: Whitney Museum of American Art at Philip Morris, 1998.

———. *Shirin Neshat: 2002–2005*. Milan: Charta, 2005.

———. *Shirin Neshat, Women of Allah: photographies, films, videos*. Paris: Paris audiovisuel, Maison européenne de la photographie, 1998.

———. *Through the Eyes of Shirin Neshat*. Auckland: Auckland Art Gallery, 2004.

———. *Tooba*. México: Instituto Nacional de Bellas Artes, 2003.

———. *Women of Allah*. Turin: Marco Noire Editore, 1997.

ZAYA, OCTAVIO, ed. *Shirin Neshat: la última palabra*. León: MUSAC; Milan: Charta, 2005.

Group Exhibition Catalogues

ABBASPOUR, MITRA MONIR. *Trans-national, Cultural, and Corporeal Spaces: The Territory of the Body in the Artwork of Shirin Neshat and Mona Hatoum*. Riverside, Calif.: University of California at Riverside, 2001.

Contemporary Photography and the Garden: Deceits & Fantasies. New York: Harry N. Abrams in association with the American Federation of Arts, 2004.

CRISTALDI, MIRIAM. *Materia immateriale: identità, mutamenti e ibridazioni dell'arte nel nuovo millennio: Marina Abramovich, Joseph Beuys, Claudio Costa, Giulio De Mitri, Shirin Neshat, Alessandra Tesi, Bill Viola*. Livorno, Italy: Edizioni Peccolo Livorno, 2003.

Echolot: Oder, 9 Fragen an die Peripherie: Ghada Amer, Ayse Erkmen, Fariba Hajamadi, Mona Hatoum, Gülsün Karamustafa, Kim Soo-Ja, Tracey Moffatt, Shirin Neshat, Qin Yufen. Kassel: Museum Friedricianum, 1998.

Genders & Nations: Artistic Perspectives: Shirin Neshat, Chila Kumari Burman. Ithaca, N.Y.: Herbert F. Johnson Museum of Art, 1998.

HEYNEN, JULIAN, ed. *Sammlung Ackermans*. Ostfildern-Ruit: Hatje Cantz, 2002.

HORRIGAN, BILL. *Shirin Neshat, Two Installations*. Columbus, Ohio: Wexner Center for the Arts, the Ohio State University; New York, 2000.

Mar de fondo: Ghada Amer, Teresa Cebrián, Victoria Civera, Ayse Erkmen, Irit Hemmo, Gülsün Karamustafa, Jenny Marketou, Carmen Navarrete, Shirin Neshat, Eulàlia Valldosera, María Zárraga. Valencia: Generalitat Valenciana, Cinc Segles de la Universitat de València, 1998.

McCABE, JENNIFER. *Boundaries in Contemporary Art: Shahzia Sikander, Ghada Amer, Shirin Neshat*. San Francisco: San Francisco State Universtiy, 2003.

Non toccare la donna bianca. Turin: Hopefulmonster, 2004.

Outbound: Passages from the 90's. Houston: Contemporary Arts Museum, 2000.

Racines: Ghada Amer, Brahim Bachiri, Samta Benyahia, Mohamed El Baz, Mona Hatoum, Shirin Neshat. Grenoble: Musée Dauphinois, 2000.

RAVENAL, JOHN B. *Outer & Inner Space: Pipilotti Rist, Shirin Neshat, Jane & Louise Wilson, and the History of Video Art*. Richmond: Virginia Museum of Fine Arts, 2002.

Vanessa Beecroft, Shirin Neshat. Bologna: Galleria d'arte moderna, 1998.

VIOLA, BILL. *Bill Viola i Shirin Neshat v Gosudarstvennom Ermitazhe*. St. Petersburg: Hermitage Museum, 2003.

Vocazioni: Arte e vita come necessità: Shirin Neshat, Manuela Cirino, Cecilia Guastaroba, Silvia Levenson, Maria Morganti. Cinisello Balsamo, Milan: Silvana, 2000.

ZANGANEH, LILA AZAM, ed. *My Sister, Guard Your Veil; My Brother, Guard Your Eyes: Uncensored Iranian Voices*. Boston: Beacon Press, 2006.

JUDY PFAFF

Monographs and ExhibitionCatalogues

PFAFF, JUDY. *Judy Pfaff*. Saint Louis, Mo.: The Saint Louis Art Museum, 1989.

——. *Judy Pfaff*. Savannah, Ga.: Savannah College of Art and Design, 2002.

——. *Judy Pfaff, Autonomous Objects*. Charlotte, N.C.: The Spirit Square Center for the Arts, 1986.

——. *Judy Pfaff: Collages and Constructions*. Buffalo: Buffalo Fine Arts Academy, 1982.

——. *Judy Pfaff: Elephant*. Waltham, Mass.: Rose Art Museum, 1995.

——. *Judy Pfaff, Installation Artist*. Ann Arbor, Mich.: Produced by the University of Michigan Media Union Library, Regents of the University of Michigan, 2003.

——. *Judy Pfaff, Installations, Collages, and Drawings*. Sarasota, Fla.: John & Mable Ringling Museum of Art, 1981.

——. *Judy Pfaff, Outside/Inside/Landscapes*. New York: Independent Curators International, 1998.

——. *Judy Pfaff, Power Boothe*. New York: ARC Video Dance, 1987.

——. *Judy Pfaff: 10,000 Things*. New York: Holly Solomon Gallery, 1988.

——. *Judy Pfaff: Transforming Traditions*. Ashland, Ore.: Schneider Museum of Art, Southern Oregon University, 2000.

——. *Notes on Light and Color*. Hanover, N.H.: Dartmouth College, 2000.

——. *Stone, Scissor, Paper*. Tokyo: Wacoal Art Center, 1986.

SANDLER, IRVING. *Judy Pfaff*. New York: Hudson Hills Press, in association with Elvehjem Museum of Art, University of Wisconsin-Madison, 2003.

Studies and Group Exhibition Catalogues

COAD, ROBERT JAMES. *Between Painting and Sculpture: A Study of the Work and Working Process of Lynda Benglis, Elizabeth Murray, Judy Pfaff, and Gary Stephan*. Ann Arbor, Mich.: University Microfilms International, 1984.

Extensions—Jennifer Bartlett, Lynda Benglis, Robert Longo, Judy Pfaff. Houston: Contemporary Arts Museum, 1980.

The Fine Art Collection of Dr. Donald L. & Dorothy Jacobs. Georgetown, Ky.: Georgetown College, in association with Harmony House Publ., 2002.

HAYS, JOHANNA. *Sculptors' Drawings: Terry Allen, Viola Frey, Robert McCauley, Mary Miss, Dann Nardi, Judy Pfaff, Michael Singer.* Rohnert Park, Calif.: Sonoma State University Art Gallery, 1986.

Hesse, Lawler, Martin, Meyer, Pfaff, Smith, Winsor. New York: Holly Solomon Gallery, 1990.

LIPSKI, DONALD. *Working in Brooklyn: Sculpture: Donald Lipski, Chris MacDonald, John Monti, Tom Otterness, Judy Pfaff, Ray Rapp, Alan Saret, Art Spellings, William Tucker, Christopher Wilmarth.* Brooklyn: The Brooklyn Museum, 1985.

Presage of Passage: Sculpture for a New Century: Judy Pfaff, Richard Hunt, Brower Hatcher. Provo, Utah: Brigham Young University Museum of Art, 1999.

RICHARDS, JUDITH OLCH. *Inside the Studio: Two Decades of Talks with Artists in New York.* New York: Independent Curators International (ICI), 2004.

Sculptors' Drawings: Mark di Suvero, Chris Duncan, Curator, Brower Hatcher, Judy Pfaff, Sue Rees, Mia Westerlund Roosen, William Tucker. New York: Visual Arts Museum at the School of Visual Arts, 1997.

Sculptural Perspectives: An Exhibition of Small Sculpture of the 70s, Joel Shapiro, Judy Pfaff, Don Johnson, Tony Berlant, Thomas Bang. Santa Barbara: University of California, Santa Barbara Art Museum, 1979.

10 Artists/Artists Space: Laurie Anderson, Jon Borofsky, Scott Burton, Lois Lane, Thomas Lanigan-Schmidt, Ree Morton, Judy Pfaff, Charles Simonds, Barbara Schwartz, John Torreano. Purchase, N.Y.: Neuberger Museum, State University of New York, College at Purchase, 1980.

Visions of America: Landscape as Metaphor in the Late Twentieth Century. Denver: Denver Art Museum; Columbus, Ohio: Columbus Museum of Art; New York, 1994.

Wallworks: Judy Pfaff, Sol LeWitt, Michael Glier, Dorothea Rockburne, Vernon Fisher, Krzysztof Wodiczko. New York: John Weber Gallery, 1986.

DANA SCHUTZ

Monographs and Solo Exhibition Catalogues

SCHUTZ, DANA. *Dana Schutz: Paintings, 2002–2005.* Waltham, Mass.: The Rose Art Museum, 2006.

Group Exhibition Catalogues

DAILEY, MEGHAN. *The Triumph of Painting, Volume 2: Saatchi Gallery.* Munich: Ingvild Goetz, 2007.

GOETZ, INGVILD and STEPHAN URBASCHEK. *Imagination Becomes Reality, Part V: Fantasy and Fiction.* London: König Books, 2006.

CINDY SHERMAN

Monographs and Solo Exhibition Catalogues

BARASH, ELIZABETH A. *Cindy Sherman's Untitled Film Stills and Their Film Noir Precedents: Construction and Deconstruction*. 1988.

BARR, MARY. *Cindy Sherman*. Wellington, N.Z.: National Art Gallery, 1989.

FELIX, ZDENEK, and MARTIN SCHWANDER, eds. *Cindy Sherman: Photographic Work 1975–1995*. London: Schirmer Art Books, 1995.

KELLEIN, THOMAS, ed. *Cindy Sherman*. Stuttgart: Edition Cantz, 1991.

KNAPE, GUNILLA, ed. *Cindy Sherman: The Hasselblad Award 1999*. Göteborg, Sweden: Hasselblad Center, 2000.

KRAUSS, ROSALIND E. *Cindy Sherman, 1975–1993*. New York: Rizzoli, 1993.

LORECK, HANNE. *Geschlechterfiguren und Körpermodelle: Cindy Sherman*. Munich: Silke Schreiber, 2002.

MORRIS, CATHERINE. *The Essential Cindy Sherman*. New York: Wonderland Press, Harry N. Abrams, 1999.

SCHNEIDER, CHRISTA. *Cindy Sherman History Portraits: Die Wiedergeburt des Gemäldes nach dem Ende der Malerei*. Munich: Schirmer/Mosel, 1995.

SHERMAN, CINDY. *Centerfolds*. New York: Skarstedt Fine Art, 2003.

——. *Cindy Sherman*. Amsterdam: Stedelijk Museum, 1982.

——. *Cindy Sherman*. Basel: Kunsthalle Basel, 1991.

——. *Cindy Sherman*. Cambridge, Mass.: MIT Press, 2006.

——. *Cindy Sherman*. Dijon: Bureau d'étude et de diffusion d'art contemporain, 1983.

——. *Cindy Sherman*. Hartford, Conn.: Wadsworth Atheneum, 1986.

——. *Cindy Sherman*. London: Serpentine Gallery, 2003.

——. *Cindy Sherman*. Milan: Mazzotta, 1990.

——. *Cindy Sherman*. Munich: Schirmer/Mosel, 1982.

——. *Cindy Sherman*. Munich: Schirmer/Mosel, 1984.

——. *Cindy Sherman*. Munich: Schirmer/Mosel, 1987.

——. *Cindy Sherman*. New York: Pantheon Books, 1984.

——. *Cindy Sherman*. New York: Whitney Museum of American Art, 1987.

——. *Cindy Sherman*. Paris: Flammarion, 2006.

——. *Cindy Sherman*. Rotterdam: Museum Boijmans Van Beuningen, 1996.

——. *Cindy Sherman*. Saint-Etienne: Musée d'art et d'industrie, 1983.

——. *Cindy Sherman*. Stony Brook, N.Y.: State University of New York at Stony Brook, 1983.

——. *Cindy Sherman*. Tokyo: Parco, 1987.

——. *Cindy Sherman*. Tokyo: Shozo Tsurumoto, 1984.

——. *Cindy Sherman at the Tel Aviv Museum of Art*. Tel Aviv: The Tel Aviv Museum of Art, 1993.

——. *Cindy Sherman: Clowns*. Munich: Schirmer/Mosel, 2004.

——. *Cindy Sherman: The Complete Untitled Film Stills*. New York: Museum of Modern Art, 2003.

——. *Cindy Sherman: Fotografiska arbeten 1975–1995*. Mälmo, Sweden: Mälmo konsthall, 1995.

——. *Cindy Sherman, In Conversation with Wilfried Dickhoff*. Cologne: Kiepenheuer & Witsch, 1995.

——. *Cindy Sherman: Photographien*. Munster: Westfalischer Landesmuseum, 1985.

——. *Cindy Sherman, Retrospective*. New York: Thames & Hudson; Chicago: Museum of Contemporary Art; Los Angeles: Museum of Contemporary Art, 1997.

——. *Cindy Sherman: Una selección de las colecciones de la Eli Broad Family Foundation*. Caracas: Museo de Bellas Artes, CONAC, 1997.

——. *Cindy Sherman: Unidentified Photographs, 1981–82*. St. Louis, Mo.: St. Louis Art Museum, 1983.

——. *Cindy Sherman: Untitled Film Stills*. New York: Rizzoli, 1990.

——. *Cindy Sherman: Specimens*. Kyoto, Japan: Kyoto Shoin International, 1991.

——. *Cindy Sherman: Working Girl: Decade Series 2005*. St. Louis, Mo.: Contemporary Art Museum of St. Louis, 2005.

——. *Cindy Sherman: Zur Verleihung des Goslarer Kaiserrings am 16. Oktober 1999 und zur Ausstellung im Mönchehaus-Museum für moderne Kunst Goslar*. Goslar: Kulturressort, Verein zur Förderung moderner Kunst, 1999.

——. *Early Work of Cindy Sherman*. East Hampton, N.Y.: Glenn Horowitz Bookseller in association with D.A.P, 2000.

——. *Fitcher's Bird*. New York: Rizzoli, 1992.

——. *History Portraits / Cindy Sherman*. New York: Rizzoli, 1991.

——. *Nobody's Here But Me*. London: Arts Council of Great Britain, 1994.

——. *Untitled Film Stills / Cindy Sherman*. Munich: Schirmer Art Books, 1998.

——. *Verleihung des Wolfgang-Hahn-Preis 1997 an Cindy Sherman am 6. November 1997*. Cologne: Gesellschaft für Moderne Kunst am Museum Ludwig, 1997.

STAVITSKY, GAIL. *The Unseen Cindy Sherman: Early Transformations 1975/1976*. Montclair, N.J.: Montclair Art Museum; Santa Monica, Calif.: Smart Art Press, 2004.

TSCHINKEL, PAUL. *Cindy Sherman: Transformations*. New York: New York Inner Tube Video, 2002.

Studies and Group Exhibition Catalogues

Alibis: Richard Artschwager, Gérard Collin-Thiébaut, Gérard Garouste, Luciano Fabbro, Pierre Klossowski, Robert Longo, Carlo Maria Mariani, Cindy Sherman, Jan Vercruysse, Didier Vermeiren, William Wegman. Paris: Le Centre Georges Pompidou, Musée national d'art moderne, Galeries contemporaines, 1984.

Altered Egos: Samaras, Sherman, Wegman. Phoenix: Phoenix Art Museum, 1986.

Arte & Arte: Dara Birnbaum, Rebecca Horn, Sol Lewitt, Michelangelo Pistoletto, Alberto Savinio, Cindy Sherman, Ettore Spalletti. Milan: Fabbri, 1991.

Becher, Mapplethorpe, Sherman. Monterrey: Museo de Monterrey, 1992.

CHADWICK, WHITNEY, ed. *Mirror Images: Women, Surrealism, and Self-Representation*. Cambridge, Mass.: MIT Press, 1998.

Cindy Sherman, Richard Wilson, Richard Artschwager: The Saatchi Collection. London: Saatchi Collection, 1991.

CLAWSON, JACK A. *Cindy Sherman, Barbara Kruger and Jenny Holzer: A Study in Feminist Art*. Baton Rouge, La.: Louisiana State University, 1993.

Collaboration John Baldessari, Cindy Sherman. Zürich; New York: Parkett-Verlag, 1991.

The Controversial Women's Body: [Images and Representations in Literature and Art]. Bologna: Bononia University Press, Università degli studi di Bologna, 2003.

DANZKER, JO-ANNE BIRNIE, ed. *Hautnah: die Sammlung Goetz*. Munich: Museum Villa Stuck, 2002.

L'envers des choses: Annette Messager, Cindy Sherman, George Kuchar. Paris: Centre Georges Pompidou, 1993.

FRIEDMAN, MILDRED S., ed. *The Anxious Edge: Eight Artists: Jonathan Borofsky, Bruce Charlesworth, Chris Burden, Robert Longo, David Salle, Italo Scanga, Cindy Sherman, Hollis Sigler*. Minneapolis: The Walker Art Center, 1982.

From Beyond the Pale: Julião Sarmento and Cindy Sherman. Dublin: Irish Museum of Modern Art, 1994.

HARRIS, MELISSA, ed. *On Location: Studio Visits with Annie Leibovitz, Lorna Simpson, Susan Meiselas, Cindy Sherman, Adam Fuss, Joel-Peter Witkin, Jon Goodman*. New York: Aperture, 1993.

Her Bodies: Cindy Sherman & Vanessa Beecroft. Korea: Arario Gallery, 2004.

KIMMELMAN, MICHAEL. *Portraits: Talking with Artists at the Met, the Modern, the Louvre, and Elsewhere*. New York: Random House, 1998.

KLAUKE, JÜRGEN. *Jürgen Klauke, Cindy Sherman*. Ostfildern: Cantz; Munich: Sammlung Goetz, 1994.

KROGH-NIELSEN, ANNA. *The Possibility of a Female Gaze: Discussion of Cindy Sherman and Hannah Wilke*. Stony Brook, N.Y.: State University of New York at Stony Brook, 1995.

Louise Lawler, Adrian Piper and Cindy Sherman. New York: Committee for the Visual Arts, 1978.

Louise Lawler, Cindy Sherman, Laurie Simmons. Oslo: Kunstnernes Hus, 1993.

Louise Lawler, Cindy Sherman, Laurie Simmons: Returning the Gaze. Helsinki: Nykytaiteen museo, 1993.

LUMPKIN, OLIVIA LIBBY. *Self in Women's Art: Hannah Wilke, Eleanor Antin and Cindy Sherman*. Austin: University of Texas at Austin, 1987.

Narcissism: Artists Reflect Themselves: Andy Warhol, Chuck Close, Cindy Sherman.... Escondido, Calif.: California Center for the Arts Museum, 1996.

Ohne Titel. Göttingen: Steidl, 2006.

Périls et colères: Asta Gröting, Clegg & Guttman, Fabrice Hybert, Cindy Cherman.... Bordeaux: CAPC-Musée d'art contemporain, 1992.

Read My Lips: Jenny Holzer, Barbara Kruger, Cindy Sherman. Australia: National Gallery of Australia, 1998.

RICE, SHELLEY, ed. *Inverted Odysseys: Claude Cahun, Maya Deren, and Cindy Sherman*. Cambridge, Mass.: MIT Press, 1999.

The Rome Studio: Cindy Sherman, Michel Auder, Richard Prince, Meyer Vaisman.... Providence, R.I.: Brown University, 1993.

Sarajevo: Progetto culturale internazionale museo d'arte contemporanea Sarajevo 2000: artisti per Sarajevo, Alighiero Boetti, Nan Goldin, Ilya Kabakov, Joseph Kosuth.... Venice: Arsenale, 1997.

SCHUMACHER, RAINALD, and MATTHIAS WINZEN, eds. *Die Wohltat der Kunst: post/feministische Positionen der neunziger Jahre aus der Sammlung Goetz.* Cologne: König, 2002.

SILLS, LESLIE. *In Real Life: Six Women Photographers.* New York: Holiday House, 2000.

SMITH, SIDONIE, and JULIA WATSON, eds. *Interfaces: Women, Autobiography, Image, Performance.* Ann Arbor: University of Michigan Press, 2002.

Surrogate Selves: David Levinthal, Cindy Sherman, Laurie Simmons. Washington, D.C.: Corcoran Gallery of Art, 1989.

Von Beuys bis Cindy Sherman: Sammlung Lothar Schirmer: 329 Werke von 43 Künstlern. Munich: Schirmer/Mosel, 1999.

WALTER, CHRISTINE. *Bilder erzählen!: Positionen inszenierter Fotografie: Eileen Cowin, Jeff Wall, Cindy Sherman, Anna Gaskell, Sharon Lockhart, Tracey Moffatt, Sam Taylor-Wood.* Weimar: VDG, 2002.

KIKI SMITH

Monographs and Solo Exhibition Catalogues

AHEARN, CHARLIE. *Kiki in the Flesh / Art by Kiki Smith.* New York: Pow Wow productions, 1993.

BALSON, YANA J. *Catholicism and the Flesh: An Examination of the Female Body in the Work of Kiki Smith.* Philadelphia: 1999.

BALTROCK, THOMAS, ed. *Kiki Smith: Werke: 1988–1996.* Cologne: Salon Verlag; New York: Distributed Art Publishers, 1998.

BRADLEY, JESSICA. *Kiki Smith.* Toronto: Power Plant, 1994.

DUNGAN, ELIZABETH ANNE. *....At the Border: The Work of Kiki Smith.* Berkeley: University of California, Berkeley, 1996.

ENGBERG, SIRI. *Kiki Smith: A Gathering, 1980–2005.* Minneapolis: Walker Art Center, 2005.

HAENLEIN, CARL, ed. *Kiki Smith: All Creatures Great and Small.* Hanover: Kestner Gesellschaft; Zurich; New York: Scalo, 1999.

LAHS-GONZALES, OLIVIA. *My Nature: Works with Paper by Kiki Smith.* St. Louis, Mo.: Saint Louis Art Museum, 1999.

POSNER, HELAINE. *Kiki Smith.* Boston: Little, Brown and Co., 1998.

POSNER, HELAINE. *Kiki Smith.* New York: Monacelli Press, 2005.

SHEARER, LINDA. *Kiki Smith.* Williamstown, Mass.: Williams College Museum of Art; Columbus, Ohio: Wexner Center for the Arts, the Ohio State University, 1992.

SMITH, KIKI. *Companion.* New York: LeRoy Neiman Center for Print Studies, Columbia University, 2000.

——. *Fountainhead / Kiki Smith.* Columbus, Ohio: Logan Elm Press, 1991.

——. *Invention/Intervention: Kiki Smith and the Museums.* Pittsburgh: Carnegie Museum of Art, 1998.

——. *Kiki Smith.* Amsterdam: Institute of Contemporary Art; The Hague: Sdu Publishers, 1990.

——. *Kiki Smith.* Humlebæk, Denmark: Louisiana Museum of Modern Art, 1994.

——. *Kiki Smith.* Jerusalem: The Israel Museum, 1994.

——. *Kiki Smith.* London: Trustees of the Whitechapel Art Gallery, 1995.

——. *Kiki Smith.* Madrid: Metta Galería, 1998.

——. *Kiki Smith.* Montreal: Montreal Museum of Fine Arts, 1996.

——. *Kiki Smith*. New York: The Museum of Modern Art, 1990.

——. *Kiki Smith*. Paris: Galerie Lelong, 2003.

——. *Kiki Smith*. Santa Barbara: The University of California at Santa Barbara Art Museum, 1994.

——. *Kiki Smith*. Seoul: Kukje Gallery, 2000.

——. *Kiki Smith Convergence*. Dublin: Irish Museum of Modern Art, 1997.

——. *Kiki Smith: Forefront 31*. Indianapolis: Indianapolis Museum of Art, 1999.

——. *Kiki Smith: The Fourth Day: Destruction of Birds*. New York: PaceWildenstein, 1997.

——. *Kiki Smith: Homespun Tales*. Venice: Fondazione Querini Stampalia, 2005.

——. *Kiki Smith: New Work*. New York: PaceWildenstein, 1995.

——. *Kiki Smith: Night*. Washington, D.C.: Hirshhorn Museum and Sculpture Garden, Smithsonian Institution, 1998.

——. *Kiki Smith: Photographs: A Looking at Native American Beadwork and Baskets from the Collection of Charles and Valerie Diker*. Long Island City, N.Y.: Fisher Landau Center, 2001.

——. *Kiki Smith: Prints, Books & Things*. New York: The Museum of Modern Art, 2003.

——. *Kiki Smith: Prints and Multiples, 1985–1993*. Boston: Barbara Krakow Gallery, 1994.

——. *Kiki Smith: Realms*. New York: PaceWildenstein, 2002.

——. *Kiki Smith: Reconstructing the Moon*. New York: PaceWildenstein, 1997.

——. *Kiki Smith, Silent Work*. Vienna: MAK Gallery, 1992.

——. *Kiki Smith: Small Sculptures and Large Drawings*. Ulm: Ulmer Museum; Ostfildern-Ruit: Hatje Cantz, 2001.

——. *Kiki Smith: Sojourn in Santa Barbara*. Santa Barbara: University of California at Santa Barbara Art Museum, 1995.

——. *Kiki Smith: Telling Tales*. New York: International Center of Photography, 2001.

——. *Kiki Smith: Unfolding the Body: An Exhibition of the Work in Paper*. Waltham, Mass.: Brandeis University, Rose Art Museum, 1992.

——. *Kiki Smith's Dowry Book*. London: Anthony d'Offay Gallery, 1997.

——. *Re*. Santa Barbara, Calif.: University of California at Santa Barbara, 1994.

——. *Tidal*. New York: LeRoy Neiman Center for Print Studies, Columbia University, 1998.

——. *The Vitreous Body*. Tampa, Fla.: Graphicstudio, University of South Florida, 2001.

——. *What Girls Know About Grids: For Leslie Gore, Mo Tucker, Laura Nyro and Ma Cass*. New York: Pace Editions, 2000.

TSCHINKEL, PAUL. *Kiki Smith*. New York: Inner-tube Video, 1994.

WEITMAN, WENDY. *Kiki Smith: Prints, Books and Other Things*. New York: Museum of Modern Art., 2003.

Studies and Group Exhibition Catalogues

BEEBE, MARY LIVINGSTONE. *Landmarks: Sculpture Commissions for the Stuart Collection at the University of California, San Diego*. New York: Rizzoli, 2001.

BERSSENBRUGGE, MEI-MEI. *Concordance*. Berkeley: Kelsey St. Press, 2006.

——. *Endocrinology*. West Islip, N.Y.: Universal Limited Art Editions, 1997.

BIRD, JON, ed. *Other Worlds: The Art of Nancy Spero and Kiki Smith*. Gateshead, Eng.: BALTIC; London: Reaktion Books, 2003.

The Body Electric: Zizi Raymond and Kiki Smith. Washington, D.C.: Corcoran Gallery of Art, 1991.

Conceal/Reveal. Santa Fe, N.M.: Site Santa Fe, 1996.

DANZKER, JO-ANNE BIRNIE, ed. *Hautnah: die Sammlung Goetz*. Munich: Museum Villa Stuck, 2002.

Désordres: Nan Goldin, Mike Kelley, Kiki Smith, Jana Sterbak, Tunga. Paris: Editions du jeu de paume, Réunion des musées nationaux, 1992.

Diagnosis: Marc de Guerre, Mark Lewis, Kiki Smith, Jana Sterbak. Toronto: York University, 1990.

Favorites: Monica Bonvicini, Angela Bulloch, Anna Meyer, Lisa Milroy, Muntean/Rosenblum, Eva Schlegel, Kiki Smith, Esther Stocker, Milica Tomic. Graz: Galerie & Edition Artelier, 2003.

Gegendarstellung: Ethik und Ästhetik im Zeitalter von AIDS. Hamburg: Kunstverein in Hamburg, 1992.

GIPS, TERRY, ed. *Terra Firma*. College Park, Md.: The Art Gallery, University of Maryland at College Park, 1997.

HALL, DONALD. *Corporal Politics: Louise Bourgeois, Robert Gober, Lilla LoCurto and William Outcault, Annette Messager, Rona Pondick, Kiki Smith, David*

Wojnarowicz. Cambridge, Mass.: MIT Visual Arts Center; Boston: Beacon Press, 1993.

Hallwalls: Richard Armijo, G. Roger Denson, Carroll Dunham, Catherine Howe, John Miller, Aura Rosenberg, Kiki Smith, Julie Wachtel, Ada Whitney. Buffalo: Hallwalls, 1983.

Hesse, Lawler, Martin, Meyer, Pfaff, Smith, Winsor. New York: Holly Solomon Gallery, 1990.

In the Flesh. Ridgefield, Conn.: The Aldrich Museum of Contemporary Art, 1996.

In the Lineage of Eva Hesse. Ridgefield, Conn.: The Aldrich Museum of Contemporary Art, 1994.

Kant Park: Clegg & Guttmann, Carsten Höller, Olaf Nicolai, Kiki Smith: ein Gemeinschaftsprojekt vom Wilhelm Lehmbruck Museum Duisburg und Siemens Kulturprogramm. Duisburg: Wilhelm Lehmbruck Museum, 1999.

KIMMELMAN, MICHAEL. *Portraits: Talking with Artists at the Met, the Modern, the Louvre, and Elsewhere*. New York: Modern Library, 1999, 1998.

Laboratoires pour une expérience du corps: Damien Hirst, Fabrice Hybert, Kiki Smith, Patrick van Caeckenbergh. Rennes: Presses Universitaires de Rennes, 1995.

Me & More: Magdalena Abakanowicz, Laylah Ali, Ross Bleckner, Antony Gormley, Yishai Jusidman, Barbara Kruger, Elke Krystufek, Urs Lüthi, Tatjana Marusic, Miao Siaochun, Ernesto Neto, Chloe Piene, Kiki Smith, Zhang Huan…. Lucerne: Edizioni Periferia, 2003.

Natural History: Ellen Cooper, John Fekner, Peter Fend, Rebecca Howland, Justen Ladda, Christy Rupp, David Saunders, Kiki Smith, Anton van Dalen, James Welling. New York: The Grace Borgenicht Gallery, 1982.

NOEVER, PETER, ed. *Positionen zur Kunst*. Ostfildern: Cantz, 1994.

OBLER, BIBIANA KATHERINA. *Examining a Literal Genealogy: The Case of Kiki and Tony Smith*. Berkeley: University of California at Berkeley, 2000.

Private Öffentlichkeit. Düsseldorf: Richter, 2002.

Reflection: Seven Years in Print. New York: Miriam and Ira D. Wallach Art Gallery, Columbia University in the City of New York, 2003.

RICHARDS, JUDITH OLCH, ed. *Inside the Studio: Two Decades of Talks with Artists in New York*. New York: Independent Curators International (ICI), 2004.

RUSH, MICHAEL. *Smith, Smith, Smith*. Lake Worth, Fla.: Palm Beach Institute of Contemporary Art, 2002.

RUSH, MICHAEL, ed. *The Smiths*. Lake Worth, Fla.: Palm Beach Institute of Contemporary Art; New York, 2002.

SHONE, RICHARD. *Some Went Mad, Some Ran Away—Johannes Albers, Ashley Bickerton, Sophie Calle…*. London: Serpentine Gallery, 1994.

Signs of Life: Rebecca Howland, Christy Rupp, Kiki Smith, Cara Perlman. Normal, Ill.: University Galleries, Illinois State University, 1993.

Skulptur statt Denkmal: Ausstellungsprojekt 1993–1995. Düsseldorf: Galerie M. und R. Fricke; Ostfildern: Cantz, 1995.

SMITH, ELIZABETH A. T. *Paradise Cage: Kiki Smith and Coop Himmelb(l)au*. Los Angeles, Calif.: Museum of Contemporary Art, Los Angeles, 1996.

——. *How Braces Came To Be: A Myth for Modern Mortals*. McLean, Va.: Starflower Books, 1996.

Surface and Illusion: Ten Portfolios. New York: Aperture, 1996.

TEMBECK, TAMAR. *Transgressive Corporealities: A Feminist's Analysis of Representations of the Body in Works by Kiki Smith, Mona Hatoum, and Marie Chouinard*. Montreal: Université du Québec à Montréal, 2002.

Unnatural Science. North Adams, Mass.: MASS MoCA (Massachusetts Museum of Contemporary Art), 2000.

NANCY SPERO

Monographs, Exhibition Catalogues, and Video Recordings

DÉRY, LOUISE. *Nancy Spero—l'image parlée*. Montreal: Galerie de l'UQAM, 2001.

JENKINS, SUSAN L. *Nancy Spero: The Re-Ontologization of Female Imagery*. Los Angeles: University of Southern California, 1990.

KÄHLER, INGEBORG, and DIRK LUCKOW, eds. *Nancy Spero: A Continuous Present*. London: Phaidon, 1996.

KING, ELAINE A. *Nancy Spero: The Black Paris Paintings 1959–1966*. Pittsburgh: Hewlett Gallery, Carnegie-Mellon University, 1985.

Nancy Spero. Chicago: Video Data Bank, School of the Art Institute of Chicago, 1982.

Nancy Spero [video recording]. Chicago: The Museum of Contemporary Art, 1988.

REINHARDT, BRIGITTE, ed. *Nancy Spero*. Stuttgart: Edition Cantz, 1992.

SCHLEGEL, AMY INGRID. *Codex Spero: Feminist Art and Activist Practices in New York Since the Late 1960's*. Ann Arbor, Mich: UMI Dissertation Services, 2003.

SOSA, IRENE. *Woman as Protagonist: The Art of Nancy Spero*. New York: Irene Sosa, 1993.

SPERO, NANCY. *A Continuous Past*. Düsseldorf: Richter; Manchester: Cornerhouse, 2004.

——. *Let the Priests Tremble, We're Going to Show Them Our Sexts*. 1988.

——. *Nancy Spero*. Albuquerque, N.Mex.: The University of New Mexico at Albuquerque Art Museum, 1983.

——. *Nancy Spero*. Berkeley, Calif.: The University of California at Berkeley Art Museum, 1984.

——. *Nancy Spero*. Birmingham: Ikon Gallery, 1998.

——. *Nancy Spero*. Chicago: Video Data Bank, School/Art Institute of Chicago, 1983.

——. *Nancy Spero*. Greenville, S.C.: The Museum and Emrys Foundation, 1993.

——. *Nancy Spero*. Hartford, Conn.: Wadsworth Atheneum, 1983.

——. *Nancy Spero*. London: Institute of Contemporary Arts, 1987.

——. *Nancy Spero*. Los Angeles: The Museum of Contemporary Art, Los Angeles in collaboration with the Woman's Building, Los Angeles, 1988.

——. *Nancy Spero*. United States Information Agency, 1998.

——. *Nancy Spero, Bilder 1958–1990*. Berlin: Haus am Waldsee; Bonn: Bonner Kunstverein, 1990.

——. *Nancy Spero: 43 Works on Paper: Excerpts from the Writings of Antonin Artaud*. Cologne: Galerie Rudolf Zwirner, 1987.

——. *Nancy Spero: In der Glyptothek; arbeiten auf papier 1981–1991*. Munich: Staatliche Antikensammlungen and Glyptothek, 1991.

——. *Nancy Spero / med en essä av Susan Harris*. Malmö: Malmö konsthall, 1994.

——. *Nancy Spero: Re-birth of Venus*. Kyoto, Japan: Kyoto Shoin International Co., 1989.

——. *Nancy Spero: Selected Works from Codex Artaud 1971–1972*. Dartmouth, Mass.: University Art Gallery, 2001.

——. *Nancy Spero: Sky Goddess Egyptian Acrobat*. Rome: Galleria Stefania Miscetti, 1991.

——. *Nancy Spero: The War Series: 1966–1970*. Milan: Charta, 2003.

——. *Nancy Spero: To Soar II*. Northampton, Mass.: The Smith College Museum of Art, 1990.

——. *Nancy Spero: Weighing the Heart Against a Feather of Truth*. Malaga: Centro Galego de Arte Contemporánea, 2004.

——. *Nancy Spero: Woman Breathing*. Ulm: Ulmer Museum, 1992.

——. *Nancy Spero, Works Since 1950*. Syracuse, N.Y.: Everson Museum of Art, 1987.

——. *Notes in Time on Women, Part II: Women, Appraisals, Dance & Active Histories*. Hamilton, N.Y.: Picker Art Gallery, 1979.

——. *Raise/Time*. Cambridge, Mass.: Harvard University Art Museums, 1995.

——. *Women—Appraisals, Dance, & Active Histories*. Hamilton, N.Y.: Picker Art Gallery, Colgate University, 1979.

——. *Woman as Protagonist: The Art of Nancy Spero*. Cambridge, Mass.: Office for the Arts, Harvard University, 1995.

Studies and Group Exhibition Catalogues:

American Policy: Edgar Heap of Birds, Alfredo Jaar, Aminah Robinson, Nancy Spero. Cleveland, Ohio: Art Gallery, Cleveland State University, 1987.

Art & Ideology. New York: New Museum of Contemporary Art, 1984.

ARTAUD, ANTONIN. *Chanson / Antonin Artaud*. New York: Red Ozier Press, 1985.

Artists Draw: Tom Martin, Auste Peciura, Alan Saret, Patti Smith, Nancy Spero. New York: Committee for the Visual Arts Inc., 1979.

Athena & Arachne: Nancy Davidson, Oliver Herring, Robin Kahn, Lauren Letitia, Nancy Spero, Randy Wray. New York: Apex Art, 1994.

Baranik, Basen, Hasen, McKeeby, Petlin, Spero. Hamilton, N.Y.: Colgate University, 1969.

BIRD, JON, ed. *Other Worlds: The Art of Nancy Spero and Kiki Smith*. Gateshead, Eng.: BALTIC; London: Reaktion Books, 2003.

Conspiracy: The Artist as Witness. New York: D. Godine, 1972.

The Critical Image. Greensboro, N.C.: The University of North Carolina at Greensboro, 1991.

Détente: Rudolf Fila - Arnulf Rainer, Milan Knízák - Tony Cragg, Stanislav Kolíbal - David Rabinowitch, Karel Malich - Yves Klein, Adriena Simotová - Nancy Spero, Zdenek Sýkora - Matt Mullican, Jirí Valoch- Joseph Kosuth. Vienna: Museum Moderner Kunst Stiftung Ludwig Vienna, 1993.

Disarming Images: Art for Nuclear Disarmament. New York: Adama Books, 1984.

From the Inside Out: Eight Contemporary Artists, Eleanor Antin.... New York: The Jewish Museum, 1993.

GOLUB, LEON. *Golub/Spero*. New York: Josh Baer Gallery, 1993.

———. *Leon Golub, Nancy Spero*. Greenville, S.C.: Greenville County Museum of Art, 1986.

———. *Leon Golub and Nancy Spero, War and Memory*. Cambridge, Mass.: MIT List Visual Arts Center, 1994.

Golub/Spero [video recording]. Chicago, Ill.: Kartemquin, 2004.

Gone Beyond Gone. New York: Thread Waxing Space, 1993.

The History of the Future. New York: Franklin Furnace Archive, 1999.

Impossible Evidence: Contemporary Artists View the Holocaust: Melissa Gould, Ellen Rothenberg, Nancy Spero, Art Spiegelman. Reading, P.A.: The Freedman Gallery, 1994.

KIMMELMAN, MICHAEL. *Portraits: Talking with Artists at the Met, the Modern, the Louvre, and Elsewhere*. New York: Modern Library, 1999, 1998.

Laughter Ten Years After. Geneva, N.Y.: Hobart and William Smith Colleges Press, 1995.

Let's Talk About Sex: Sexualität und Körperlichkeit in der Gegenwartskunst. Dresden: Kunst Haus Dresden Städtische Galerie für Gegenwartskunst, 2001.

MADILL, SHIRLEY. *Identity, Identities: Shelagh Alexander, Kati Campbell, Jane Gurney, Mary Scott, Cindy Sherman, Nancy Spero, Jana Sterbak*. Winnipeg: Winnipeg Art Gallery, 1988.

Nancy Spero: A Cycle in Time: Leon Golub: Update. Salzburg: Internationale Sommerakademie für Bildende Kunst; Vienna: Galerie Christine König, 1995.

Notes in Time: Leon Golub, Violence Report: Nancy Spero, Notes in Time on Women. Catonville, Md.: Fine Arts Gallery, University of Maryland Baltimore County, 1995.

Pressplay: Contemporary Artists in Conversation. London; New York: Phaidon, 2005.

SEARLE, ADRIAN, ed. *Talking Art 1: Chris Burden, Sophie Calle, Leon Golub, Dan Graham, Richard Hamilton, Susan Hiller, Mary Kelly, Andres Serrano, Nancy Spero*. London: Institute of Contemporary Arts, 1993.

She Writes in White Ink: Janice Gurney, Mary Scott, Nancy Spero. Banff: Walter Phillips Gallery, 1985.

SPERO, NANCY. *Nancy Spero and Leon Golub: A Commitment to the Human Spirit*. Milwaukee, Wis.: University of Wisconsin, Milwaukee, 1991.

———. *Nancy Spero/Leon Golub*. Caracas: Museo Jacobo Borges, 1998.

STRAUSS, DAVID LEVI. *Leon Golub and Nancy Spero*. New York: Roth Horowitz, 2000.

True Grit: Lee Bontecou, Louise Bourgeois, Jay DeFeo, Claire Falkenstein, Nancy Grossman, Louise Nevelson, Nancy Spero. New York: Michael Rosenfeld Gallery, 2000.

ZEGHER, M. CATHERINE DE. *Persistent Vestiges: Drawing from the American-Vietnam War*. New York: The Drawing Center, 2005.

Archives

SPERO, NANCY. *Nancy Spero Papers, 1961–1979*. Washington, D.C.: Archives of American Art, Smithsonian Institution.

Index

Page numbers in italics refer to illustrations.
Page numbers in **BOLDFACE** refer to the main chapter on the artist.

Acknowledgments

The initial concept for this book—women curators and critics writing about the impact and importance of women artists—had its inception at an ArtTable luncheon in New York where, coincidentally, art historian Linda Nochlin was being honored. Over the next few years the authors continued to develop the idea; however, it did not take its present form until Christopher Lyon, Executive Editor at Prestel, became involved in the project. Chris has been instrumental in creating a strong focus for this book and we greatly appreciate the expert guidance and enthusiasm he offered throughout the process. We also wish to thank Mary Christian for her precise and informed editing and, of course, Linda Nochlin for her valuable foreword and ongoing inspiration.

James Yohe at Ameringer & Yohe Fine Art; Zach Feuer at Zach Feuer Gallery (LFL); Natasha Roje and Rebecca Sternhal at Gagosian Gallery; Cecile Panzieri at Sean Kelly Gallery; Bridget Donahue at Gladstone Gallery; Caroline Burghardt at Luhring Augustine; Peter Schuette at Metro Pictures and Jon Mason at PaceWildenstein; as well as Wendy Williams at Louise Bourgeois's studio; Jessica Larva at Ann Hamilton's studio; Alanna Gedgaudas at Jenny Holzer's studio; Jeanne Englert at Judy Pfaff's studio; and Samm Kunce at Nancy Spero's studio generously provided images and information on the artists whose work is featured in this book.

We appreciate the efforts of Amy Lucker, Library Director of the Institute of Fine Arts at New York University, in preparing the informative bibliography for this volume and assembling the statistics on monographs on women artists. Rachel Cohn worked diligently in gathering the statistics on solo exhibitions by women at museums and galleries, and Mary Delle Stelzer and Stuart Stelzer were invaluable in organizing and interpreting the data.

Most important, we would like to thank the artists, including Marina Abramović, Louise Bourgeois, Ellen Gallagher, Ann Hamilton, Jenny Holzer, Elizabeth Murray, Shirin Neshat, Judy Pfaff, Dana Schutz, Cindy Sherman, Kiki Smith, and Nancy Spero, who have given their time so generously to us and whose remarkable bodies of work attest to the strength and diversity of women's contributions to the contemporary visual arts.

Eleanor Heartney, Helaine Posner, Nancy Princenthal, and Sue Scott